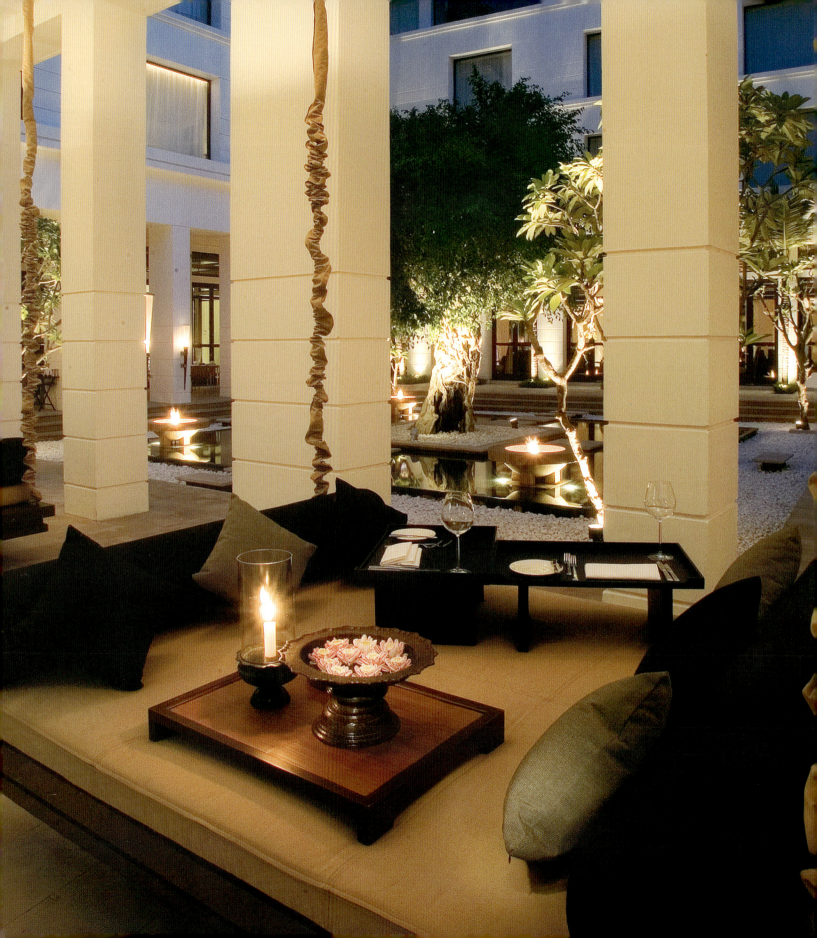

paradisebydesign

TROPICAL RESIDENCES AND RESORTS BY BENSLEY DESIGN STUDIOS

Bill Bensley

PERIPLUS EDITIONS
Singapore • Hong Kong • Indonesia

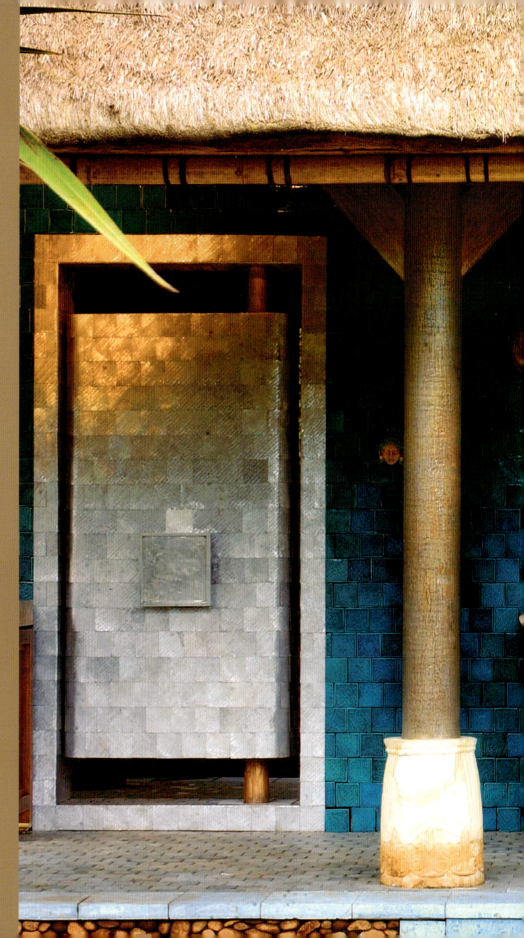

Published by Periplus Editions
www.periplus.com

Copyright © 2008 Bill Bensley

All rights reserved. No part of this publication may be reproduced or utilized in any form or by any means, electronic or mechanical, including photocopying, recording, or by any information storage and retrieval system, without prior written permission from the publisher.

ISBN: 978-0-7946-0493-6

Distributed by
North America, Latin America & Europe
Tuttle Publishing
364 Innovation Drive, North Clarendon
VT 05759-9436, USA
Tel: 1 (802) 773-8930; Fax: 1 (802) 773-6993
info@tuttlepublishing.com
www.tuttlepublishing.com

Japan
Tuttle Publishing
Yaekari Building 3rd Floor, 5-4-12 Osaki
Shinagawa-ku, Tokyo 141-0032
Tel: (81) 3 5437-0171; Fax: (81) 3 5437-0755
sales@tuttle.co.jp
www.tuttle.co.jp

Asia Pacific
Berkeley Books Pte Ltd
61 Tai Seng Avenue #02-12, Singapore 534167
Tel: (65) 6280-1330; Fax (65) 6280-6290
inquiries@periplus.com.sg
www.periplus.com

Indonesia
PT Java Books Indonesia
Kawasan Industri Pulogadung
Jl. Rawa Gelam IV No. 9, Jakarta 13930
Tel: (62) 21 4682-1088; Fax: (62) 21 461-0206
crm@periplus.co.id
www.periplus.co.id

15 14 13 12 8 7 6 5 4 3 2
Printed in Hong Kong 1111EP

Front endpaper Two-dimensional mural at the Kirana Spa by Shiseido in Sayan, Bali (page 108), inspired by the Klungkung school of painting and produced by Pesamuan of Sanur, Bali. **Back endpaper** At the front entry gate of the Bensley Residence (page 144), a gecko is simply rendered in cement and stained saffron. **Page 1** Detail of the glass mosaic wall behind the reception desk at Le Touesserok, Mauritius (page 228). **Page 2** Swing seating in the Meric restaurant at the Hotel de la Paix in Siem Reap, Cambodia (page 218). **Page 3** A cast bronze sign at the Anantara Spa, Anantara Hua Hin Resort, Thailand (page 192), means number one in Thai. **Pages 4–5** Exquisite hand-painted terracotta tiles by Pesamuan of Sanur, Bali, line up perfectly with beaten aluminum tiles of the same size on the thick swivel doors of the rest rooms in the Bale Cinik Garden at Villa Rosha (page 72). A wood-framed mirror, ordered from Milan but in fact made in Java, dominates the wall. **Pages 6–7** The steps leading into the saltwater waterfall pool at the Marriott Mumbai (page 42).

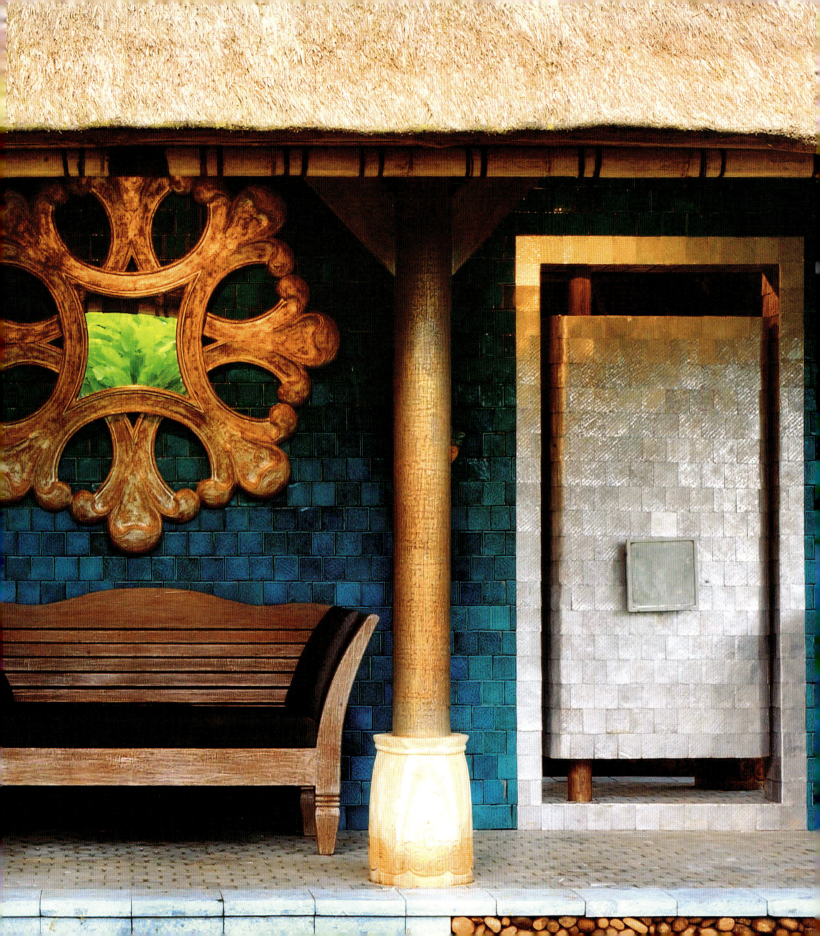

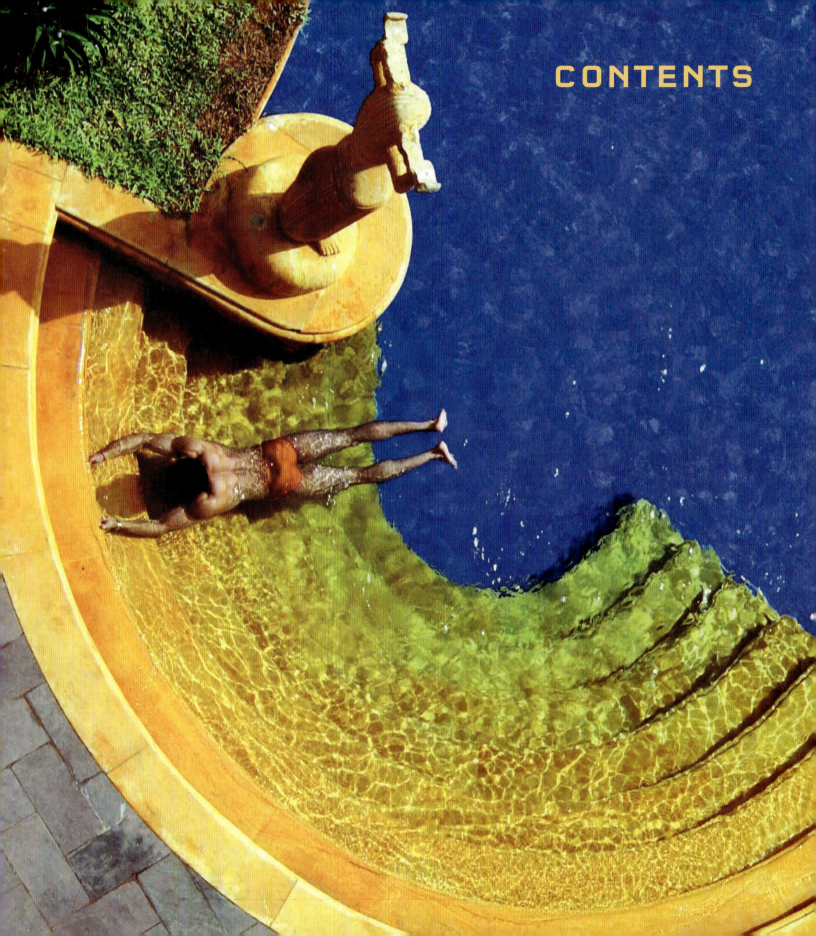
CONTENTS

- 8 Introducing Paradise

PARADISE IN CHINA
- 18 **Paradiso:** Lord Love a Duck
- 26 **Casa California:** Spain Meets Guangzhou
- 34 **Sheraton Sanya Resort:** The New Waikiki

PARADISE IN INDIA
- 42 **Marriott Mumbai:** On Bollywood's Beach
- 50 **Udaivilas:** Setting New Standards
- 60 **Amarvilas:** At the Foot of the Taj Mahal

PARADISE IN INDONESIA
- 72 **Villa Rosha:** A Home Without Walls
- 96 **Karawaci Residence:** Far from Suburbia
- 108 **Kirana Spa, Bali:** The Spa on the Hill

PARADISE IN MALAYSIA
- 124 **Kebun Mimpi:** The Garden of Dreams
- 130 **The Fathil Residence:** An Islamic Twist on the Malaysian Vernacular
- 138 **Four Seasons Langkawi:** Malaysian Mystique

PARADISE IN THAILAND
- 144 **The Bensley Residence:** Baan Botanica
- 154 **The Howard Residence:** Teak, Silk and Lots of Loving Tender Care
- 172 **Marriott Hua Hin:** Tropical Safari
- 178 **Marriott Phuket:** A Beachside Coconut Grove
- 188 **Anantara Koh Samui:** Serious Monkey Business
- 192 **Anantara Hua Hin:** On the Water's Edge
- 202 **Anantara Spa by Mandara, Hua Hin:** Testing the Waters
- 208 **Anantara Golden Triangle:** All Rooms With Views to Burma and Laos
- 212 **Four Seasons Resort and Residences, Chiang Mai:** A Northern Thai Classic

OTHER TROPICAL PARADISES
- 218 **Hotel de la Paix, Siem Reap, Cambodia:** Art Deco Relived
- 228 **Le Touessrok, Mauritius:** A Tropical Oasis of Tranquil Luxury
- 232 **Oberoi Mauritius:** Sunset in Paradise
- 240 Acknowledgments

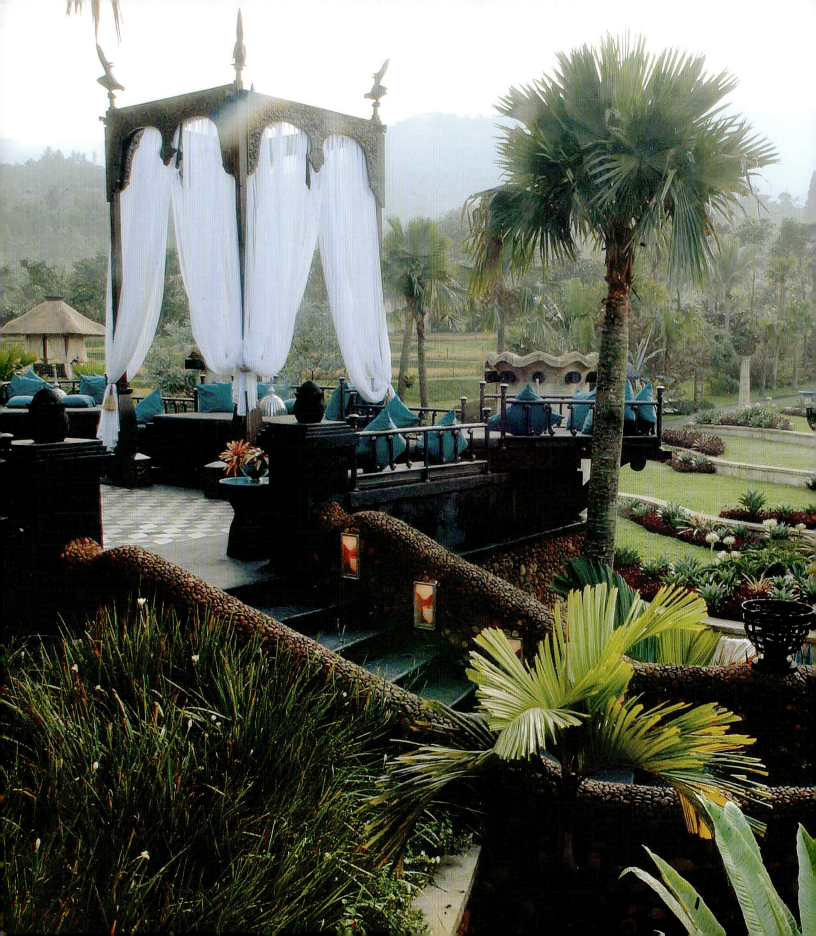

INTRODUCING PARADISE

Raking up fallen rubber tree leaves, barefoot, is one of my earliest memories. Paradise for me was Orange County, southern California, at a time when orange trees still grew mile after mile and you could smell their heavily scented blossoms all the way to the beach. Working in our large suburban garden was a daily affair when I was growing up in the 1960s and 1970s. My father, an English migrant to the United States, has gardening in his blood, and from the time I was small he taught me the art of raising vegetables, flowers, bees and animals as well as basic gardening techniques. "Dad," as he is fondly called by everyone, has lived with me in Bangkok since 1995 and I am still learning from him!

As a teenager I would make our yard look so good that people would stop in the street and take photographs of it. By high school I was employed by almost all the residents on our street, which in the springtime was a riot of color. My best clients, the Rosenblums, gave me my first gardening budget of $25, which I promptly spent on ranaculus tubers and tulips.

In my school's career education class, I was assigned to telephone people in various professions and ask them to speak to our class. One day, purely by accident, I reached M. Purkiss Rose, Landscape Architects. I asked the man on the line, Roco Campanazi, what a landscape architect was, and he went on to explain the profession, as best he could, to a very naïve sophomore. He ended up coming to speak to my class, and the slides of his gardens at Knotts Berry Farm held me spellbound.

Inspired, I was soon enrolled at Cal Poly Ponoma, which has an excellent landscape architectural program. I loved the subject. It combined my artistic talents with my passion for gardening. And I did well, winning a number of awards, a first place in a national design competition and then a full scholarship to a Boston college—Harvard! Here, I was the youngest in my class of 35 and was way over my head. My classmates hailed from all over the world. One of them was Lek Bunnag from Thailand. Lek was the brightest in our class and meeting him was the highlight of my graduate studies. We have been firm friends ever since and he has taught me far more than I ever learned at Harvard. We graduated in 1984, and not having any solid plans, I accepted Lek's offer to join him and his lovely wife Louisa in Singapore. First, though, I hitchhiked through Europe for four months on $8.34 a day and had the time of my life before eventually landing in Singapore, completely out of funds. A day later, I landed a job in a landscape architectural company, Belt Collins. Ray Cain and his team were very good to me. They gave me my first pay check in advance, then sent me around the region designing gardens for five-star resorts for five fun-filled years.

Right At the Anantara Hua Hin in Thailand (page 192), we placed both the Mandara Spa and the resort's oval swimming pool on the edge of extensive waterways, blurring the boundaries between nature and the built environment.

In those years I became a true Baliphile, reading everything I could lay my hands on about the Indonesian island and exploring every corner of it. I was thoroughly smitten by its people, culture and landscape. I went on to learn the language fluently—both spoken and written, including the language of Balinese architecture—and designed a whole series of gardens.

In 1989, Thailand—Lek Bunnag's homeland—woke up economically, and I started my own studio, tiny at first—35 people in a parking garage—under the wing of Dang Kongsak of Leo Design. Lek started his own company in the same garage. It was there that I drafted the plans for the rice fields of the Regent Chiang Mai for my long-time client and friend Bill Heinecke. I met the now-expert horticulturist Jirachai Rengthong in 1989, who was to bring an intrinsic richness into the planting of our projects. Lek and I soon outgrew the garage and set up our own studio, which we shared for the next 13 years until it had expanded so much that we were tripping over each other. Our company director, landscape architect Brian Sherman, and I moved our studio to the old Iraqi Embassy building in 2003, just a few minutes' walk from Lek's studio. We have lots of room here—and voluminous tropical gardens—in which to experiment, with the bonus of a swimming pool and gymnasium for our numerous staff.

The best part about having our studios in Thailand and Bali is that I truly believe these places are home to the most creative and naturally artistic people in the world. With the exception of myself and Brian Sherman, all our designers are either Thai or Balinese. In these places, people still know how to craft with their hands, drawing comes naturally to almost all of them, and the natural world is still very much a part of their everyday lives. Successful agrarian societies possess the spare time to indulge in the hobbies they enjoy, unlike us city dwellers where time and function dominate our lives. We produce large numbers of drawings in our studios, not purely for commissioned projects but for the sifting of ideas, for expunging what is irrelevant and for understanding what might eventually emerge. The best advice I can give on this subject is, "If you ever need to think about manpower, cost or time in the process of creative design, then you can never do justice to a project." In our studios, when a project demands it, manpower, cost or time is of no consequence.

My studio in Thailand is a cauldron. Being the magpie collector and excessive shopper that I am, it has become a repository of culturally significant artifacts and materials that provide catalysts for the germination of ideas. Books also play a huge role. Numbering into the hundreds, permeating both the conscious and subconscious levels, they provide another important springboard for creativity. But the ultimate success of our studios lies with our talented designers.

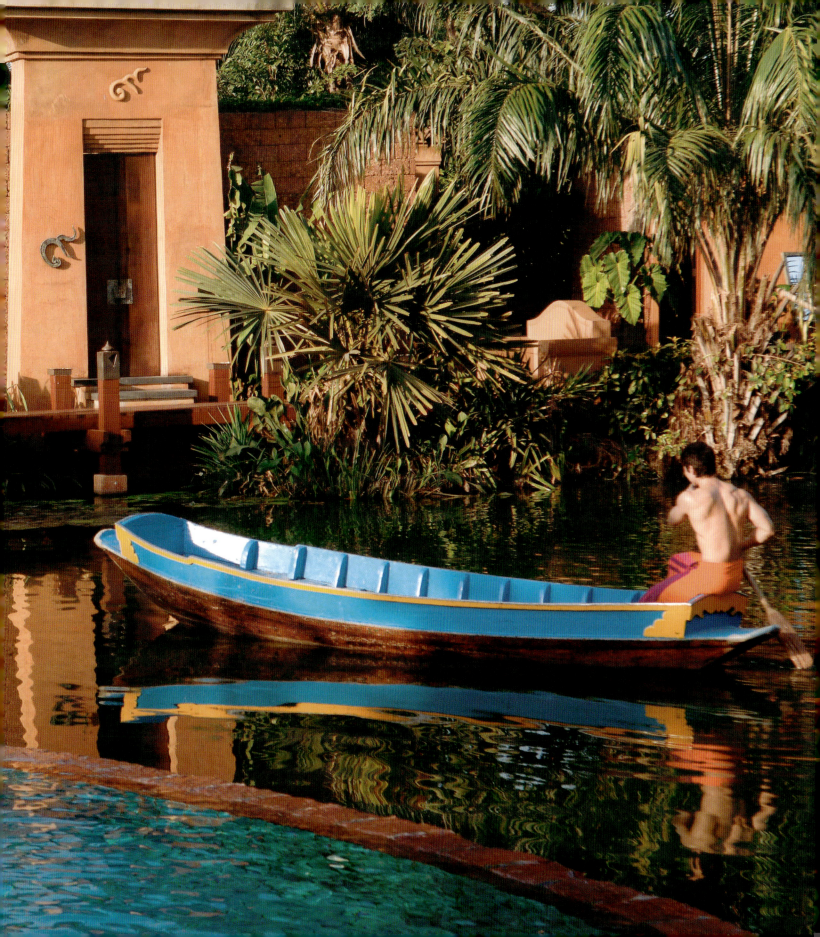

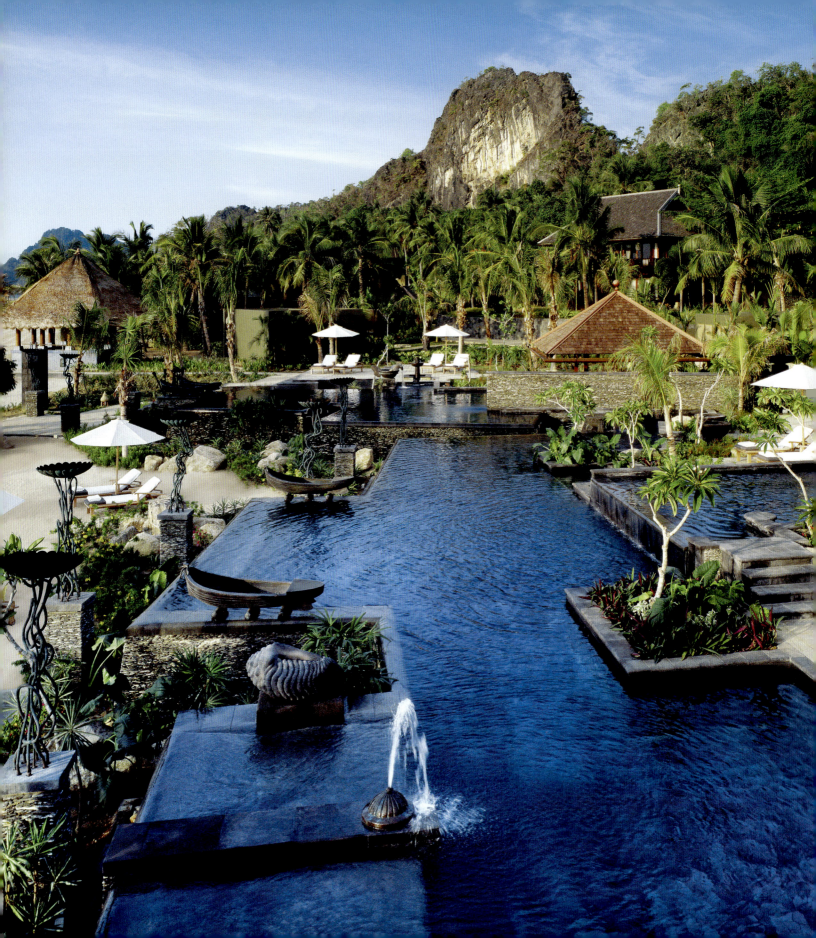

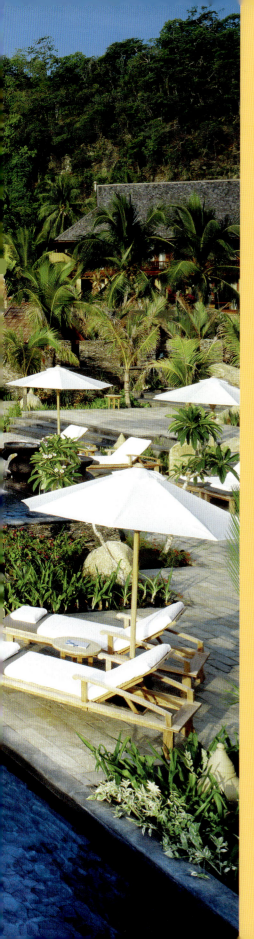

Left Magnificent limestone cliffs look down protectively over this dynamic poolscape at the Four Seasons Resort Langkawi, Malaysia (page 138). Facing north across the Andaman Sea to the islands of Thailand, this multilayered pool features playful areas for children as well as quiet corners for adults. One of my design principles is to never build a poolside deck that can accommodate more than eight loungers, as no one likes to be squashed with others like sardines.

All designers, without exception, must be able to draw with their hands. Hand–eye coordination, I believe, is essential in order for designers to be able to think clearly about what it is they want to create. While some designers are especially strong in certain skills, such as drawing perspectives, I try very hard not to pigeonhole that talent but to nurture other talents and open the door for them to gather expertise in other areas.

Bensley Design Studios has undertaken a huge amount of work in many countries over a very short period of time, especially in the hospitality arena, and this has created a strong bond of common experience amongst the staff. To date, we have been commissioned to design in some 26 countries around the world, with a focus on the Asia Pacific. I employ 80 designers from various disciplines: architects, landscape architects, interior architects, fine artists, a lighting designer, horticulturists and drafting technicians.

Designers organize their work spaces in the studio as they like, sitting with whom they like. I don't believe in forming departments, and I purposely mix project teams so that people can learn from each other. Design transcends disciplines, and I believe all good design arises out of passion and the ability to draw inspiration from varied and multiple sources—as well as the ability to think laterally. I believe our studios provide an excellent example of how talented designers can work together in harmony with a singular direction as opposed to "teamwork," which often involves a compromising of ideas to satisfy the entire team.

I first hired an interior designer because I wanted to learn more about interior design. The same with our lighting designer. Our best interior designer is a landscape architect by training. One of our best landscape architects is a trained draftsman, and our best horticulturist was trained as a political scientist! I impose very few rules, but I do insist that nobody does freelance work. If someone needs extra money, we have an open-ended overtime policy. Anyone can work for as long as they like, because in all design work there is always something else that can be drawn or considered. Our designers thrive under this system and are very loyal; I have been working with almost all of our key designers for well over ten years now.

Clearly, artwork is one of the most salient characteristics of our body of built work, and I attribute this to our stable of seven fine artists—designers in their own right—who help us to explore and develop our ideas and take them in new directions. The confluence of their unique perceptions, blended with those of the designers, imbues our work with an effective mix of design, craft and art. Indeed, this is the concept of the cauldron, where ideas are fomented and emerge in ways we often never fully expect.

Right The chic Hotel de la Paix in Siem Reap, Cambodia (page 218), was an exciting new adventure for me in hotel design. The Arts Lounge shown here is where local artists are encouraged to display their avant-garde works. The bar and Khmer stone mural behind it are front and back lit by LED light that changes color every few hours to suit the mood of the bar.

Ultimately, though, ours is a cauldron of passion—for beauty and for life. The artworks that appeal most to me are generally those that evoke primal or primordial sensations as well as those that are executed with seemingly nonchalant ease and simplicity. The best artwork leaves the onlooker amazed at the creator's ability and craft. This was why my initial impetus was to engage artists in the studio. Besides helping us to design our projects, they have made numerous "installations" for projects where subcontracting this artwork would have resulted in second best. I also think of gardens as a framework or canvas to be accentuated by artwork—unique artwork, never to be repeated in any other project.

I love to sculpt stone because stone has a quality of permanence. Over the years we have designed hundreds and hundreds of stone sculptures that are now in the form of carefully catalogued drawings. I have found that simply issuing our beautiful drawings to a stone craftsman to execute is not enough as it leaves too much room for interpretation. We prefer instead to create wax models so that we can study the artwork in three dimensions. This presents stonemasons with less ambiguity and reduces the chance of a disastrous outcome.

Our artists are also a tremendous help with presentations to clients. We have developed a technique, a particular style, of presenting very long and colorful conceptual drawings to them. Sometimes the drawings are 50 feet (15 meter) long and are usually all hand-drawn, which is very labor-intensive. In our way of working, many designers and artists work simultaneously on the same sheet of long paper in a highly involved and collaborative manner, with lots of intuitive touches. With large, very descriptive drawings it is easy for our clients to be drawn into our designs, to understand and appreciate them on a scale that deviates from the norm. We also try to adopt the graphic style of a particular country, especially in places with a rich traditional history and style of drawing. For example, in India we draw as the Mughals did, with their false perspectives and stacked elevations. In China, we adopt the calligraphic style of black ink on rice paper, using their unique perspectives.

Our design studio is a complex organism, ever growing and, I hope, ever changing. It survives through sustenance as well as experience. Sustenance is achieved through new designers, clients, projects and ideas. Experience is the cumulative learning curve of the entire studio. The results, both luxury lifestyle resorts and extravagant private residences—completed projects, ongoing work and future designs—all set amidst tropical gardens, are vividly profiled in this informative behind-the-scenes account of how resorts and residences are crafted. Sit back and enjoy our handiwork!

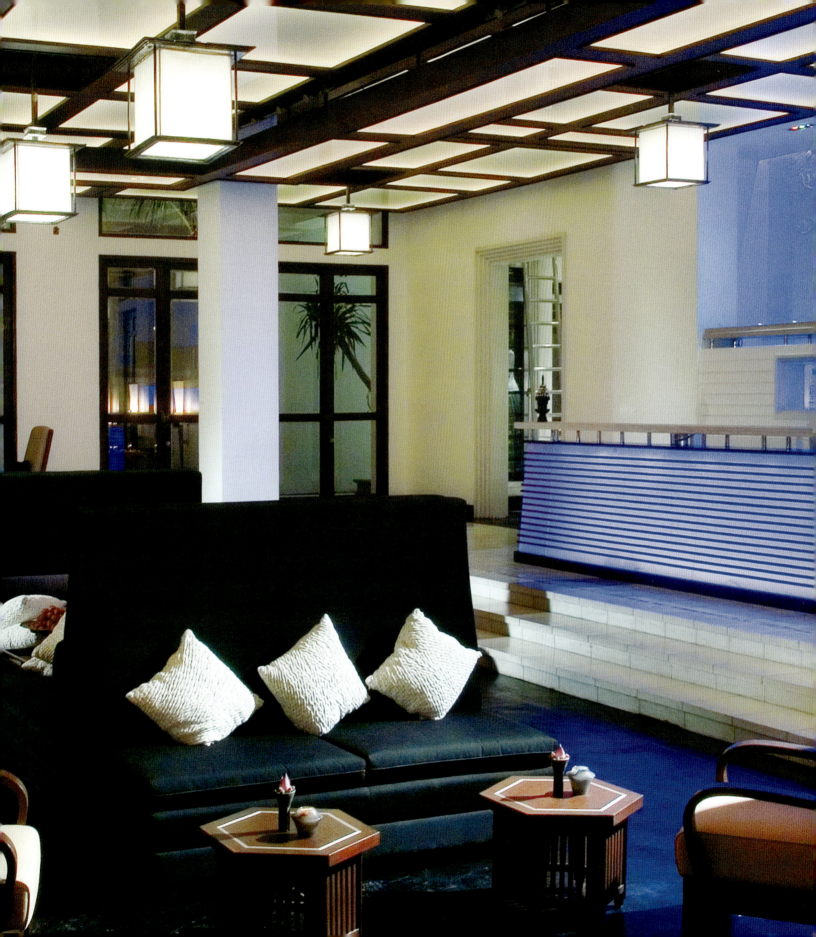

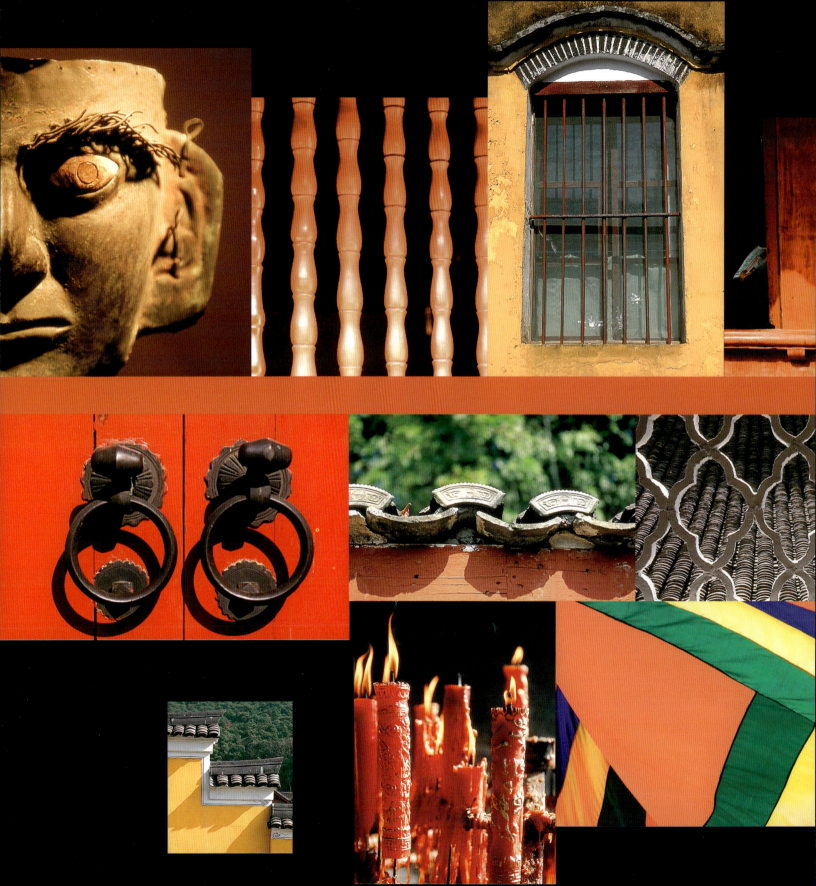

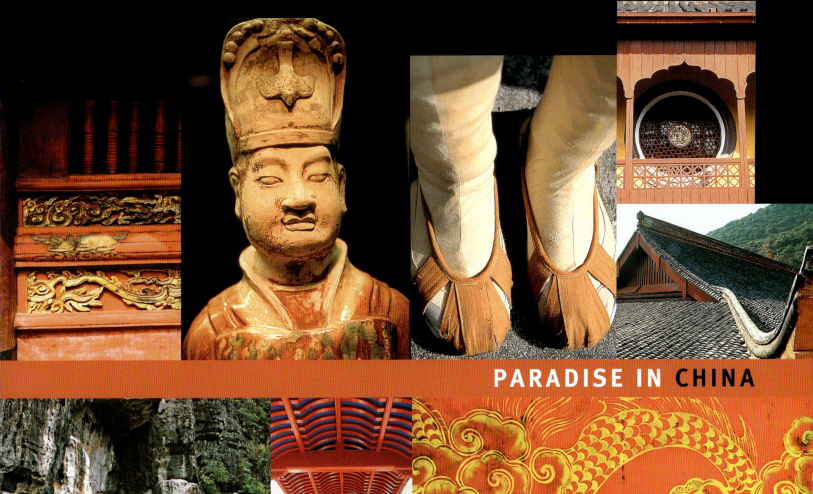

PARADISE IN CHINA

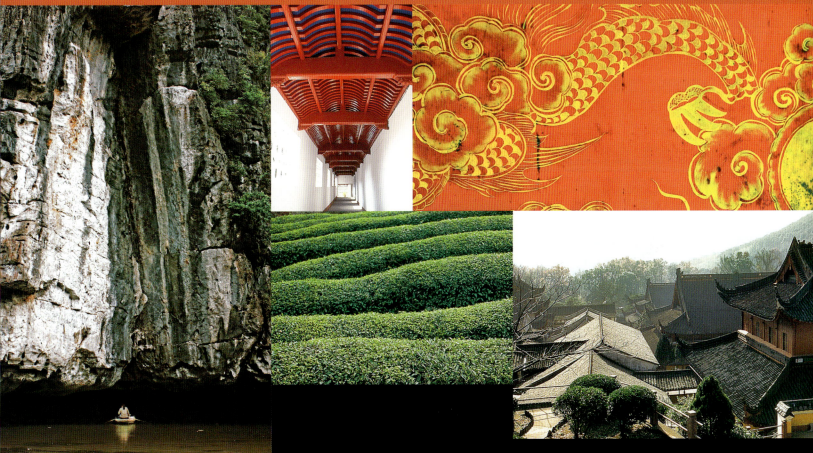

PARADISO
LORD LOVE A DUCK

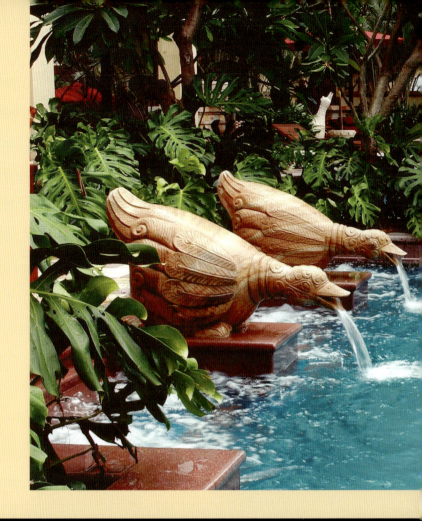

Who cannot suppress a chuckle at the sight of a fat duck? Who cannot appreciate the humor of animal caricatures? The tropical gardenscape at the Paradiso Luxury Residences in Shenzhen, located in the Pearl River Delta in southern China, forms a playful contrast to the four 30-story towers that look across the ocean to Hong Kong, only 12 miles (25 km) away. Built initially to cater to the wealthy local population, the resort/condominium development quickly became a magnet for Hong Kong and Guangzhou weekenders and its intensely detailed landscaping a much talked of feature. The gardens, commissioned especially to produce a resort-like ambience, an unusual concept in China at the time, are dotted with a fantastical menagerie of sculptures—ducks, chickens, peacocks, swans, frogs, fish and many other creatures—in and among pools, pathways and playgrounds. Nature, both real and imaginary, abounds in all its beauty.

Although the foundations for the buildings had been laid before we came on to the project, we were drawn into doing more than garden design. To add both function and aesthetics to the empty areas on top of the podium and along the walkways, we created "streetscapes" using the buildings' façades. Wall shutters and suspended lanterns were installed. Fountains and walls "interrupted" walkways. Various pond features produced interesting light reflections. To cater to Chinese taste, we also created

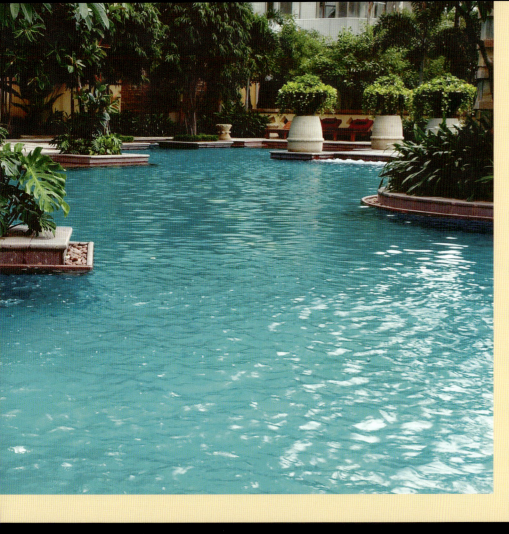

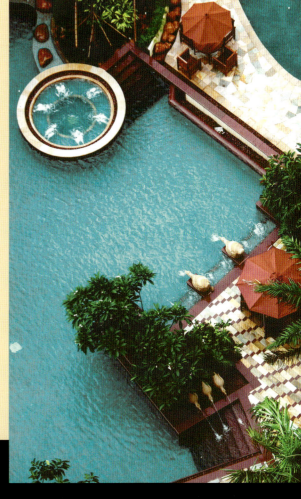

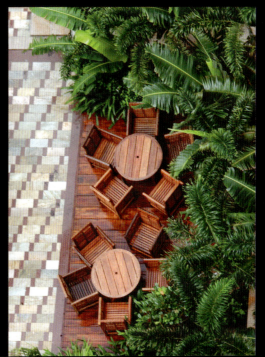

tearooms, airy seating areas and an iron-canopied birdcage room (where humans sit in the birdcage, not the birds!) looking out over the gardens. All of this gave us the opportunity not only to extend the gardens—no area is left unadorned!—but also to create a protected yet inherently gardenesque environment among a group of clean-lined high-rise buildings.

Above left While studying Nepalese architectural traditions, I learned the local technique of repoussé—hammering a thin piece of metal, usually brass, over a carved wooden surface to create a pattern, thus allowing the craftsman to add a great deal of detail without breaking the metal. Here, we used copper over wood carved with a relatively simple pattern of a fighting cock. **Below left** Farming is the backbone of the Chinese economy, with rice the staple crop in the south. Bensley Design Studio artists painted around 16 sepia paintings on wood, some over 13 feet (4 meters) high. The paintings are embellished with thousands of small squares of gilt to depict the sun setting on the rice fields. **Above** Bronze duck fountains in a row are a recurrent theme in the resort's two swimming pools. **Above right** Taken from the top of the adjacent residential tower, this photo illustrates the beauty of the plan and the variety of materials used in the intensely detailed garden. **Right** The pattern, texture and color of the local stone pool deck is a delightful contrast to the smooth, linear wooden platforms.

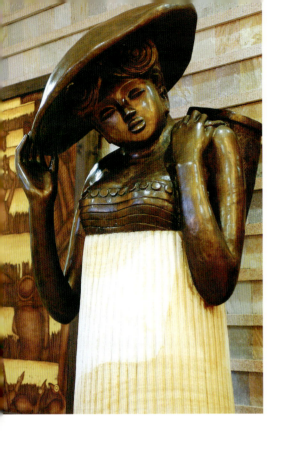
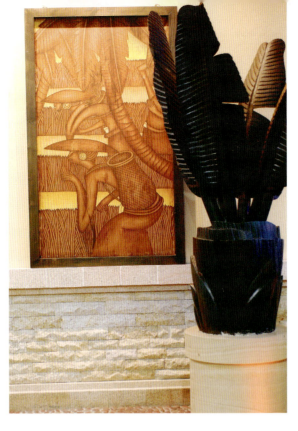

Far left Putu Mahendra, who heads our Bali studio, designed a number of sandstone and bronze maidens as well as the sepia and gold paintings on wood. The paintings were done by artists in our Bangkok studio and shipped to Shenzhen. **Left** To complement the tropical content of the painting behind, we designed this bronze banana tree, which sits on a solid carved sandstone base. **Below** Encircling the children's pool, carved gray granite fish on stacked stone bases invigorate the waters.

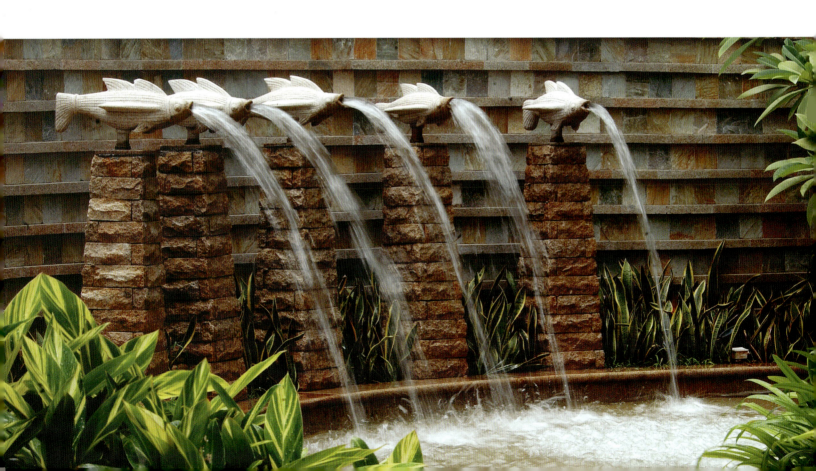

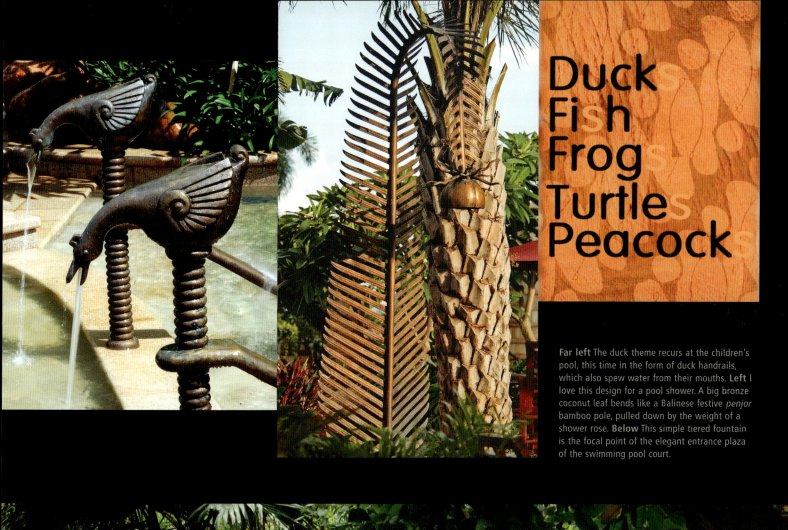

Duck
Fish
Frog
Turtle
Peacock

Far left The duck theme recurs at the children's pool, this time in the form of duck handrails, which also spew water from their mouths. **Left** I love this design for a pool shower. A big bronze coconut leaf bends like a Balinese festive *penjor* bamboo pole, pulled down by the weight of a shower rose. **Below** This simple tiered fountain is the focal point of the elegant entrance plaza of the swimming pool court.

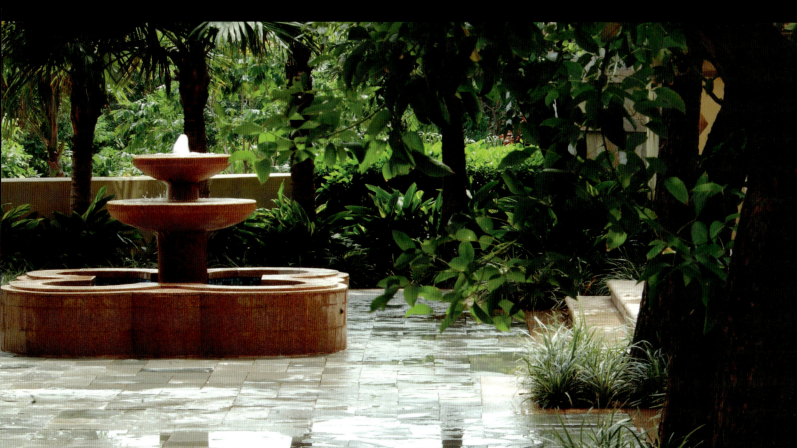

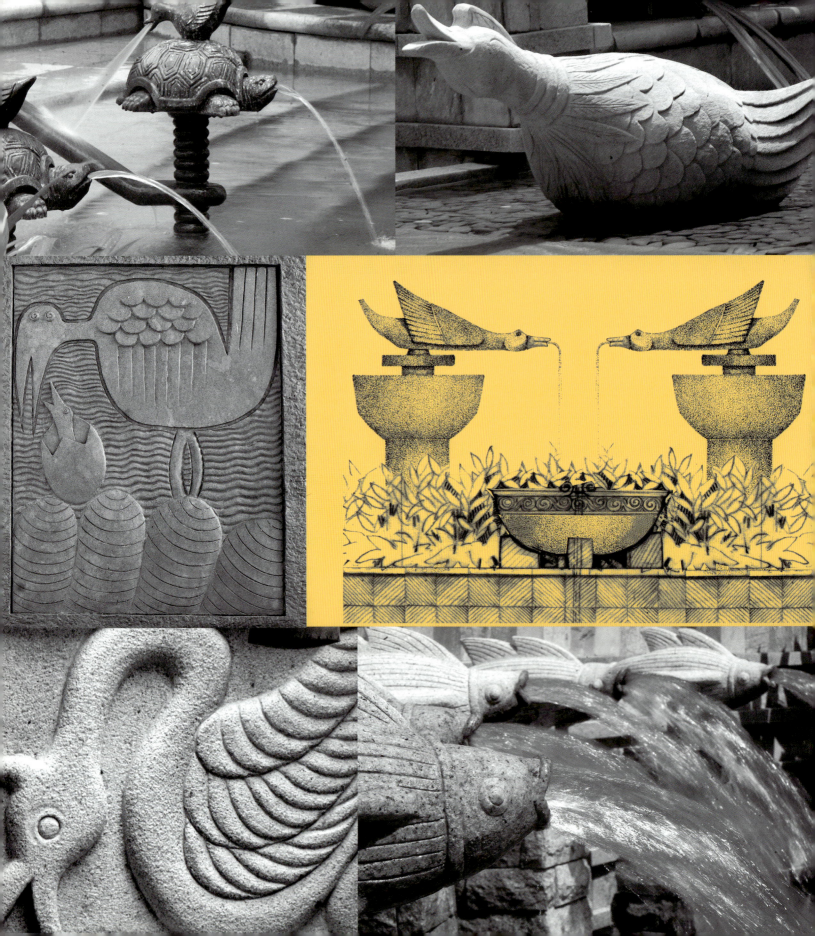

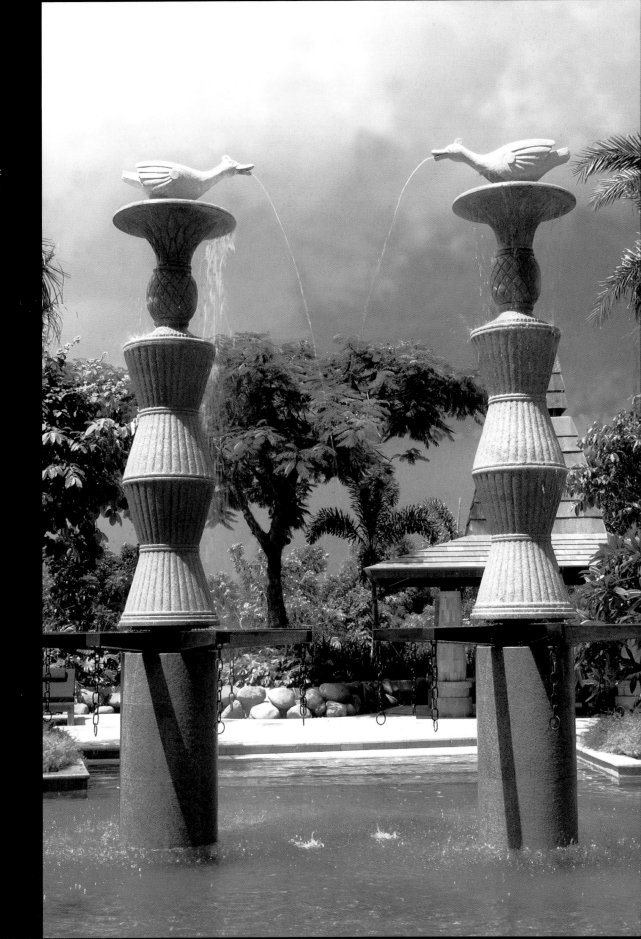

Far left At the other end of the children's pool, bronze turtles carrying ducks on their backs form handrails for the steps leading into the pool. **Left** One of a fat family of geese squawks in a shallow pond near the swimming pool. **Center left** In the footsteps of Dr Seuss, this fanciful bird is hatching an eager-mouthed chick. **Center right** Our rendering of two angry geese squaring off against each other. **Below left** A detail of the granite mural on the wall of the pool shower. **Below right** Water gushes into the children's pool from the mouths of five granite fish. **Right** Soaring above the children's pool, these duck totem poles provide some shade as well as create white noise to mask the sounds of traffic on the streets below.

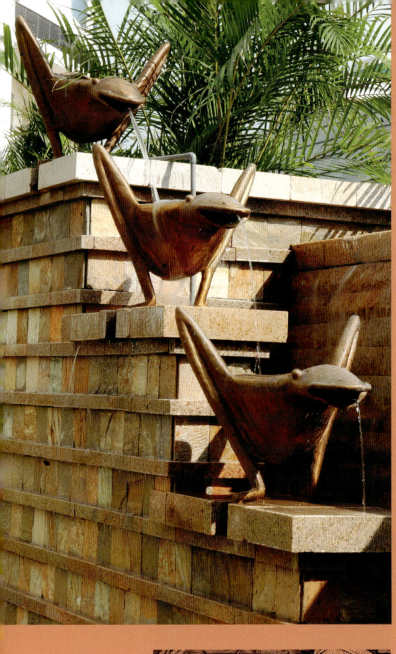

Opposite far left Inspired by the children's game of leap frog, these bronze figures dribble water down the stepped wall of the tennis courts. **Center left** We even had fun with the duck head handles of the pool showers! **Left** A Bensley Design Studios' drawing of the fanciful peacocks that we made for the front entry steps. The finished peacocks are cast in bronze and are over 3 feet (1 meter) wide. **Opposite below left** I liked Putu's drawing of Chinese farmers tending their rice fields so much that we used it on the back of our calling cards for many years. **Below center** This 13 feet (4 meter) high carved sandstone sun emanates warmth and light in the breezeway below one of the residential towers. **Below** Half-gate half-window, this detail designed by Brian Sherman is really more folly than function. Using the Nepalese method of repoussé, the doors are clad with copper sheets hammered over carved wood into the images of plump fighting cocks.

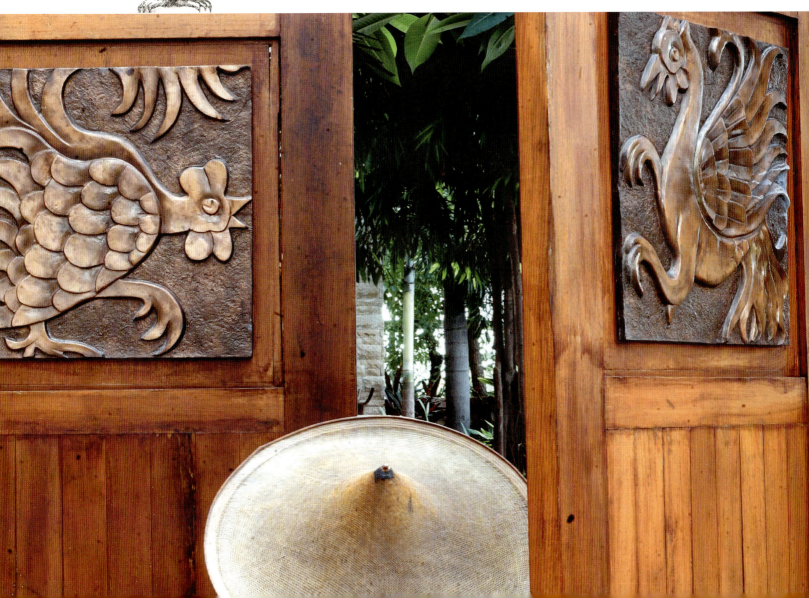

Left A grand Spanish-style tower stands sentinel at the entrance to New World Casa California, one of Guangzhou's most beautiful residential estates. **Right** This dramatic 16 foot (5 meter) high granite retaining wall runs parallel to the lap pool, providing privacy for swimmers from the surrounding residences. **Far right** The segmented stone of the lower tier of this fountain adds an especially elegant touch.

CASA CALIFORNIA
SPAIN MEETS GUANGZHOU

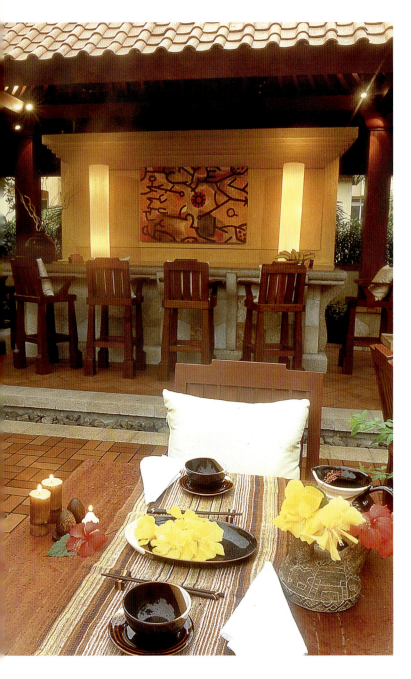

Above A pavilion bar with an adjoining brick-paved courtyard is an ideal place for the occupants of Casa California to host private parties. Set in the center of the complex, it is shielded by plants for privacy. **Above right** The Spanish design on this walkway, inspired by many trips to Mexico, was executed using age-old Chinese techniques of setting stones with bricks. **Opposite** In the garden foyer of the main swimming pool we placed this fountain, traditional at first glance, but assembled from 18 full segments of solid granite, like pieces of an orange. Unaffordable in the West, the solid granite steps in front will last for years.

The New World Casa California, a luxurious low-density residential complex on Er Sha Dao, an island in the middle of the Pearl River in Guangzhou (formerly Canton) on China's southeast coast, is an oasis of calm in what is the heart of one of mainland China's busiest and most densely populated commercial and manufacturing regions. The design intensity and detail of the landscaping surrounding the duplexes and apartments within the complex has generated a great deal of enthusiasm from other developers keen to invest in the landscaping of residential projects.

The first architectural plans we saw had a Mediterranean feel about them. We took these a step further by adding a Spanish lifestyle architectural element, and then came up with the name "Casa California," which refers to a region between northern Mexico and southern California. As the original building design affected the aesthetics of our gardens, which then reflected back on the building, the architects, SRT, who operated out of Hong Kong, revised their plans to accommodate our new Spanish look.

Simple, inexpensive and readily available materials such as bricks and terracotta tiles were used throughout the gardens, but we put them together in such a way that they added richness and quality to the finished product. Clay drainage pipes, normally put underground, which we found in a service yard, came in handy for decorative walls and wall screens—much to the amazement of the workers! Similarly with the huge steel cooking woks, like those in the workers' barracks, that we used for art installations.

We also incorporated techniques employed in the courtyard gardens of old Chinese merchant houses, such as the pebble pattern pavement. Although we used Spanish motifs, the construction methods were similar to those used in China for millennia. Many workers could recall their grandparents using the same methods before the 1949 revolution, and were happy to be involved in work that brought back a sense of history.

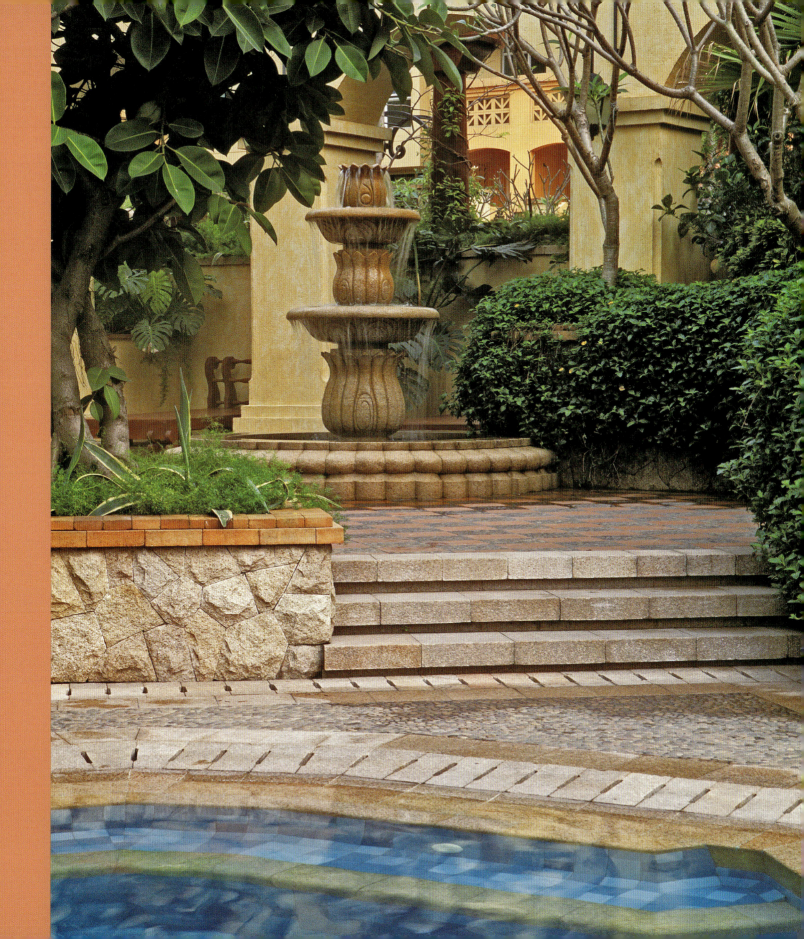

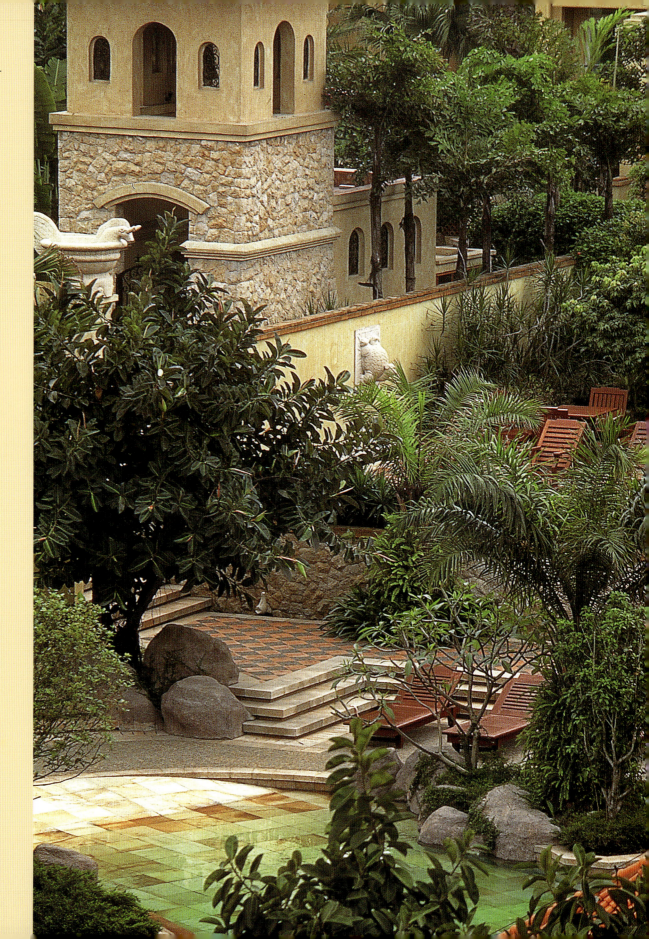

Right Gently sloping sandstone pavers form a clever mock beach edge to the children's pool.

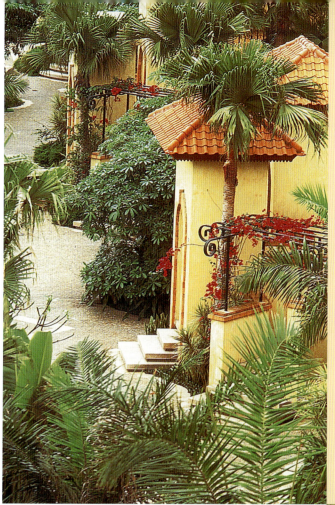

Above Each of the ground-floor residences has its own private garden enclosed by an elaborate Spanish-style gate accentuated by brilliant bougainvillea. **Above right** Fanciful sandstone turtles form stepping stones to a secluded corner of the garden. **Right** The Bensley Design Studios' interpretation of a dwarf Spanish horse stands proudly along the pathway to the estate's private gardens.

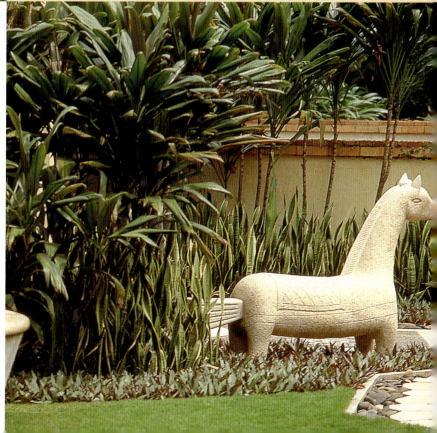

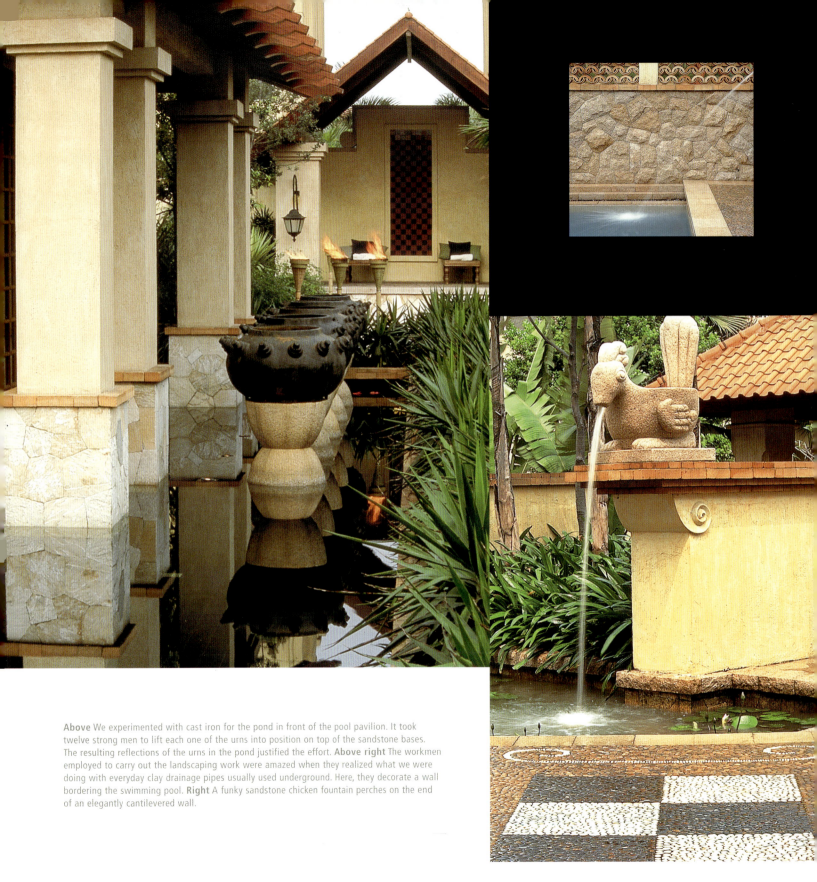

Above We experimented with cast iron for the pond in front of the pool pavilion. It took twelve strong men to lift each one of the urns into position on top of the sandstone bases. The resulting reflections of the urns in the pond justified the effort. **Above right** The workmen employed to carry out the landscaping work were amazed when they realized what we were doing with everyday clay drainage pipes usually used underground. Here, they decorate a wall bordering the swimming pool. **Right** A funky sandstone chicken fountain perches on the end of an elegantly cantilevered wall.

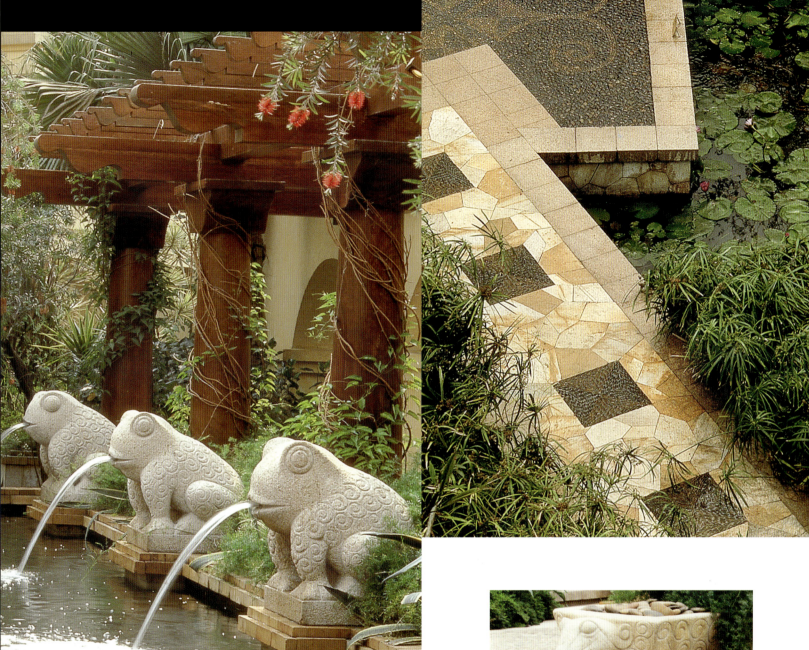
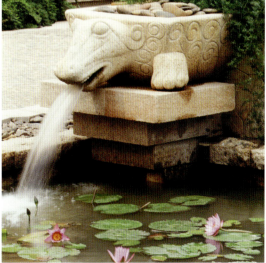

Above Comical frogs in a row, all "tattooed" with curlicues and "whistling" water. **Above right** Using three different colored types of slate we made a plaza with some very strong graphics. **Right** An odd planter—perhaps a cross between a dog, a turtle and a crocodile—is an interesting conversation piece near a lotus pond.

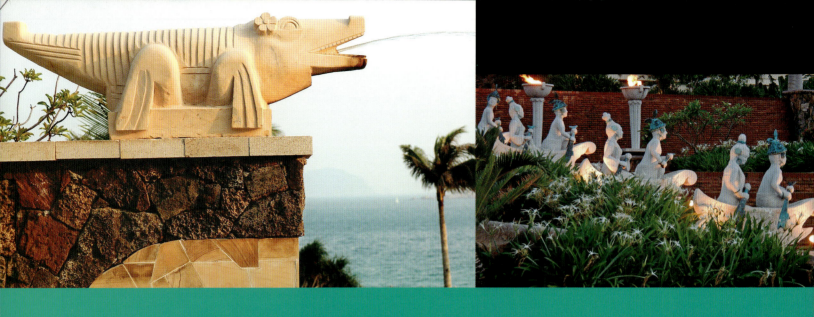

SHERATON SANYA RESORT
THE NEW WAIKIKI

Set amidst swimmable lagoons, powdery white sands, swaying palms and lush gardens in Yalong Bay on China's only tropical island, Hainan, 1 mile (1.6 km) off the country's southern coast, the Sheraton Sanya Resort is not surpisingly known as the Hawaii of China, with which it shares the same geographical latitude. The resort has played host to several Miss World pageants, and dozens of signed portraits of the world's most beautiful girls grace the walls of this fine resort where a simple fishing village once stood.

The Sheraton Sanya Resort was our first resort garden project in China. For the design, we used our knowledge of how resorts work by breaking the vast garden bordering the pristine bay down into smaller components to create a number of very different spaces offering a variety of experiences and functions—a beach zone, a lush garden zone around the lower pool, and other terraces with different environments around the various restaurants—all of which include a mixture of ancient Chinese and Western elements. In this way, large groups, noisy families, young couples wanting togetherness, loners seeking privacy and others can be segregated. Dining areas and relaxation areas are thus individually marked.

In some of the ground-floor units, it is possible to swim out of the terrace into a sun-protected pool, also comprising many little nooks and crannies to explore

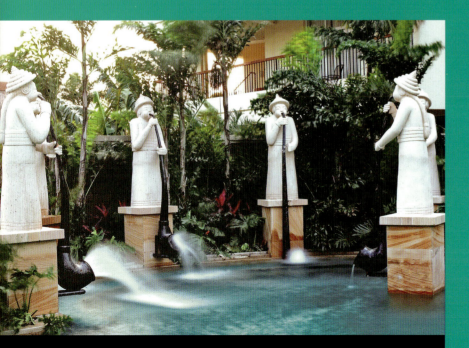

Above left A cute sand-stone crocodile lords over the children's pool. **Above center** At the front entrance to the resort, stone captains in traditional dress ride the rapids in their boats. **Below left and opposite** Chinese musicians carved in sandstone play brass long horns-cum-fountains in a quiet corner of the lagoon pool. Smiling sandstone "caves" offer refuge from the sun—or a place on which to enjoy the sun.

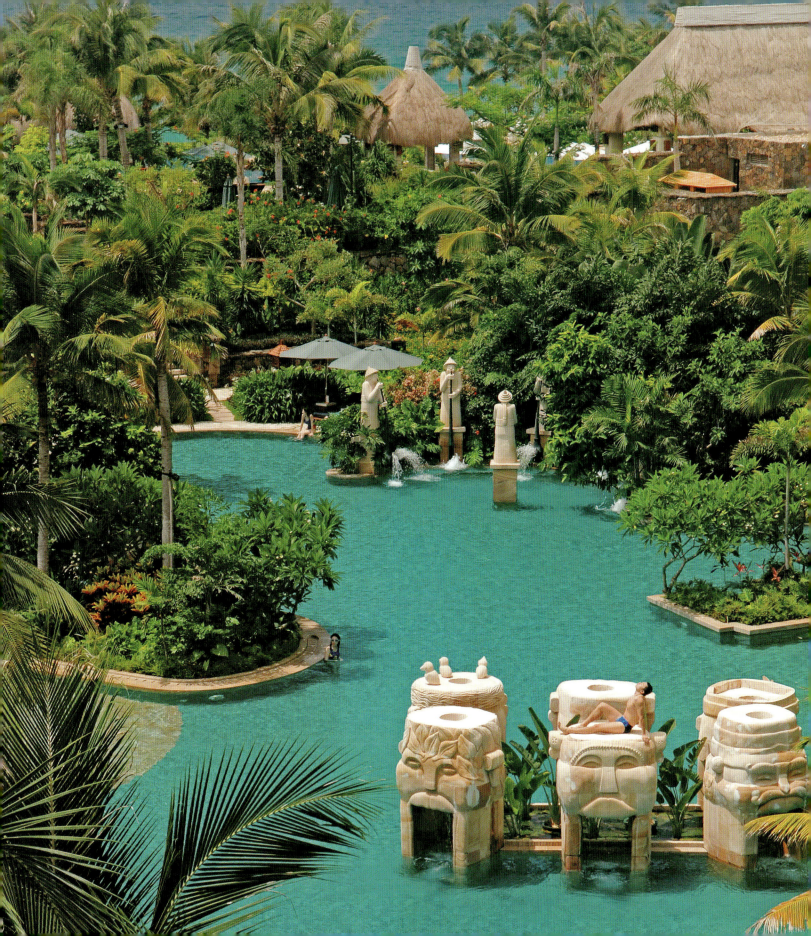

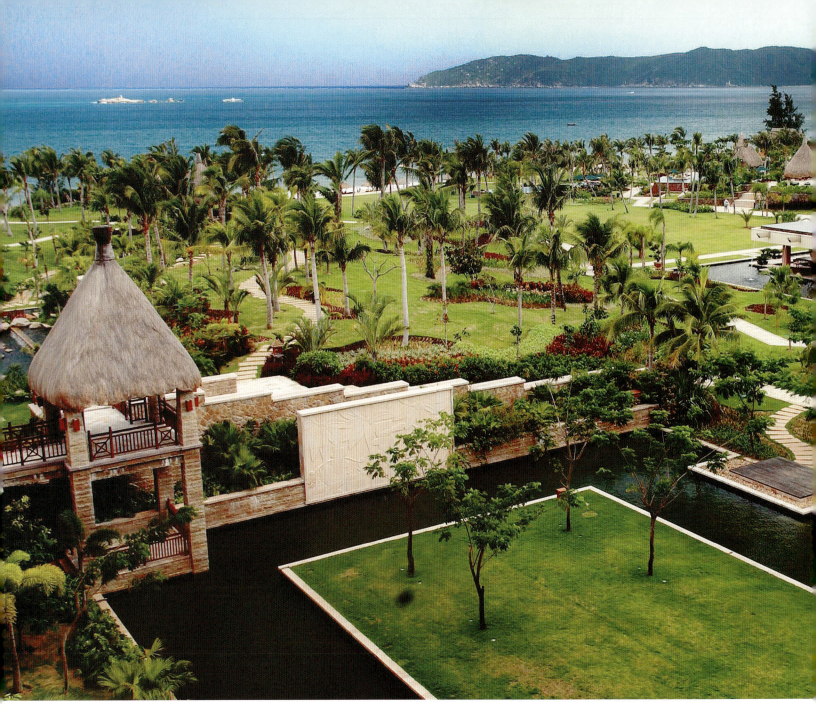
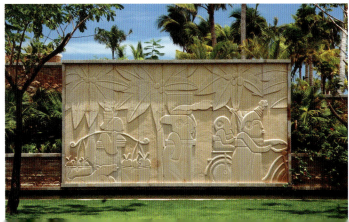

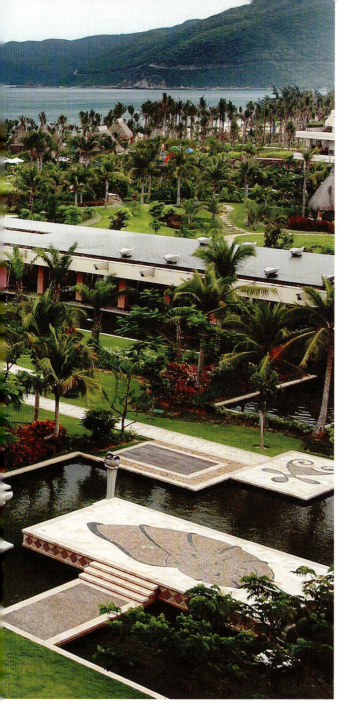

or in which to seek sanctuary. For sun worshippers, we built a more exposed pool on top of the sand dune overlooking the ocean—another first for China.

Although our client did not fully understand why we put so much emphasis on the design of each garden area, the concept was based on the premise that people would come here for at least three or four days and they should have an opportunity to experience every one of the gardens, and to use them, not just look at them from the balconies of their rooms.

The biggest challenge to our design was the existence of the sand dune on the beach. Around 16 feet (5 meters) high, some of it natural, some of it man-made, the dune obscured the view of the ocean—the very thing that world-weary travelers come to see—from the ground floor of the hotel. Our solution was to carve a corridor through the dune. Oceanographers were asked to come and examine it, and they concluded that we could reduce its height by 6–9 feet (2–3 meters) without compromising its role as a natural protection barrier for the site. With government approval, obtained only towards the end of the resort's construction, we were able to go ahead, thus contributing to the success of our tropical ocean-facing garden, a unique attraction in China.

Local artisans on Hainan Island were commissioned to carve the huge sandstone sculptures that are a stunning feature of the resort. The ones in the dining area comprise a series of 8 foot (2.5 meter) high abstract human figures pulling in a fishing net from the sea. Brian Sherman, our company director and a landscape architect, got the inspiration for this while jogging down the beach one morning. He saw some fishermen on the beach, their boat grounded on the sand and 20–30 men pulling the net in from the sea (with not much fish in it—the sea is pretty overfished here!).

Above Various zones in the expansive gardens are demarcated by pathways, palms, water and walls. The three-meal restaurant, cooled by the surrounding pond, juts out into the park-like landscape. In the foreground is a special space for dances and other performances, which can be viewed by people seated on the lawn. **Far left** A humorous sandstone mural depicts the rural Chinese moving to the beach in search of sun and sand. **Right** Designed to delight children, one can swim right into these smiling caves.

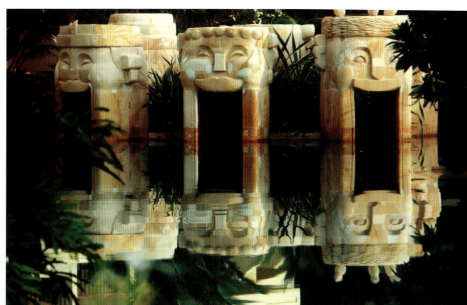

Below A serene view of the palm-filled pond flanking the three-meal restaurant.
Right Refreshing blue waters are churned up by the 10 foot (3 meter) tall horns of half a dozen musicians.

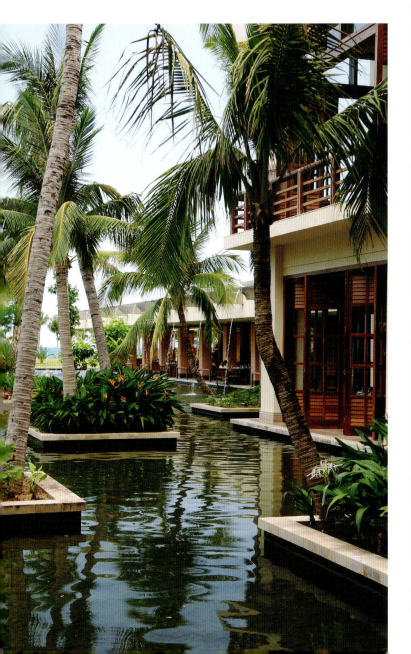

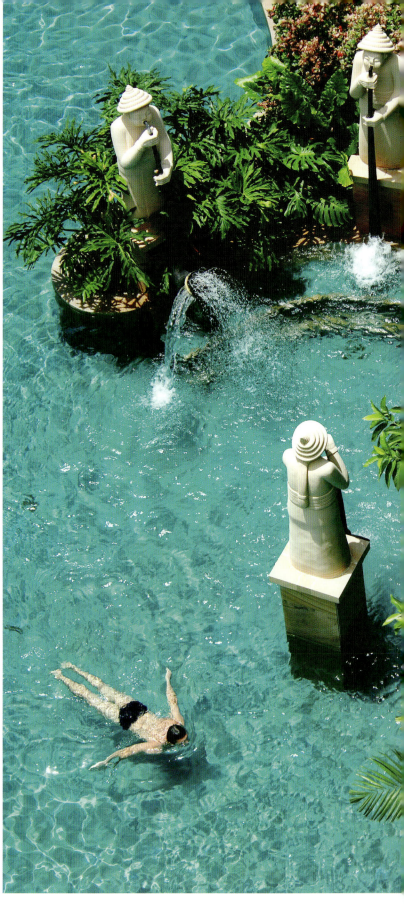

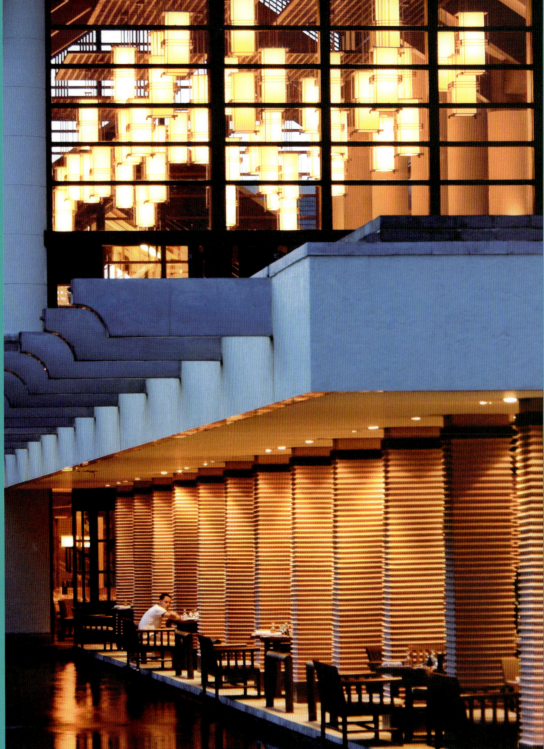

Above The lanterns of the main lobby, in combination with the columns of the restaurant, provide some interesting textures. We designed this lineal restaurant that leads out to the sea and is flanked by a pond full of coconut palms.

PARADISE IN INDIA

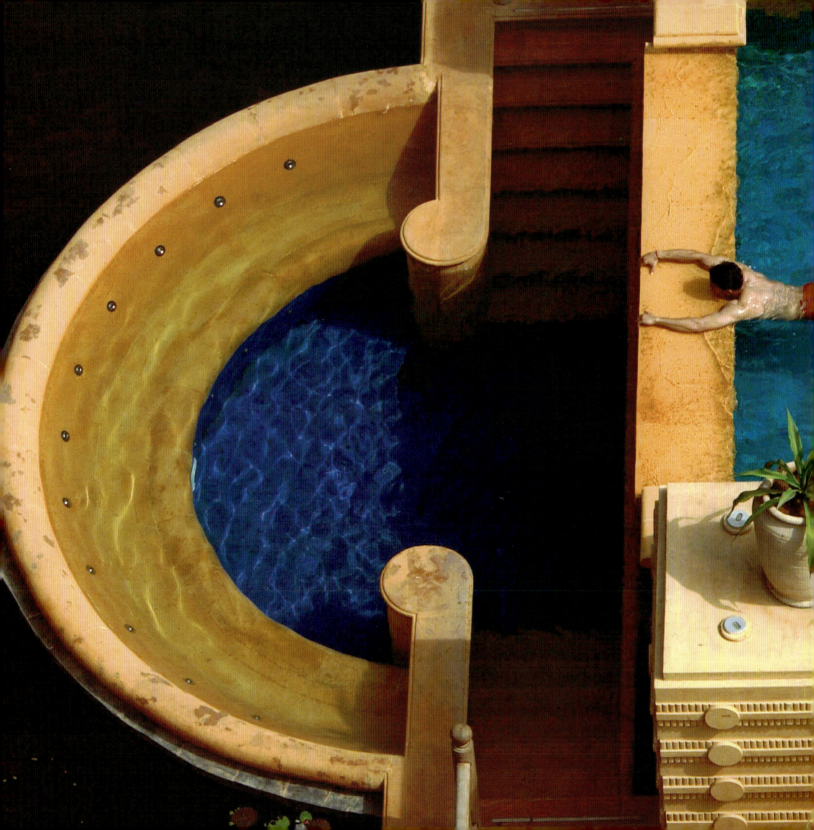

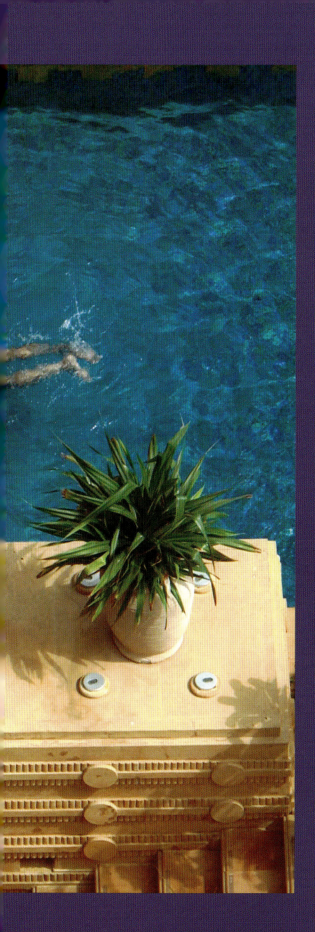

MARRIOTT MUMBAI
ON BOLLYWOOD'S BEACH

Left The end of the main lap pool facing inland overlooks a bold, semicircular spa pool seemingly sunk in a lotus pond (page 46). **Right** A traditional stone medallion drops water into the ponds at the entrance to the hotel.

Far left Italian Bisazza glass mosaic tiles manufactured in India were used on the pool walls to create some fabulous patterning. **Left** A doorman sportingly stands below one of the fountains at the main entrance to the hotel, raising his hands in the traditional Indian greeting. **Below left** We called this tall sculpture of a lean man kissing his plump wife on the back of a turtle the "Kiss of Rajasthan." Located in the naturalistic saltwater pool, it symbolizes eternal love. Waterbeds flank the statue. A decorative stone frame, designed as a setting for taking holiday photos, is positioned behind. **Right** The "wet living room" in the shade of a pavilion in the main pool.

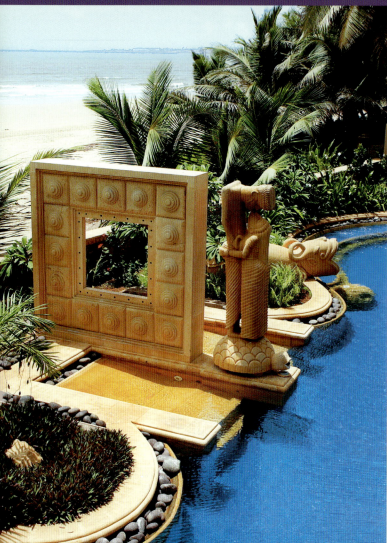

Located in the fashionable up-market Juhu area overlooking the Arabian Sea, just minutes away from Mumbai's many film studios, the opulent JW Marriott is the favorite hotspot of Bollywood celebrities and stars and their followers and the hotel of choice for the many business travelers drawn to this rapidly developing business center 20 minutes from the airport. Long before India's recent unprecedented economic growth, co-owner and architect Vijay Raheja had the foresight to orchestrate the construction of India's only JW Marriott. Bensley Design Studios was commissioned to create a tropical seaside garden for the hotel.

The main landscape preoccupations were with space and the framing—as well as screening—of vistas. The water park and the lavish sculpture garden that we came up with were thus built well above one of the world's most heavily used beaches on the ocean side. On the street side, guests drive up one floor to the lobby, which is blocked off from the chaotic urban scenes of Mumbai by a huge screen and water feature. The subtle play of water and landscape throughout asserts an air of both harmony and power.

The garden design is primarily aquacentric: four pools of varying shapes and sizes—a straight-edged main pool composed of two intersecting lap pools, a curvaceous saltwater waterfall pool, a children's pool featuring an alligator slide and a semicircular spa pool—are linked by torch-lit pathways scattered with pavilions bearing a great variety of roof shapes, lawns dotted with sculptures inspired by Indian folklore and lush plantings.

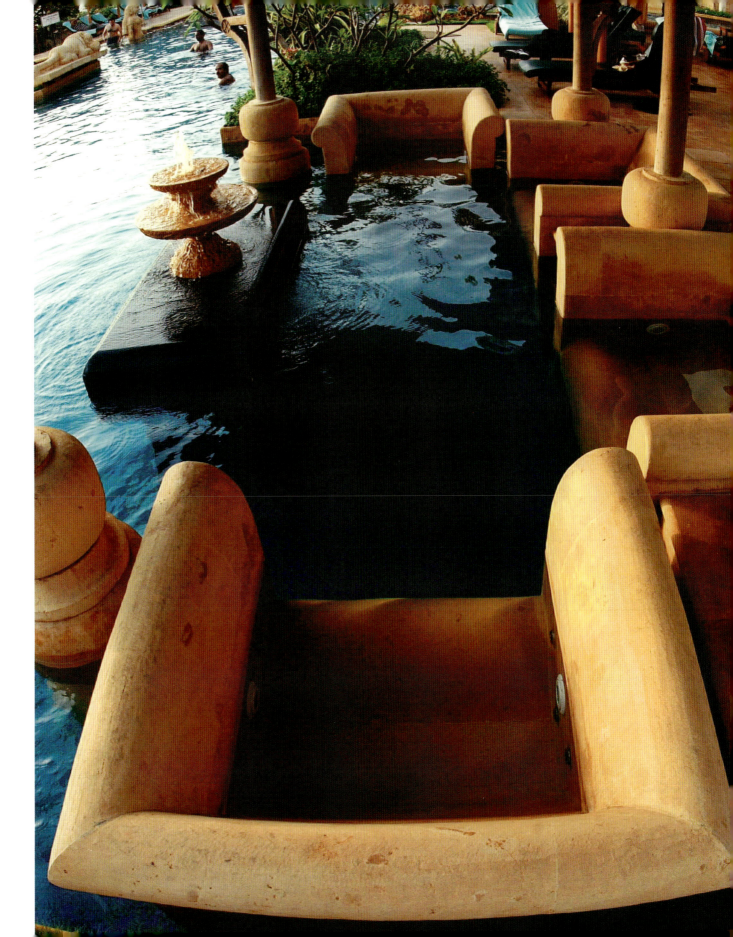

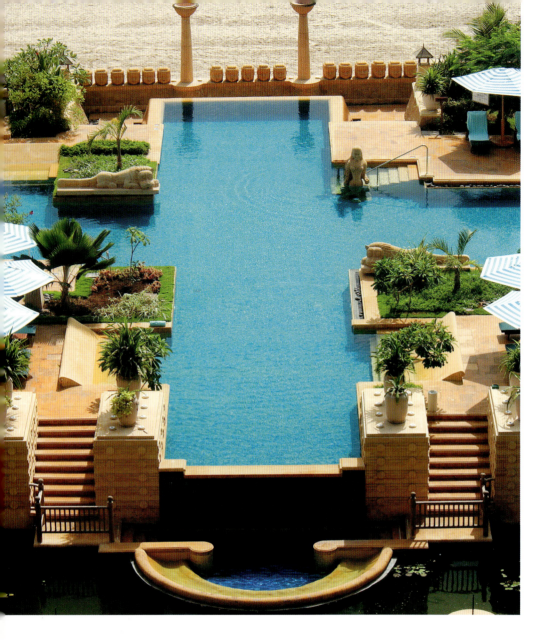
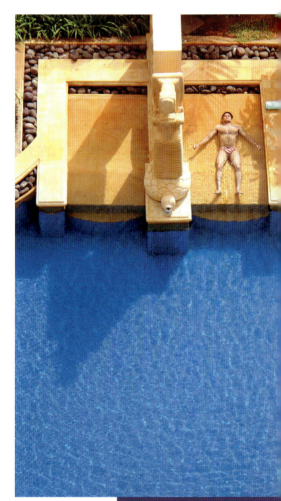

Left The straight lines of the main pool, with its intersecting lap pools, are softened by clusters of poolside furniture, stone sculptures and pockets of plants. **Below** Large shallow waterbeds in the saltwater pool are ideal for keeping cool while pursuing the ultimate tan.

In the main pool, we included our now much-copied idea, originally created for rock icon Mick Jagger's pool in Bali, of a wet living room with armchairs, couch and coffee table.

The gardens are accentuated with custom-designed Indian stone sculptures, some colossal, crafted by the skilled artisans of Rajasthan, which took six men more than five years to complete.

A major problem that we continue to have here is with the annual monsoons; the winds bring the salt water into the resort, killing off a lot of the plants. Bamboo mat screens are erected each monsoon season to try and combat the problem.

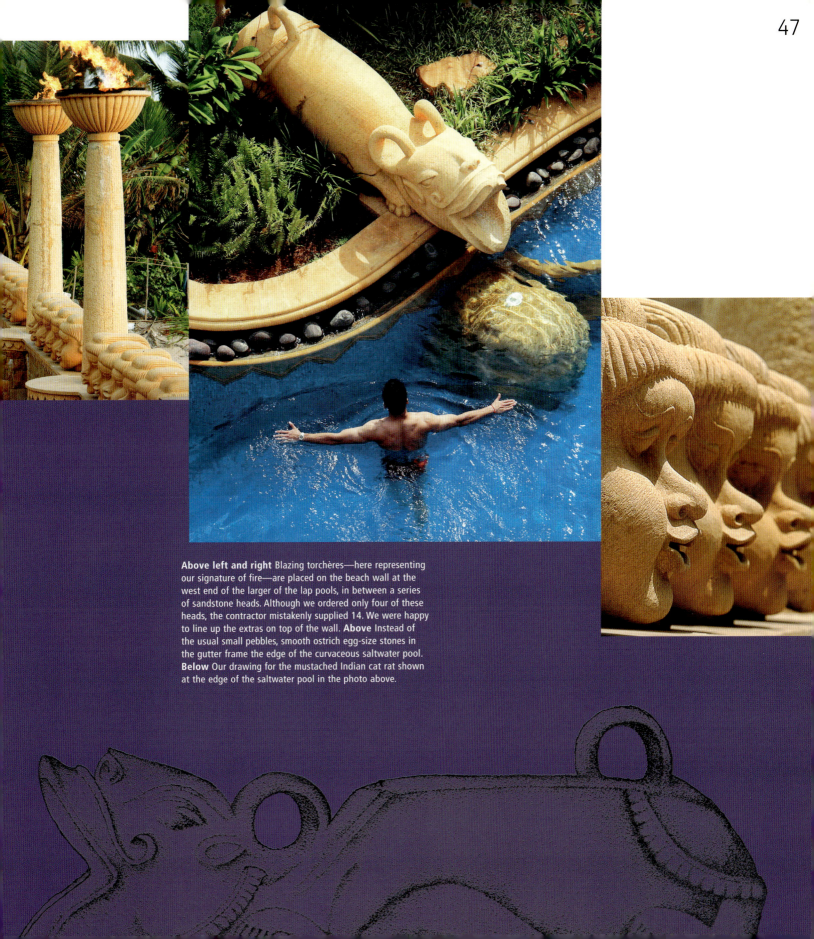

Above left and right Blazing torchères—here representing our signature of fire—are placed on the beach wall at the west end of the larger of the lap pools, in between a series of sandstone heads. Although we ordered only four of these heads, the contractor mistakenly supplied 14. We were happy to line up the extras on top of the wall. **Above** Instead of the usual small pebbles, smooth ostrich egg-size stones in the gutter frame the edge of the curvaceous saltwater pool. **Below** Our drawing for the mustached Indian cat rat shown at the edge of the saltwater pool in the photo above.

Left Our drawing of one of the many sandstone medallions sprinkled throughout the gardens. **Right** A close-up of the sculptural edge of the saltwater pool. **Below** The semicircular curve of the spa pool is repeated in the waterfall edge of the lily pond. The ponds keep everyone but the gardeners off the lawns.

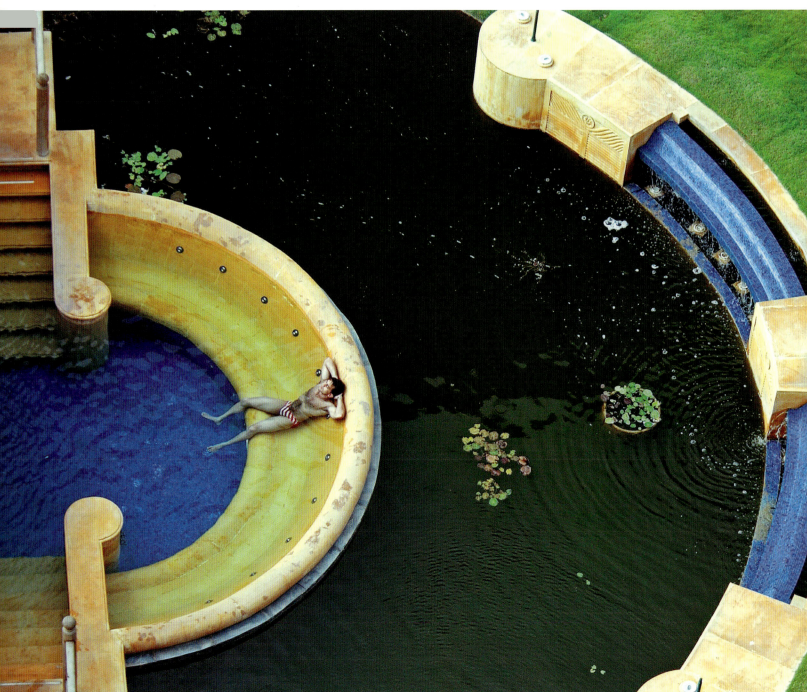

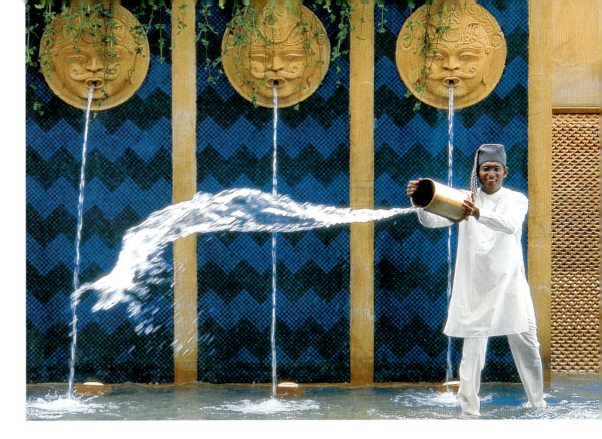
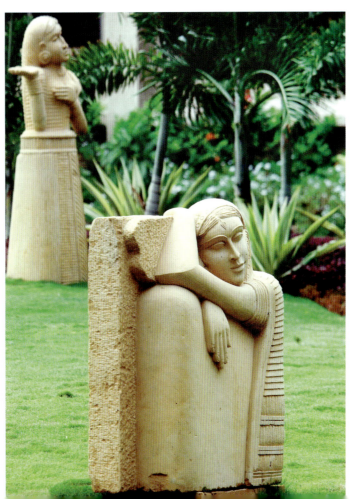

Above A dramatic "chaddah wall"—a legacy of Mughal gardens where water was scarce and was thus celebrated—blocks both the views and noise of the city beyond at the lobby level, one floor up from the street. A series of overlapping concave, spoonlike impressions carved into panels of sandstone allows only a small amount of water to run and bounce off the wall, creating a delightful dancing effect. Dressed in a perfectly pressed and starched white uniform, a doorman—at my request—throws water about from the pools in front of the wall.
Left Visible from the lobby, a purposely unfinished sculpture of a beautiful Indian woman graces the main lawn.

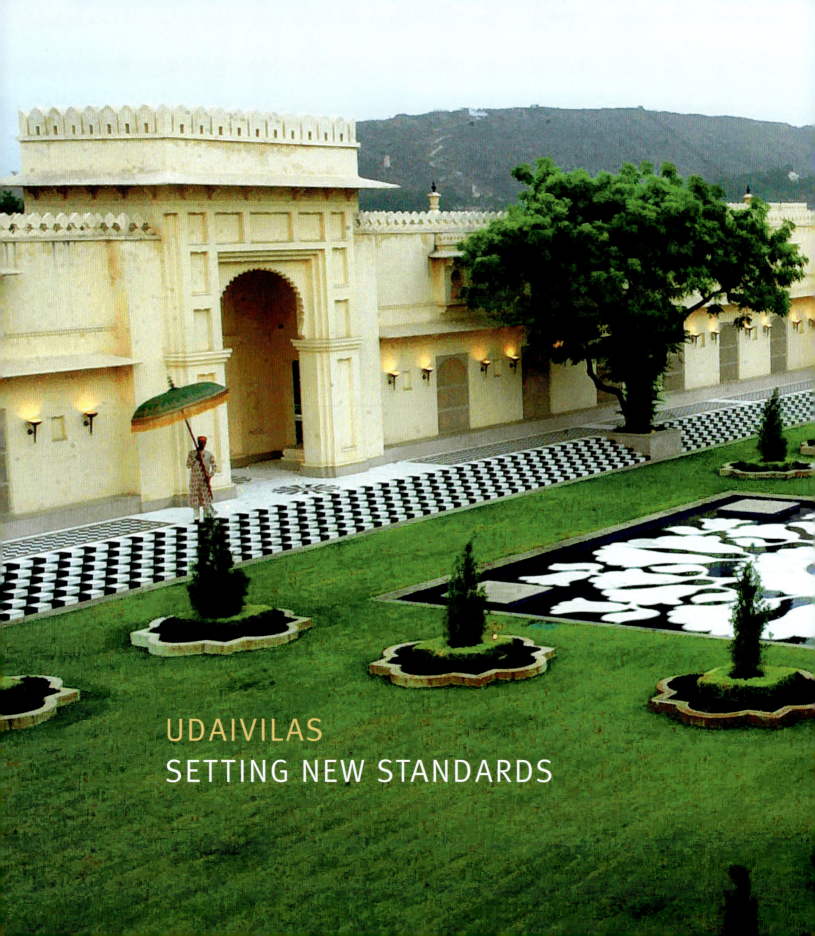

UDAIVILAS
SETTING NEW STANDARDS

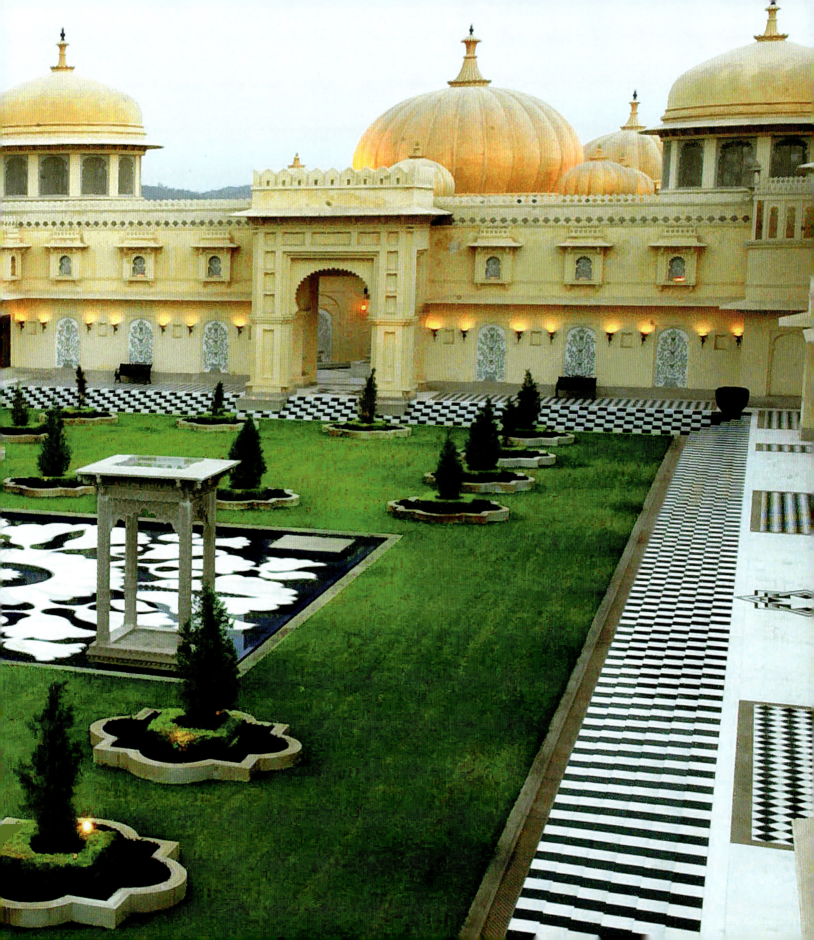

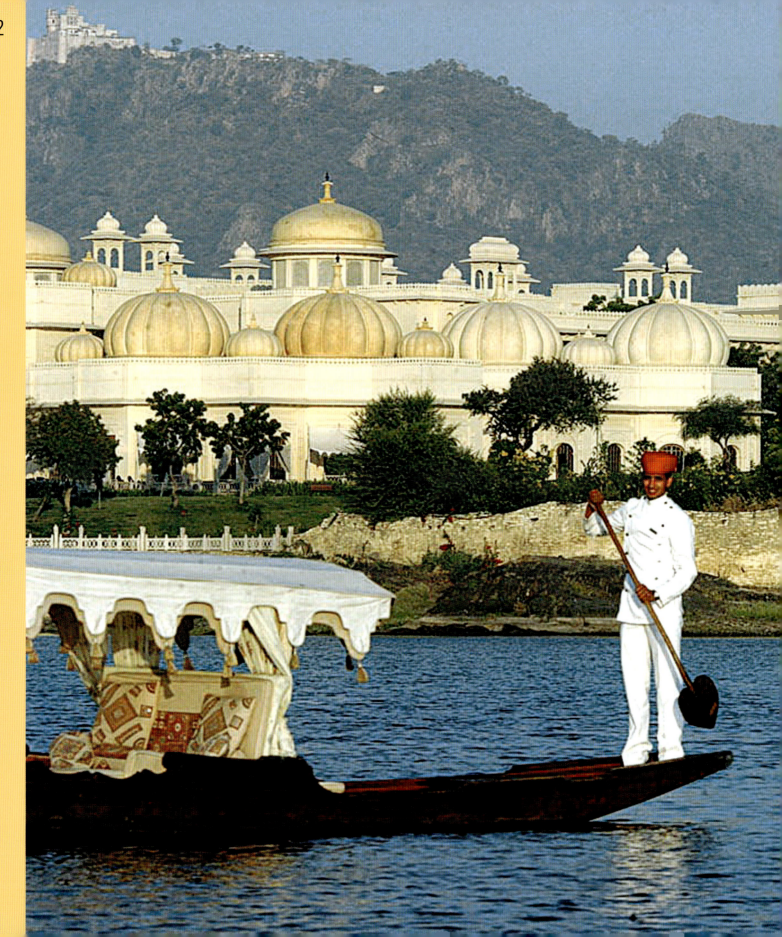

Occupying 30 acres (12 hectares) of former hunting grounds on the banks of Rajasthan's stunning Lake Pichola, facing the city of Udaipur, the old Rajput capital of Mewar fabled for its 17th-century palaces, Udaivilas is a newly built Indian palace hotel. But there is nothing "bling" about this palace, voted by the readers of *Travel and Leisure* as the best hotel in the world in 2007. Udaivilas appears as though it has always been there. Even though it is totally new, built from modern bricks and mortar, it is steeped in history. Its landscaped gardens, massive fortified walls and gates, profusion of domes, cupolas, arches and pavilions, grandiose tiled courtyards, decorative fountains and reflecting pools, open-air corridors flanked by hand-carved stone columns, hand-painted murals, inlay and sumptuous interiors re-create the style of the palaces of the Mewari princes, said to have descended from the Sun God who ruled Rajasthan some 300 years ago.

The vision of veteran hotelier P. R. S. Oberoi, chairman of the Oberoi Group, who wanted to build an "ancient palace" using vernacular methods within a specifically Mewari environment—but one which guests did not realize was new!—and with all the comforts of the most sophisticated city hotel, minus the "bling," Udaivilas is clearly not just another palace. Every detail here, except for the wireless connections, is traditional and opulent. A labyrinth of underground service tunnels also allows staff in golf buggies to whiz fresh and ever so hot meals to rooms. Guests are left to walk undisturbed at ground level without the constant passing of laundry, engineering, room service, and guest delivery buggies. Mr Oberoi has clearly set new standards for the hotel industry with the addition of this new prince of a resort.

warriors, and other aspects of the lives of Udaipur's maharajas are all featured. We were constantly amazed at how Indian craftsmen could interpret and execute our patterns for paving and tabletops. **Left** Rooted in Mewari traditions, the sun motif figures prominently in the resort, here formed from a shield and daggers. **Above** A typical Rajasthani overlapping star motif made of inlaid marble greets guests just outside the arrival gate. **Below** Our drawing of an elephant sculpture. **Bottom** This exquisite marble panel was obtained from one of the rambling antique "farms" on the outskirts of Delhi.

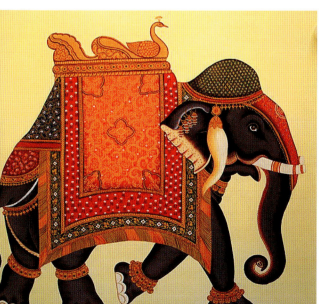

Pages 50–1 Although many guests arrive at the hotel by boat, those who arrive by car pass through a fortress-like gate before alighting at the huge gate to the left and walking around this open courtyard, with its beautiful sunken garden filled with a stylized marble lotus, before entering the lobby. **Opposite** Against the backdrop of the Aravalli Range, topped by the ruins of the Monsoon Palace, and the spectacular City Palace, a gondola silently navigates the waters of Lake Pichola. **Left** Painters of the Mewar School specializing in miniatures produced colorful and exquisitely detailed wall murals like this in the traditional style for the corridors and walls of suites. Elephants, camels, kings, processions,

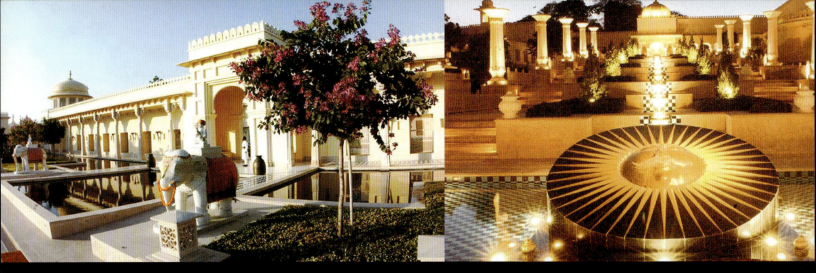

The architect for Udaivilas was Nimish Patel of Abhikram, a world-renowned expert on traditional Rajasthani architecture and vernacular building methods, who started on the project in 1985. We joined his team in 1994, working until the completion of the hotel in 2002. The lavishly appointed interiors were implemented by the Canadian Jeffrey Wilkes of LTW Designworks, based in Kuala Lumpur, Malaysia.

In conceptualizing gardens for the hotel that would complement the open-sided rooms and fluid spaces (admirably suited to the hot, arid climate) and ornamental features of Nimish Patel's architecture, we drew inspiration from elements of Udaipur's ancient palaces: spacious courtyards adorned with huge slabs of black and white Indian marble, reflecting pools and flowing water, formal lawns, statuary and geometric motifs. In order to convey a

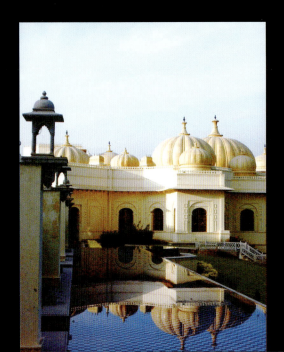
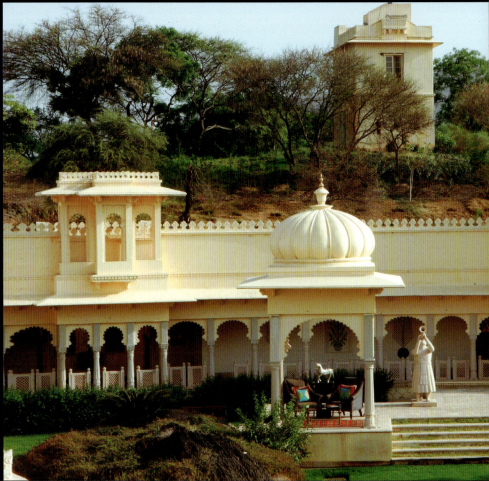

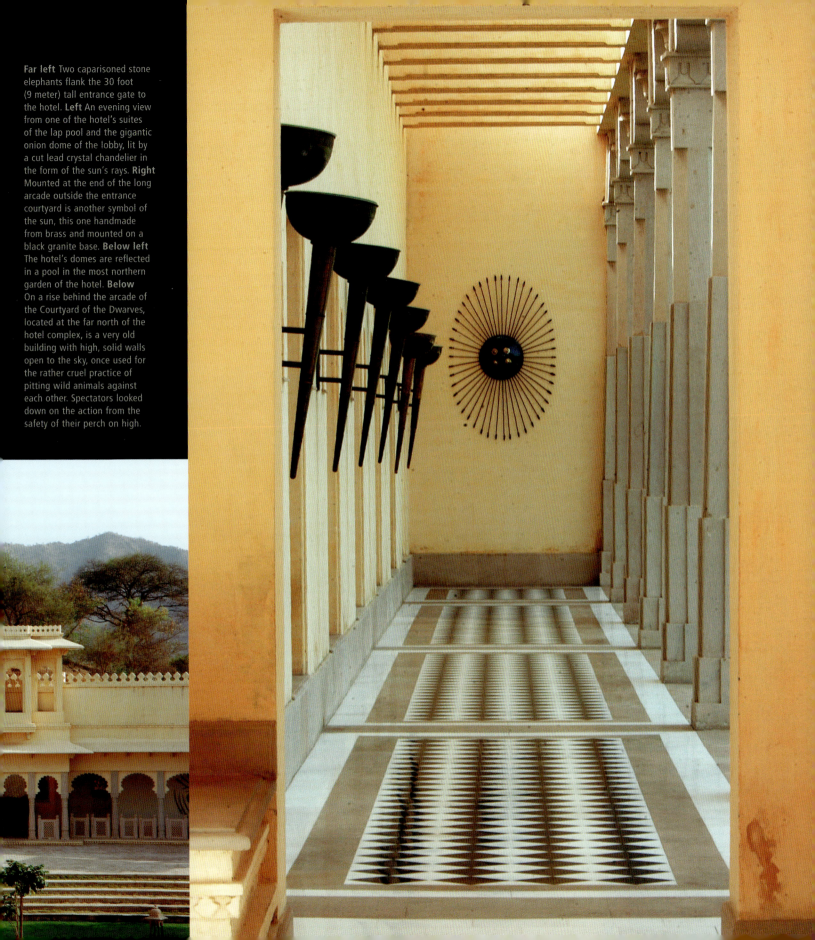

Far left Two caparisoned stone elephants flank the 30 foot (9 meter) tall entrance gate to the hotel. **Left** An evening view from one of the hotel's suites of the lap pool and the gigantic onion dome of the lobby, lit by a cut lead crystal chandelier in the form of the sun's rays. **Right** Mounted at the end of the long arcade outside the entrance courtyard is another symbol of the sun, this one handmade from brass and mounted on a black granite base. **Below left** The hotel's domes are reflected in a pool in the most northern garden of the hotel. **Below** On a rise behind the arcade of the Courtyard of the Dwarves, located at the far north of the hotel complex, is a very old building with high, solid walls open to the sky, once used for the rather cruel practice of pitting wild animals against each other. Spectators looked down on the action from the safety of their perch on high.

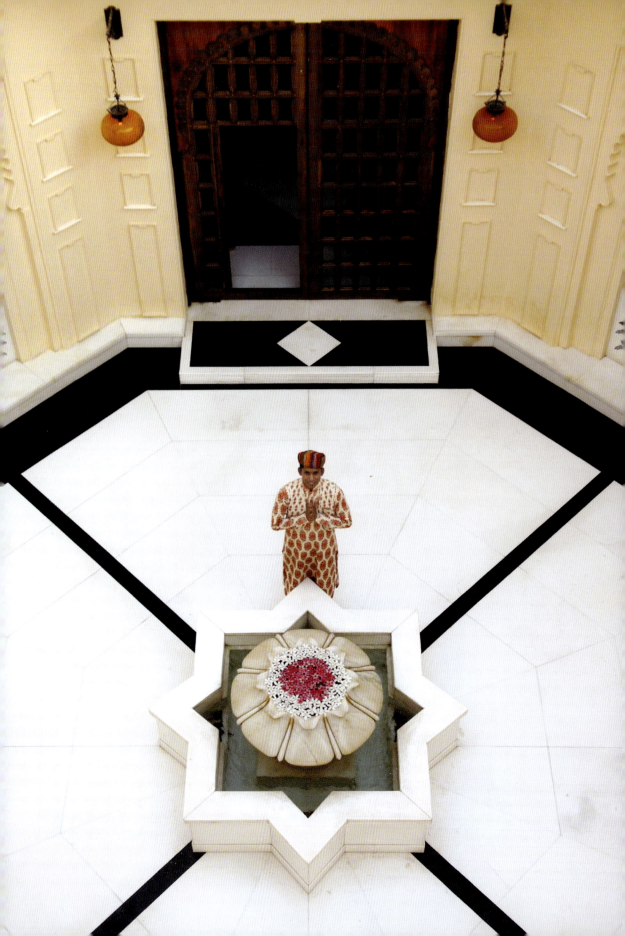

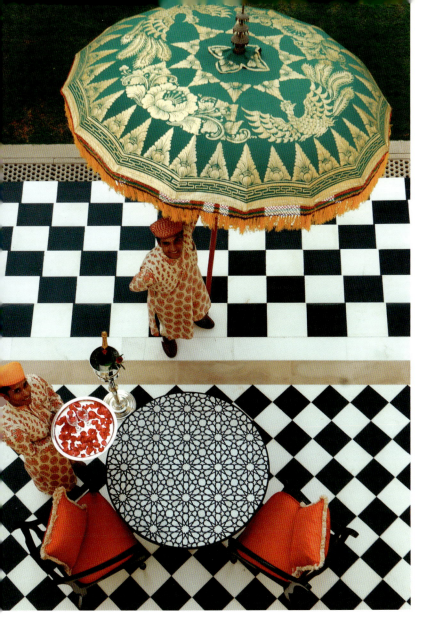

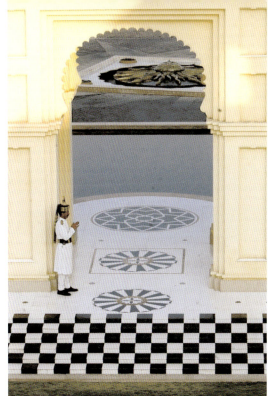

Opposite LTW Designworks deftly created this small open-to-the-sky courtyard that leads to the lobby. As the quarries of the white Maharani marble have long been depleted in India, pure white marble had to be sourced from Greece. **Above left** Normally things Balinese do not travel well internationally, but this oversized tasseled umbrella looks perfectly at home here. **Above** On arrival at the main entrance gate, visitors alight beside a grand metallic fountain shaped like the sun. **Below left** This old neem tree (*Azadirachta indica*) in the entrance courtyard was one of the few trees originally on the site. We worked hard to retain every single tree. **Right** A fine drawing of a Rajasthani maiden.

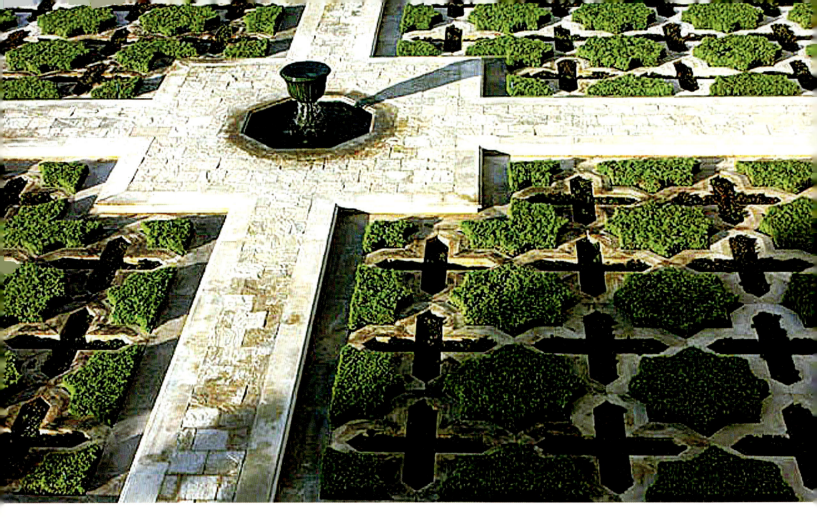

rich, dream-like ambience as well as our design intentions, we also borrowed the traditional Mughal miniaturized style of painting in our concept drawings. Using false flat perspectives, a riot of colors accentuated by some 300 sheets of gilt and fanciful ancient symbols for trees and human figures, we came up with 148 feet (45 meters) of drawings. Most of our ideas were adopted. One exception was our design for a black and white swimming pool wrapping continuously around the entire building. Instead, a black and white stepped lap pool became the centerpiece of the main courtyard while a separate 689 foot (210 meter) long pool was built along the edge of the spa, allowing for fantastic views.

Altogether there are five open garden courtyards at Udaivilas, made possible by the rarity of rain in this part of India. The first, adorned with a pure white marble stylized lotus in a reflecting pool set into a formal garden, and an old neem tree, lies inside the main entrance gate (pages 50–1) and leads to the gorgeous cobalt blue domed reception lobby. The most formal courtyard, surrounded by suites with their own private sunning and dining gardens, is dominated by the lap pool (page 59). Another (above) is based on the old Mughal water gardens at Jaipur.

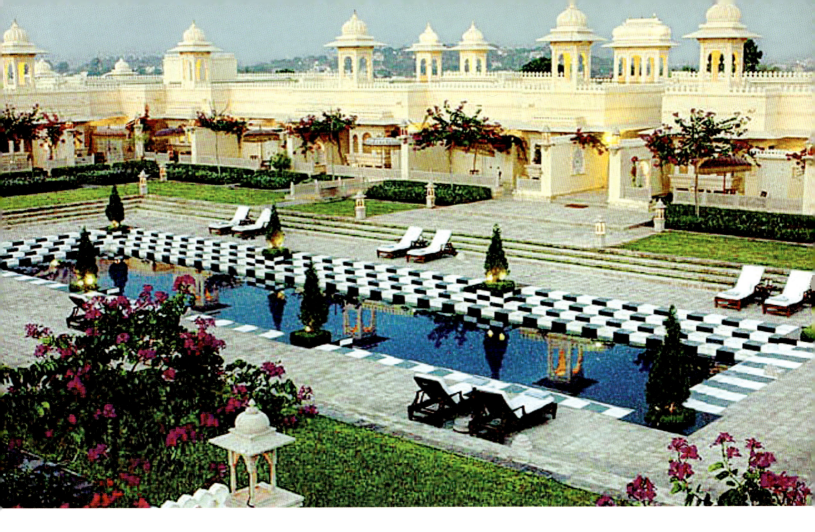

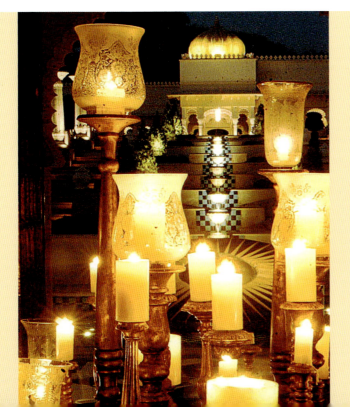

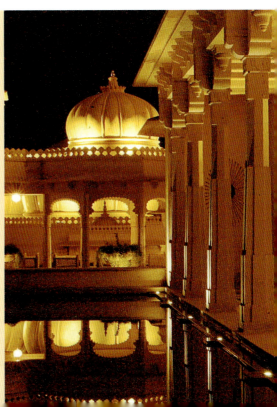

Above left For this Mughal-inspired courtyard we used red and green varieties of *Alternanthera bettzickiana*, a bushy perennial herb, in geometric planters surrounding a central fountain reached by intersecting pathways. **Below left** Our drawing of one of the water features that were built on the retaining wall facing the lower levels of the spa. **Above** The purplish red flowers of the orchid tree (*Bauhinia blakeana*) add vivid splashes of color to the most formal of the five garden courtyards and relieve some of its symmetry. **Left** Candles grouped on a round table in a foyer, the brainchild of veteran lighting designer Anthony Corbett, appear to float on the cascading water feature beyond. **Right** Reflections in a still water body of the streetside arcade and the bulbous dome behind add an element of romanticism to the hotel at night.

AMARVILAS
AT THE FOOT OF THE TAJ MAHAL

Situated just 2,000 feet (600 meters) from India's most famous monument, the 400-year-old Taj Mahal in Agra, is the six-story, 105-room Amarvilas hotel, one of the prestigious properties in the Oberoi "vilas" group. Built in an über-palatial style to complement the monumental splendor of the Taj, its buildings and gardens have also been designed so that guests can enjoy magnificent views of the Taj.

The Taj Mahal, an immense structure of white marble erected in Agra between 1631 and 1648 by order of the Mughal emperor Shah Jahan in memory of his favorite wife, Mumtaz Mahal, is one of the world's Seven Wonders and a jewel of Muslim art in India. It sums up many of the formal themes that have played through Islamic architecture, including Indo-Islamic styles, in which Hindu elements are combined with an eclectic assortment of motifs from Persian and Turkish sources.

Many of the architectural elements of Amarvilas, as well as the materials, predominantly sandstone and marble, and meticulous workmanship, take their inspiration from the Taj. The hotel's magnificent collonaded forecourt, lit at night by blazing stone torches, carved stone fountains, reflecting pools, scalloped-edged arched cloisters, filigree screens, geometric marble patterning and inlay work contribute to its wonder and timeless style.

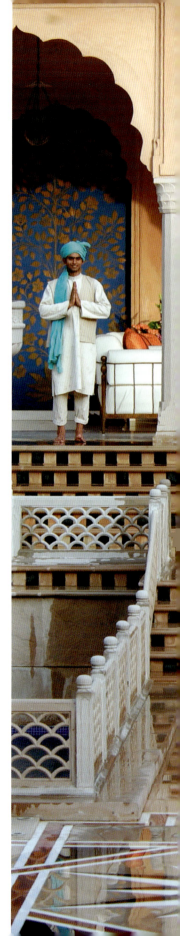

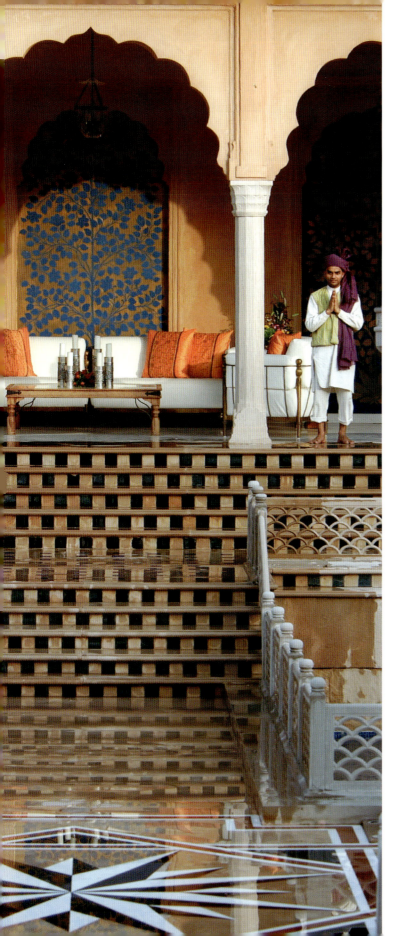
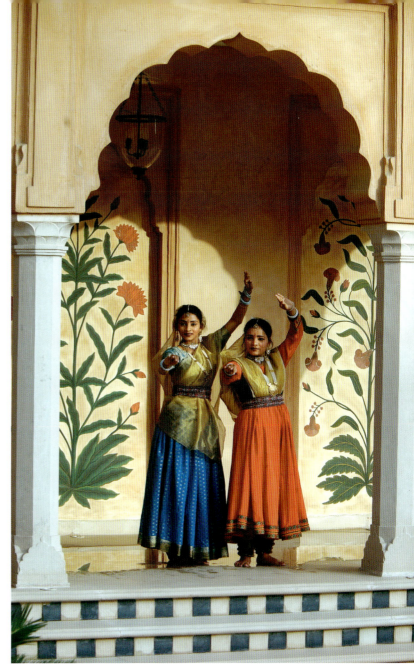

Left Outside the impressive domed lobby, a colonnaded terrace with gold leaf floral patterning on cobalt blue overlooks a water courtyard enhanced with two-toned geometric marble inlay. The railings have been painstakingly carved from single pieces of Indian Dholpur sandstone. **Above** The back walls of this arcade are adorned with floral motifs painted by artists from Jaipur, Rajasthan, in the Mughal miniature style but enlarged to 8 feet (2.5 meters).

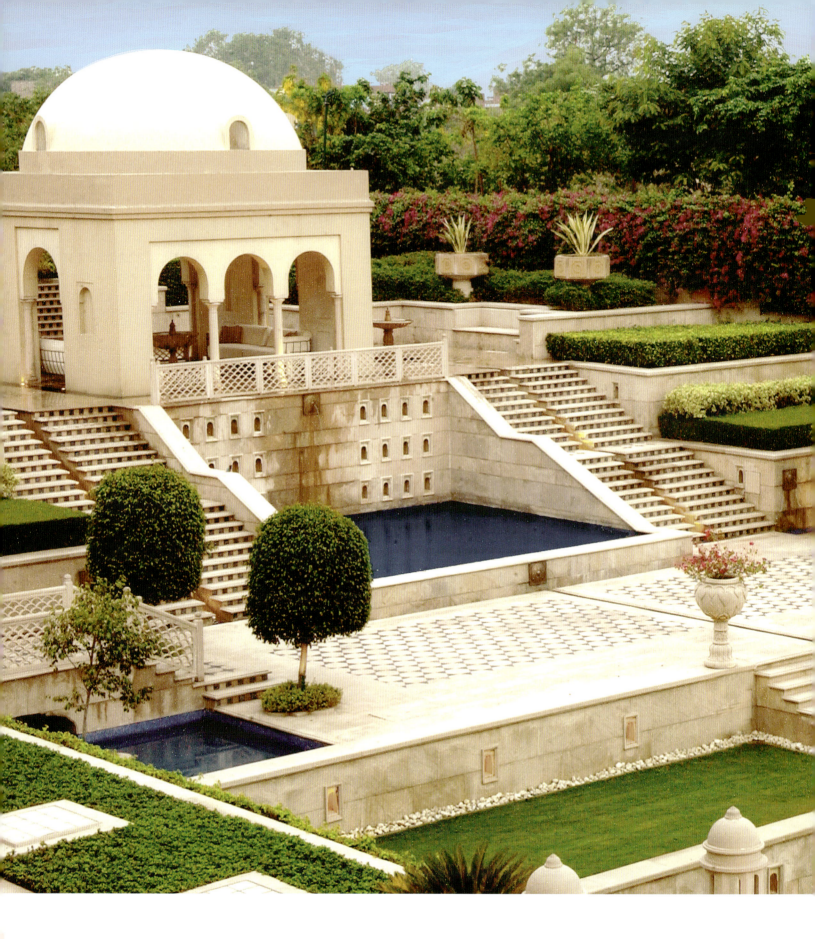

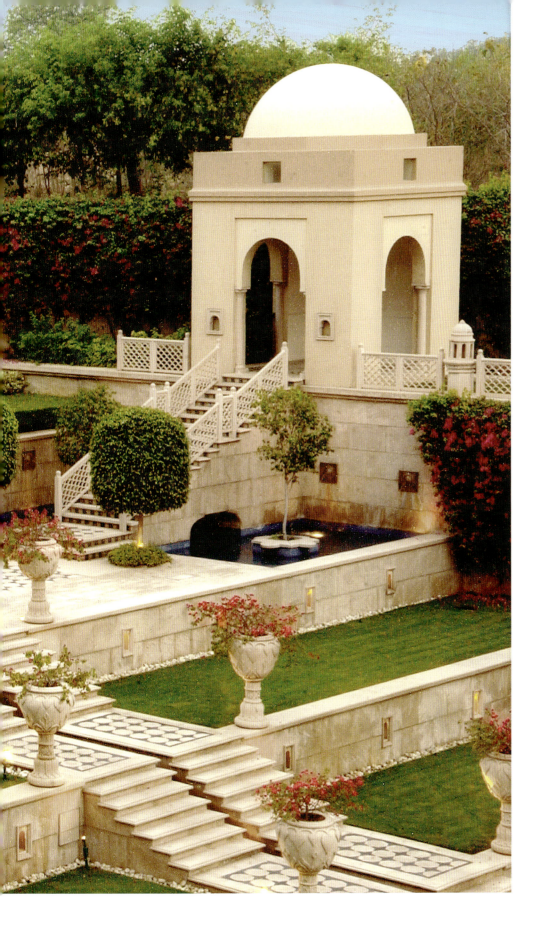

Left The site for the two terraced water gardens rising from the central swimming pool was perfectly flat when we started. This garden, to the south of the pool is, at first glance, a mirror image of the garden rising on the north side. But that would have been too easy! While the basic massing of the pavilions is the same, as well as the level changes, the fine detailing of the water bodies and channels is unique to each. We used Dholpur sandstone almost everywhere for a monolithic effect, accented only on the terraces and steps by black granite. On the back of the wall niches we fitted mirrored mosaics with an arch of Pakistani onyx (a golden, translucent marble) in front and a light bulb in between. As one moves past, the sparkle of the mirrors cannot fail to catch the eye. **Below** Our pointillism drawing of an Indian *chhatri*, an elevated, dome-shaped pavilion, which is also an element common in Mughal architecture.

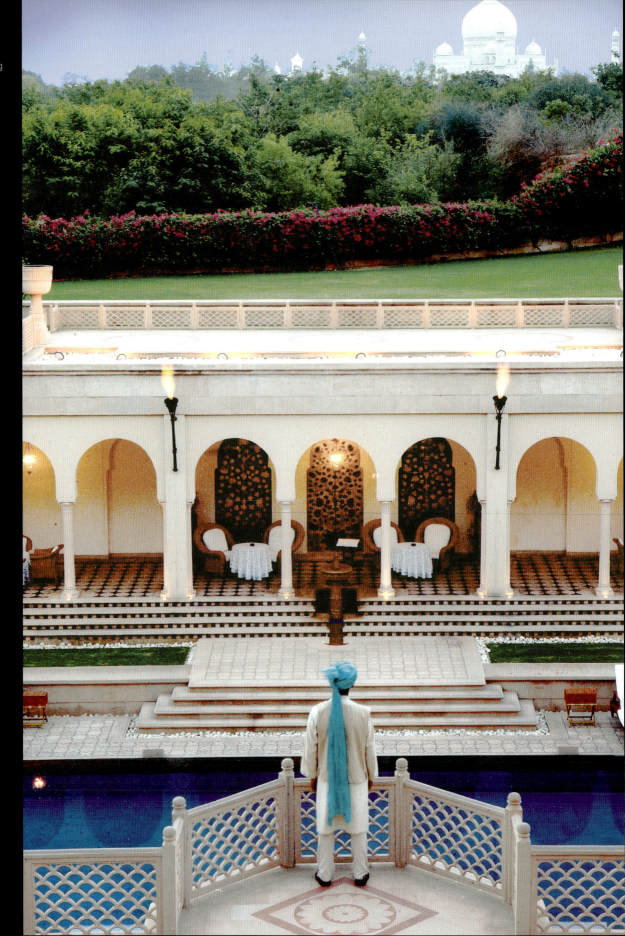

Right We dropped the swimming pool some 26 feet (8 meters) into the earth so that guests from the lobby could enjoy an unobstructed view of the Taj Mahal. Clearly nothing we built would ever be able to match its magnificence. Here, a turquoise turbaned waiter looks down on the pool restaurant and to the Taj beyond. **Opposite above left** The solid Dholpur stone columns supporting the arcade at one end of the swimming pool are reflected in the water splashed on the absorbent sandstone floor. **Opposite above right** The exquisite uniforms of all the staff at the hotel display impeccable taste. **Opposite below** LTW Designworks created this amazing space called the Ladies Bar. The waiter's turban complements perfectly the color of the wall paneling.

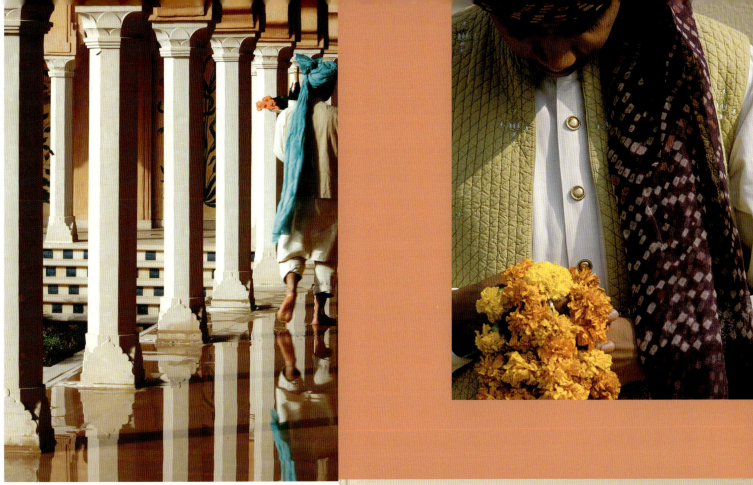

Amarvilas took eight years to build from conception to completion—we came on to the project about a year after the building work commenced—but for four of those years some 600 artisans employed by the Oberoi Group labored to embellish both the inside and out of the hotel with age-old crafts and techniques, among them geometric patterning of pure white Italian Thassos marble with red Indian Samathra sandstone or dark-veined Italian marble and beige Karoli stone from Rajasthan on the courtyards and interior floors; carved stone filigree balustrades; and stylized painted floral designs and gold leaf floral stenciling on the walls. The overall effect is one of austerity and quality craftsmanship rather than flamboyance.

All rooms in Amarvilas face the Taj, their ceiling-to-floor windows and private terraces allowing unparalleled views of the Taj's creamy translucence. Similarly, the view from the lobby over the boundary wall to the Taj is unimpeded. To achieve this, we pushed the lapis-hued, mosaic-lined pool

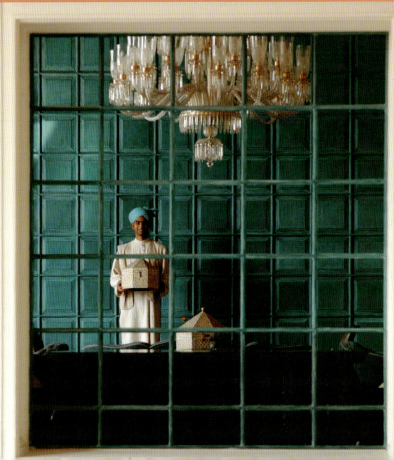

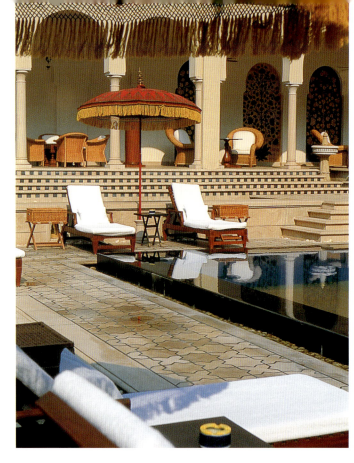

26 feet (8 meters) into the ground, which required a huge amount of excavation and initially met with a great deal of resistance from bewildered Indian engineers. At one end the swimming pool extends under columned arches, giving the illusion of flowing right underneath the hotel. At the other end is a colonnaded terrace.

We were also forced to tear down the original porte-cochere because it was obstructing the view of the Taj from the lobby. Happily, this gave us the opportunity to minimize the impact of vehicles on the guest experience. In place of the porte-cochere, we built a beautiful water courtyard in front of the hotel lobby. Guests alight in the driveway, then climb a few steps to a magnificent colonnaded forecourt filled with four stone torchères (lit at night) set in the midst of four reflecting pools fenced off with stone filigree balustrades and filled with carved stone fountains, before climbing a few more steps to the lobby. Along the walls of the colonnade we commissioned artisans to stencil delicate floral pictures in gold leaf on a blue background.

On the opposite side of the hotel building to the lobby, rising on terraces on both sides of the central swimming pool (page 68), we created Mughal-inspired water gardens filled with pavilions, pools and lawns (pages 62–3). Although the two gardens appear at first glance to be identical, there are, in fact, subtle differences between them: for example, on one side the water flows down the stairs in the center; on the other side it flows down the sides.

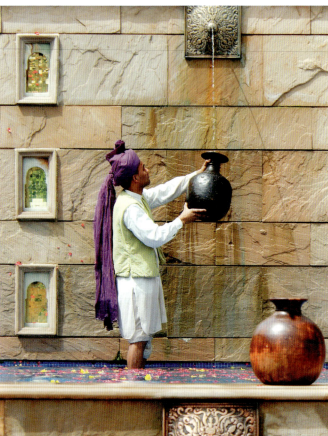

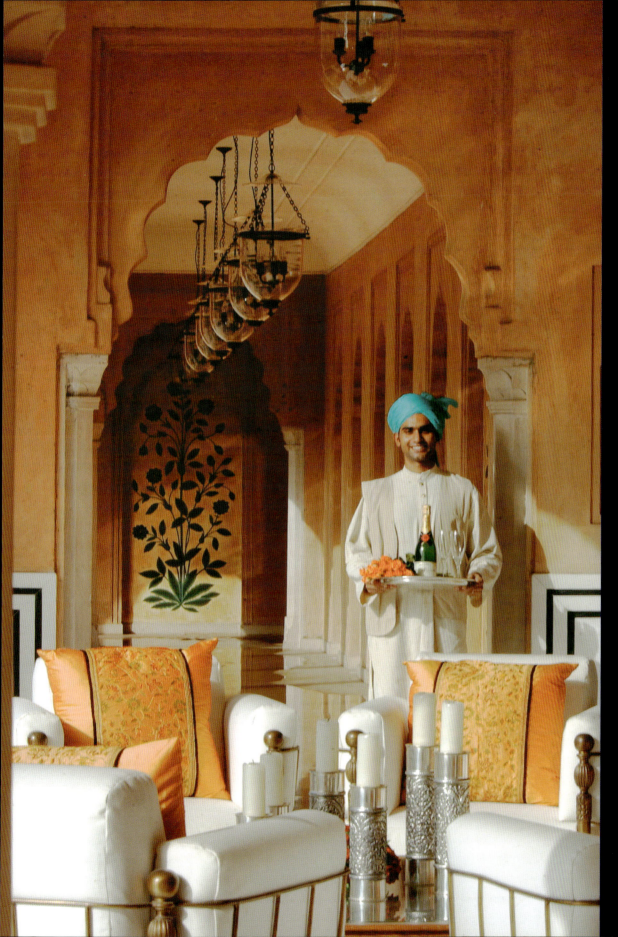

Opposite above left The blue mosaic-lined swimming pool was one of the first all-around infinity pools to be installed in India. The crisp black granite edge reflects the pool restaurant beyond. Large Balinese umbrellas provide shade around the pool. **Opposite below left** Normally the bellboys do not obtain water from the fountains set into the walls of the terraced water gardens. I just asked this lad to do it for fun. **Opposite below center** Our drawing of a bronze wall sconce. **Left** Sipping champagne in the comfort of the opulent water courtyard arcade is a truly delightful experience.

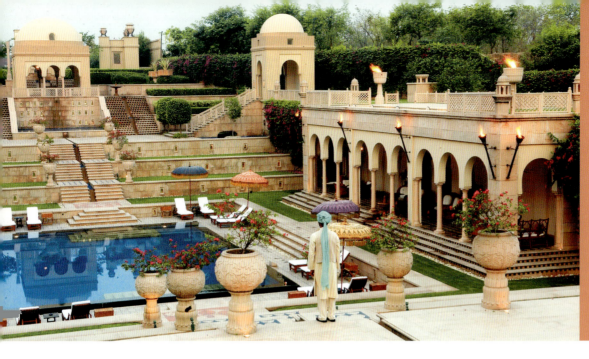

Left An overview of the azure swimming pool, the colonnaded pool restaurant and one of the terraced water gardens. Blazing torches light the area at night. **Below left** The processional steps down the water garden are not for the faint-hearted. **Below right** A romantic view of the pool restaurant through the "floating" arches at the hotel end of the pool.

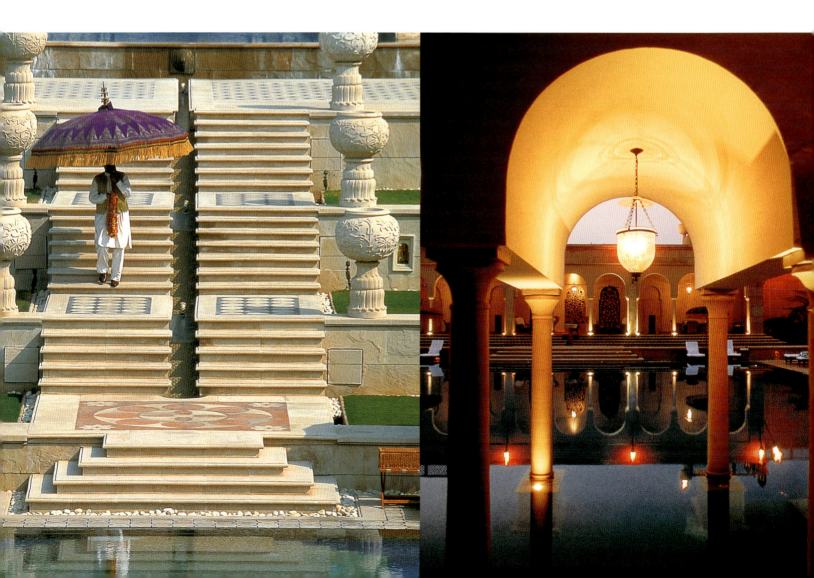

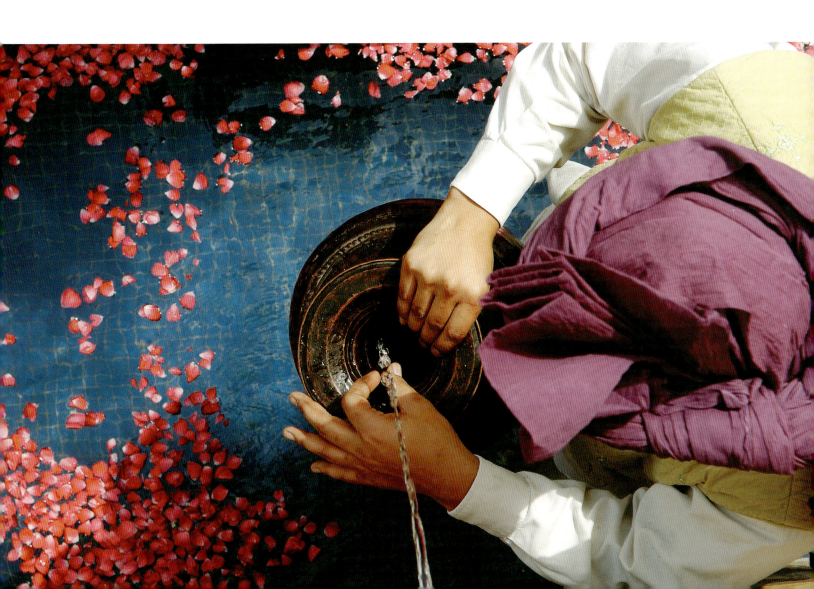

Left A magical view of the colonnaded forecourt greets guests arriving at Amarvilas at dusk. **Below** A bellboy lost in a fountain.

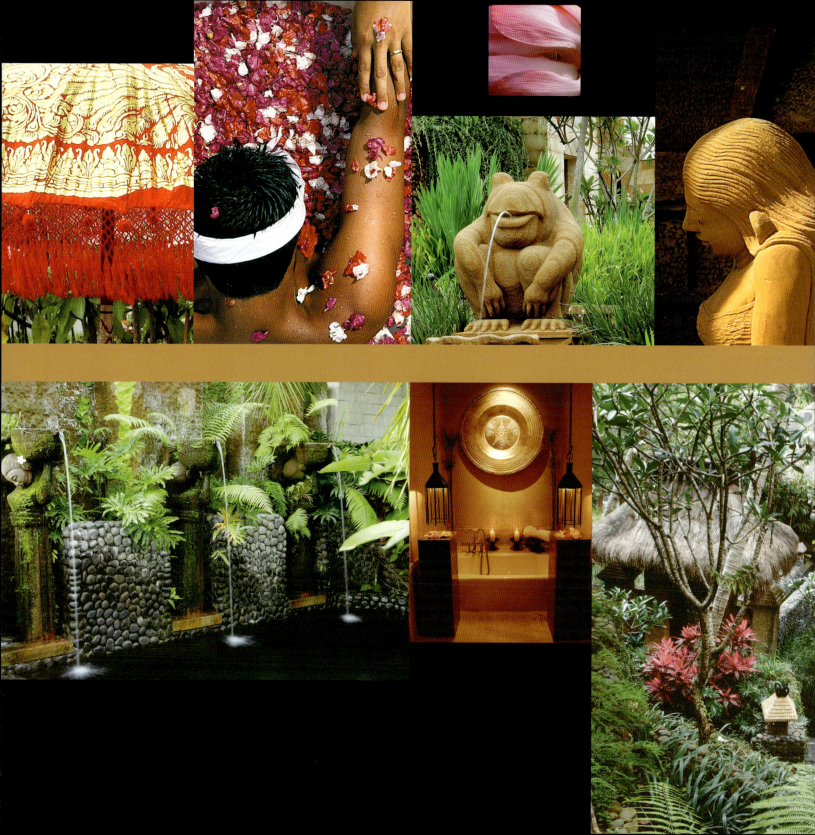

PARADISE IN INDONESIA

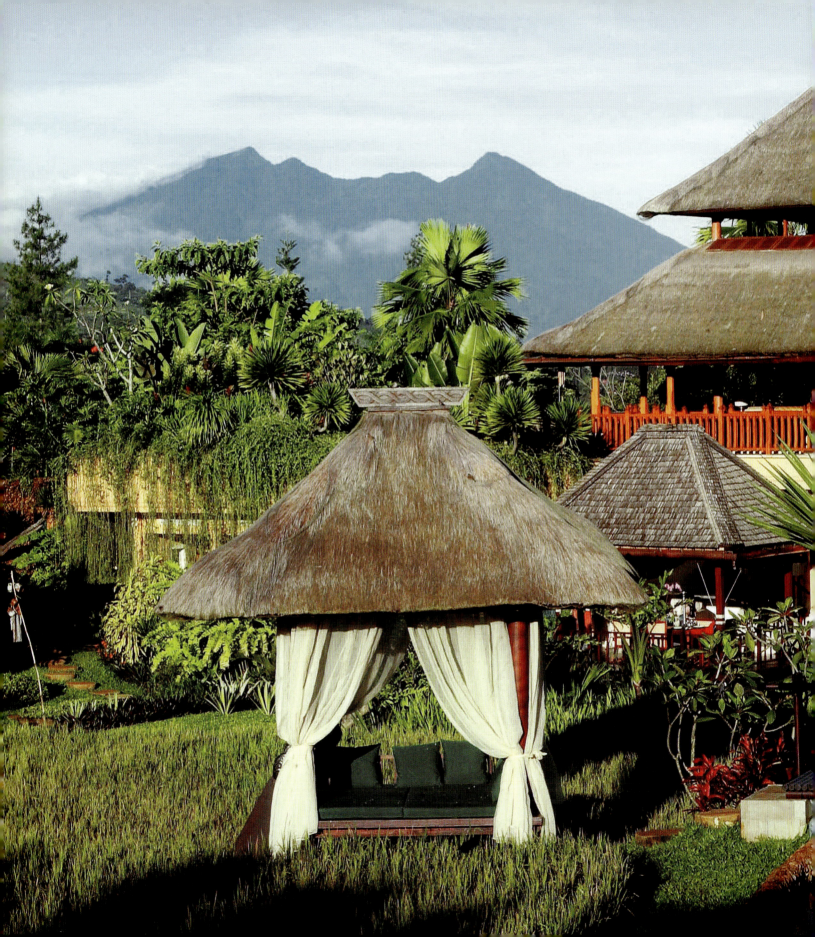

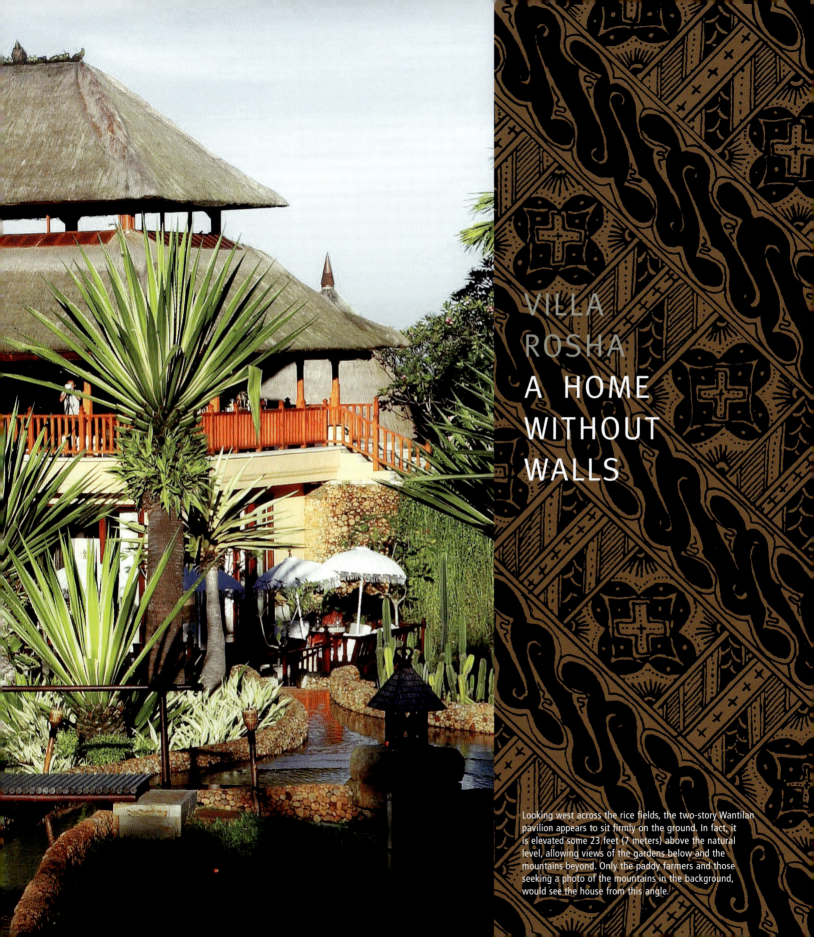

VILLA ROSHA

A HOME WITHOUT WALLS

Looking west across the rice fields, the two-story Wantilan pavilion appears to sit firmly on the ground. In fact, it is elevated some 23 feet (7 meters) above the natural level, allowing views of the gardens below and the mountains beyond. Only the paddy farmers and those seeking a photo of the mountains in the background, would see the house from this angle.

Tucked away on paddy land overlooking the rolling hills in the mountainous region of Puncak, 37 miles (60 km) south of the Indonesian capital of Jakarta, this weekend house provides a wonderful escape from the hustle and bustle of the city, about two hours' drive away. In love with all things Balinese, our client, originally hailing from Brooklyn, USA, but for a quarter of a century a successful businessman in Indonesia, briefed us on what he wanted: Balinese architectural elements, many places to sit and relax and "water everywhere." At nearby Bogor, Sir Stanford Raffles, governor of Java from 1811 to 1816, set up the famous Bogor Botanical Gardens, and with good reason: the volcanic soils here are extremely rich, the temperature is consistently cool and it is one of the rainiest places on earth—perfect conditions for a lush garden. For these same reasons, the various gardens at Villa Rosha are our head horticulturist Jirachai Rengthong's best planting design to date. In this stunning home without walls, we also had the good fortune to have all our ideas realized, from the architecture, gardens and sculpture to the interior design.

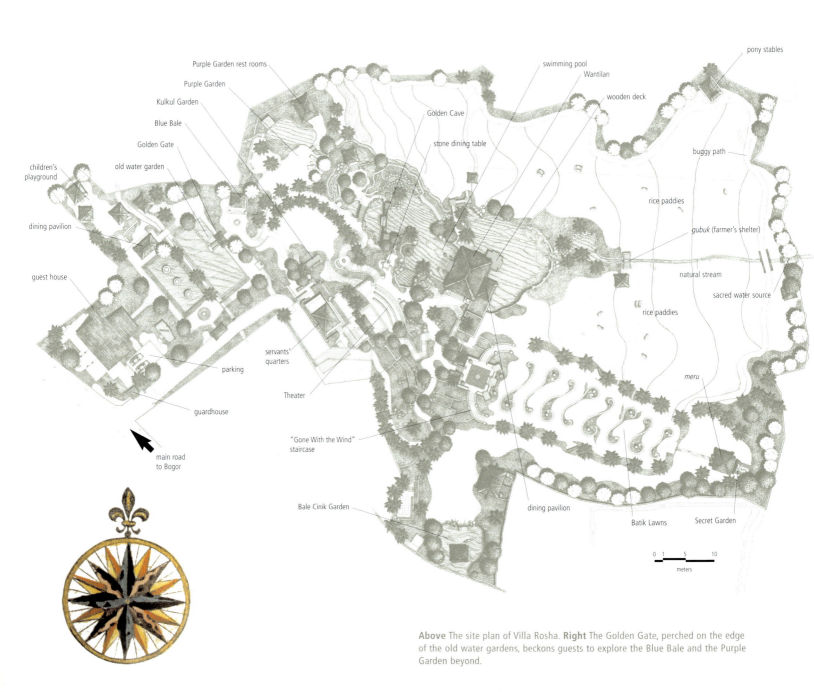

Above The site plan of Villa Rosha. **Right** The Golden Gate, perched on the edge of the old water gardens, beckons guests to explore the Blue Bale and the Purple Garden beyond.

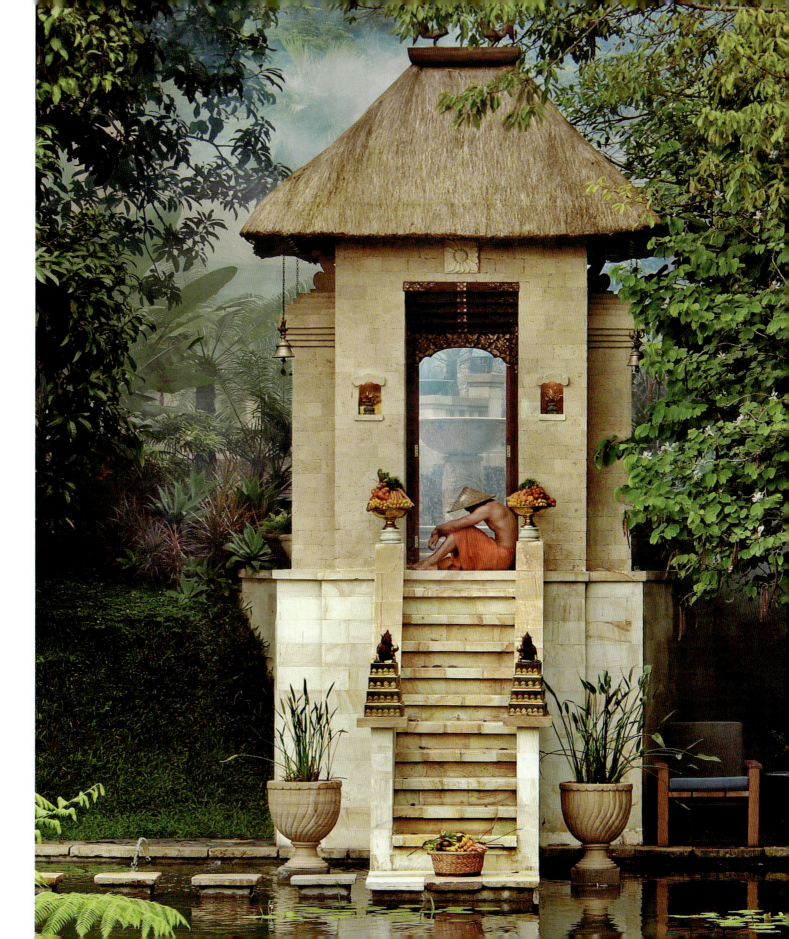

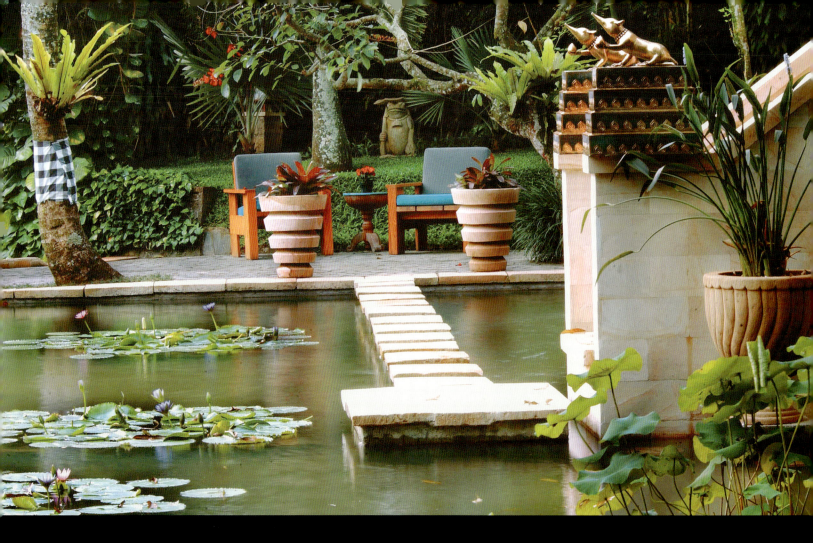

THE OLD WATER GARDEN

A long time ago, my client employed my very old acquaintance Made Wijaya, a long-time resident of Bali, to create a garden for his original bungalow on the site. Made skillfully diverted a stream that flowed naturally though the property into two overflowing ponds filled with stepping stones, which still exist and have been incorporated into our garden design. When my client purchased an additional 22 acres (9 hectares) of land adjacent to his property, we used this old water garden as an entryway to our newly designed house and expanded gardens.

On the edge of the old water garden, we built a Golden Gate (page 75), a variation of the imposing gates placed at the main entrances to Balinese residential compounds and temples, which one can pass under to skirt around the back of the pond, or climb up and over to reach the Blue Bale pavilion beyond. Raised high on sandstone steps and topped by a thatched roof, the gate is ornamented with an exquisite twin-leafed Balinese door (closed in the photo shown) covered with hundreds of pieces of gold leaf specially brought from Thailand. As with most Balinese gates, niches and bases form spaces for floral offerings and statuary. Here, flanking the steps, a pair of antique bronze temple mice purchased in Bhaktapur, Nepal, promise good fortune to anyone rubbing their noses as they ascend the steps. The bases for the mice are new and were made in Yogyakarta.

Because the old lotus-filled water garden is blessed with the most mature trees on the property, it lends a sense of antiquity to the newly erected Golden Gate.

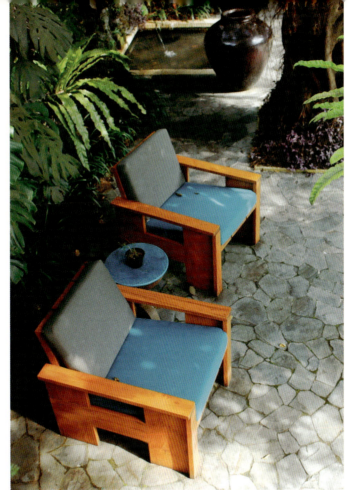

Left Nestled within the old water garden, a series of stepping stones provides a naturalistic walkway to the Golden Gate, guarded by a pair of bronze Nepalese lucky mice. **Above** A secret door to the Kulkul Garden. **Center** The fabric on these oversized garden chairs is color coordinated with the ceramic tabletop. **Right** A down light, beautifully carved from a single piece of coconut wood, hangs in the ancient ficus tree near the pond. **Below** Section through the Golden Gate at the old water gardens.

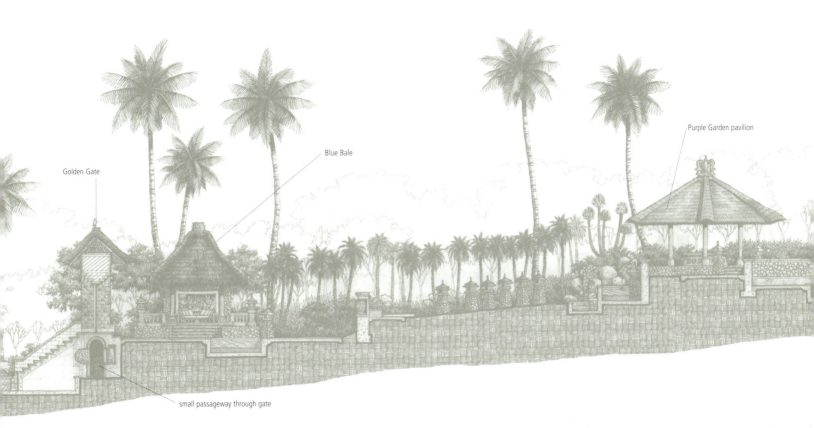

Golden Gate · Blue Bale · Purple Garden pavilion · small passageway through gate

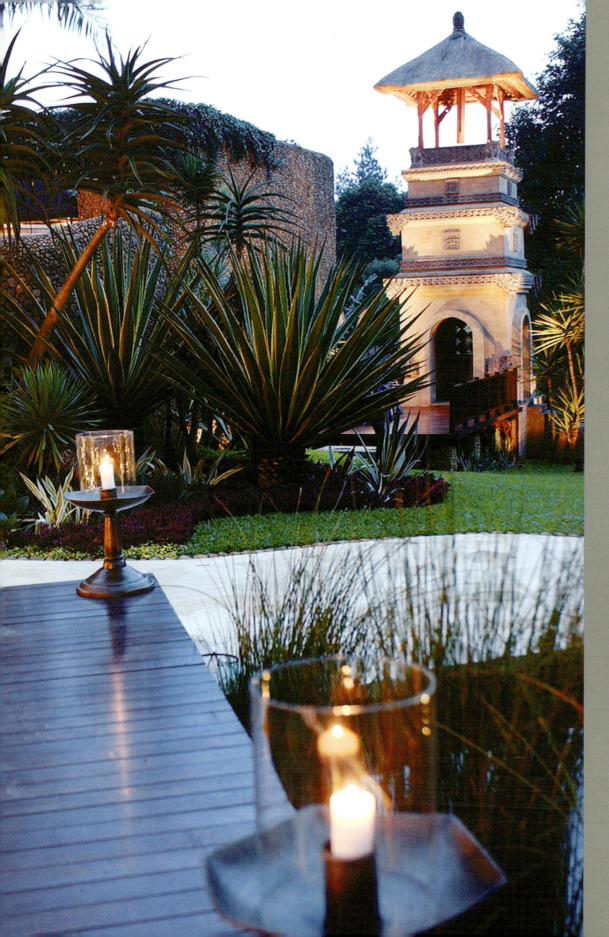

Left The imposing *bale kulkul* drum tower, adjacent to the raised swimming pool, stands sentinel over the garden in front, while functioning as the entranceway to the theater. The bridge in front of the arch hides the division between the freshwater swimming pool and Golden Cave waterfall on the left and the organic pond waters on the right. **Right** A solid sandstone tabletop floats above a base of brown mountain stones whose small sizes and smooth surfaces make them ideal for covering curved surfaces. **Far right** A small fountain in front of the Blue Bale, so-named after its blue furnishings and decorative accents, is adorned with tiny blue ceramic stars.

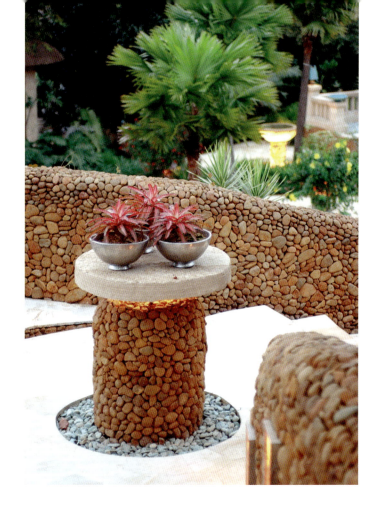
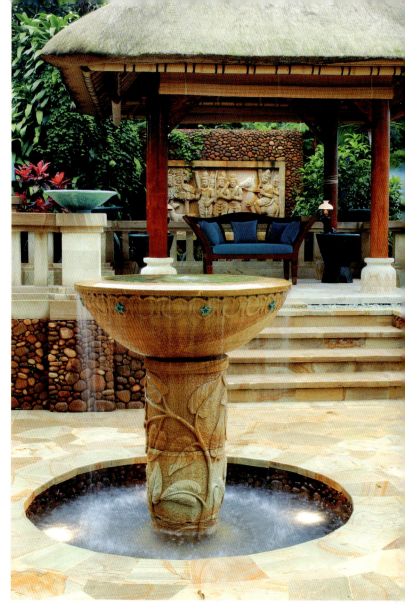

THE KULKUL GARDEN

A *bale kulkul* is a Balinese tower-like structure occupying a prominent position in a village and housing a *kulkul*, a suspended hollow wooden slit drum, which is struck in different ways to summon villagers to assemble, alert them to fire, etc. Our *bale kulkul* is placed at the corner of a bromeliad and aloe-fringed lawn shaded by a mature *Ficus benjamina* in the water garden below. A pathway bordered by allamanda-covered lanterns and a man-made stream halves the garden, starting at the Golden Gate, passing the Blue Bale and the Golden Cave, and up the winding steps to the Wantilan or living pavilion. Only when one takes a side trip to the theater is it necessary to pass through the *bale kulkul*. To the south of it is a secret door and a "blind" wall or *aling-aling*.

The land on which Villa Rosha and its gardens stand was originally gently sloping rice fields. To alleviate the monotony of the flatish site, we raised the Wantilan living pavilion and the swimming pool by 23 feet (7 meters) above the natural grade. This also created a void for the Golden Cave under the pool and the 19 foot (6 meter) high waterfall which crashes down in front of it, giving animation and freshness to the Kulkul Garden. The Golden Cave has a glass ceiling to allow one to watch the swimmers above. The light that streams into the cave though the swimming pool water dances delightfully off the walls. The mist and noise that come into the cave, where we built a pair of bunk beds accessible only by ladders, is also a delight, especially for children.

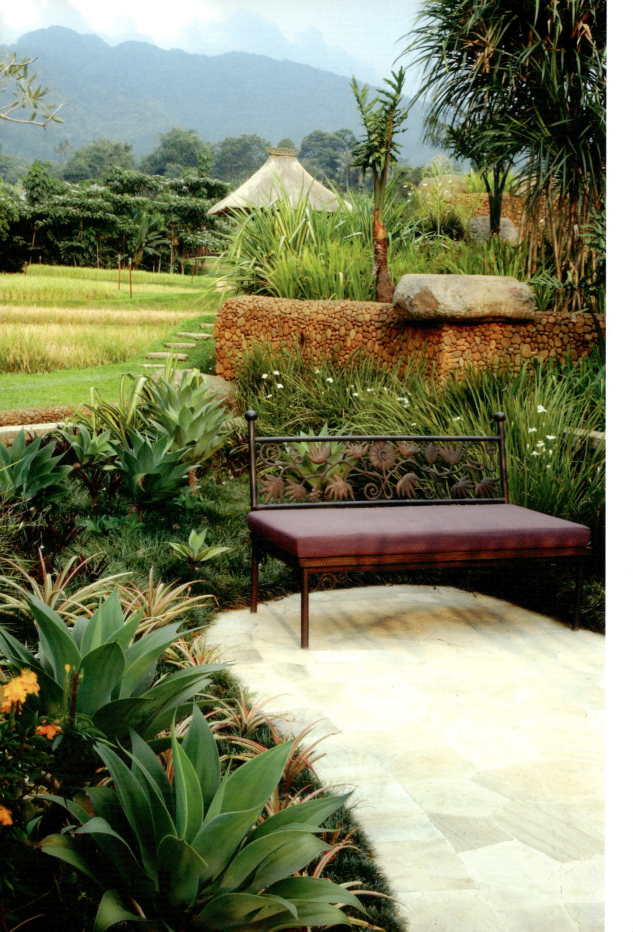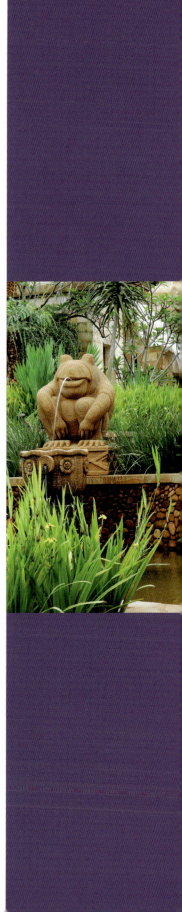

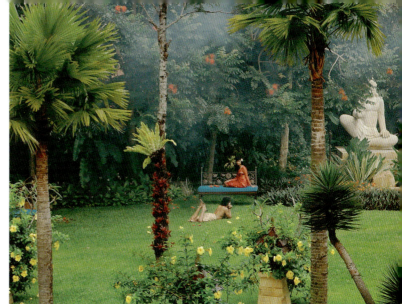

THE PURPLE GARDEN

The Purple Garden is an antechamber to the Kulkul Garden and occupies the lowest part of the rice paddies. To cater for large garden parties, we built a small pavilion to house two rest rooms. The front wall of the pavilion is clad in eggplant-colored ceramic tiles manufactured by Pesamuan in Bali, while the inside walls are covered with lime green tiles. A freestanding wall between the male and female toilets supports a shared washbasin made from a singular piece of onyx. Lime green silk lanterns, purchased in Hoi An on the east coast of Vietnam, hang above the basins. Surrounding the rest room pavilion, we planted a variety of "purple" flowering plants and trees with evocative names to accentuate the eggplant-hued tiles of the building: fragrant angel mist (*Angelonia goyazensis*), giant potato trees (*Solanum wrightii*), purple heart (*Setcreasea purpurea*), Moses in a cradle (*Rhoeo discolor*) and the succulent century plant (*Agave americana*).

Far left A view looking north from the Purple Garden to the terraced paddies and the local mountains beyond. The wrought-iron design on the back of the bench, appropriately covered in purple fabric, was inspired by the *Agave attenuata*, sometimes called the "lion's tail" or "swan's neck" because of its curved stem. **Center top** A bromeliad garden covers the southern slope below the Wantilan perched prominently above. **Center left** A full-figured frog frolics in the foliage next to a small grass pathway that winds its way up through the edges of the rice paddies. In the background, the water from the swimming pool falls in front of the Golden Cave. **Center right** The constant cool tropical air of the mountain environment is perfect for bromeliads like this one. **Center bottom** Our horticulturist, Jirachai Rengthong, playfully wears a pair of angel trumpet flower (*Brugmansia aurea*) earrings on a path in front of the swimming pool. **Above** My attempt to set up a tropical scene from *Romeo and Juliet* failed, but one can still appreciate the depth of the Purple Garden from this viewpoint.

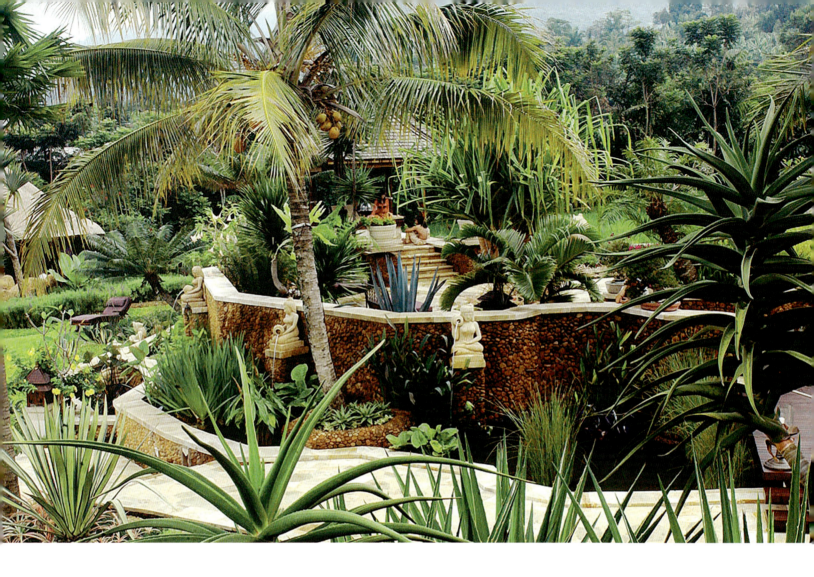

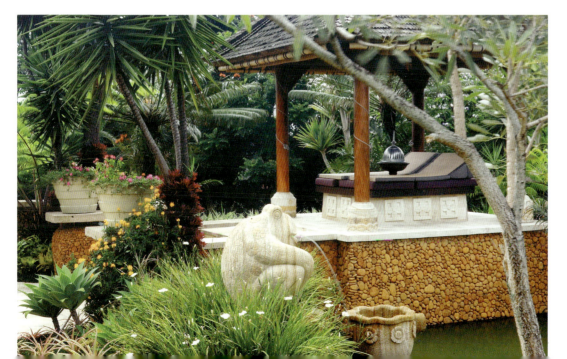

Above An unusual collection of plants in this corner of the Purple Garden—decidedly more sculptural than purple—harmonize perfectly with the sandstone wall sculptures and the irregular shapes and levels of the stone walls and paths. **Left** Sharing space with a pond, this shade pavilion with its bamboo and ironwood shingle roof separates the Purple Garden on one side and the rice terraces on the other. Built into the stone platform are triangular Thai cushions covered in plum-colored Sunbrella fabric. Nearby another fat frog spews water into the pond.

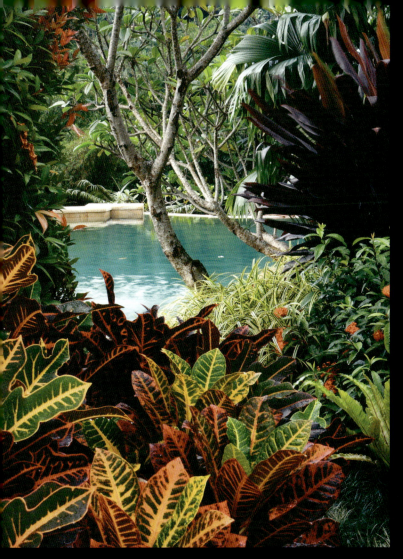

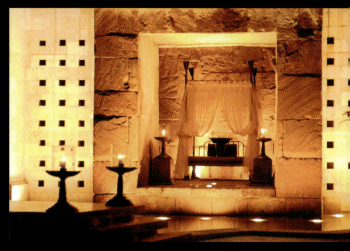
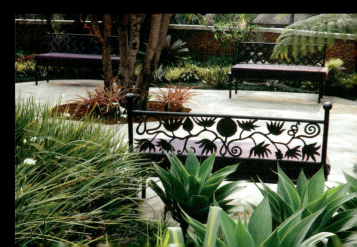

The installation of a glass-bottomed pool was a nightmare involving many experts, special glues, fixing agents and resins, and anyone but this owner would have cemented it in the first year. We filled and emptied the pool six times over a period of 18 months before it finally stopped leaking. It was the owner himself who finally found the correct resin-to-glass-to-cement seal.

The Golden Cave is clad with huge slabs of natural cleft gold sandstone. The centerpiece is a custom-built bronze four-poster day bed with a woven leather mattress. Bunk beds are built into the stone walls on both sides. Dozens of candles light this delightful space in the evening. During the day, rays of dazzling light shine through the blue waters and glass bottom of the pool.

Above The stunning raised swimming pool can be glimpsed through dense plantings of lush tropical species. **Above right** Tropical tree ferns frame this 6.5 foot (2 meter) high Balinese beauty ensconced in a niche on one side of the waterfall. **Center right** A view of the inside of the Golden Cave without the water falling in front. **Right** More wrought iron and wood benches inspired by the curvy-stemmed *Agave attenuata* encircle a tree.

Right The *alang-alang* grass-thatched roof above the backstage wall of the Balinese-style theater is covered with a brilliant red passion flower creeper (*Passiflora coccinea*), while the central part is topped by two carved cockerels; cock-fighting has very deep and ancient roots in Balinese culture. The twin-leafed door in the center of the stage, also in the Balinese style, is elaborately carved and painted. Behind the door are large backstage rooms for costume changes. The false windows on the façade take the form of carved ventilation grilles. A pair of bronze Balinese Baris or "warrior" dancers flanks the stage. **Below** The cobblestone path running behind the theater allows the owner to tour the grounds in his golf buggy and to bring in stores for the Wantilan.

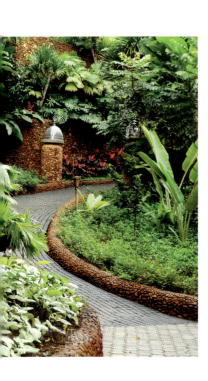

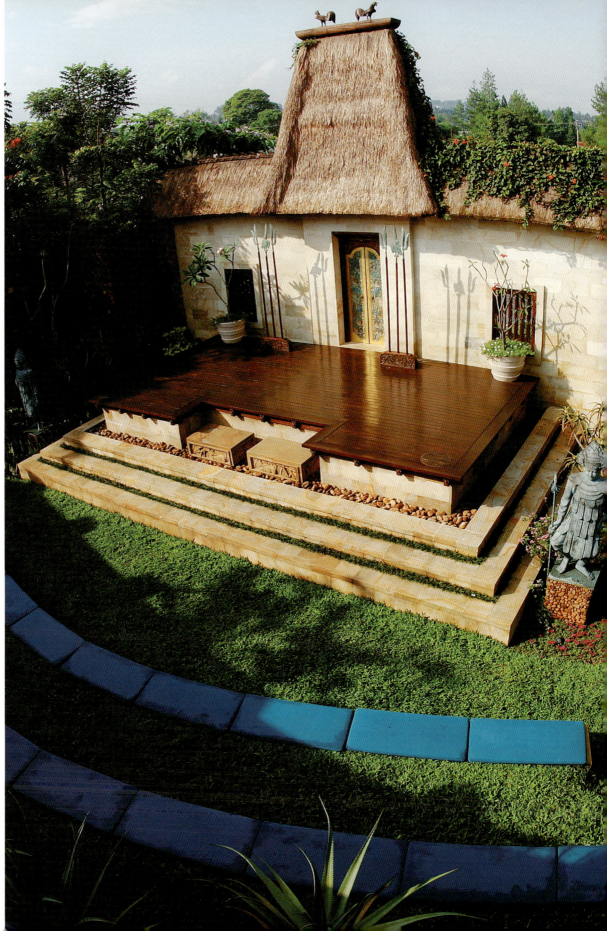

THE THEATER

The owner of the estate requested that a small theater be built to provide entertainment for his children and their numerous classmates and family members. Although located in the open, the theater has a removable tent to protect the players and audience from the many rainy days common in the area. The stage has a backdrop fashioned after a Balinese palace with a working door in the center flanked by two false windows. Behind the door are rooms for costume changes and storage of props. Seating is in the form of an amphitheater with rising tiers of sandstone blocks ranged in a semicircle. Covered with comfortable (removable) cushions for performances, the seating can accommodate about 100 guests. Enclosing the seating, a stone wall is graced with four Balinese Legong dancers cast in antique pewter.

Above On the stone and brick wall behind the amphitheater-like seats, a series of Balinese Legong dancers cast in antique pewter with silver *lamay* dresses "dance" in the cool breeze, bringing life to the vignette. **Left** The stepping stone pathway leading up to the theater from the Kulkul Garden passes between a variety of tall, spiky-leafed plants. Bamboo torches light the way at night.

THE WANTILAN

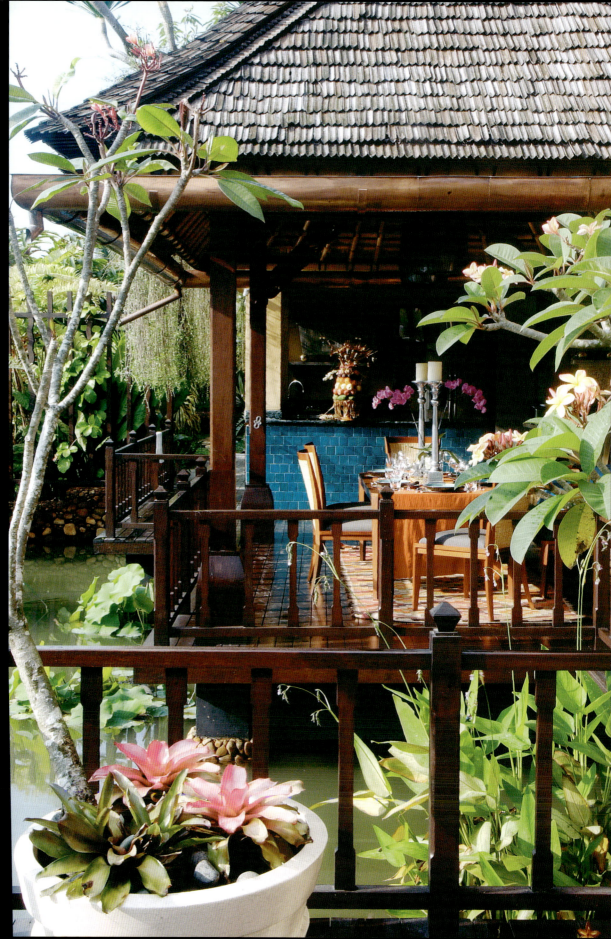

Open-sided *bale* or pavilions are ubiquitous in Bali. Most people do not live in houses in the conventional sense of the word but divide their daily activities between a number of different pavilions grouped around a central courtyard within a family compound, secluded from the outside world by a high wall, or, if a public pavilion, located in the center of a village. Each pavilion is associated with a particular activity and is distinguished by the number of posts supporting the roof, the type of roof structure (hipped or pointed) and the materials used.

The Wantilan at Villa Rosha, a contemporary reinterpretation of the Balinese

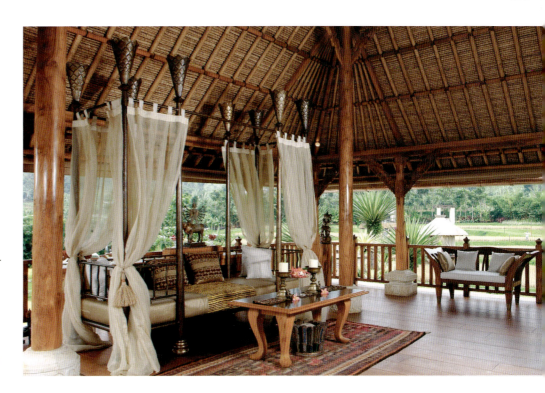

Left The dining pavilion and kitchen on the east side of the Wantilan appear to float over the water gardens. Pesamuan hand-glazed *pejaten* tiles cover the servery. **Right** This eight-poster bronze day bed made in Solo makes a stunning centerpiece in the Wantilan, from which the owner and his guests can enjoy 360-degree views of the surrounding countryside. **Below** The wooden deck just off the east side of the master bedroom features a 10 foot (3 meter) long day bed suspended over the water.

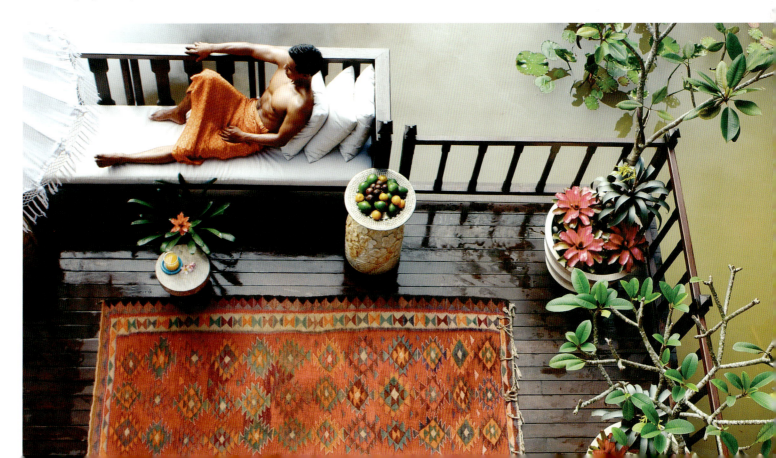

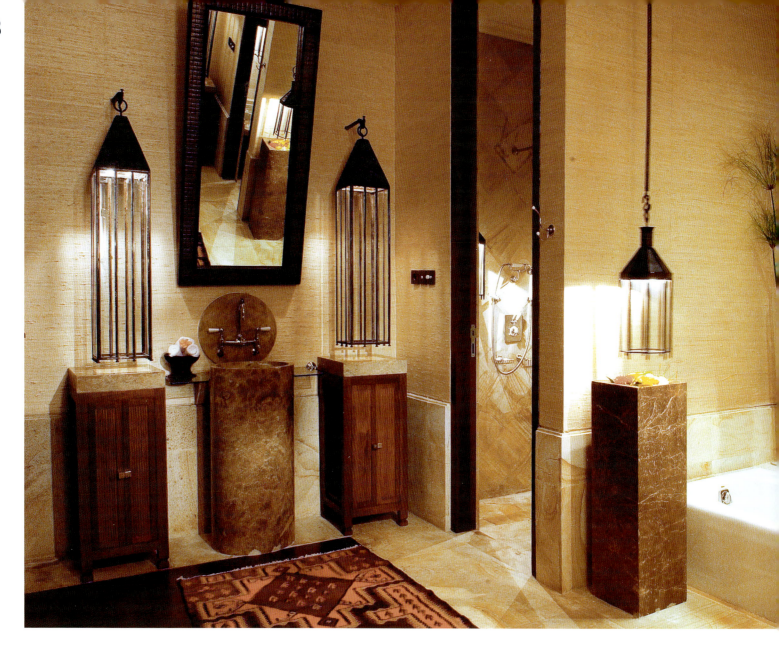

cockfighting pavilion (*wantilan*), is open on all four sides and has a two-stepped thatched roof for the ventilation of hot air. Perched 23 feet (7 meters) above ground level, it allows splendid views of farmers working in the surrounding rice fields and of the hills in the distance as well as the various gardens embracing the Villa Rosha estate. Although it took an actual size mock-up in bamboo to convince the owner to build the Wantilan at this height, what was originally meant to be a simple pavilion without walls turned into a much more comfortable and useful weekend getaway; because of the raised floor, the Wantilan was able to accommodate at ground level a master bedroom, then a children's bedroom, then a guest toilet, and finally a kitchen with an attached dining pavilion. The brief kept growing—as did the house! I imagine in the future we will add a guesthouse or two.

From the swimming pool, the Wantilan appears as a single-story structure. It is only from the rice fields, where few people venture, that one can see the full two-story façade of the bedrooms and dining pavilion.

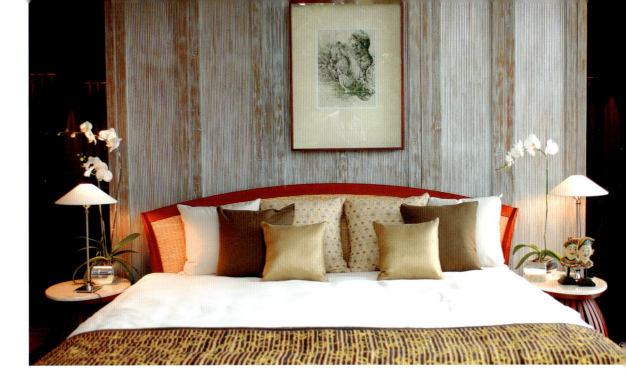

Left The master bedroom bathroom features a series of six custom-made hanging bronze and glass lanterns. I wanted the lanterns to just clear the top of the cabinets, thereby encouraging the owner to use the cabinets below. The washbasin and the pedestals at each end of the bathtub are made from solid Bandung marble. The silver medallion above the bath was made in Solo, the city of silversmiths. **Above** One day, when going through the owner's art collection, I stumbled across this wonderful pencil sketch by Australian artist Donald Friend, one of my favorite artists. I had it framed and gave it place of honor above the bed. The back of the bed, a freestanding armoire, neatly partitions the bedroom and bathroom. The beautiful handmade batik cloth at the foot of the bed has been embellished with embroidery in gold thread. **Below** This section through the Purple Garden, Golden Cave, swimming pool, Wantilan and dining pavilion illustrates the relationship of the built-up areas of the swimming pool and Wantilan to the original ground level, indicated by the dark line at the bottom. From the pool on the west (left) side, the Wantilan appears to be a single-story building, while the east (right) side drops away to the dining pavilion below. The Golden Cave, with its waterfall facing the Purple Garden, is also illustrated here.

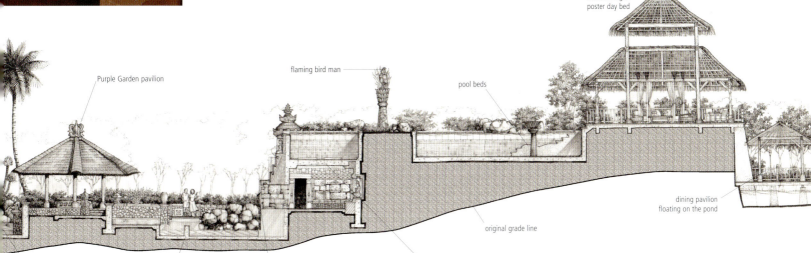

THE RICE PADDIES

We used rice fields on the upper terraces of the estate to tie in seamlessly with the neighboring farmlands and hillsides. These step down towards the Wantilan in small increments. The natural stream entering the estate is first dropped through a waterfall and then channeled down a round boulder stream to the Wantilan's pond, where it is split into a narrower aqueduct and falls into the pond at five waterfalls. From here, the water flows past the master bedroom alongside the lower paddies, through the Kulkul Garden, and out of the property.

Below From the deck of the master bedroom one can see the stables beyond the rice paddies. **Right** We harnessed the public irrigation waters to make these ponds, waterfalls and streams. Towering false agaves (*Furcraea gigantea*) make an awesome sight. **Below right** Our version of a *gubuk* pavilion in which farmers sit and pull strings tied with strips of cloth or aluminum foil to scare away birds as the valuable rice crop ripens.

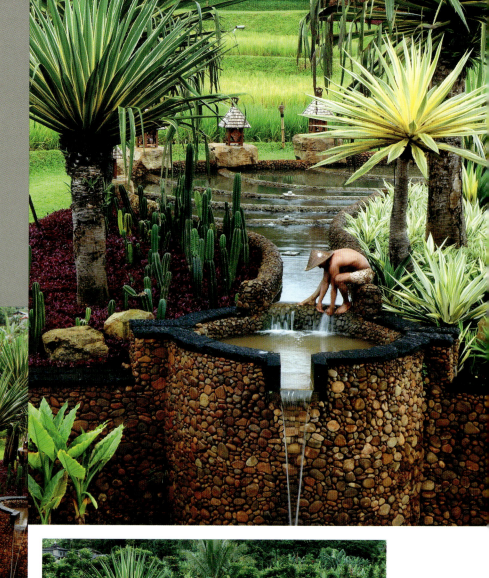

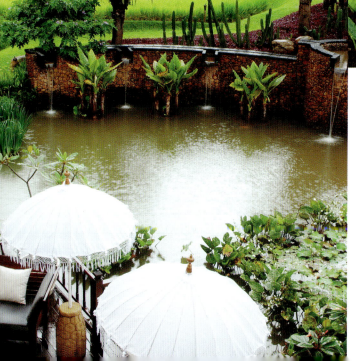

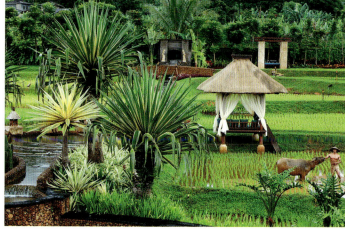

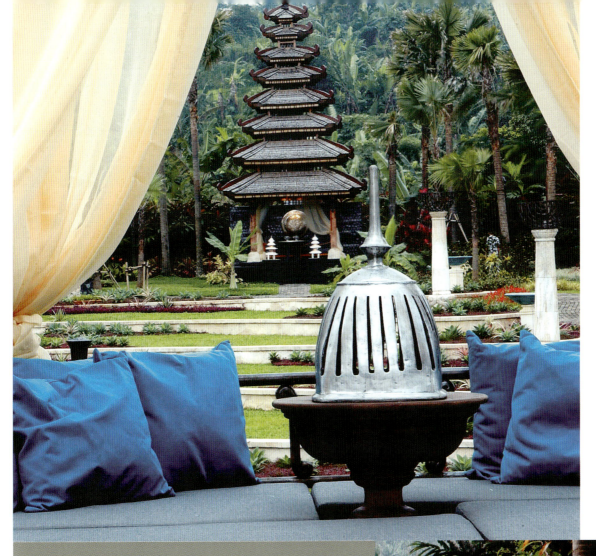

Left Overlooking the stepped retaining walls of the Batik Lawns and on the same axis as the eight-tiered *meru* at the far end, an imposing cantilevered day bed on a raised plaza makes a dramatic statement (see page 8). It is here that the owner entertains his most important guests. The "Gone With the Wind" staircase at the side of the platform, flanked by balustrades formed from thousands of stones, also confers a grand sense of entry. Fire torchères of braided sheet metal atop tall stone bases provide lighting for evening functions. **Below** Two silver *meru* models, also with an even number of roofs, stand in front of the large *meru*.

THE BATIK LAWNS

Part of the client's brief was a spectacular garden where he could entertain hundreds of people. We designed the Batik Lawns for such an occasion. In plan view (page 74), the stepped Batik Lawns mimic the very popular Javanese *parang* ("broken dagger") batik motif. We formed the edges of the pattern with seat height walls and filled the centers with lawns. Encircling the batik pattern are more than 50 sadang palms (*Livingstonia rotundifolia*) to reinforce the idea that this is a separate "room" within a palace of gardens. At the far end of the lawns is a reinterpretation of the traditional Balinese *meru*, which symbolizes the legendary Mt Meru of Indian mythology, the abode of the gods. It is usually made from wood and raised on stilts on a masonry base and surmounted by an uneven number of thatched roofs of diminishing size. Our secular *meru* is made of cast aluminum and has an even number of roofs.

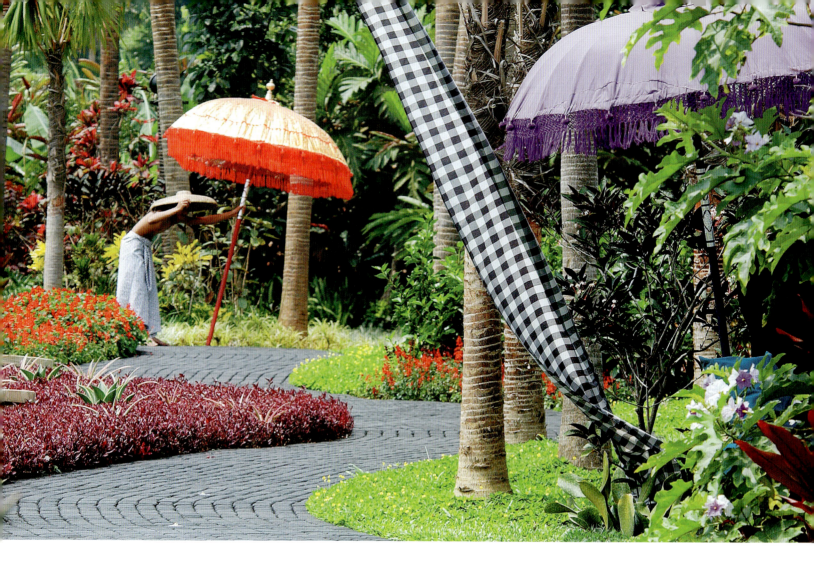
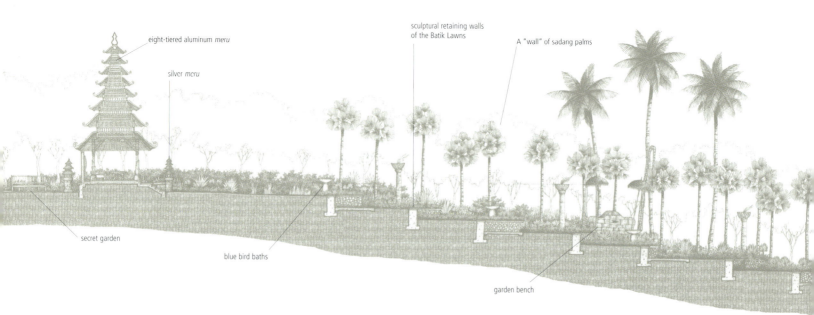

eight-tiered aluminum *meru*

silver *meru*

sculptural retaining walls of the Batik Lawns

A "wall" of sadang palms

secret garden

blue bird baths

garden bench

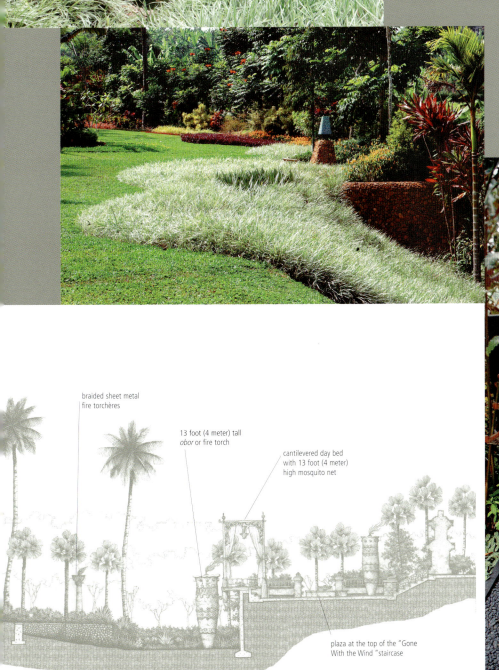
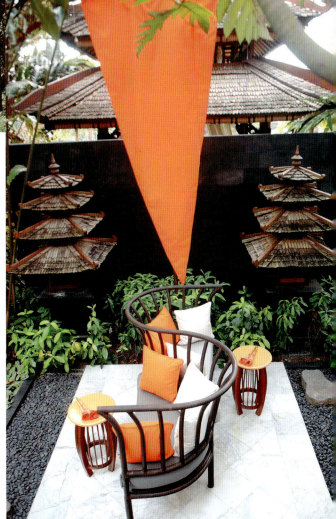

Far left The Batik Lawns at Villa Rosha are planted with dozens of sadang palms (*Livistona rotundifolia*) to form a natural enclosure to the property, but the profusion of colorful, carpet-like ground cover steals the show. **Left** South of the Wantilan is this very small water garden with a lush foreground of lily turf (*Ophiopogon jaburan variegata*). **Center** A luxuriant swathe of ground cover on the south side of the Batik Lawns is punctuated by blue ceramic lanterns. **Opposite below** Section through the *meru* and the Batik Lawns to the "Gone With the Wind" staircase and the giant day bed. **Below** Behind the *meru* is a secret garden made from materials left over from the more important parts of the grounds. These two *meru* models were originally made for the front of the *meru* but were much too large and were replaced with finer silver ones.

braided sheet metal fire torchères

13 foot (4 meter) tall *obor* or fire torch

cantilevered day bed with 13 foot (4 meter) high mosquito net

plaza at the top of the "Gone With the Wind" staircase

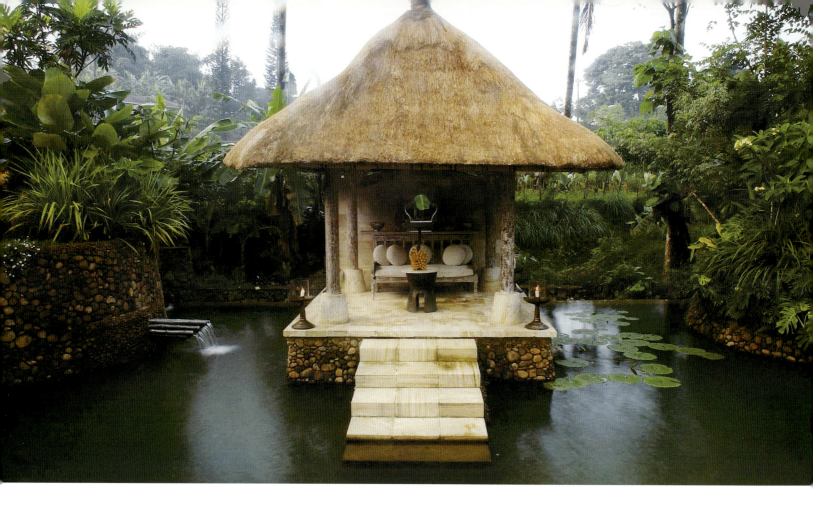

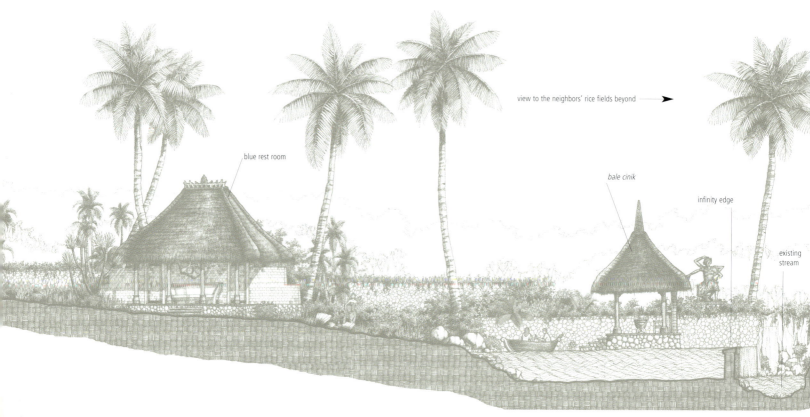

- blue rest room
- view to the neighbors' rice fields beyond
- bale cinik
- infinity edge
- existing stream

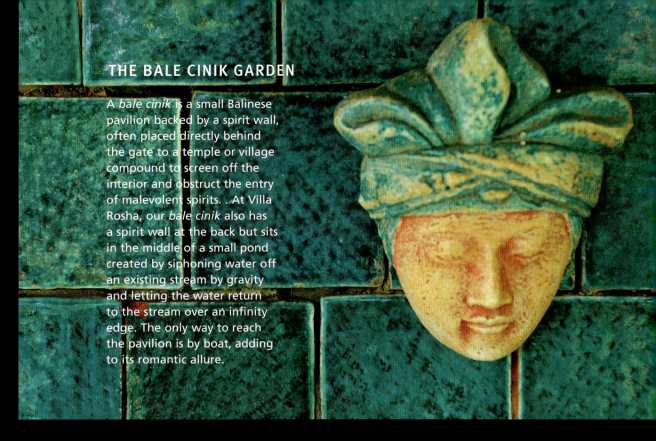

THE BALE CINIK GARDEN

A *bale cinik* is a small Balinese pavilion backed by a spirit wall, often placed directly behind the gate to a temple or village compound to screen off the interior and obstruct the entry of malevolent spirits. . At Villa Rosha, our *bale cinik* also has a spirit wall at the back but sits in the middle of a small pond created by siphoning water off an existing stream by gravity and letting the water return to the stream over an infinity edge. The only way to reach the pavilion is by boat, adding to its romantic allure.

Left The thatch-roofed *bale cinik* sits serenely in the midst of a man-made pond. **Below left** Section through the Bale Cinik Garden from the blue rest room to the *bale cinik* pavilion. Water, taken from the public canal upstream, is piped into the pond and flows out over the infinity edge wall at the back of the pavilion. **Right** A small sculpture indicating the entrance to the male rest room. **Below** This stunning little pavilion is simply an open-air rest room.

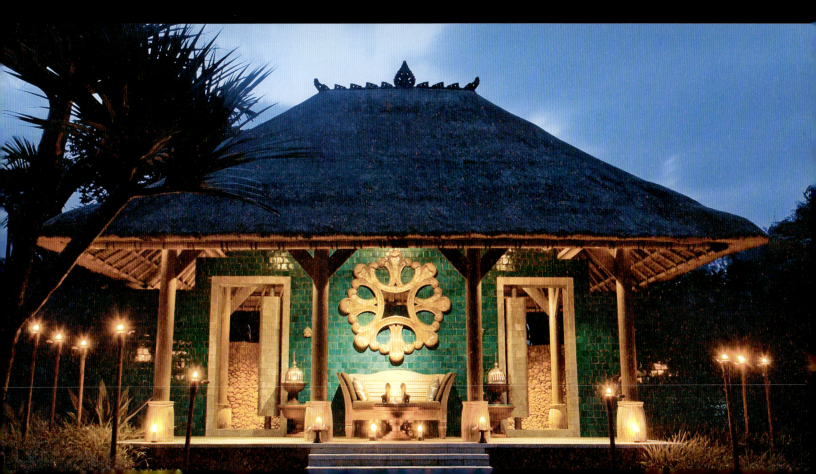

KARAWACI RESIDENCE
FAR FROM SUBURBIA

Our team designed this expansive residence, situated in a quiet, green cul-de-sac in Lippo Karawaci, a pioneering planned township in Tangerang, 30 miles (48 km) west of central Jakarta, for the same owner of the getaway weekend estate, Villa Rosha, profiled on pages 72–95.

The owner first approached me in 1996 for a design for the garden of his Karawaci house—his first home. The architectural plans he showed me were for a traditional two-story house placed squarely in the middle of a block of land, with a pool out back. I asked him frankly if he wanted to live in a box or in something more exciting, and he agreed that the original design needed a major rethink. Our discussions revealed, in fact, that he much preferred a more indoor–outdoor concept, with more exposure to the beautiful 18-hole golf course bordering the site.

Our client's first taste of Asia was Thailand in the 1960s, so it is not surprising that this home is flavored with Thai architectural spice. He hired Thai architect Lek Bunnag to design the actual house, while Indonesian architect Ketut Hardika followed up with the architectural detailing. Bensley Design Studios was engaged to do the interiors and gardens. The collective result was a family home with a difference.

Above These three torchères, carved in stone from central Java and adorned with Thai motifs, directly face the formal living pavilion from the motor court entrance.
Right Located at street level, this courtyard fountain, inspired by an exquisite bronze bowl purchased many years ago in the Thieves Market in Phnom Penh, is perfectly centered with the bed in the guest room on the left.

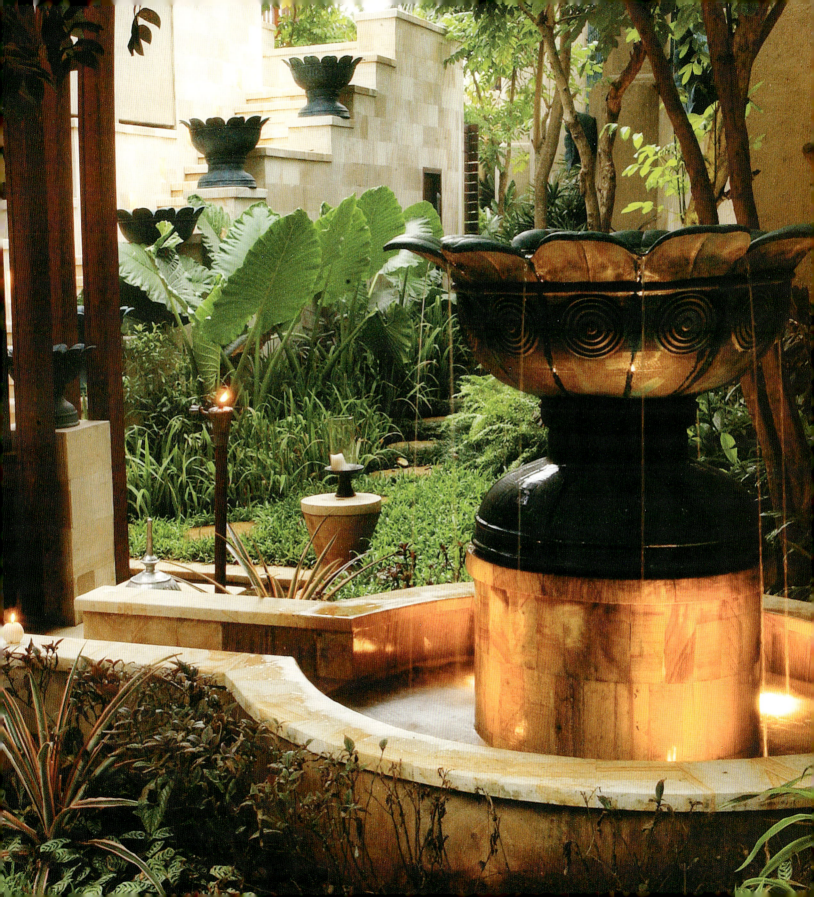

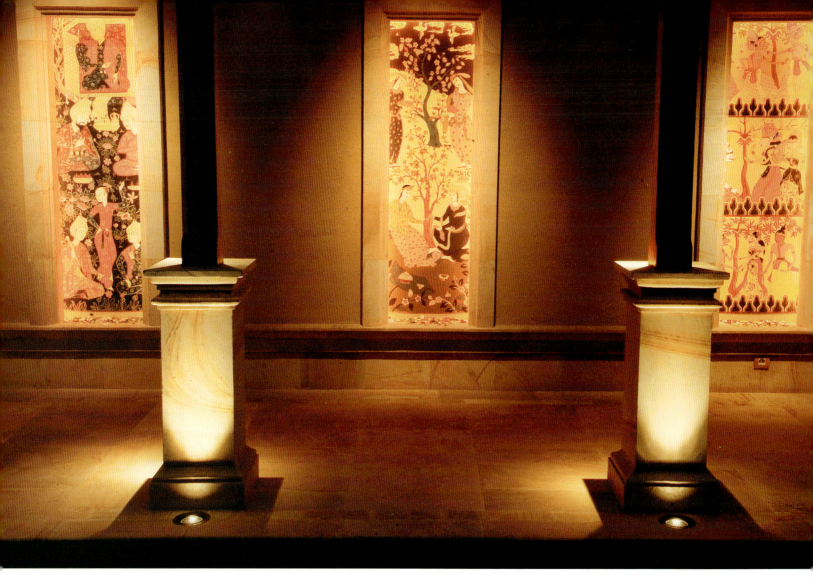

Security can be an issue in Jakarta, and it is usually necessary to erect a high wall to keep people out. This automatically blocks the ground-floor view of a conventional house. Lek's solution was to elevate the entire site by 8 feet (2.5 meters). At the new raised level we built a garage surrounded by pavilions constructed of plantation grown teak, including a formal living room with a lofty pointed roof entered via a series of small pavilions with overlapping roofs in the style of a Thai temple, and an octagonal outdoor dining room. A covered arcade or walkway connects the living room with the dining pavilion and with the rest of the house.

The approach to the house is up a winding path, around a stone-paved motor court resplendent with water and fire features to the entrance of the formal living room. The floor of the porte-cochere, decorated with a pattern of smooth pink pebbles from the Indonesian island of Flores, makes a perfect foreground for an antique statue of Shiva, one of the principal deities of Hinduism, that I found in Chennai, India. The "fire" behind the statue comes from three stone torchères on the other side of the court some 26 feet (8 meters) away. The grouping of statue and torches

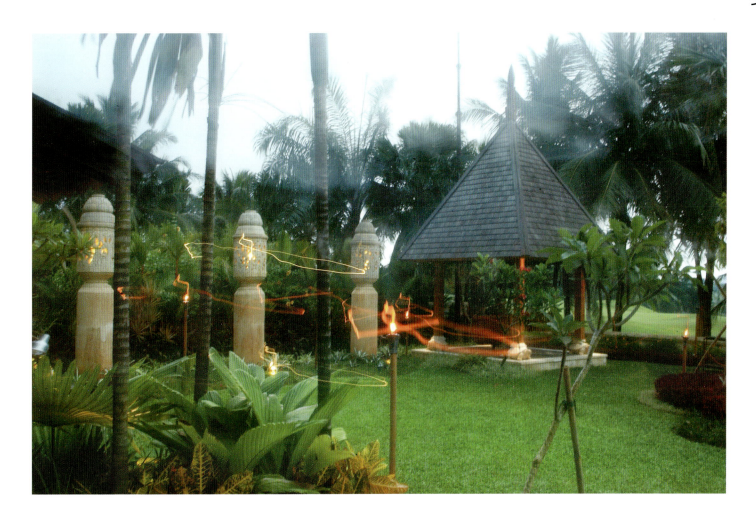

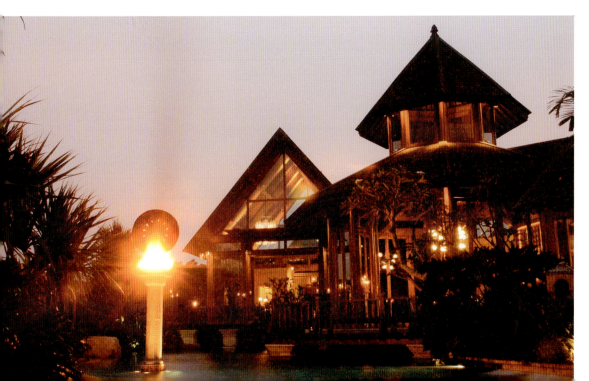

Opposite above Painted scenes from the Hindu epic, the *Ramayana*, glow in these niches, three of a series of 24 lining the covered walkway between the formal living pavilion and the rest of the house. Balinese painters were commissioned to render 24 regional interpretations of the famous epic. **Opposite below** Four very old Burmese stone temple elephants adorned with Balinese temple umbrellas crouch in obeisance at the front door to the formal living room pavilion. **Above** A swing pavilion in front of the master bedroom allows views of golfers in action on the course beyond. **Left** The formal octagonal-shaped dining room and the Thai temple-like living pavilion behind appear to be suspended over the swimming pool, creating a resort feel. Both structures are made of plantation grown teak.

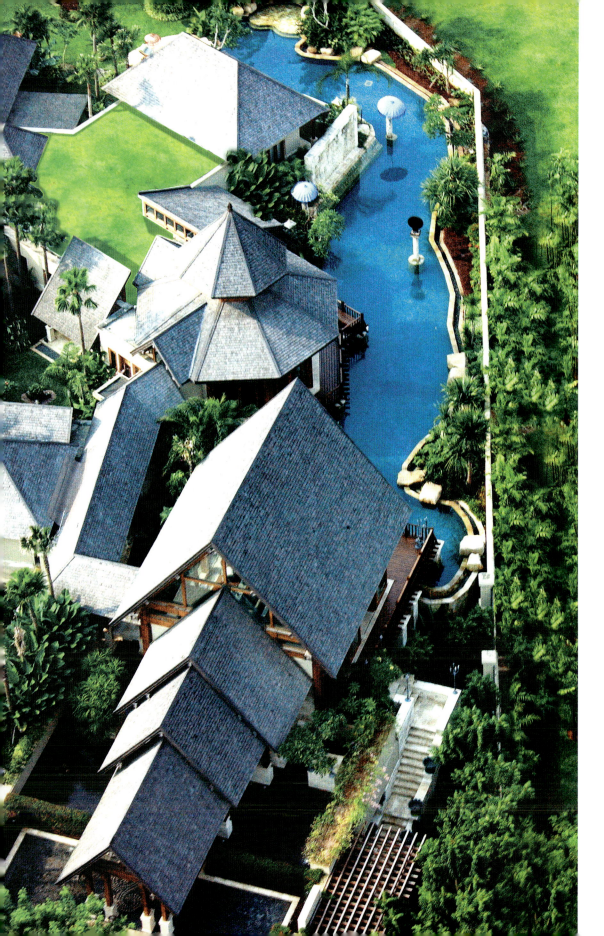

Left This aerial view of the Karawaci residence highlights its dramatic contemporary Thai-inspired roofscape. The pointed-roof entrance and formal living room in the foreground are linked with the octagonal formal dining room by a covered walkway. The owner's office is on the ground floor below the dining room, while the master bedroom, children's rooms and family dining room are to the left of the octagonal dining room. **Right** Comfortable sofas and armchairs interspersed with decorative artifacts from around the region characterize the decor in the owner's study-cum-office. A striped table runner adds contrast to the manly monotones, while bracts of bright red "lobster claw" heliconias add splashes of color. **Far right** Decorative pink pebbles, an antique statue of the Hindu god Shiva lit by background "fire," slim hanging lights and lush green plants combine to form a tactile and visual delight at the entrance to the formal living room.

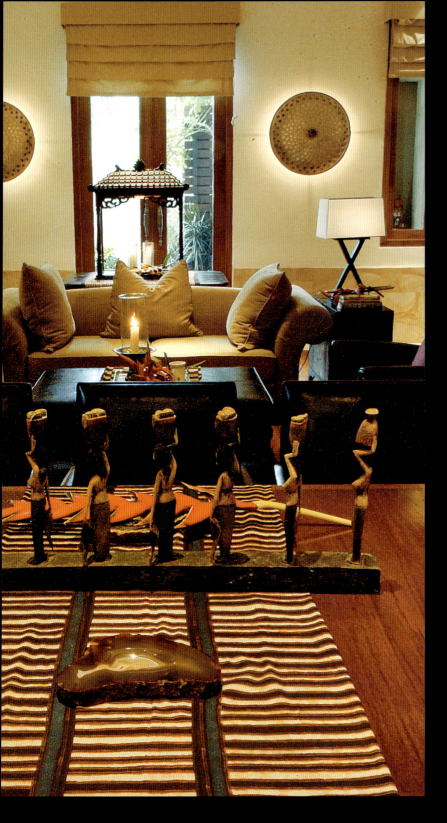

is in direct alignment with the massive front door of the living room reached along a short arcade. Flanking the front door, which was rescued from a bank in Yangon, are two pairs of very old Burmese stone elephants bearing cheerful Balinese temple umbrellas on their backs. A splendid antique Thai *garuda*, a large mythical bird or bird-like creature that appears in both Hindu and Buddhist mythology, gazes down from its perch inside the door to the living room beyond.

Although designed to seat six people at most, the Thai-style living room is both spacious and spectacular. Four huge lanterns, inspired by northern Thai white paper hot air festival balloons (*komloi*), hang from the lofty, pointed ceiling, seemingly flying through the sky. The top of the monolithic coffee table is made of long pieces of mother-of-pearl placed on a translucent background. Resting on top is a beautiful low silver table holding a collection of silver ceremonial containers in different shapes and sizes. Over the seven years that we worked on this home, I collected these highly decorative containers from Tibet, Chiang Mai, Bhutan, Cambodia and India. Underneath the table are four lights that give the illusion that the table is floating. In actual fact, it is guarded by four huge, cast aluminum side tables with miniature versions on top in the form of hurricane lamps.

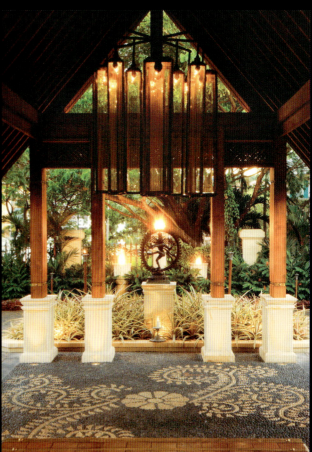

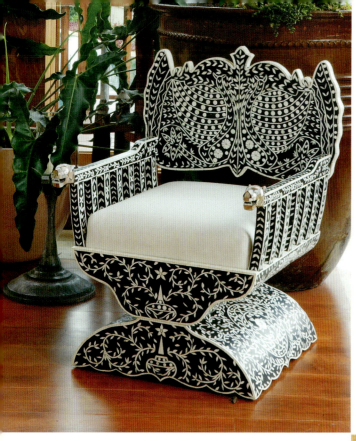

Niches inset into the wall of the living room are perfect backdrops for some freestanding wooden Thai statues from the Jim Thompson collection which the client obtained when he lived in Thailand in the 1960s. Also in this room are two ornate chairs made in Bali from mahogany inlaid with buffalo bone, with ornate lions at the ends of the armrests.

A covered walkway connects the living room to a large octagonal dining pavilion. To add interest to the walkway, we installed 24 niches, and for each commissioned Balinese artists to render different episodes of the ancient Hindu epic, the *Ramayana*, as it would be told in 24 different parts of Asia, from India to Burma to the Philippines. (The *Ramayana*, which tells the story of a Hindu prince, Rama of Ayodhya, whose wife Sita is abducted by the demon king of Lanka, Ravana, is one of the most important literary works on ancient India, and has had a profound impact on art and culture in the Indian subcontinent and Southeast Asia.)

The dining room, furnished entirely with items designed in our studios and custom-made—from the dining table down to the plateware—is dominated by a spectacular chandelier crafted by an old friend, John Underwood. In our design for the chandelier, we employed the ubiquitous Thai *kanok*, a vegetal motif with a flame-like contour, and woven *faux* rhino skin. In the center of the

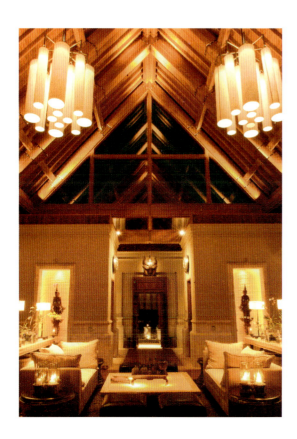

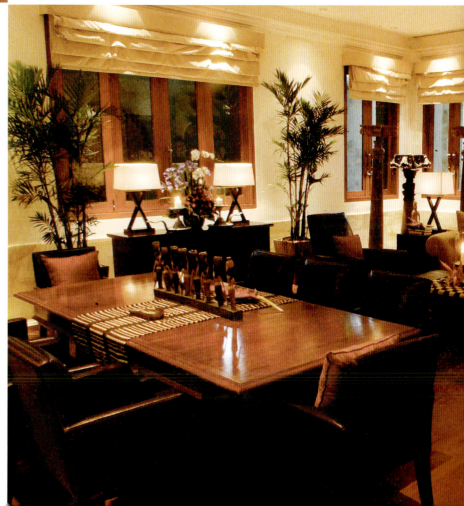

Far left Inspired by palatial Indian furniture, we had this inlaid bone chair made in Bali. **Below left** The lofty, pointed ceiling of the formal living room is accentuated by "floating" *kamloi*-style lighting fixtures, custom-made in Java. **Below center** Another view of the owner's office, which is set at ground level with the other buildings on the estate built up around it. Manly leathers and rich woods complement the room's strong lines **Right** A novelty feature in the powder room of the formal living pavilion is a vanity counter and solid marble basin suspended like a swing. A flexible drain pipe allows the unit to move a few inches.

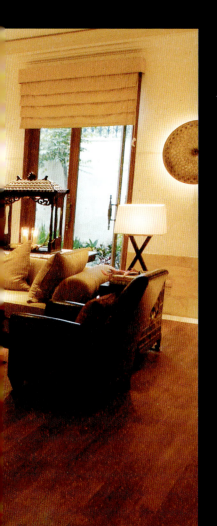

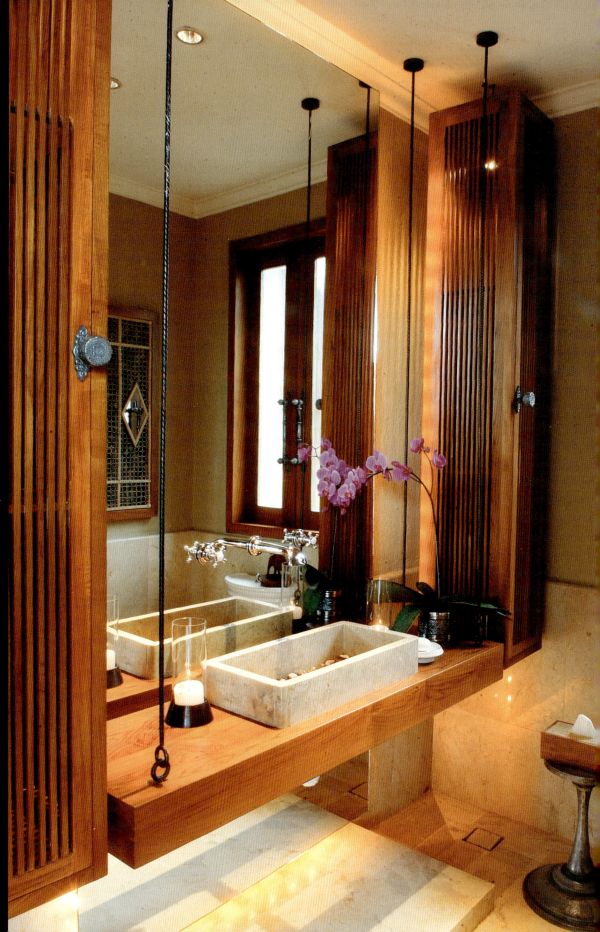

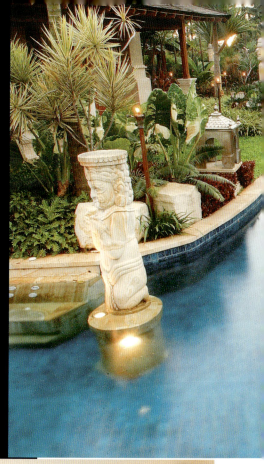

Left Deep, plushly upholstered benches hang over the swimming pool, providing overflow party seating for the formal octagonal dining pavilion. **Below** The family room, like the study, is furnished with comfortable seating in a muted palette. Another novelty feature in the residence is the fake antique Burmese door on the right of the room, constructed to balance with the real door on the left which leads into the master bedroom. **Right** The blue-tiled swimming pool meanders from the formal living pavilion, past the octagonal dining pavilion, before turning and heading around the children's rooms to the lawn of the swing pavilion. I love to make a water body turn and disappear out of sight, leaving the rest to the imagination.

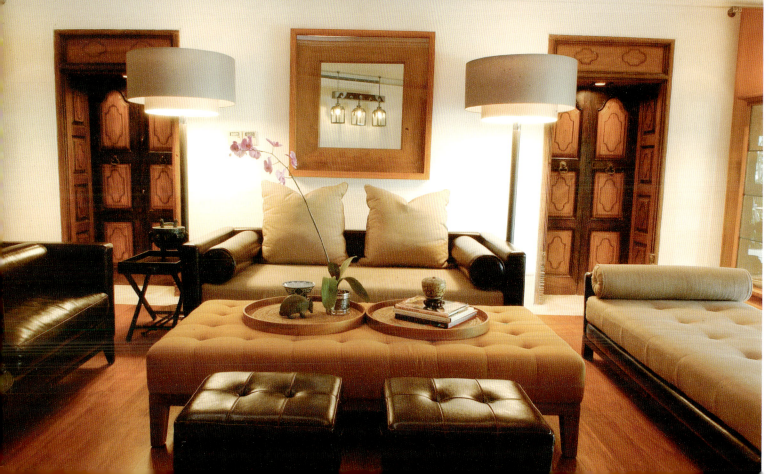

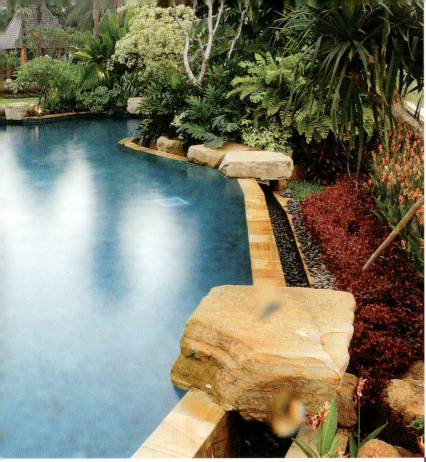

12-seater table is a huge lazy Susan. The silk-slashed dining chair covers were astronomically expensive. Even the Dutch-inspired plates were designed by us—and individualized with six different logo prints and an inscription.

To offset the heat generated by the vast expanse of glass surrounding the dining pavilion, it was necessary to install an air-conditioning system. To disguise the ducting, we placed a wooden grid panel covered with cast aluminum plumeria flowers in one corner of the room. Air shoots out gently from holes made behind each of the flowers and cools the room in a matter of minutes—a special requirement of the client.

Below the formal living room, the family room leads to the perfectly symmetrical master bedroom, but only through the antique Burmese door on the left. The door on the right is a folly and provides the necessary balance for the room.

Below left The family dining room has a super thick one-piece marble teppanyaki table that took a huge amount of manpower to install. **Below** The sheer volume of the formal dining pavilion and the client's instructions to have instant cool, quiet air the moment he walks in, posed a tough design problem. The result is this wooden panel of aluminum plumeria flowers that disguises the air-conditioning ducting behind the flowers, acting as a baffle, and disperses gently into the room the required cool air. We designed all the fittings and tableware in the room especially for the client.

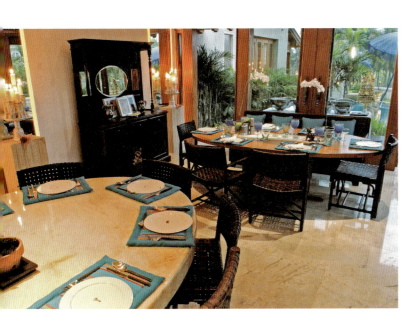

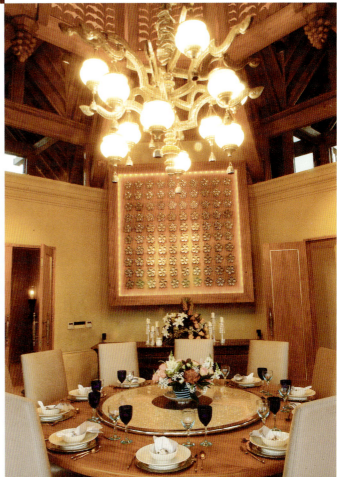

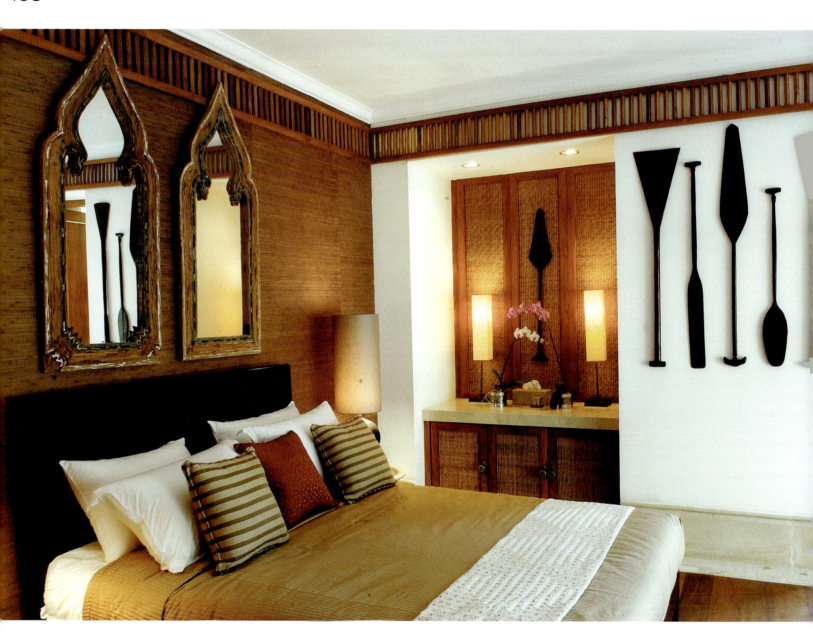

Two oval dining tables take up much of the space in the family dining room located between the formal octagonal dining room and the family room. One of the tables, 10 feet (3 meters) long and made from a single piece of thick marble, needed 25 men to carry it inside. The mirror in the beautiful old dresser we found in Chiang Mai echoes the oval shape of the tables. Around the perimeter of the room, on pedestals, are big dining trays called *kantok* from northern Thailand, covered in mother of pearl inlay decoration. The candles sitting on the trays were specially made in cast silver and all have mother-of-pearl drops to match the trays.

The owner's study-cum-office is set at ground level with everything else, except the guest room, built up around it, including the swimming pool. Like the rest of the house, it is an exercise in balance and harmony, with dark, manly leathers harmonizing with rich woods. I had the silver wall sconces made in central Java.

Adding splendor to the guest room at street level are two beautiful Thai Rattanakosin-period mirror frames mounted above the bed on a wall of Korean grass paper and a very old wooden chair, found in China. The small collection of antique boat paddles is also Thai. The marble basin in the adjoining bathroom is suspended like a swing, with a flexipipe underneath.

The candelabras outside the guest room, like those scattered throughout the gardens, are made from cast silver and aluminum. You can turn the house lighting all the way down, and the whole house and gardens can be romantically lit with candles. In the mornings, of course, there is wax everywhere!.

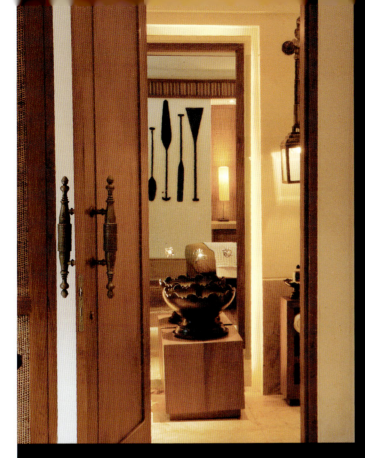

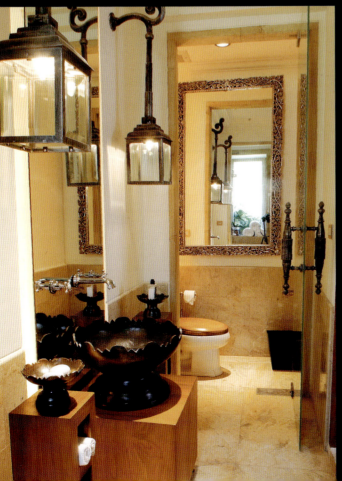

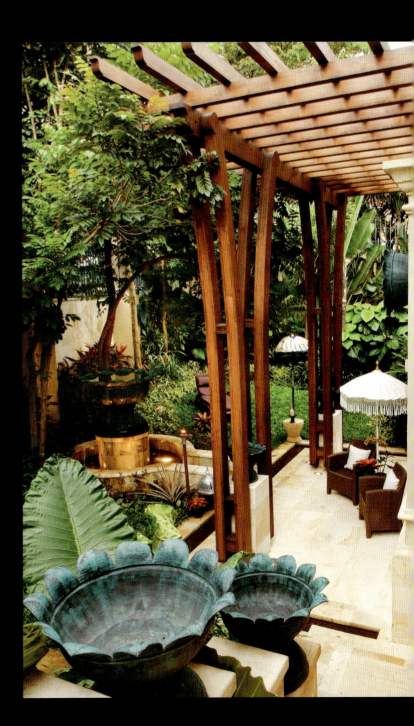

Opposite Two antique Thai mirror frames and a collection of old Thai boat paddles make decorative statements from utilitarian objects in the ground-level guest room. **Left** The paddle collection on the bedroom wall is reflected in the mirror above the vanity in the ensuite bathroom. **Below left** On top of the vanity unit, I used a large reproduction Cambodian bronze bowl for the washbasin and two smaller versions, placed on each side of it, for soap and hand towels. **Below** A trellis with posts fashioned after a pair of chopsticks seems to float above the sandstone deck of the guest room courtyard. This leafy enclave is particularly atmospheric at night, when candles and ambient lighting cast a romantic glow.

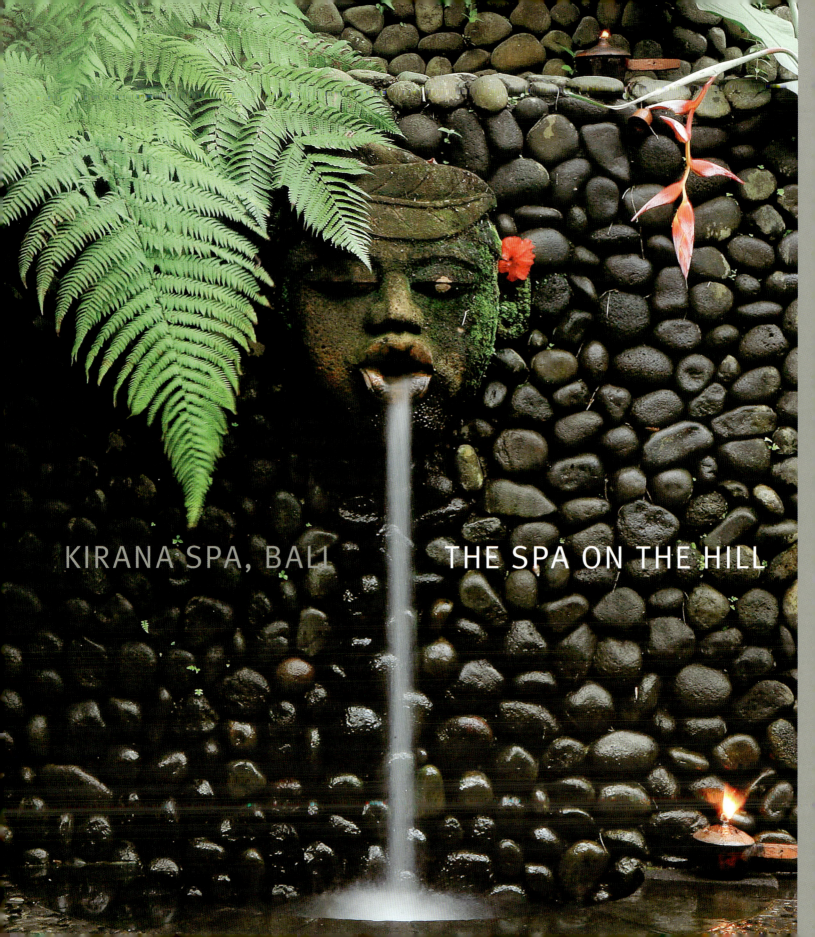

KIRANA SPA, BALI THE SPA ON THE HILL

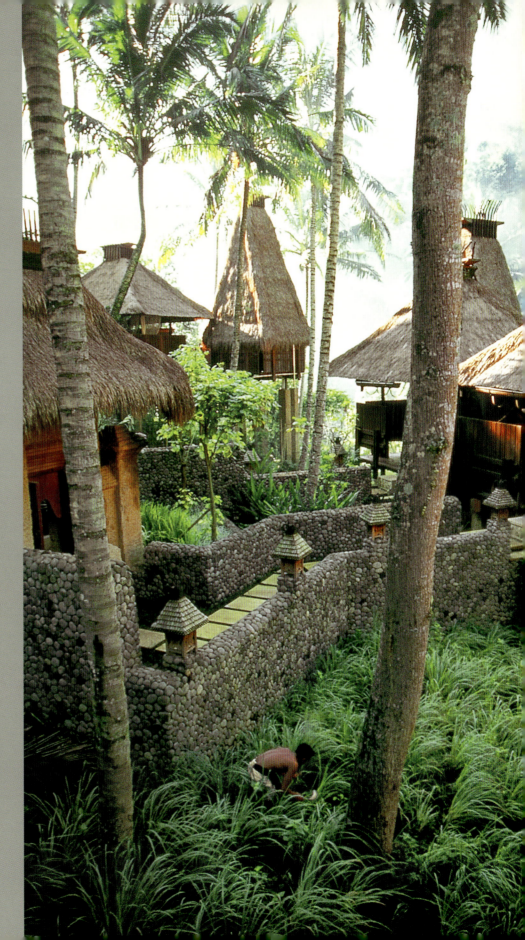

Located on the outskirts of Ubud, the artisan center of Bali, in a verdant valley filled with the sounds of birds and gurgling streams, Kirana Spa is an unparalleled spa facility. Winner of SpaAsia's "Best Day Spa" award—meaning that there is no accommodation, simply thirteen of the best treatment rooms in the world—it was conceptualized by Japan's leading cosmetic company and the third largest cosmetic producer in the world, Shiseido, and was the company's first venture into the luxury spa-resort market. The spa is a joint project between Shiseido and PT Puri Saren Agung, a hotel management company belonging to Ubud's Sukawati royal family.

Shiseido's concept for a landmark spa on the Indonesian island of Bali rather than in Japan—purportedly because the company wanted to be a part of the gathering of people from all over the world in a place renowned for its natural beauty and appreciation of the arts—first blossomed in 1996. Shortly after, my old friend and mentor, Thai architect Lek Bunnag, and I were hired to work on the flagship venture, with Lek given responsibility for designing the architecture and the interiors and Bensley Design Studios the gardens. Between us, Kirana—a Sanskrit word that means "beauty" in Indonesian—was born, and early in 2002 the spa began receiving its first clients.

Looking to change what might be considered a dowdy image of Japanese housewives and their whitening creams, Shiseido realized in the mid-1990s that they needed to project a new image. By way of orientation to the project, Lek and I were given a quick course on Shiseido's century-old history. We were scheduled, shuffled in and out, and rubbed, slathered and massaged with a myriad of Shiseido products at the newest, chicest and most expensive Shiseido spas in Japan. Our verdict: "Not inspired. Too clinical. Shiseido definitely needed a new unhurried, natural, even mystical image."

Left Water falls from this stone mask, made from a soft volcanic sandstone called *paras*, into a stone well never to be seen again. **Right** Perched on the banks of the Ayung River that runs though the middle of the Balinese village of Sayan, this part of the spa is built on very high stilts just in case the river ever floods.

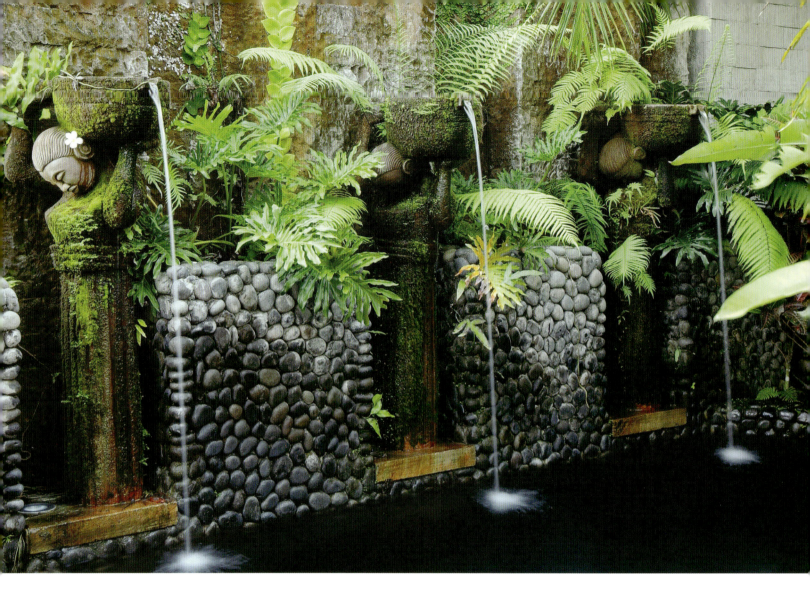

Spread over an area of 194,000 square feet (18,000 square meters), Kirana Spa blends in seamlessly with the natural surroundings—tropical flowers and trees are an integral part of the spa—and is constructed using the finest of local materials: dark gray volcanic stones smoothed from centuries of water rushing over them in the island's fast-flowing rivers, white pebbles and butterscotch-hued paving slabs. The water for the spa is pumped from a source some 490 feet (150 meters) below the surface.

Following the topography of the site, we divided the spa into two distinct garden areas: the upper gardens and the lower Ayung Gardens, built within a coconut grove already on the site. Spread throughout the upper gardens are eight spa suites and one "to die for" Kirana Suite, each with its own swimming pool, spa bath, shower, steam room and, most innovatively, an open-to-the-elements private spa room with no walls—but with air conditioning! The remaining treatment rooms are in the lower gardens. A beautiful stepped swimming pool at the upper level is available to all guests for as long as they like before and after treatments.

The first time I visited the site, I did not go down to the bottom of the valley, as it was just too steep. Today, one can walk down a very narrow series of paved switchbacks (a nightmare to build) and 198 steps later reach the lower Ayung Gardens. Here, the calm is punctuated by the sound of rushing water from the Ayung River at the bottom and the occasional shrieks of river rafters shooting the rapids. These gardens are fully mature as we built within an existing coconut grove. We kept the gardens here wild, using a palette of grasses: black sugarcane (*Saccharum officinarum*), white bamboo grass (*Arundo donax var. variegata*), alang-alang (*Imperata cylindrica*), and lemongrass (*Cymbopogon citratus*) in a large rice-like paddy field. We figured the spa could use a bit of lemongrass in their treatments, and we were right.

Lek also let the edges of the *alang-alang* roofs hang loosely as opposed to the traditional 90-degree cut, which works harmoniously. In the same more natural style, he designed the treatment suites like wooden tree houses, which float ethereally above the paddies of lemon grass. Along the outer edges of these paddies,

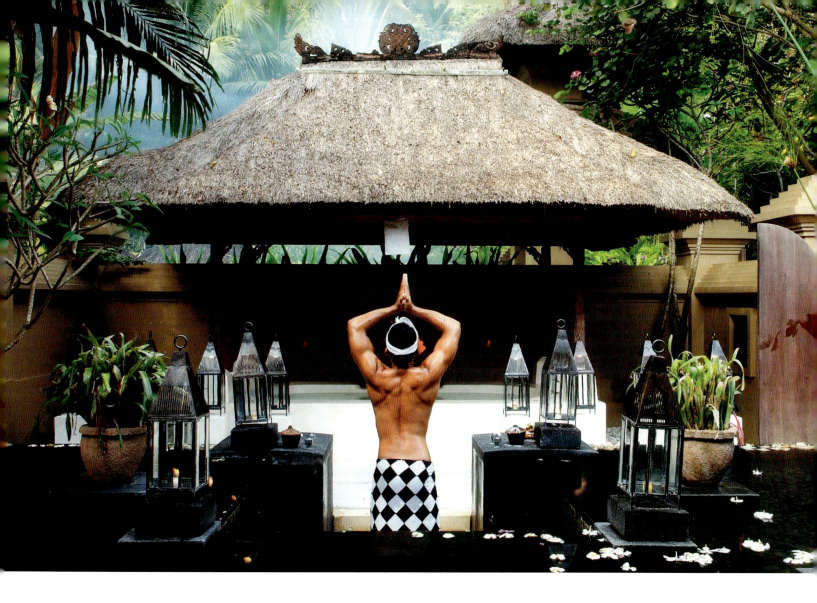

Above left As part of the spa's innovative filtration system, water flows out of a wall into the urns of maidens and then into a pool. **Above** Putu Dedik pays homage at the double bath pavilion of the Sayan Suite, gorgeously illuminated in the evening by candles in Lek's brass and glass lanterns. **Below** In the classical Klungkung style of Balinese illustration, Putu Mahendra designed dozens of witty cartoons for the lobby and consultation pavilions depicting the sometimes embarrassing moments of the spa experience.

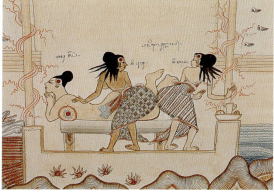
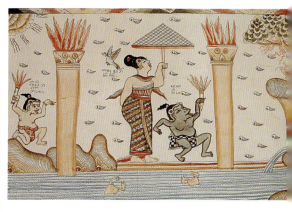

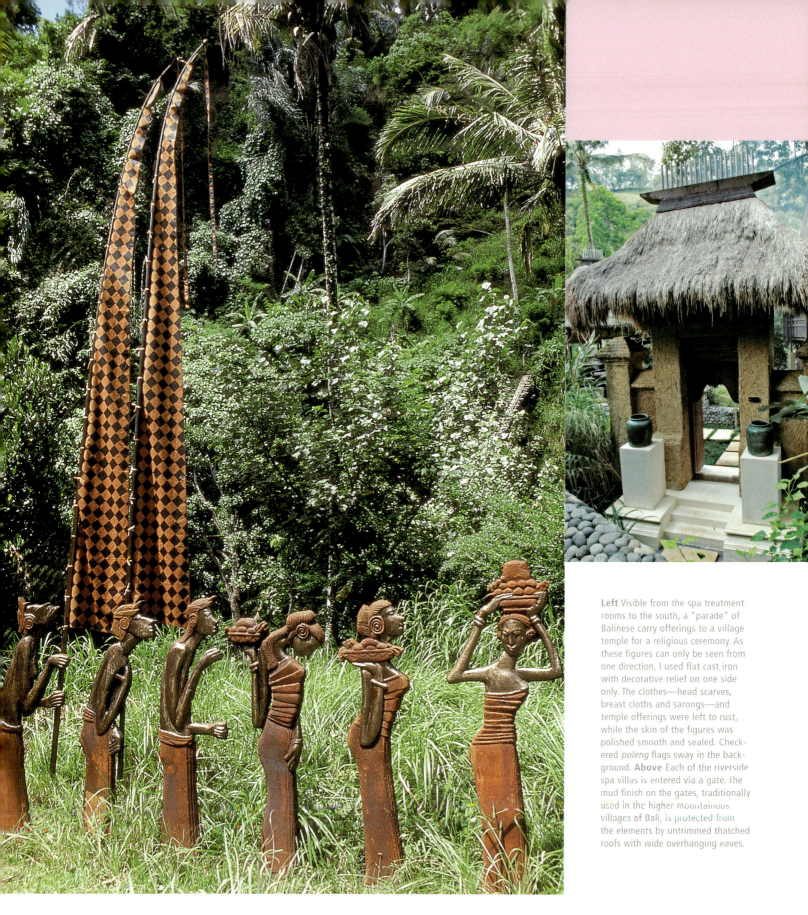

Left Visible from the spa treatment rooms to the south, a "parade" of Balinese carry offerings to a village temple for a religious ceremony. As these figures can only be seen from one direction, I used flat cast iron with decorative relief on one side only. The clothes—head scarves, breast cloths and sarongs—and temple offerings were left to rust, while the skin of the figures was polished smooth and sealed. Checkered *poleng* flags sway in the background. **Above** Each of the riverside spa villas is entered via a gate. The mud finish on the gates, traditionally used in the higher mountainous villages of Bali, is protected from the elements by untrimmed thatched roofs with wide overhanging eaves.

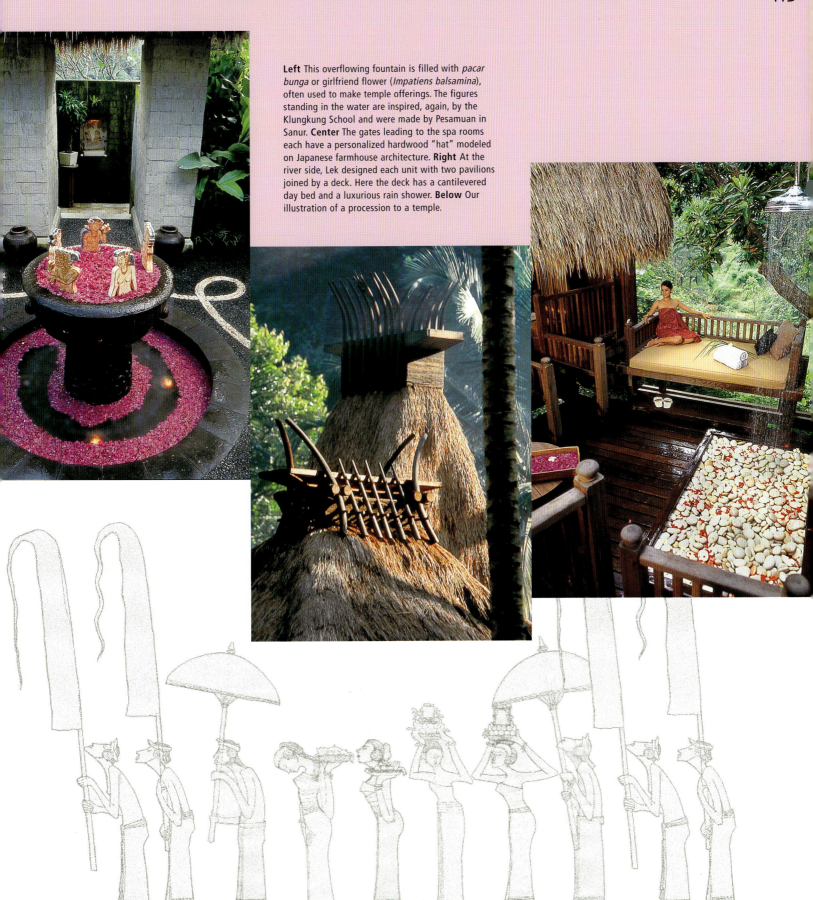

Left This overflowing fountain is filled with *pacar bunga* or girlfriend flower (*Impatiens balsamina*), often used to make temple offerings. The figures standing in the water are inspired, again, by the Klungkung School and were made by Pesamuan in Sanur. **Center** The gates leading to the spa rooms each have a personalized hardwood "hat" modeled on Japanese farmhouse architecture. **Right** At the river side, Lek designed each unit with two pavilions joined by a deck. Here the deck has a cantilevered day bed and a luxurious rain shower. **Below** Our illustration of a procession to a temple.

Below As a variation on the Klungkung traditional oil on canvas, here we tried painting on cementaceous ceramic with a high-fire glaze. **Bottom** The consultation pavilion is decorated with comical and somewhat erotic depictions of spa life, while the soft furnishings reflect the same palette of soft natural colors and paints used in the ancient Klungkung style of illustration. **Right** Two golden lamps with black metal shades from Palanquin flank the front desk. **Below center** Lek's elegant women's locker rooms are private yet enjoy sweeping views of the Sayan Valley. **Far right** The upper portion of the spa is built into a very steep cliff. A gentle warm rain sweeps though the valley almost daily, making the spa an ideal environment for many of the tropical plants we used.

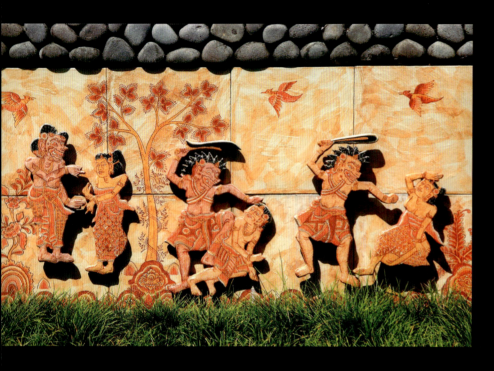

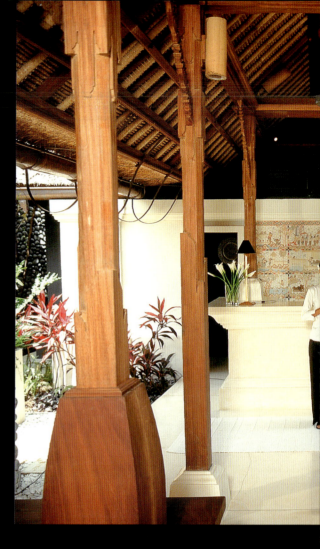

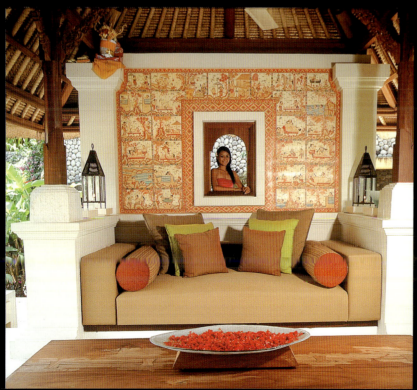

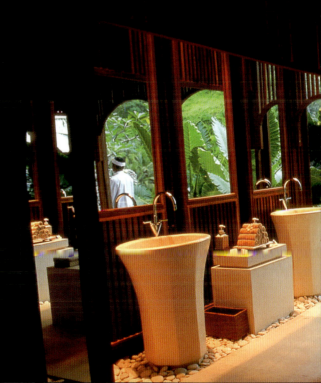

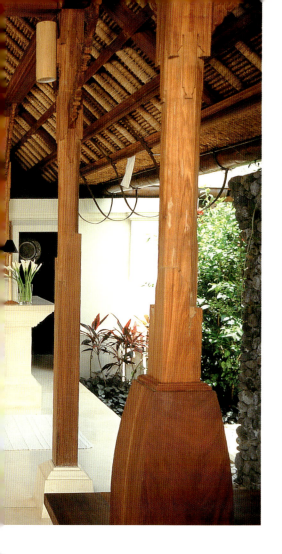
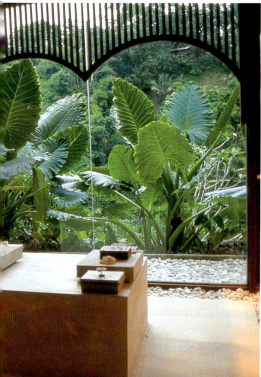
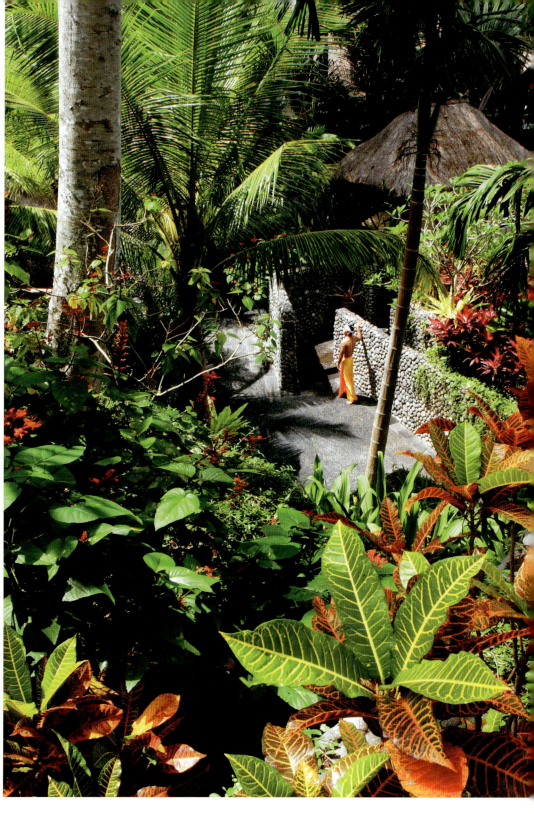

following the course of the Ayung River, we created a Balinese *upacara* or walk to a temple festival with some 24 greater than life-size Balinese human figurative sculptures. Cast in iron in Java, we simply let the iron go rusty in places where we wanted to indicate clothing and polished and sealed the areas of skin. The traditional *umbul-umbul* or tall flags that are carried in such festivals are here made from a printed *poleng* or checkerboard design on Sunbrella fabric. The *poleng* design used in the garden and throughout the interiors of the spa is a Balinese traditional representation of the balance of good and evil.

We have always enjoyed working with Japanese clients and Shiseido was no exception, graciously hosting trips to Kyoto and Tokyo during the cherry blossom festivals. While our clients were not too keen on the idea of making this spa in Bali look like a Japanese garden, I wanted to adopt some aspects, just to set it apart from the other wonderful gardens in Bali. Having been inspired by the way that crystal clear water moves through the arcane gardens of Kyoto, I wanted to create a similar experience in Bali, which I coined *tirta hantu* or water ghost since I wanted the effect of running water to be ever present, disappearing and reappearing along the journey to the bottom of the valley. As we did not have an unlimited budget for ponds, pools and filtration systems, I designed a system that would simply pump water up to the top of the garden, some 490 feet (150 meters) above the Ayung River, and let the water run back down by gravity in a

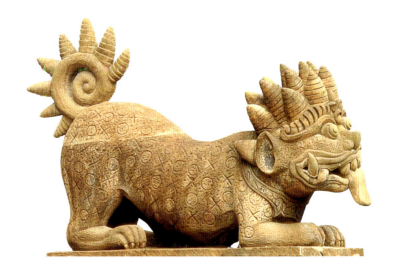

Above I stained this sandstone fantastical Balinese *singha* lion with iron sulfate to make it turn this golden yellow. **Right** Drawing inspiration from my favorite Balinese temple, Gunung Kawi, a complex of rock-cut monuments, I constructed the eastern wall of the main pool with layers and layers of *paras silekarang* or soapstone and then carved it to give the impression of being one piece, as in the original temple. **Below left to right** The sarong-covered legs of an oversized maiden mirror those of the young woman in front. A more traditional Balinese figure decked out with plumeria flowers, one behind each ear. A naughty painted figure of a Balinese *ogoh-ogoh* or ogre peaks into the women bathing beyond. Thirteen foot (4 meter) high bronze torchères light the path in front of the women's baths. Om swasti swasti om. A very large painted ceramic Barong face is the source of a refreshing bath for Dewa Mayun. Lek's sexy door handles mimic the lines of a female body.

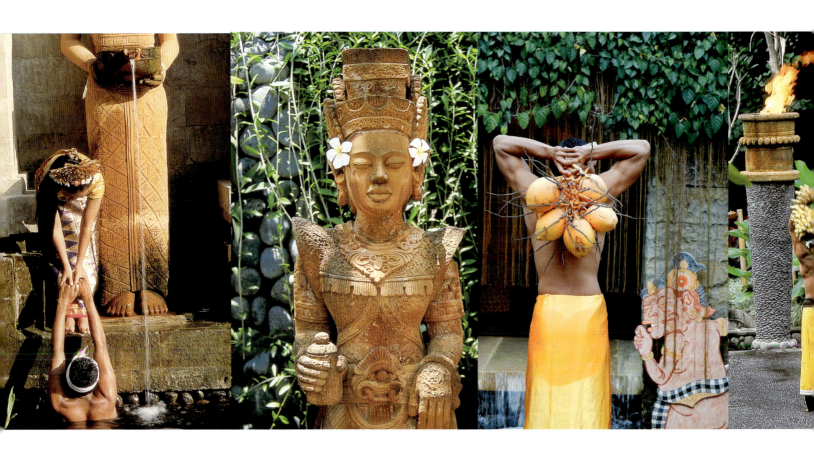

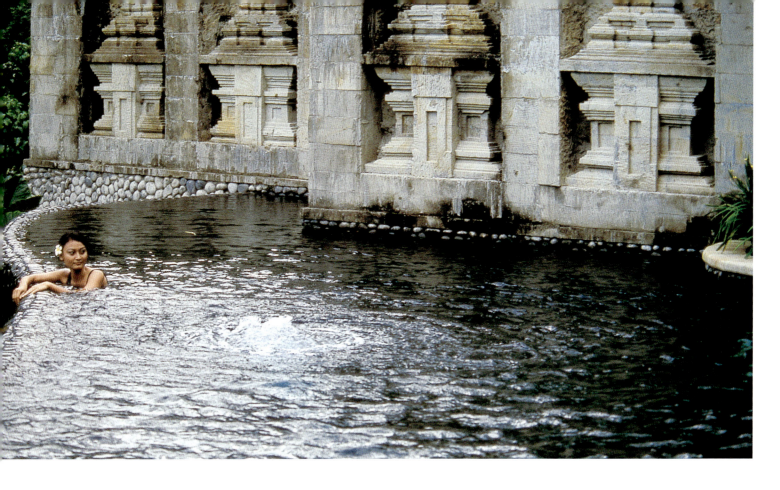
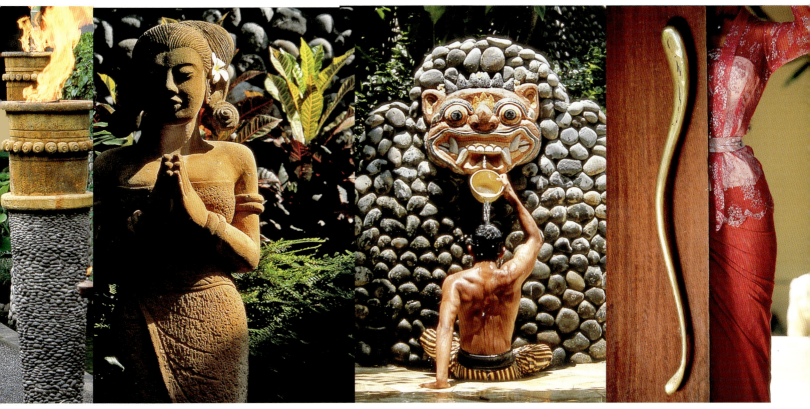

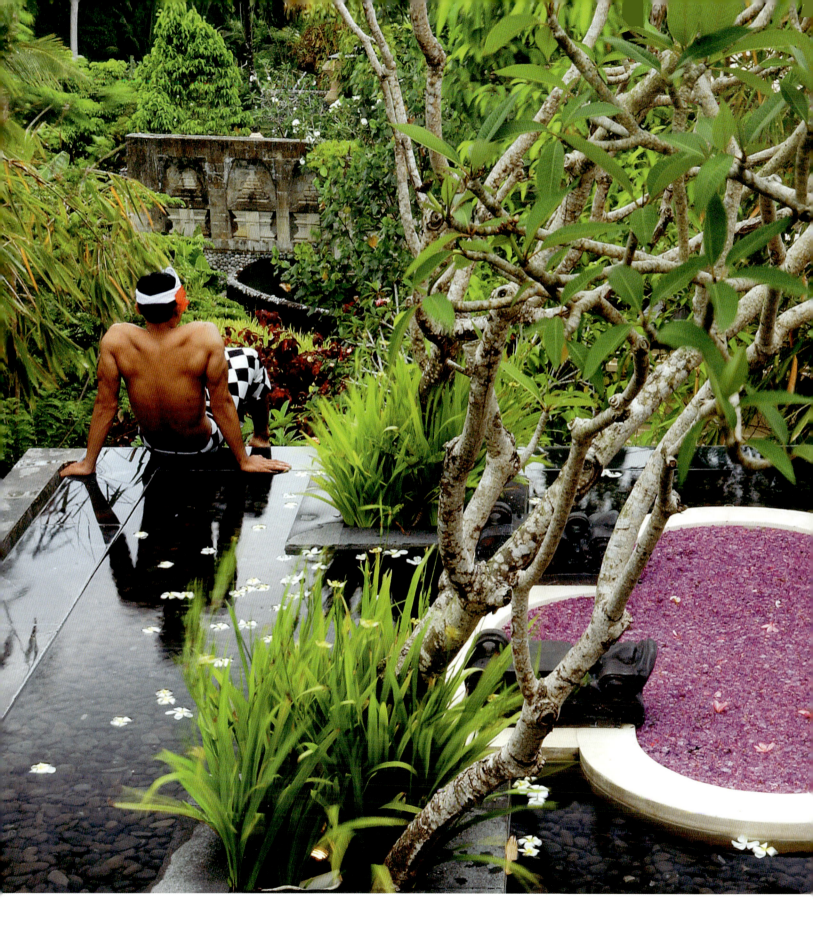

Left What surely must be one the world's most romantic baths nestles in the shallow, crystal-clear waters of Kirana Spa amidst expansive views of the man-made and natural habitat. **Right** One of a series of delightfully plump girls that we drew as a mascot for the spa. **Below** This double-headed cow, which appears in the ancient Klungkung paintings, is here transformed into bronze, made to order and cast in central Java.

myriad of ways. Sometimes it falls out of a wall into a maiden's urn, then into a channel running alongside the pathway (so Kyoto-like) and then through the mouth of a fish into a pebble-filled pocket before it disappears. In another instance, water falls from behind a royal frog king who sits within a mosquito net! At the main swimming pool, water seemingly percolates from the ceiling of a cave and drips into the satchel of a Balinese dwarf standing in a cave pond, which seemingly overflows into a snake-like channel bisecting the pool deck, then runs though the head of the snake and into the pool. The garden is full of scenarios like this and has to be explored in person to understand and appreciate them.

We chose round gray river stones as a basic background palette for all landscape walls, and Klungkung saffron for accents. We also commissioned the talented atelier of Pesamuan in Sanur to produce a series of five vignettes portraying scenes in three dimensions. Bright flashes of orange also occur at the lobby and the consultation pavilions where our architect Putu Mahendra, with typical Balinese wit, portrayed the story of the building of these gardens and the humorous goings on behind closed spa doors.

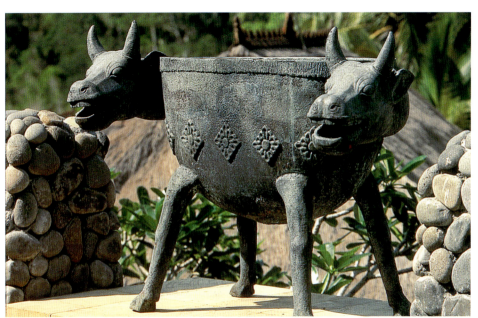

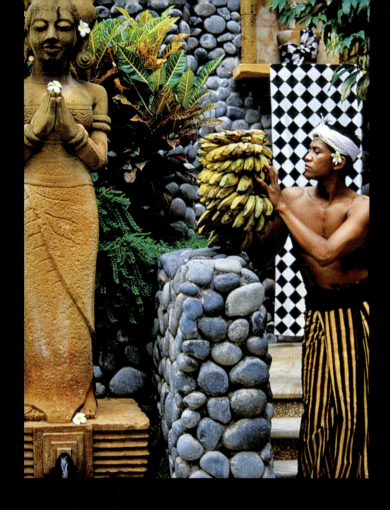

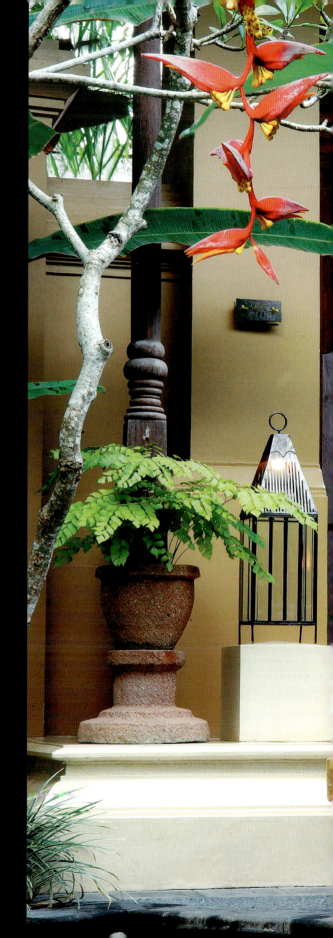

Above This stairway, leading from the consultation pavilions down to the treatment suites, terminates in a small plaza graced by three Balinese beauties. Here, Dewa is tempting the first of them with a large bunch of bananas. In the background, a checkered *poleng* sarong, back lit from the floor, hangs in front of a niche for offerings. **Left** Another drawing from Bensley Design Studios of a Balinese beauty with umbrella. **Right** The gates to the upper spa pavilions are more refined than those down in the valley, being made of terrazzo, gray river stones and crisp painted plaster. **Far right** A very large mantra made of smooth Indonesian pebbles in three colors is set into the garden floor. The double-headed cow bench in the background was one of the many fun elements injected into the project.

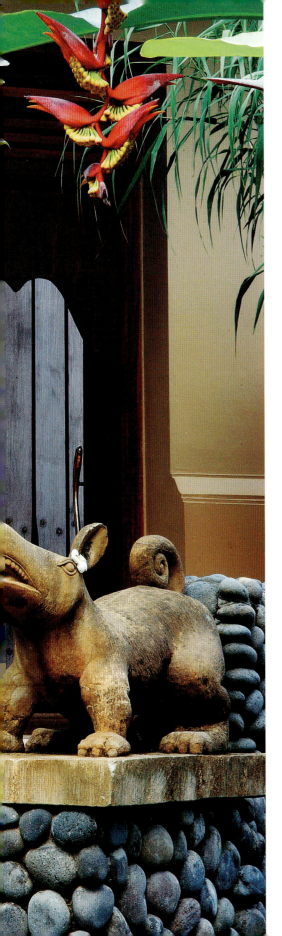
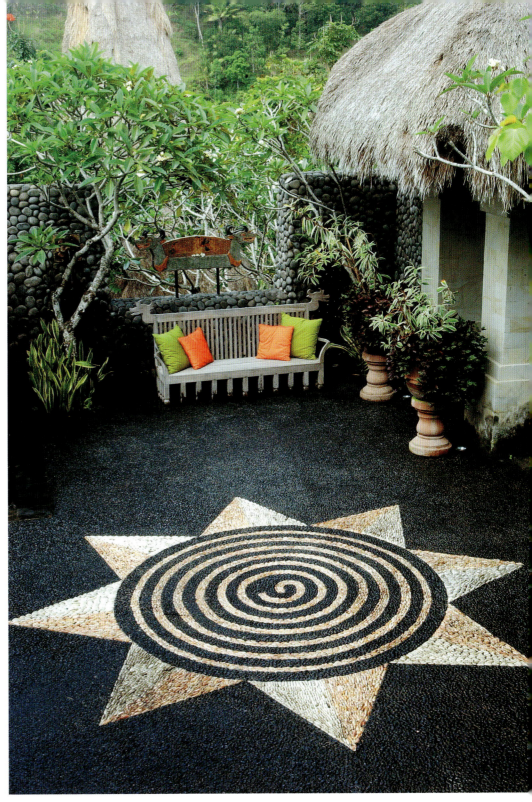

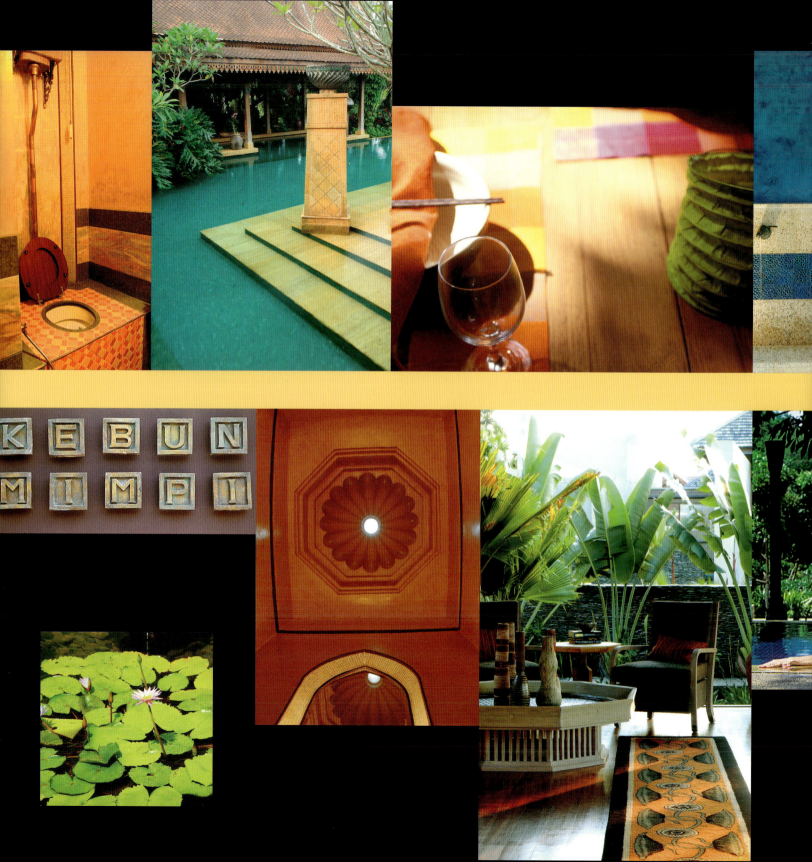

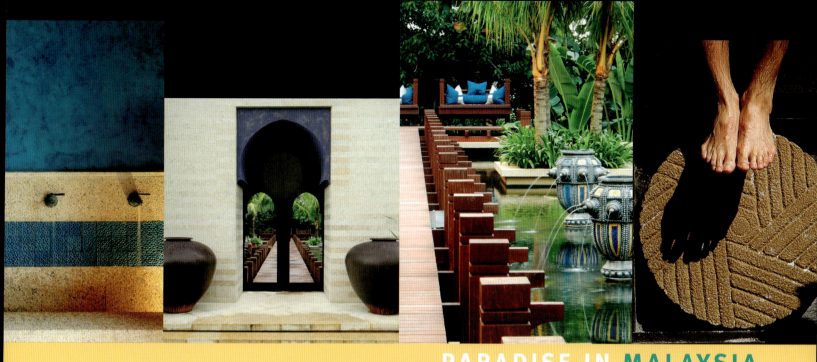

PARADISE IN **MALAYSIA**

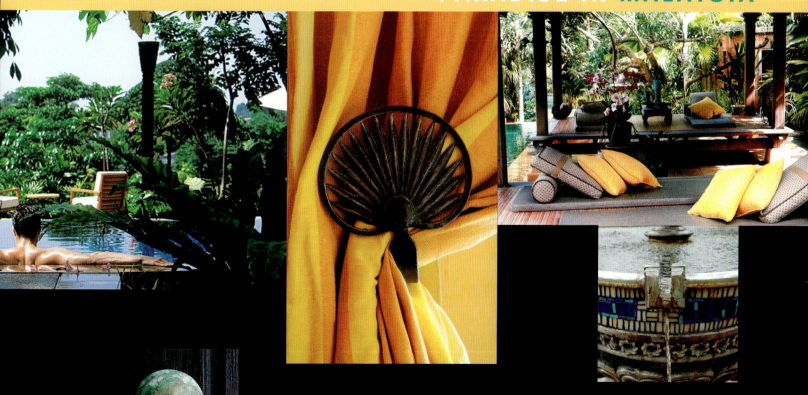

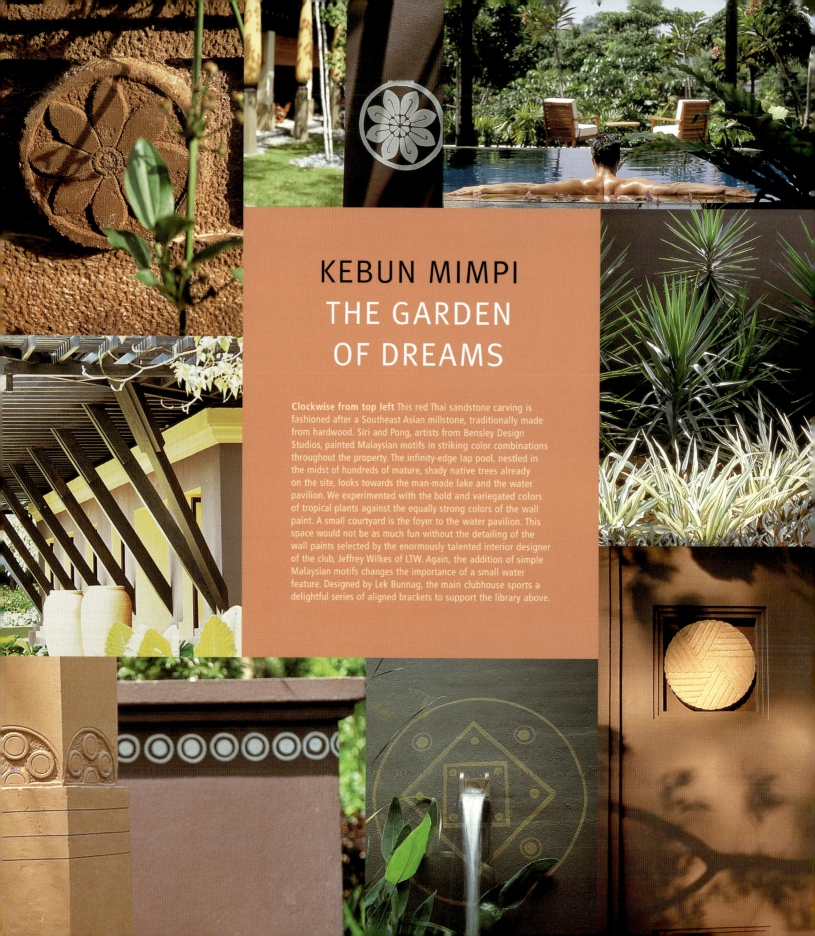

KEBUN MIMPI
THE GARDEN OF DREAMS

Clockwise from top left This red Thai sandstone carving is fashioned after a Southeast Asian millstone, traditionally made from hardwood. Siri and Pong, artists from Bensley Design Studios, painted Malaysian motifs in striking color combinations throughout the property. The infinity-edge lap pool, nestled in the midst of hundreds of mature, shady native trees already on the site, looks towards the man-made lake and the water pavilion. We experimented with the bold and variegated colors of tropical plants against the equally strong colors of the wall paint. A small courtyard is the foyer to the water pavilion. This space would not be as much fun without the detailing of the wall paints selected by the enormously talented interior designer of the club, Jeffrey Wilkes of LTW. Again, the addition of simple Malaysian motifs changes the importance of a small water feature. Designed by Lek Bunnag, the main clubhouse sports a delightful series of aligned brackets to support the library above.

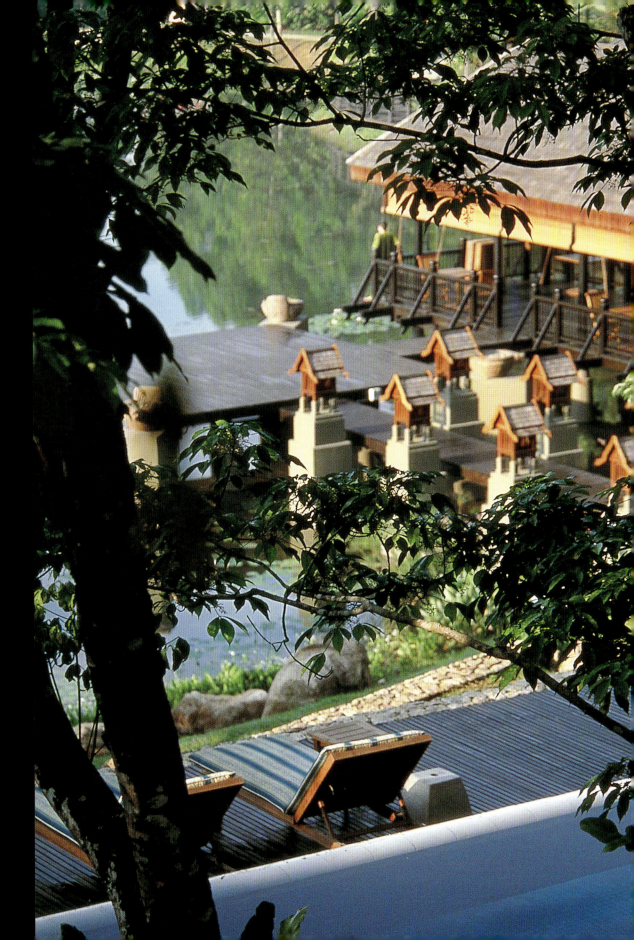

Right Looking out over the infinity-edge pool to the pond, pier and multifunctional open-air water pavilion in this exclusive clubhouse development. The pond's pier is flanked by lanterns modeled after the quintessential Malay kampong house.

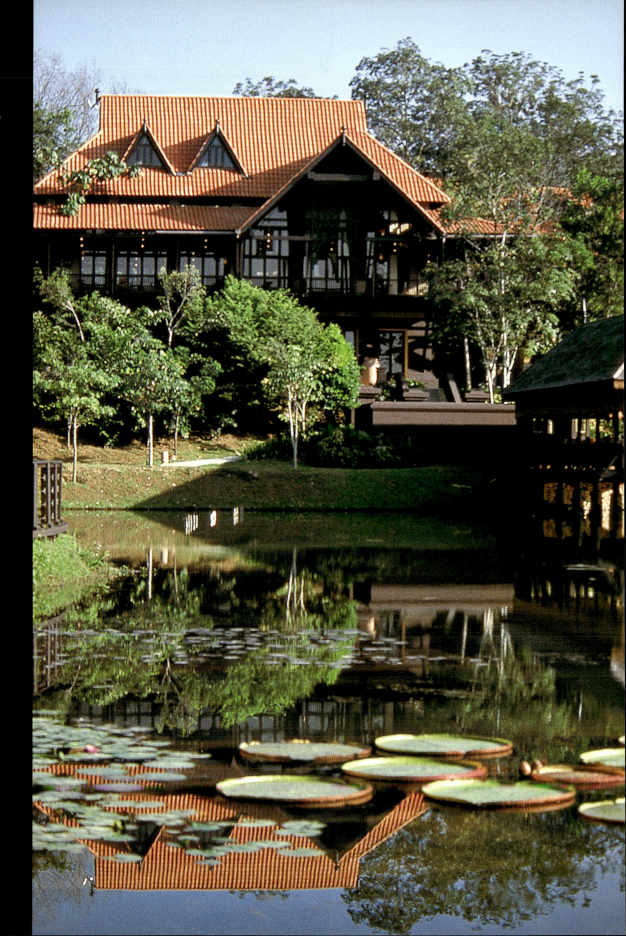

Right The striking hipped roof of the three-story multipurpose pavilion is reflected in the man-made lake where giant Victoria lilies (*Victoria amazonica*) thrive in its warm waters. The pavilion houses a gymnasium on the ground floor, an administration office and multipurpose space on the first floor and, above this, a cosy attic-style reading room-cum-library accessed via a sculptural spiral staircase. Glimpsed through the trees on the right is the two-story open-air dining pavilion. In the foreground is the lake's pier, an open-air water pavilion. **Opposite above** The pond's pier is flanked by picturesque lanterns modeled after the quintessential Malay wooden house. **Opposite below** Slender sculptural columns elegantly span the sides of the dining pavilion.

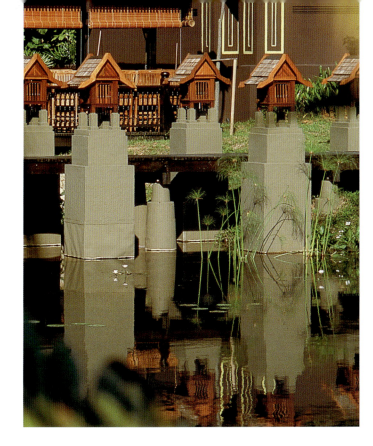

The high wall encircling the compound is made from granite, which we covered with plaster and one of seven different kinds of porter's paints from Australia. These paints are very chalky, with great colors like eggplant, baby blue, mustard and lime green. Lek designed a set of columns which are layered with the colors of "wet mud," mustard and eggplant paint. The wide, overhanging eaves of Lek's umbrella-like pavilions protect against the rain and sun but allow great cross-ventilation; his cantilevered seats overlooking the lake are wonderful resting spots.

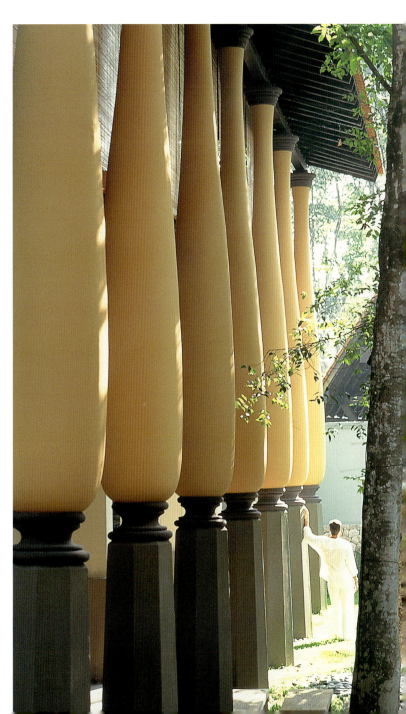

Kebun Mimpi ("Garden of Dreams") is a charming clubhouse complex at the heart of Bukit Gita Bayu ("Windsong Heights"), an exclusive 120 acre (48 hectare) gated residential estate 9 miles (15 km) south of Kuala Lumpur. The secondary jungle that had run riot over the site—an abandoned rubber estate—was consciously retained and forms a lush backdrop to the residential mix of individual and cluster bungalows and low-rise apartments as well as the clubhouse pavilions built around a man-made lake and a landscaped buffer zone. In keeping with their desire to conserve as much as possible of the existing natural environment and terrain, the developers (our clients) made it a priority to save all the trees, and many of the contractors took heed. The result was a garden that was fully matured even before the club opened.

Perched on the edge of the lake, Kebun Mimpi was designed by Lek Bunnag, while Jeffrey Wilkes of LTW conceived the interiors. Bensley Design Studios was responsible for the landscaping. There are four main components to the clubhouse: a two-story open-air restaurant; a three-story air-conditioned gymnasium, office and library; a 115 foot (35 meter) lap pool with a swing pavilion that skims just over the water at one end; and, down on the pond, a multipurpose open-air pavilion. Miniature Malay houses form lanterns along the walkways. One side of the bronze-cast pool gate reads KEBUN; the other side reads MIMPI.

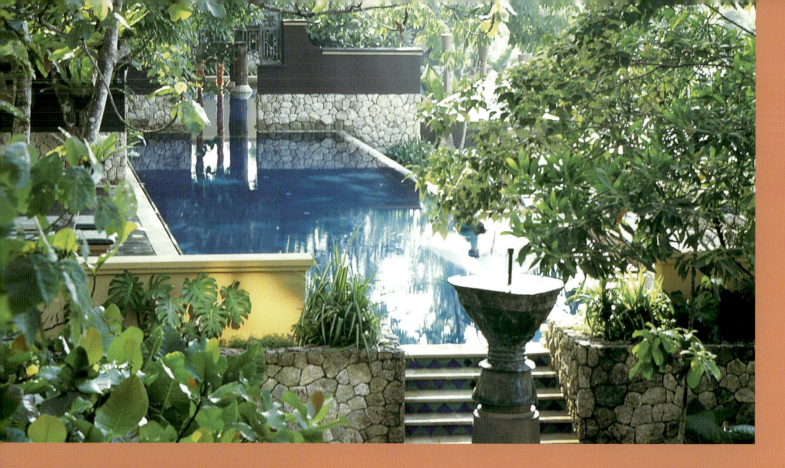

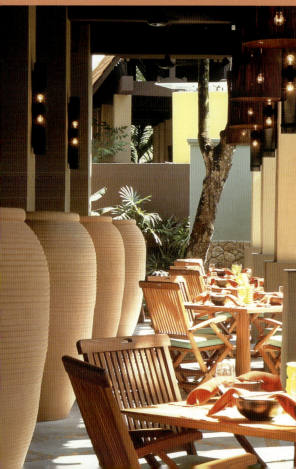

Top A high wall and a gate bisect the lap pool at Kebun Mimpi. Swimmers can glide through the gate to the pool on the other side. **Far left** Jeffrey Wilkes and Simon Gan, who own Ombak, one of the most exciting interior design shops in Malaysia, accentuate the planes of the architecture's rich and vibrant colors in the table settings. **Left** A giant rain shower with Thai ceramic tiles on the back wall of the well-ventilated indoor/outdoor shower stall. **Above** Rendered in unusual lime green and eggplant, this little niche is a jazzy focal point for the ground-floor restaurant. **Right** Upstairs in the café, banquet seating is dramatically cantilevered over the pavilion's edge.

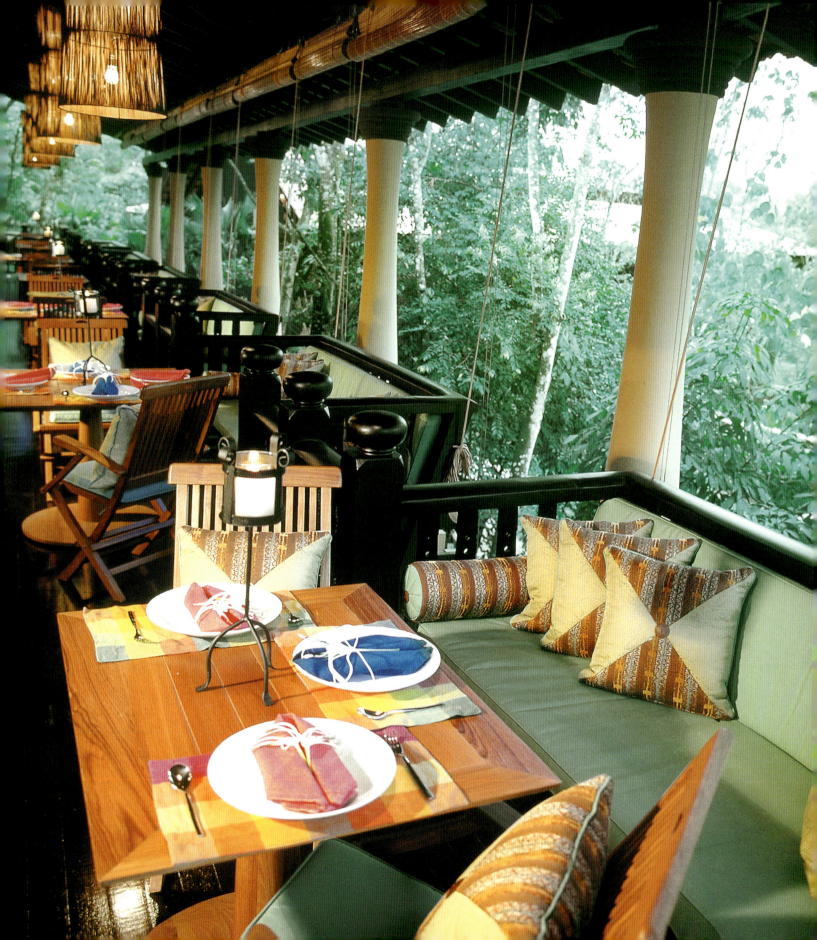

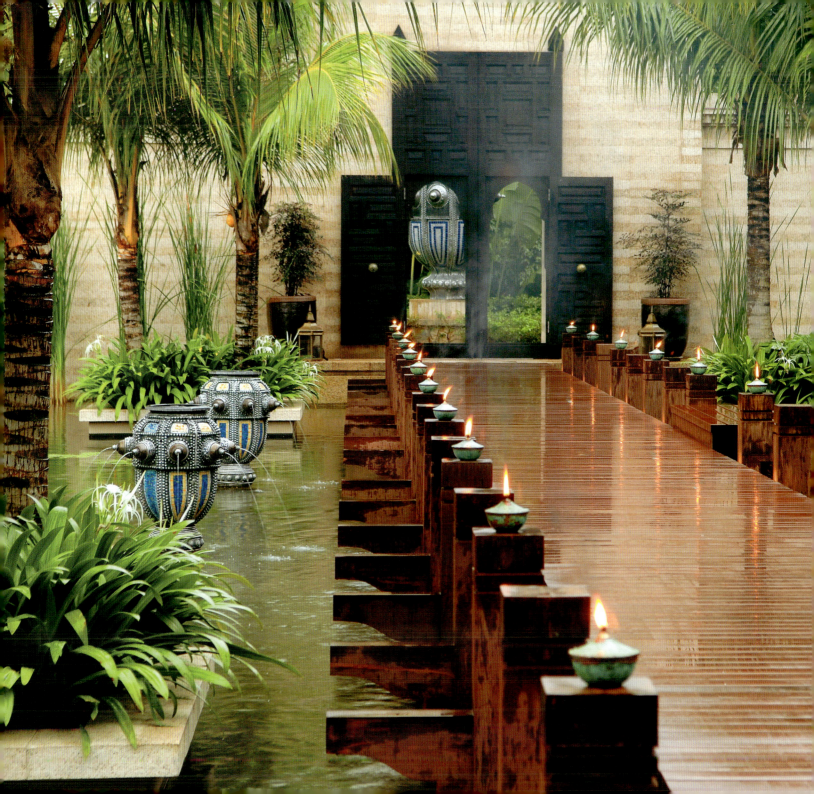

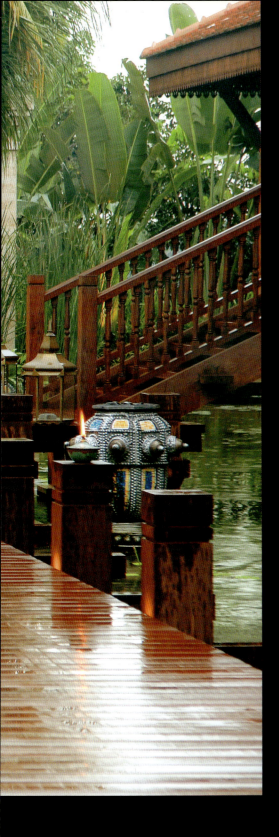
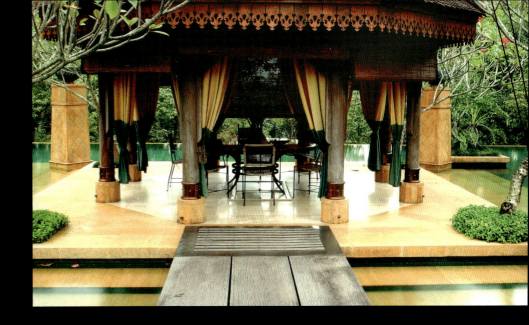

THE FATHIL RESIDENCE
AN ISLAMIC TWIST ON THE MALAYSIAN VERNACULAR

Left A wooden boardwalk traverses the lily pond to an Islamic-style wood and plaster gateway. **Above** The dining pavilion, set in the middle of the swimming pool, is a firm favorite with the Fathil family. Fire-emitting brass bowls sitting on Spanish fossil stone plinths at each corner are seldom lit for fear of burning the frangipani above them. **Right** I gave the name "garden jewelry" to the many giant urns in the grounds because of their wonderful hand-assembled ceramic tile patterns.

Located on the top of a hill in Kuang, a quiet village 30 minutes' drive north of Kuala Lumpur, the Fathil residence enjoys a commanding view over 247 acres (100 hectares) of land. Sadly, much of the jungle that we previously admired is now suburban housing. But there are still extensive paddocks and stables surrounding the property, full of beautiful horses, including Arabians. All of the owner's family are avid equestrians and are among the region's best riders.

Singapore-based H. L. Lim, the architect and interior designer of this property, first introduced us to the owner, Dato' Haji Mahamad Fathil bin Dato' Mahmood, in 1993. Since then we have worked with Dato' Fathil and his wife to infuse Lim's very modern buildings with elements from Malaysia's rich architectural and cultural heritage, and to convert the gardens into a tropical paradise. For the Fathil residence, our brief was to make the house much more Malay. We thus converted the buildings into the architectural style of the northeast of Malaysia, employing lots of wood and small roof tiles, and also created beautiful wooden pavilions, which provide much-used spaces in the landscape. Various Islamic elements have also been introduced, such as arches, columns and tiles, along with several hallmarks of the Bensley Design Studios like courtyards, walkways and fountains. The latest development at the residence has been to extend a pavilion behind the house into a place suitable for celebrations and large gatherings. This we have called Balai Bong Bang. More recently, we have been engaged to build homes for the Fathils' two sons.

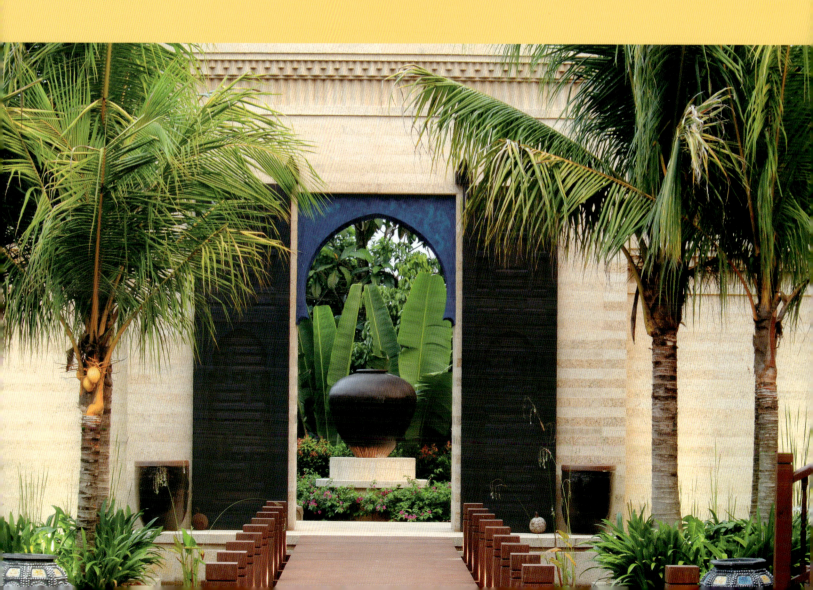

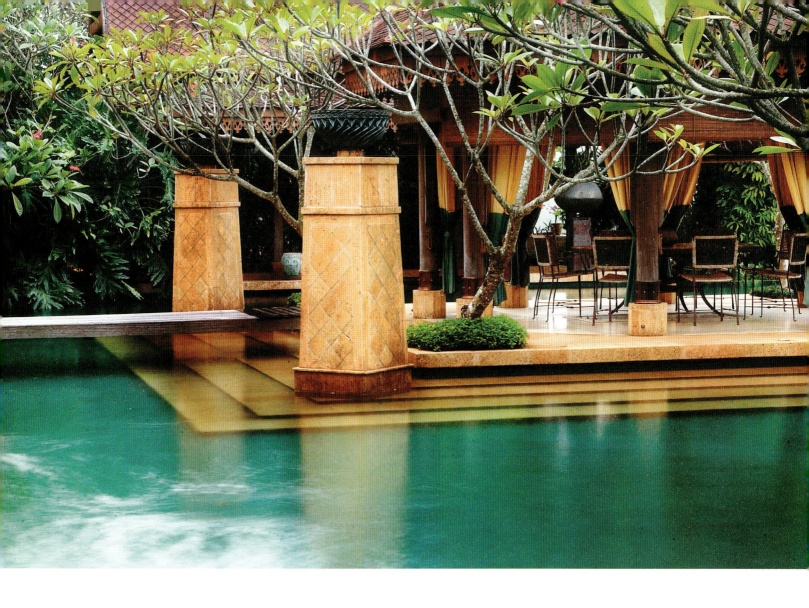

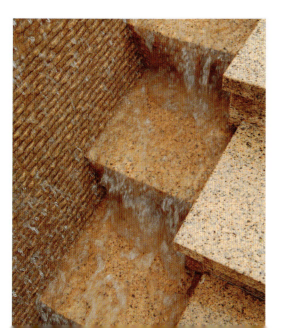

Opposite above left A mosaic of Italian glass and Malaysian pewter, orchestrated by an American, designed by an Australian and assembled by Thai craftsmen, is truly an international effort. **Opposite below** Visible through the Islamic gateway is a huge handmade water jar that we purchased in Ratchaburi, Thailand. **Above** A thick wooden plank mysteriously links the "island" in the pool to the main house. **Left** Serrated granite from Vietnam makes for a very sharp-looking water feature at the far end of the Balai Bong Bang lily pond. **Right** Sharing space with the lily pond, this piece of "garden jewelry" is a delightful contrast to the earthy palette of wood and stone.

Below This exotic piece of "garden jewelry" was inspired by jewelry from one of the Malaysian royal courts. **Bottom** Clusters of comfortable armchairs and sofas are scattered around the lily pond, their furnishings picking up the colors of the tropical palms nearby.

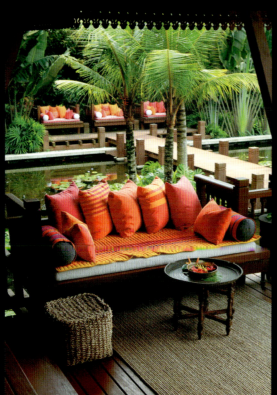
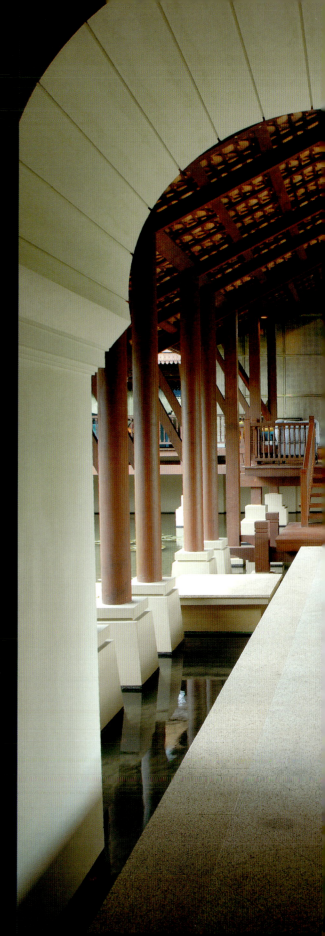

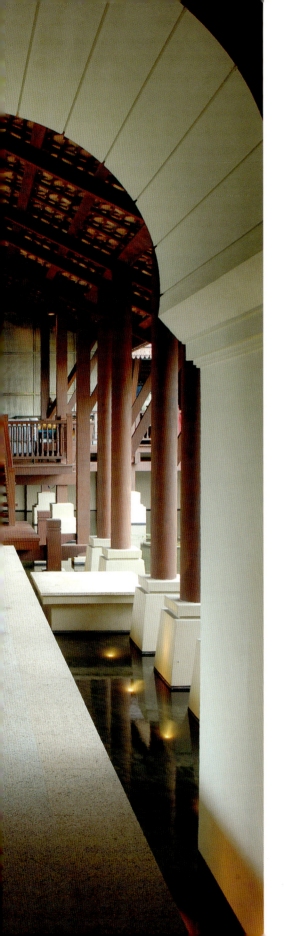

Left The Balai Bong Bang is connected to the ablution room by a stepped Malay roof connector. **Below** The arched and ribbed arcade connects the ablution rooms to the rest rooms, the gym and the kitchens behind.

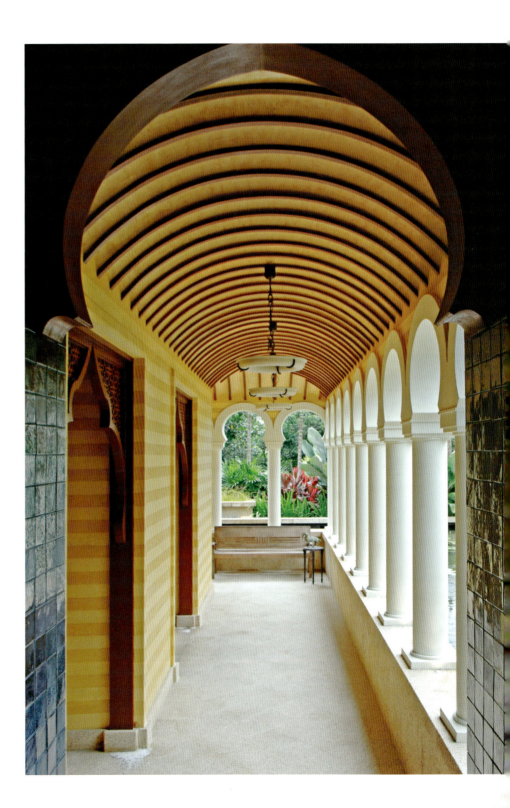

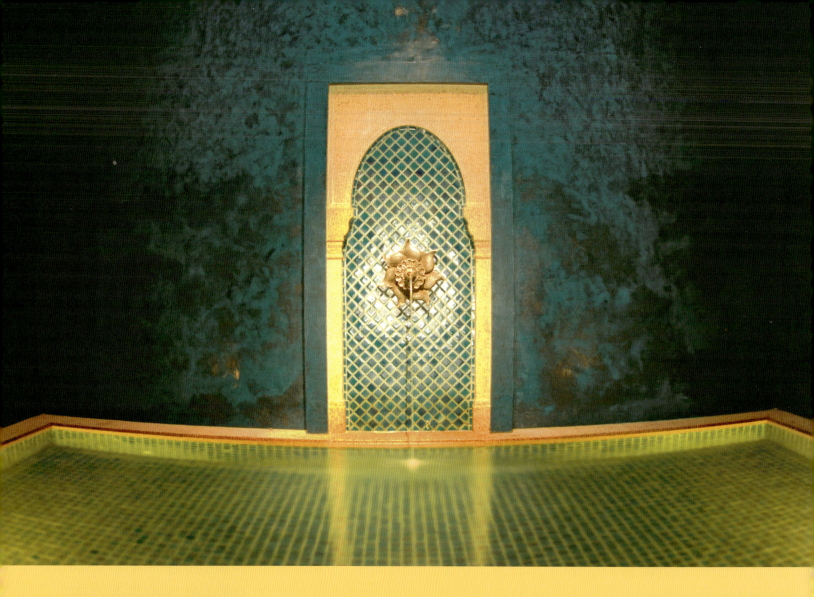

Above A feature of the Fathil residence is an exquisite ablution room leading off a prayer room. Built behind thick walls and domed ceilings, this cistern provide water for the ablution room. **Left** The domed ceiling in the ablution room has an oculus that provides a constantly moving light source on a sunny day. **Right** The ablution room comprises three separate compartments—the foyer, the cleansing room and the cistern—each in a different shade of blue. In the foreground is the playful open drain of these three rooms.

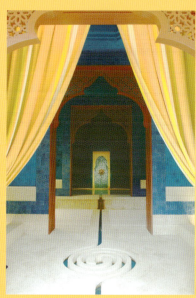

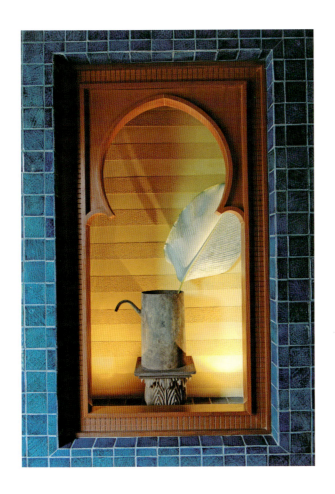
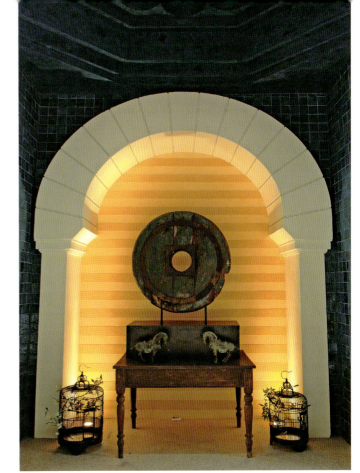
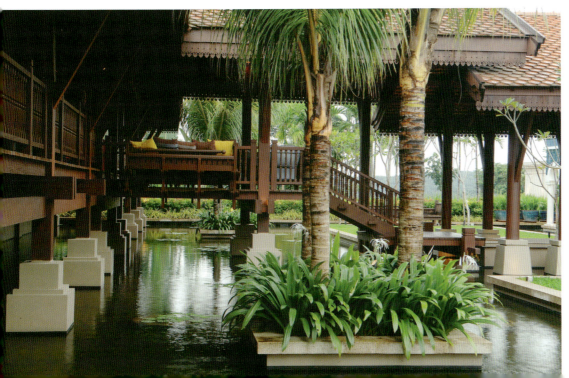

Above left We worked with Richard Farnell, the Canadian maestro of interior design, on the finishing touches. **Above right** The back wall of the prayer room is formed of a series of horizontal bands in smooth and rough Italian plaster work. The table supports an old wagon wheel from Laos. **Left** The Malay pavilion, set on piles, is connected to the prayer and ablution rooms by a traditional covered porch with comfortable seating and a series of steps with carved wooden balustrades. Carved fascia boards fringe the eaves of the roof, which is covered with small northern Malaysian tiles.

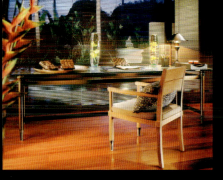

FOUR SEASONS LANGKAWI
MALAYSIAN MYSTIQUE

The Four Seasons Resort Langkawi, located at Tanjung Rhu on the northernmost tip of Langkawi Island, the largest in an archipelago of 99 islands in the Andaman Sea, combines indigenous architecture with idyllic views. Set in a scenic and untouched enclave backed by limestone cliffs and shaded by luxuriant casuarina and other tropical trees, the resort fringes a magnificent bay overlooking a 1.2 mile (2 km) long, 197 foot (60 meter) wide white-sand beach and the clear, cool waters of the Andaman Sea. (It was necessary to dredge the bottom of the bay to create the beach, something we shall have to repeat every 7–8 years to prevent the sea from reclaiming its territory.) Lek Bunnag was the architect, and Bensley Design Studios completed all the gardens and interior design. Jeffrey Wilkes from LTW helped add the interiors' finishing touches. Our involvement in the resort has, in fact, spanned some nine years as the project has evolved and expanded; most recently, Kingdom Holdings from Dubai has purchased the property from Malaysia Airline Systems, and we have been engaged to design a substantial luxury residential section.

The 91 rooms in the resort include a magnificent two-story royal villa tucked away in a secluded corner at one end of the resort's beach with a private swimming pool and spa room; a couple of two-bedroom villas perched on a hillock at the southern end of the resort, and 22 stand-alone one-bedroom beach villas overlooking the azure sea. The remaining rooms are in the two-story Melaleuca pavilions (*Melaleuca* being a tree which grows endemically in the area) set in the resort's tropical gardens.

Above In one of the beach villas, Lek designed a beautiful writing room with a view of the villa's own lily-filled reflecting pond. We designed the writing table to be as inconspicuous as possible, with a big clear glass top to maximize transparency to the gardens. **Right** Limestone mountains give character to the eastern end of the 1.2 mile (2 km) long resort. The beach villas all sit back from the man-made white-sand beach so that guests can enjoy 180-degree views of the sea, filled with limestone outcrops and dotted with fishing boats, as well as their own private gardens complete with plunge pools and lily ponds. We had worked on this project for seven years before the "beach makers" came and sucked up sand from the bottom of the bay to make the beach. Before that, the retaining wall shown here in the foreground was often washed by the ocean waves.

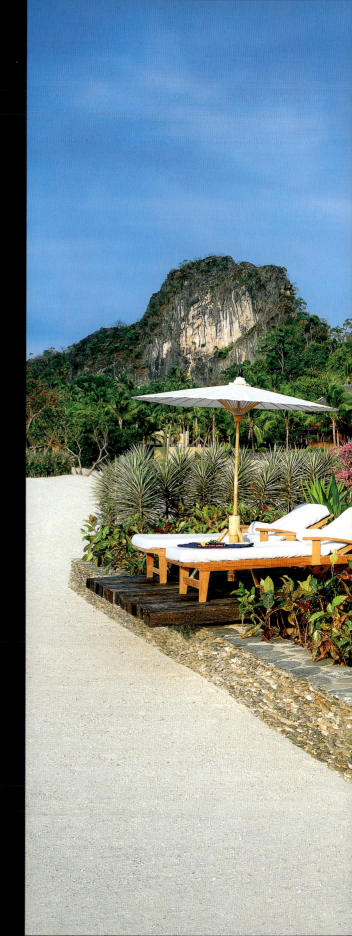

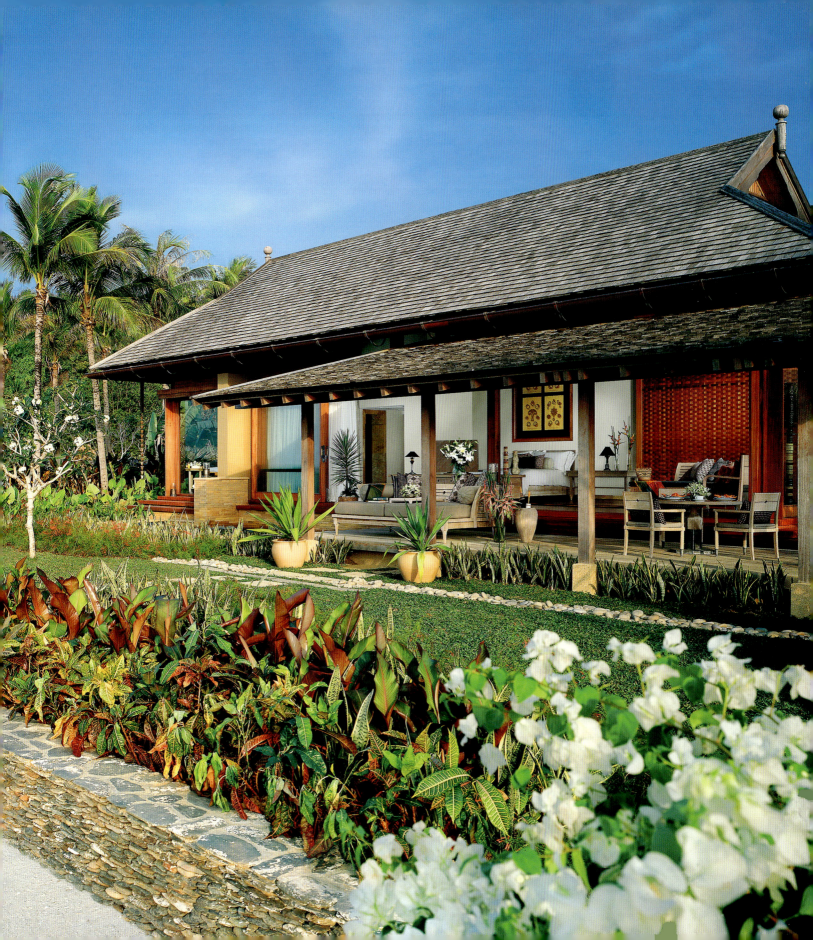

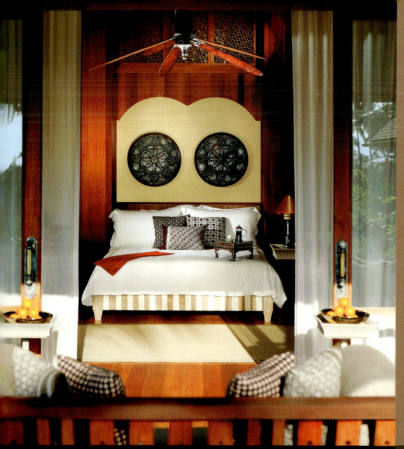

Left This "standard room" at the resort, in one of the Melaleuca pavilions, boasts an imposing 16 foot (5 meter) high ceiling, antique Malaysian jewelry inspired pewter ornamentation and batik fabrics. I named the pavilions Melaleuca because of the large stands of white paperbark trees (*Melaleuca leucadendron*) populating the nearby estuaries; native to Australia, the species has become endemic in Langkawi. As Malaysia is a melting pot of Malays, Chinese and Indians, I tried to incorporate cultural elements from each group. The bed, with its white canvas straps, pays homage to the traditional beds found throughout rural India. I first experimented with this in my home (see page 152). The gentle double curve above the two pewter medallions is sometimes found above windows and porches in old Malay homes in the state of Perak. The pewter-hued batik accent pillows on the bed and sofa pick up the colors in the Royal Selangor Pewter-like elements in the room. **Below left** The floating island vanity, with its hanging mirrors and Chinese-influenced pewter lanterns, is a true exercise in the luxury of space. Nothing about this resort, from the site planning to the room plans, is crowded. From the bed, we joke, the toilet is in another time zone, as this villa is so luxuriously spacious. **Below right** The first-floor Melaleuca bathtub, Islamic in design, is very private. The space is lit from an oculus at the top of the dome; there are no windows, thus no visibility to the private bathing spaces in the gardens on the ground floor. The driftwood-finished pedestal tray used to hold shampoos, soaps and other toiletries is modeled after a traditional Malay brass tray used for presenting ceremonial gifts. **Right** Five massive doors at the front of the beach villas slide open to allow sea breezes to enter. The finishes of the furniture are clearly in harmony with the environment. We wanted the furniture to look as if it had been bouncing in the sea, washed up on the beach and bleached by the sun for years.

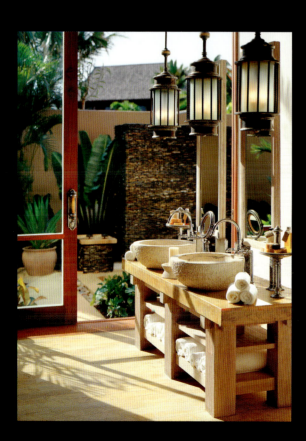

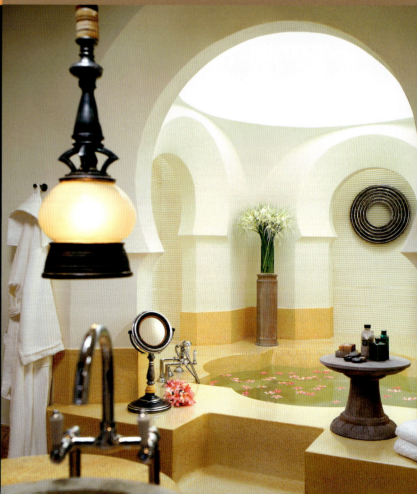

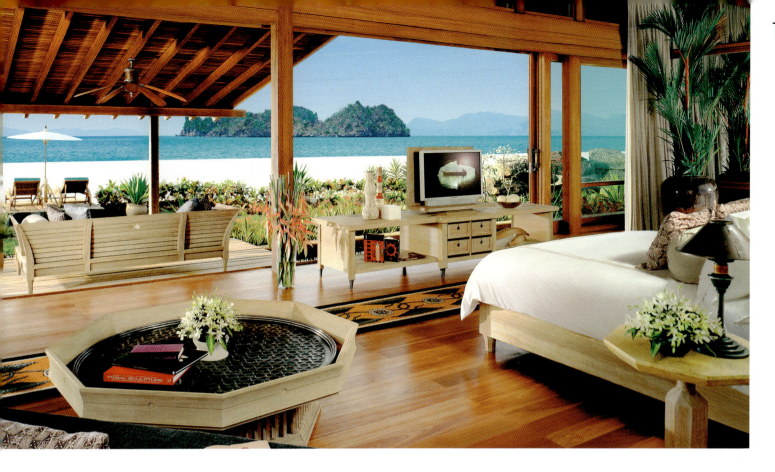

Although all suites at the resort are exquisitely accented with rich tropical woods and heavily grained Spanish marble, each is given a distinctive touch. The upper Melaleuca suites, occupying the top floors of the two-story Melaleuca Pavilions, are accessed by Malay-style staircases. Special features are the high ceilings (16 feet; 5 meters), twice that of a normal room, spacious verandas and dome-shaped bathtubs set below an oculus in the ceiling, allowing the Amarillo marble bathrooms to be flooded with light. Heavy spade-shaped niches in the bathrooms display Moorish and Malay artifacts and large scented candles. The lower Melaleuca suites, occupying the ground floor of the two-story pavilions, open onto beautifully landscaped gardens, and are entered through pebble-washed patios. Their special feature is a secluded outdoor bathing area with a terrazzo soaking tub and showers which mimic a gentle tropical rainfall.

The furniture in the suites is all done with what I call a "driftwood finish." This is an unpolished, scarified finish created by rubbing the wood with a wire brush until the grain emerges. The end result suggests that the wood has been recently picked up from the beach, bleached by the sun—although it is, of course, perfectly functional. The grayness of the wood harmonizes beautifully with the grayness of the cast aluminum on show throughout the resort, including the old Malaysian earrings crafted by John Underwood, which are blown up to an enormous scale on some of the walls, reflecting Malaysia's traditional, highly valued Royal Selangor Pewter.

With the white-sand beach a step down from the deck, the beach villas each have a garden path leading to a private plunge pool and reflecting pond. An interesting aspect of the beach villa interior design is that every piece of furniture contains a small detail of cast aluminum suggestive of an Islamic design. The cleverest aspect of Islamic design is the way in which it can convert a circle into a square into an octagon, etc. This idea of the transformation of geometric forms into the most simplistic things—in the foot of chairs, in lamp bases, in table legs—is something we chose to explore in depth.

The Alhambra-style inspiration moves beyond the guest rooms. The resort's lobby, the highest building in the resort, has an Islamic-style tower, a cupola, above the building that lets in light. To reach the lobby, one must pass through the courtyard of a hundred lanterns in front of the entranceway's porte-cochere. Then the courtyard of the date palms flanking the porte-cochere must be negotiated; fire comes out of the sand here in the evenings. A narrow passageway follows, with a tiny opening that, in turn, opens out through very thick 26 foot (8 meter) high walls to reveal a gigantic pond framed by the limestone hills. In the middle of the pond is a greeting pavilion. The tiles used here are crimson and charcoal, almost Byzantine in nature.

Elsewhere, in the beach bar built right on the sand, there is an inner sanctum with Chinese Islamic wooden screens shielding the pool tables. More crimson can be found here, as well as shocking pink. Waitresses wear fez hats and luxurious silk outfits

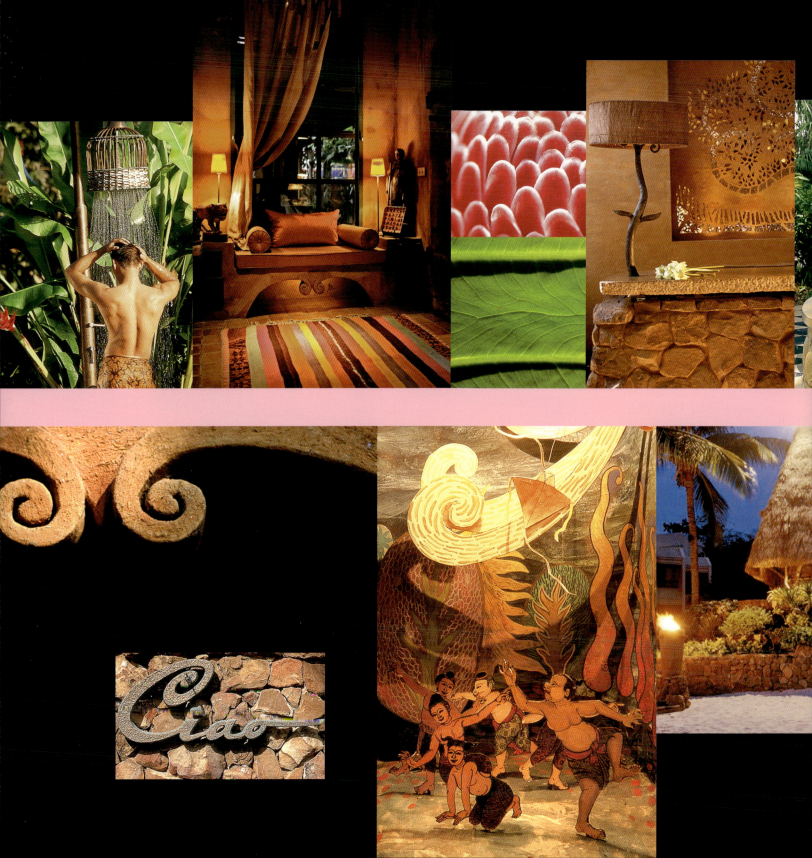

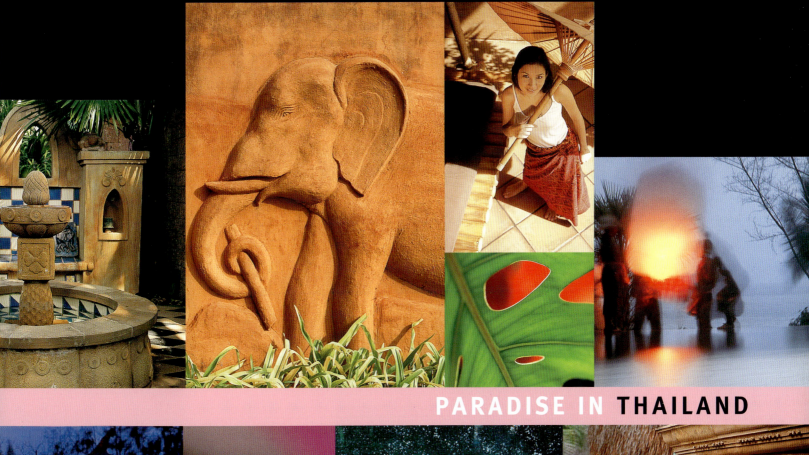

PARADISE IN THAILAND

THE BENSLEY RESIDENCE
BAAN BOTANICA

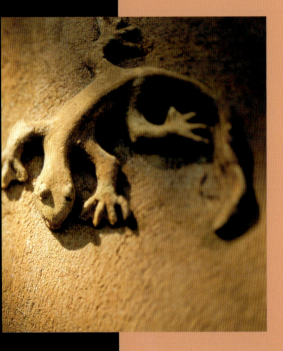

Above The gecko is a welcome guest in most homes in Southeast Asia as it eats pesky flies and mosquitoes, and when small, like we have made it here in cement, is quite cute. But it can grow to a formidable size, some 18 inches (45 cm) long. **Opposite** This unusual pair of *chofah* ("needle of the sky") is pinned to the wall just outside our front door. A Thai architectural element, the *chofah* is normally placed on the end and apex of the roof of Thai temples. The fabric used for the pillows is from the Congo, purchased there when we were designing a home for the owner of Banque Centrale du Congo.

Tucked into a small *soi* (lane) in Bangkok's outer suburbs and fortified by tall laterite-clad walls and a bell tower, our Thai colonial-style home is a quiet green sanctuary, a fairytale hideaway in the middle of a city known for its traffic and nightlife and for its contrasts between modern and traditional, a city that is ordinarily very hard to escape from.

Touted as hunter-gatherers by our friends and colleagues, my partner Jirachai and I live with quirky antiques, refurbished found furniture and green art works from all over the world. Our home is a veritable cross-cultural amalgamation of everything that appeals to us, an engaging composition of things primarily Thai, Mexican, Moroccan, Burmese, African, Indonesian and Indian, an amusing array of objects showcasing the rich seduction of the handmade. Permeated with light, the spaces throughout the house and garden reverberate with a certain luminosity and vivacity. Many light sources, mostly employing small fixtures, offer a delightful lighting scheme that is both subtle and vibrant. Thick walls, niches, verandas and bright colors provide the architectural backdrop. The experience is as much auditory as textural as water cascades murmur throughout the day.

As my 85-year-old father, who lives here with us, tells everyone, "The house changes every week!" He can walk into the lounge in the morning and find that walls have changed color, furniture has been rearranged and new installations have appeared. He, in fact, has contributed to this merry-go-round of change by crafting much of the wooden furniture scattered around the house in his workshop next to the kitchen.

Baan Botanica's garden is no afterthought to the house, no place to be viewed rather than participated in. Rather, it is an intimate collection of pocket gardens, all unique, peppered with rare tropical plants, ornaments and water features. One garden leads to the next through a series of gates, a bell tower and an ornately roofed outdoor massage pavilion. Bangkok old-timer, writer William Warren, planted the original garden for a friend of his who lived here. Today, the rain tree (*Samanea saman*) that he installed as the plot's centerpiece dwarfs our house.

It is perhaps the expansive swimming pool, or "watering hole" as we call it, that garners the most admiration from visitors and provides us the most welcome relief from Bangkok's often grueling heat; because the city is located almost on the equator, the sun can be intense. We wanted to evoke the idea of a natural tropical lagoon and so created sinuous curves and nooks and crannies interspersed with landscaped rocks and steps. To provide the necessary shade over the water surface, we planted large-leafed evergreen plants rather than profusely flowering ones—the answer also to low maintenance. A grinning mosaic-tiled frog on the floor adds a touch of humor.

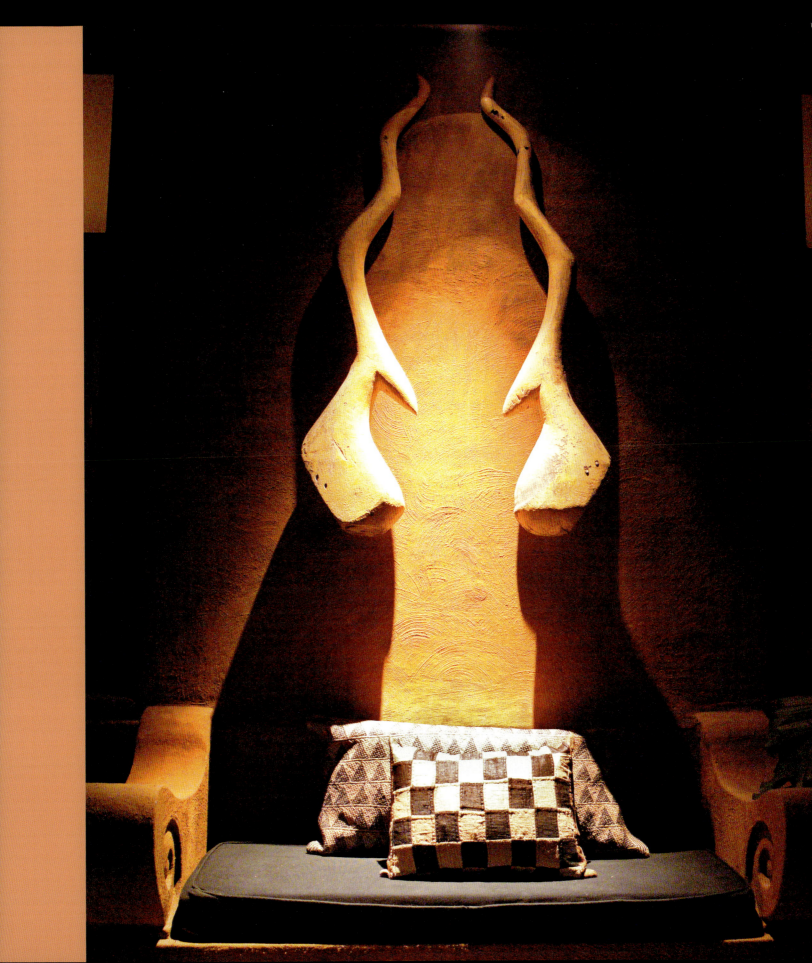

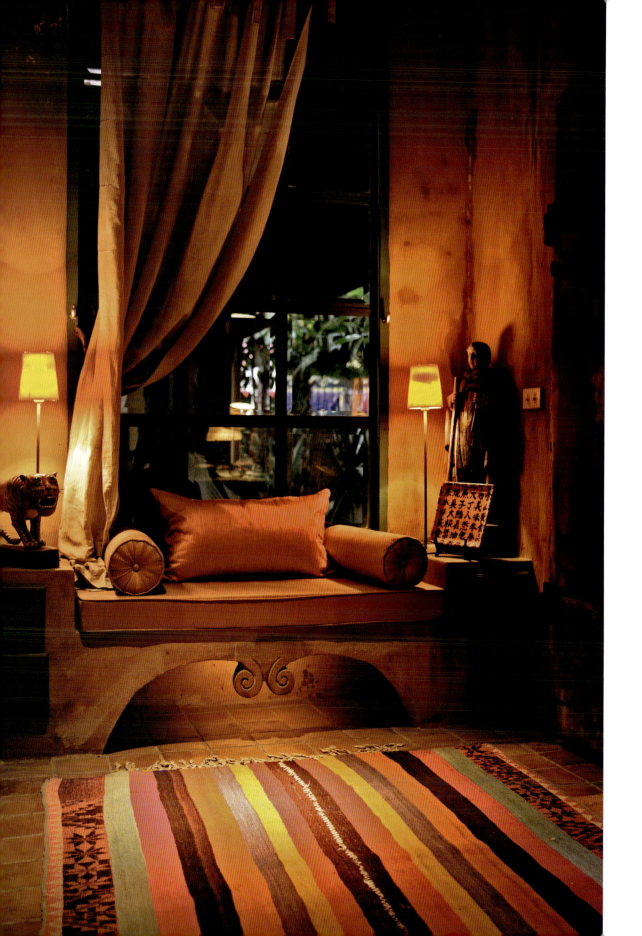

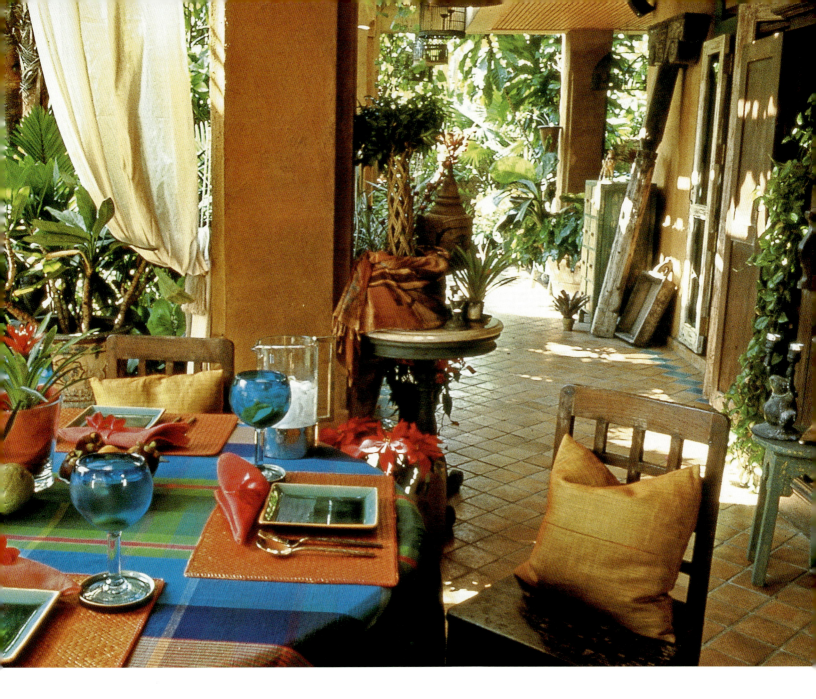

Left Just inside our very thick old front door, salvaged from a 1940s post office in Rangoon, we built a small cement bench. The rug is an old piece from rural Argentina that Jirachai and I bought while on a fly-fishing trip. **Above** This is the heart of our home, the dining table on the veranda which wraps around three sides of the house. Many a colorful guest has graced this equally colorful table setting. **Right** A close-up of a Swiss cheese plant or *Monstera deliciosa*.

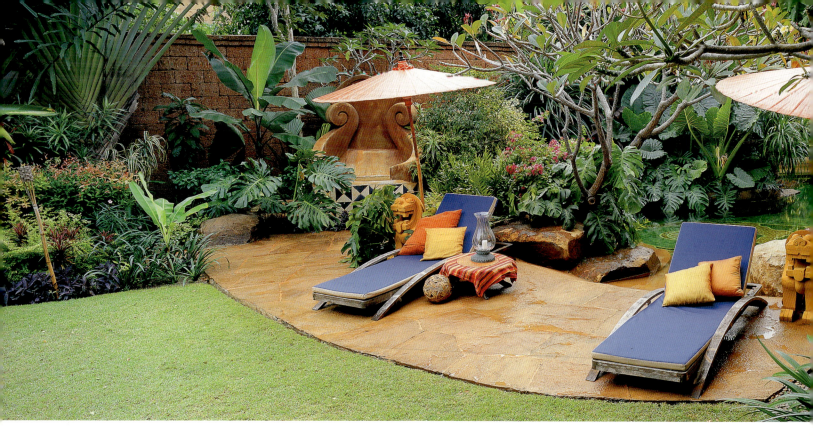

Adjacent to the bell tower, a large blue gate, much like a fortress portal, forms a dramatic transition from the entrance courtyard, dominated by the massive rain tree, into the garden. The gate effectively conveys what our home is all about: a blend of influences and objects from all over the world. The light blue twin-leafed door is from China; its freestanding deeper blue structure is classic Balinese; the lion at the top (not visible here) is borrowed from Portugal; the swirling *nung*, painted near the top, is the Thai symbol for the number one (and also Jirachai's nickname); the leaf design we carved further down is Indian; and the door's blue paint is from Mexico. It is a six-nation door, combined to create a very Bensleyesque object! Inside the gate, a fountain in the shape of a mythological bird adds the sound of soothing water in a slab-bordered pond inset with water plants and flanked by luxuriant foliage.

Altogether, we have three outdoor–indoor dining areas. Our newest is a freestanding pavilion in the garden that incorporates four sets of antique wooden doors from the northern Thai province of Sukhothai. The pavilion, topped by an ornate iron dome-like roof, is a perfectly symmetrical square, 13 x 13 feet (4 x 4 meters), with a dining table positioned squarely on top of a five-sided fountain—so that all the diners around it can dangle their feet in the water! The second area is a reclaimed wooden table built by my father and positioned poolside. The third, and the most loved, is on the veranda, which wraps around three sides of this Thai colonial-style home, and overlooks the lawn and pool.

Above Our two sun lounge chairs, shaded by broad red umbrellas planted in the backs of sandstone lion-dogs, face the lawn, placing the swimming pool behind in a jungle-like environment of dense foliage. Carved sandstone chairs make novel seats for guests. **Above right** Large wooden doors, painted broken blue and carved with big dimples, like a golf ball, swing open to allow us to drive into the property. The perimeter wall is clad with Thai laterite, which when first mined has a soft, mud-like quality. **Right** As an alternative to driving in through the front gates, guests can pull the colorful rope in front of the blue door, which rings a bell at the top of the tower, then we come running to greet our guests! **Far right** Just to the side of the pool, we built a wood and wrought-iron pavilion and dressed it with white canvas curtains. This is a very pleasant place to enjoy a Thai massage.

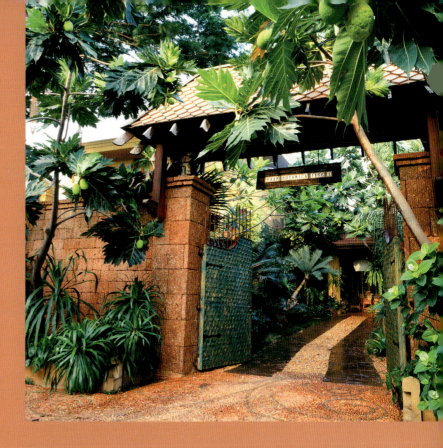
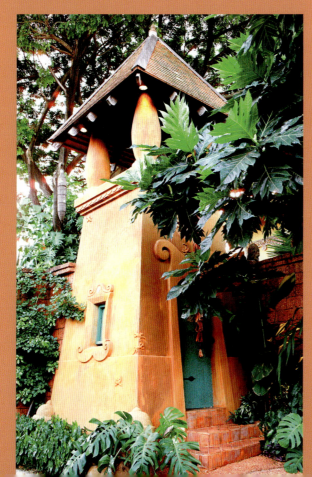
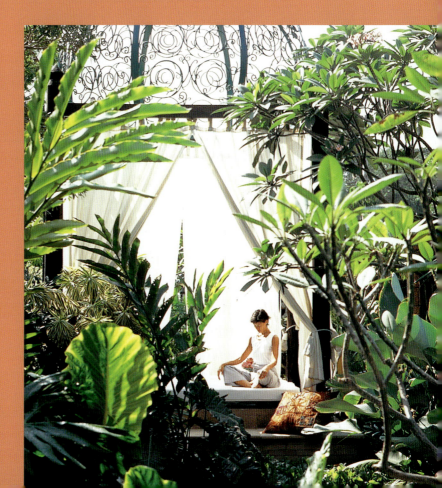

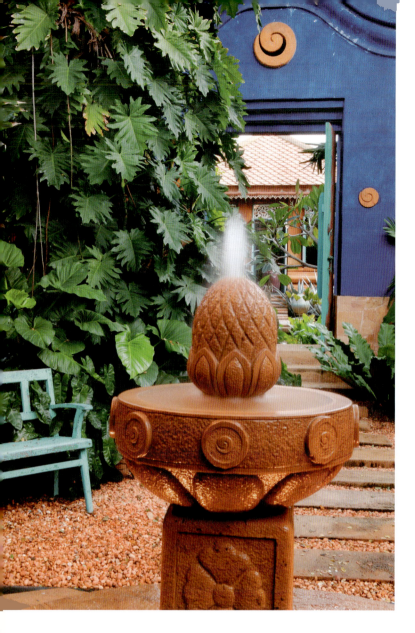

The master bedroom, like the rest of the house, is liberally decorated with art and artifacts from all over the world: Bali, Java, Afghanistan, Congo, Nepal (two very large, very old lamps from Bhaktapur stand ominously close to the end of the bed on a wooden trunk), Morocco, the Czech Republic, Burma (a wonderful wall of square drawers which were originally built for a post office), not forgetting Thailand itself.

In our guest bedroom, which we call the White Room, we reassembled an old British colonial snooker table that we found in Burma to make the square base of the king-size bed, and then used the Indian method of woven straps to form a somewhat springy base for the mattress. Needless to say, we had to add some Thai steps at the end of the bed in order for guests to reach the high, throne-like platform. Overlooking the bed is an image of the Lord Buddha painted on recycled wood planks. Outside the room is a smoking porch.

Baan Botanica is my personal experimentation ground. For example, the hanging, bird-less cages on the guest bedroom's balcony was the control experiment for the Anantara Hua Hin's restaurant installations. We are magpies; constantly returning home with things from all over the world. This house is the ultimate repository and living chronicle of our lives. Almost all our discoveries are offered to the resorts—at no mark-up—so that clients get to choose between all this diversity, all these things we have picked up during our global décor-centric shopping sprees.

Above The blue "six-nation door" marks the transition from entrance courtyard to garden.
Right A pocket garden with a lotus pond.
Opposite Because Bangkok sits right on the equator and the sun can be intense, it is a relief to take refuge in our "swimming hole" decorated with a friendly mosaic frog. Almost 80 percent of the water surface is shaded by overhead foliage. The key to making this work—and to not ending up with a maintenance nightmare on your hands—is to plant large-leafed evergreen plants that do not flower profusely.

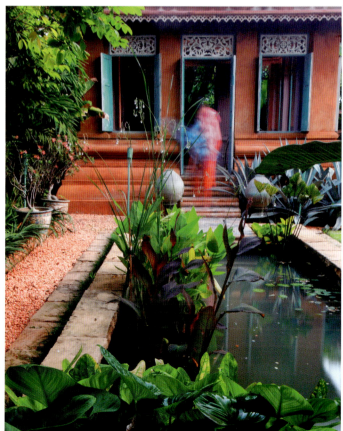

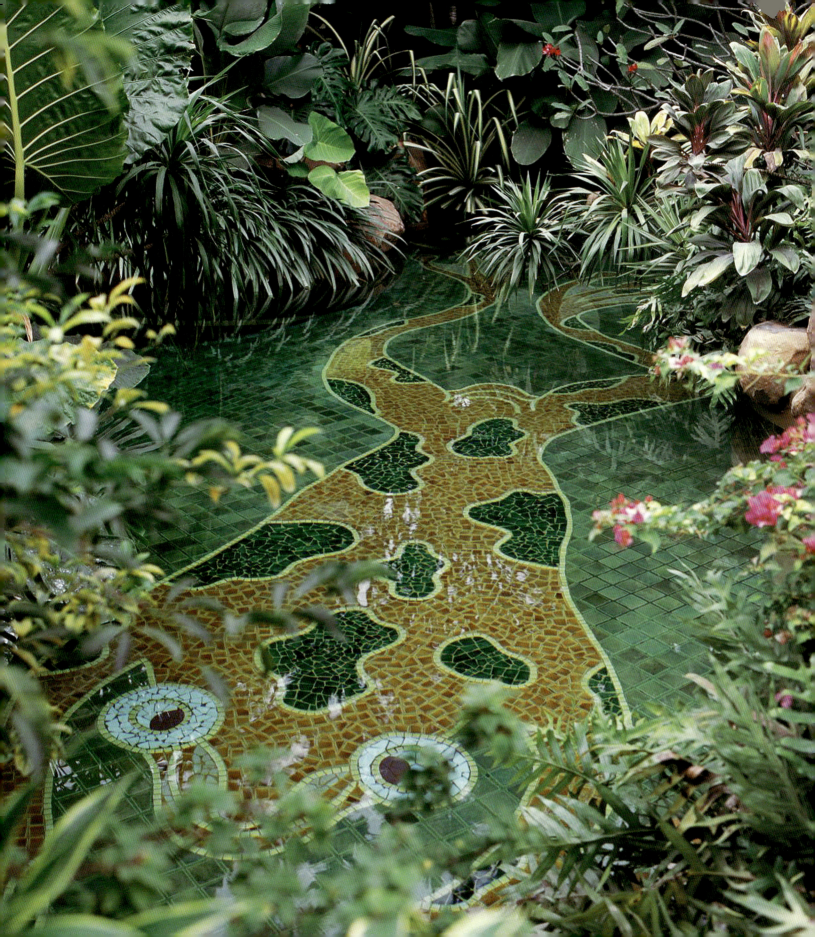

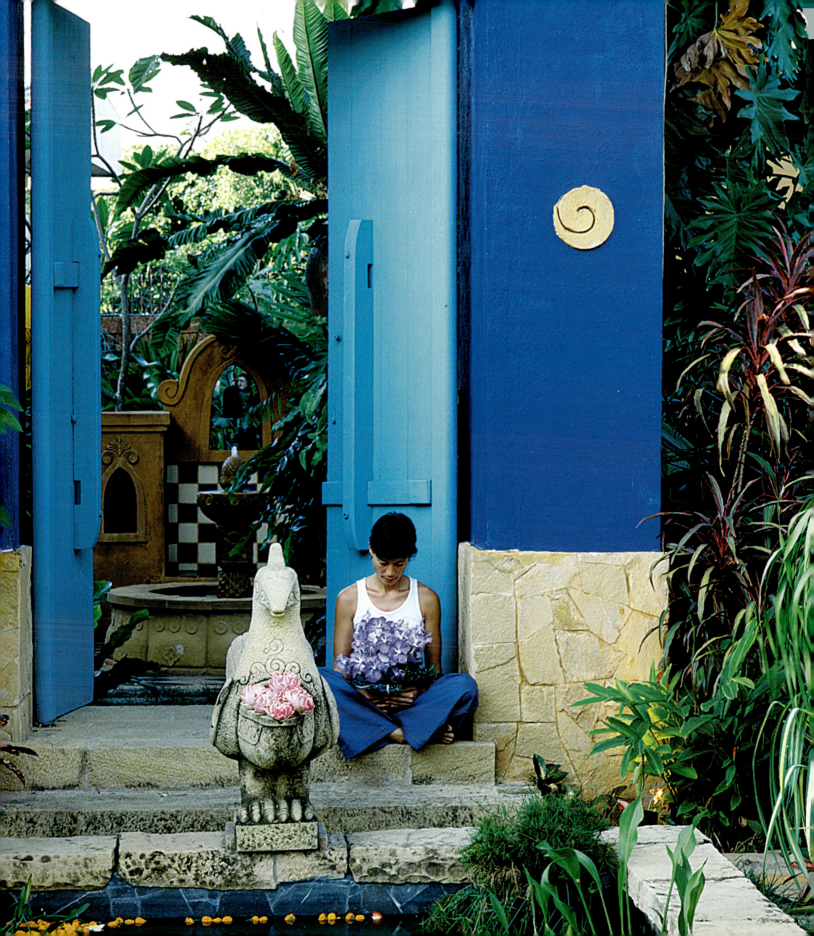

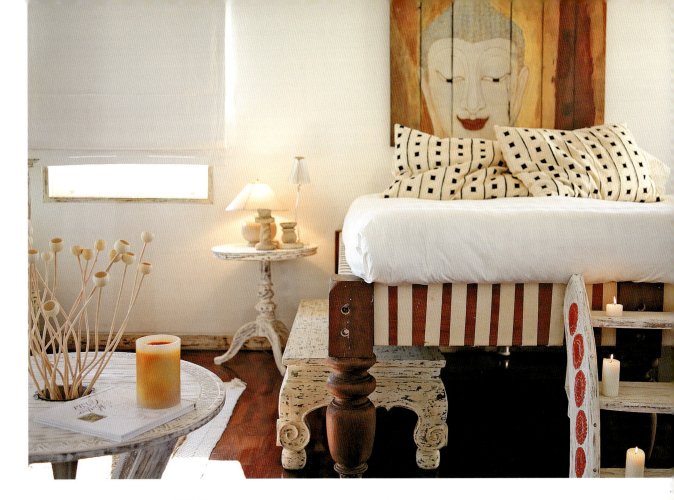

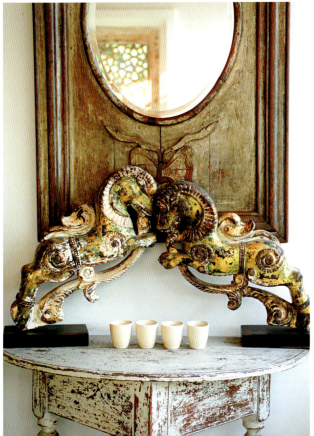

Opposite The huge blue "six-nation door" dividing the entrance courtyard and the garden captures the essence of the house's décor. It is also quintessentially Bensleyesque in its combination of elements from a number of different cultures. **Top** The guest room, appropriately called the White Room, boasts a king-size bed re-assembled from an old British colonial snooker table from Burma and an image of the Lord Buddha painted on recycled wood planks. **Left** Outside the White Room is a smoking porch where we have hung an old mirror frame with two horses in front. **Above** A yellow blossom forms a delicate contrast to bright pink linen.

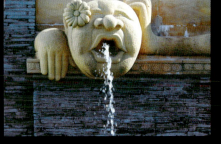

THE HOWARD RESIDENCE
TEAK, SILK AND LOTS OF TENDER LOVING CARE

Spread over a sprawling 7 acre (3 hectare) site just five minutes from the Four Seasons Chiang Mai, the Howard Residence epitomizes all that Howie, who hails from Boston, and Jerri, his gorgeous wife and an accomplished dancer and choreographer, stand for: a passion for beauty, for the exotic and for the good life—not forgetting collecting! Over the last six years, Howie and Jerri have graduated from being clients to our best friends. We travel the world with them—on shopping sprees, of course!

When Howie came to visit me a few years ago at the Four Seasons Chiang Mai, we had a conversation about his dream home over an expresso. As he talked about pavilions and "water, water everywhere," I sketched a simple plan on a paper napkin (which he still keeps) of three separate Thai pavilions—living, dining and kitchen, and master bedroom—arranged around a traditional formal rectangular courtyard opening to the wonderful view of the nearby mountains, adding a very still pool in the center of the courtyard, perfect for reflections. Also following Thai tradition, I decided to raise the pavilions off the ground to avoid the perennial floods but also to take advantage of the views. While Howie's office, the guest pavilion and Jerri's mom's bedrooms and dining room were assigned important places in the garden, they were located outside the formal courtyard. As I love water gardens, to complete the plan I drew a very large pond with lots of bridges and pavilions articulating the edges. My simple original sketch is, more or less, what you see on these pages.

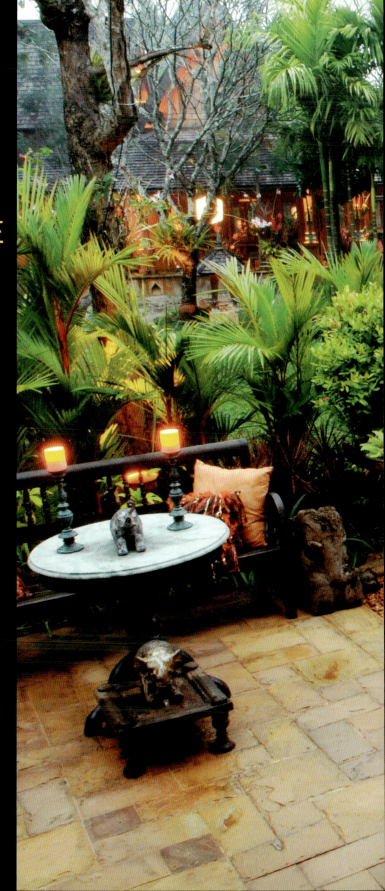

Above Fondly referred to as "Headache Man," this sandstone sculpture aerates the water gardens below the master bedroom Jacuzzi. **Right** Just outside the guest room is a little fountain pond with a pinkish wall and terracotta wall sconces. Beyond, on the left, is the dining pavilion. On the right is the living pavilion.

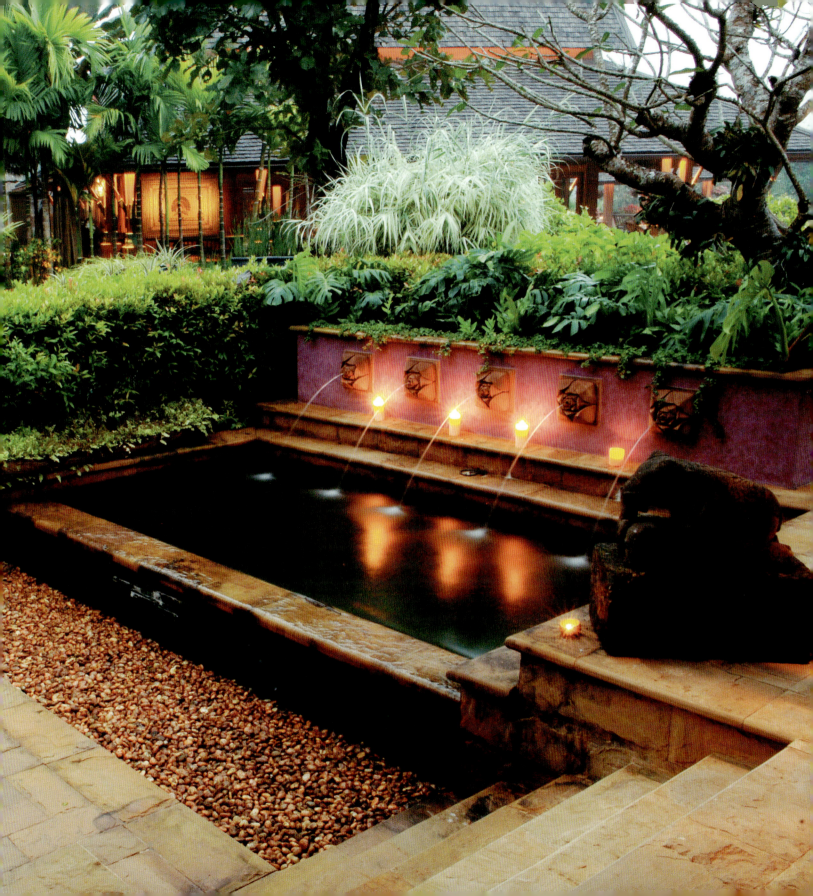

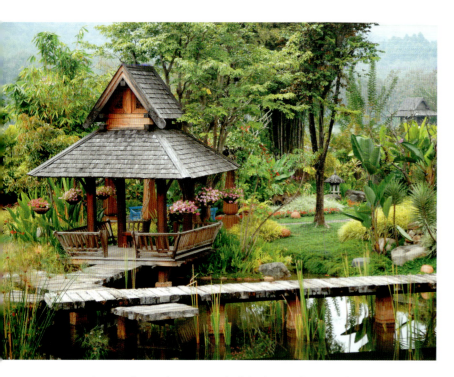

As it turned out, the courtyard of the living, dining and master bedroom became a swimming pool. But true to plan, the entire west aspect of the residence sits on an extensive water garden. At every turn there is water falling out of something or into something. Water flows from solid boulders, out of boats and the rain waters fall 16 feet (5 meters) into the water gardens from the mouths or three Thai bird busts. All of the pavilions are linked by simple bridges set in Shangri la-like gardens and the sky above. When an interviewer from *Architectural Digest* asked Howie, "So what do you do when it rains?" he answered, "You get wet." This is not a new idea, as basically all Southeast Asian vernacular dwellings are built as a compound of buildings with various uses. The Western idea of attached functions, with the exception of perhaps the ancient royal palaces, simply did not exist.

After Howie accepted the basic plan, years of detailing and modeling followed. Knowing that Howie was an avid shopper, we established two basic principles: buy collections and restrict the permanent features to two colors, saffron and pale green. Strangely, both colors are produced by rust. The majority of the saffron walls are created by an iron sulfate wash, where orange rust is visible in the cement. The pale green derives from the green patina of the much-used copper. The entire estate is built around this scheme, from the pale green patina faucets and bath towels to the saffron hues of the teak wood and silk furnishings.

Above A bridge made from recycled railroad ties provides sturdy access to one of the three pavilions on the edge of the water gardens. **Right** A giant bamboo frames a view of a British colonial iron bed, a garden folly with a mattress of annual sage flowers (*Salvia* sp.), a diaphanous cotton canopy and hanging candle frames. Beyond is the ever-changing view of the Mae Rim Mountains.

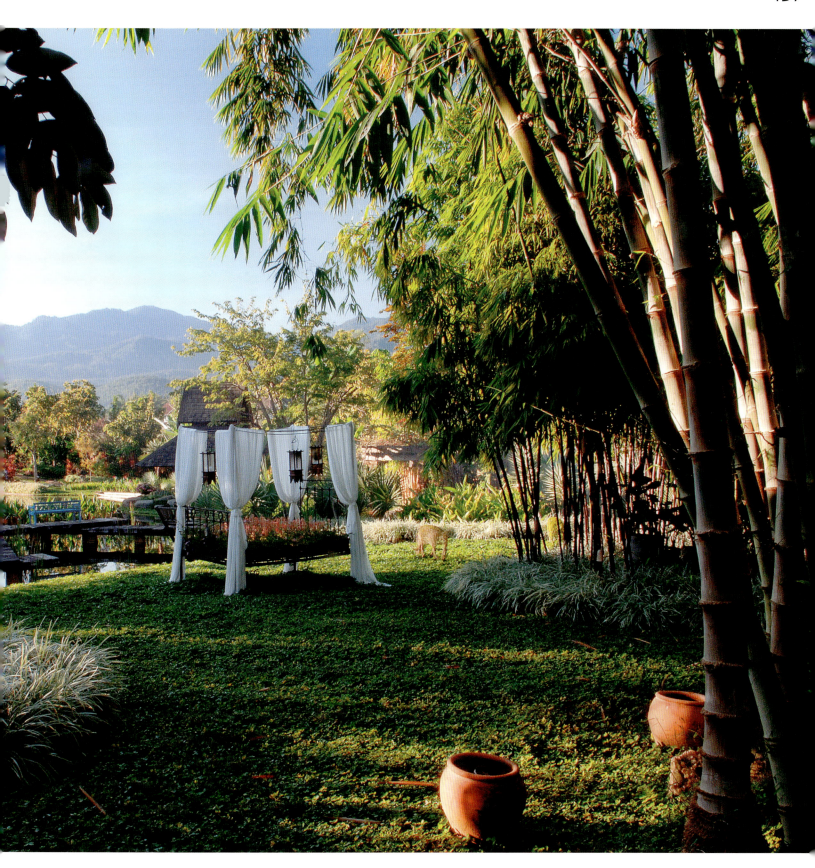

I could not have asked for a better client. Howie, an experienced real estate developer and restaurateur (his Howie Burgers are to die for!) knew a thing or two about building. He was his own contractor, carpenter, engineer and technical advisor. He personally installed an incredible sound and light system, perfectly automated to the touch of his remote control. It took him six months of research to find the best way to get a huge flat-screen television to rise out of the wide-paneled teak wood floor, and for it to recede, unnoticeable, when not in use.

But perhaps what sets the Howard residence apart from others is the water garden. Over a period of two or three years, Jirachai built a garden of superb beauty, vignette by vignette. In these 7 acres (3 hectares) we can see perhaps 20 different subgardens, each with its own character. We purchased plants, one by one, to create a garden that now boasts some 350 species.

When *Architectural Digest* featuring the Howard residence hit the newsstands in October 2007, it was a proud day for all of us! We have had so much fun putting together this home for Howie that I often encourage him to sell it so that we can make a new one, and he may do just that!

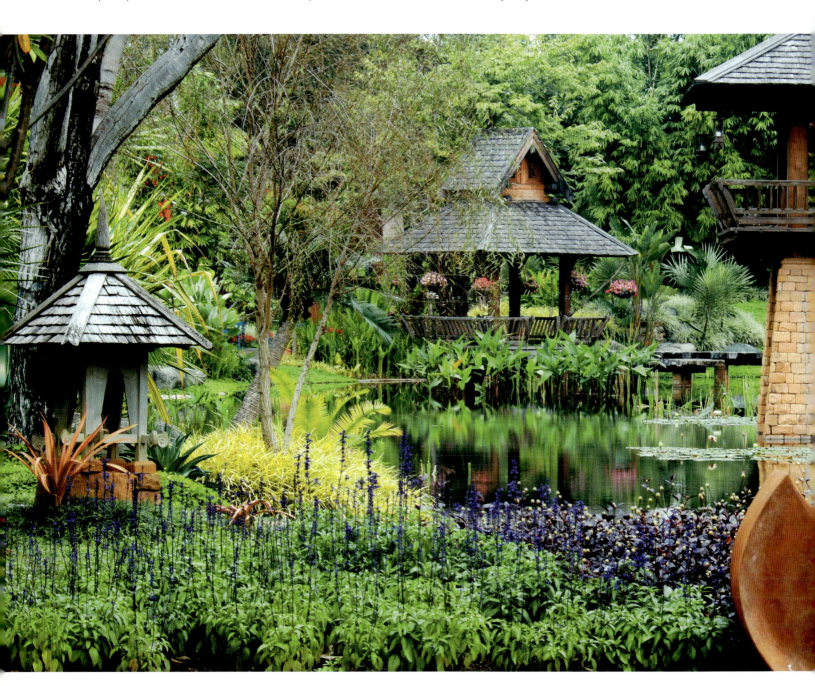

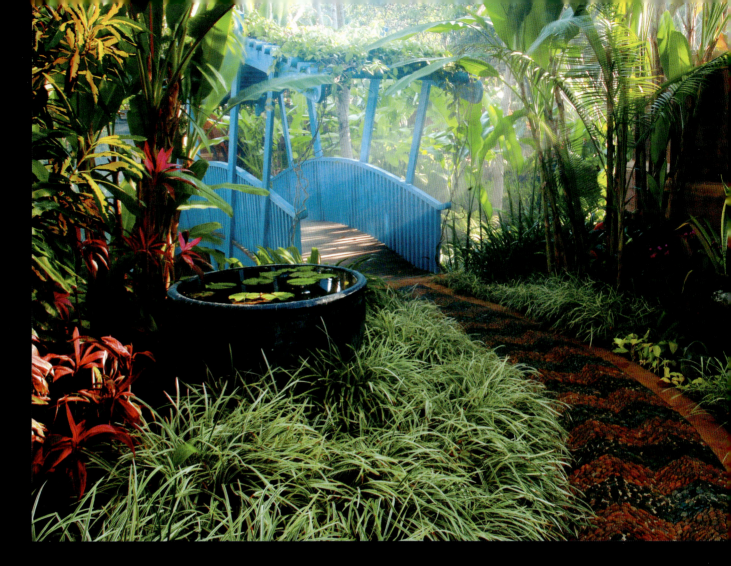

Left This is my favorite landscape photograph because of the huge depth of field and the way the four architectural elements, all clearly Thai in style but set quite apart from each other, are included in the frame, while the varied textures, soft colors of the plants and reflections dance around these elements. **Above** A laterite path turns the corner to the blue "chopstick bridge." Late afternoon light filters though the smoky atmosphere caused by the neighbors burning their rice straw. **Right** At poolside, an eclectic grouping of objects—a Vietnamese chess set on a Thai chessboard table, an African footstool, two low Indian iron and wood chairs and Silver, a child's rocking horse from Burma—harmonize perfectly with the texture of the pool deck paving and pool tiles beyond.

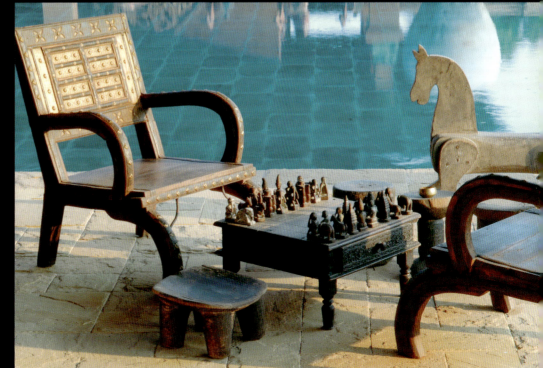

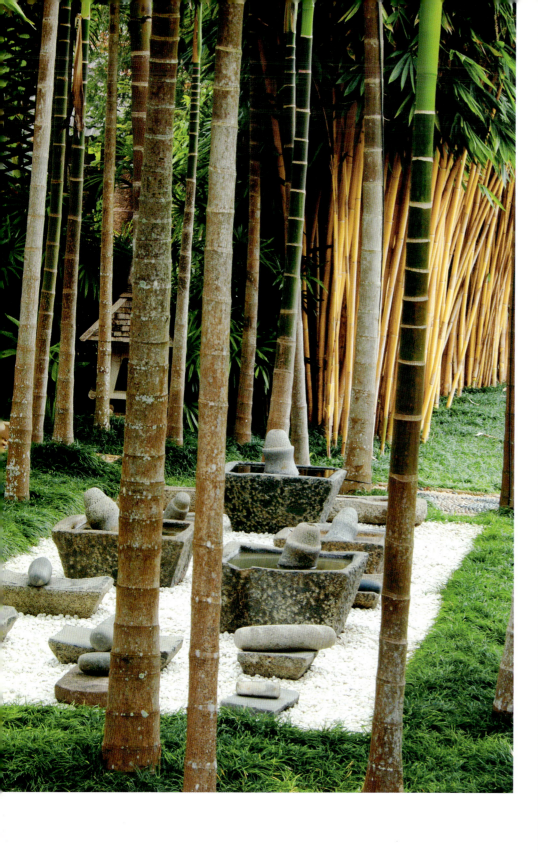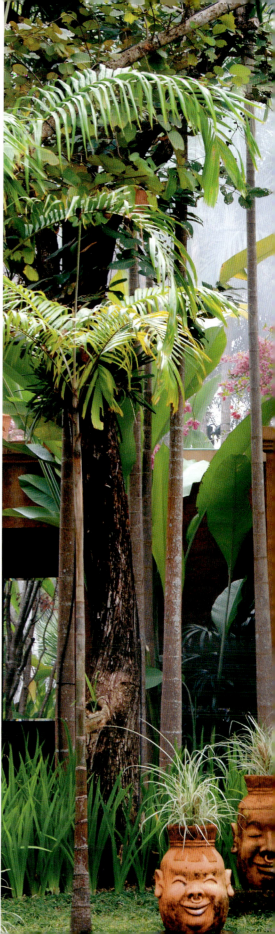

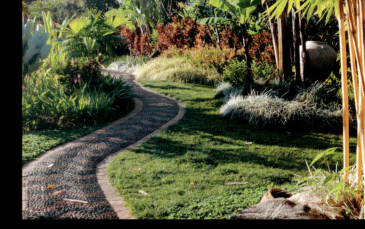

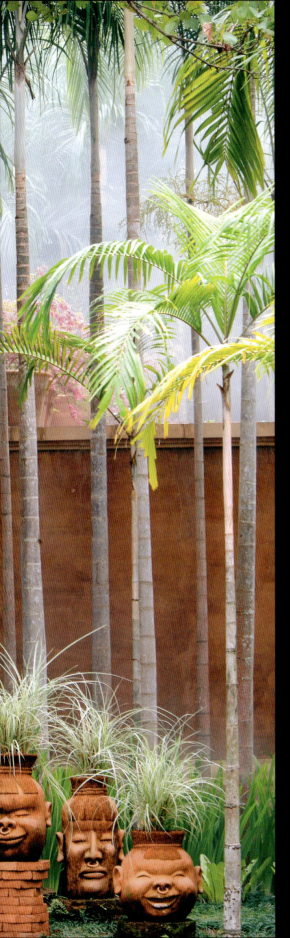

Far left When we first started on this project, I suggested to our client, an avid shopper, that he scour the antique markets, villages and shops in Thailand and elsewhere with the purpose of assembling a series of collections. Objects make a greater impact and are much more meaningful when viewed as a group, like in a museum, rather than as single, one-off pieces. Here, a stunning collection of very old and heavy gray stone Burmese mortars and pestles rests on a white gravel bed, for contrast, framed by 33 betel nut palms (*Areca catechu*) planted in Mondo grass (*Ophiopogon japonicus*). **Center** This unusual vignette is composed of five terracotta heads made locally and planted with an ornamental grass, set in front of very quick-growing, appropriately named fountain palms (*Carpentaria acuminata*). In the background is the rest room and changing rooms for the stage, as theater is a frequent happening at the residence. **Above** Brown and black pebbles are set into concrete in a herringbone pattern to form an artistic pathway. **Below** The door of the side entrance to the Secret Garden is clad in small copper tiles. The wooden railing window, above right, is painted to match. When this book went to press, the Secret Garden was in the final stages of completion. Gardens, of course, are never finished.

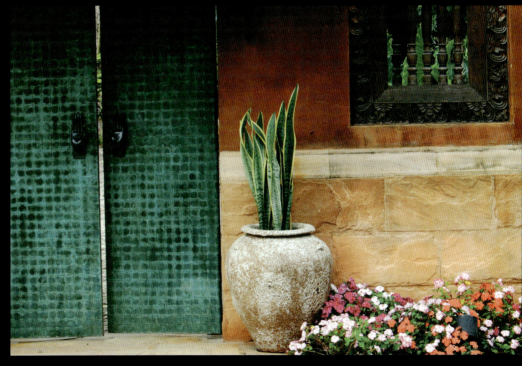

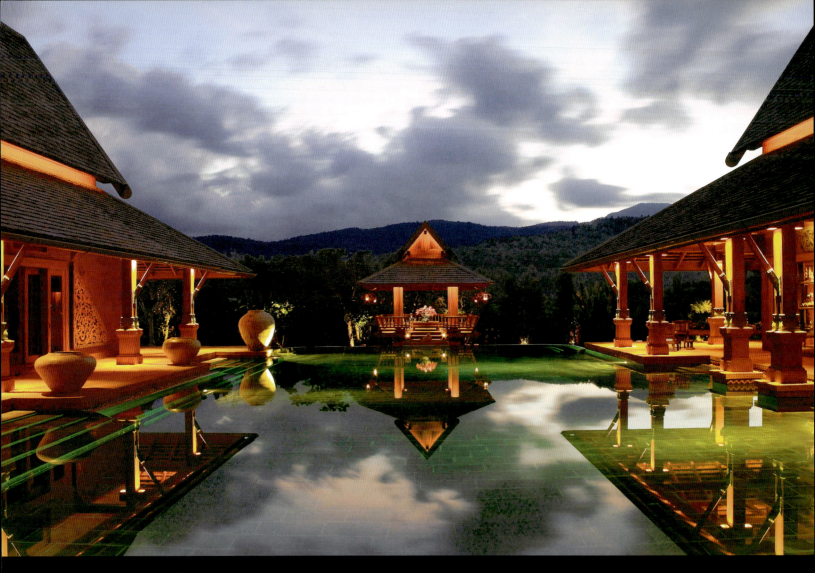

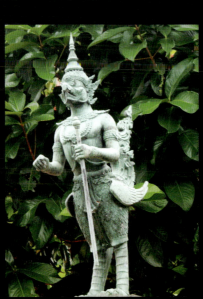
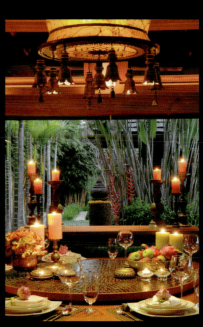

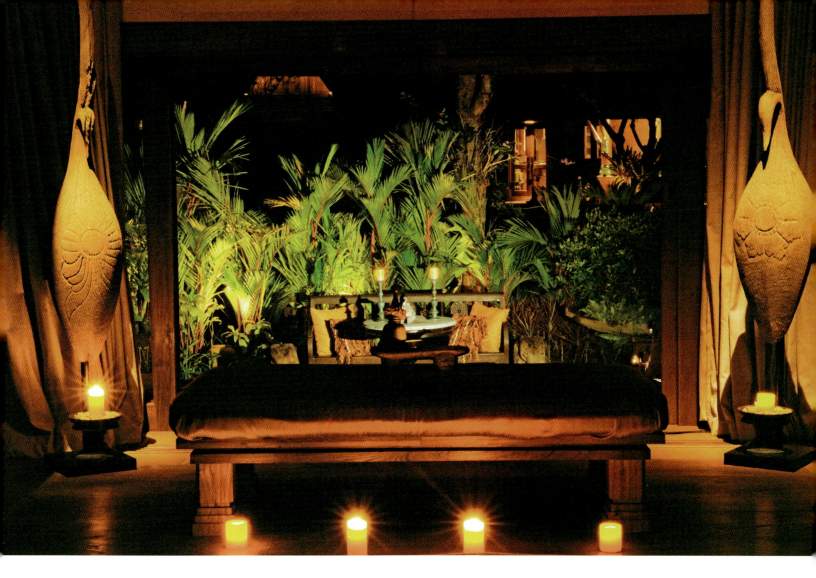

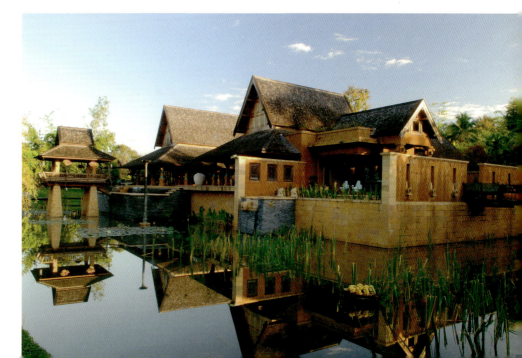

Above left The green sandstone-clad swimming pool, invitingly fresh at any time of the day, forms the courtyard of the living, dining and master bedroom pavilions. At the far end, a quirky Chiang Mai-style dining pavilion we call the Sala Nam stands high on stilts above the pond, allowing the most expansive views of the highly detailed and meticulously kept water gardens. **Far left** A mirror hanging in a very old wooden frame at the front door of the master bedroom pavilion reflects a spirit house in the background. **Center left** One of a pair of half-human half-bird *kinnari* bronze statues which we had made to stand guard at the courtyard of the cars. **Left** The dining table in the Sala Nam is located at the confluence of the two major axes, one through the swimming pool shown above left, and this one looking through to the mortar and pestle garden, with the Secret Garden (still a secret) behind. **Above** The guest bedroom (our home in Chiang Mai) looks out to the Secret Garden and a small water feature. Two wooden Thai *chofah* temple roof elements, standing in the far corners of the dining pavilion, are unusual for their chunky proportions. **Right** A pair of toilets, his and hers, are visible on the flat roof of the bathroom annex to the master bedroom pavilion. From here the owners can enjoy extensive views in private. To the left is the Sala Nam and in between the living pavilion.

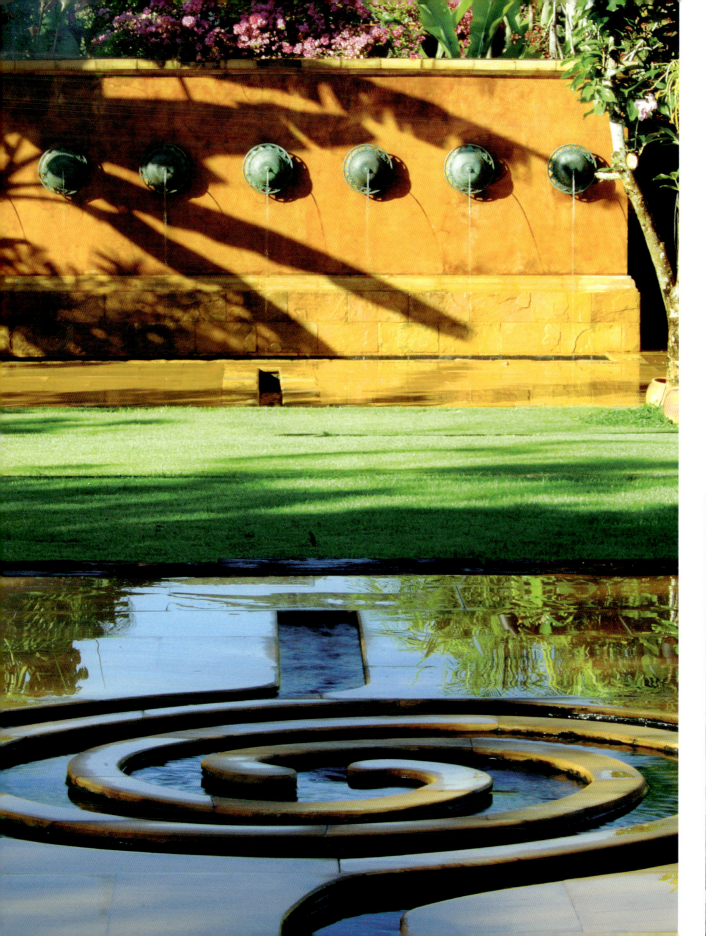

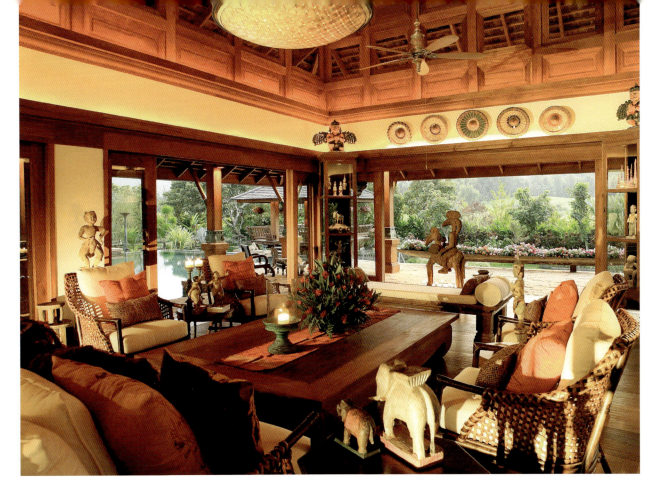

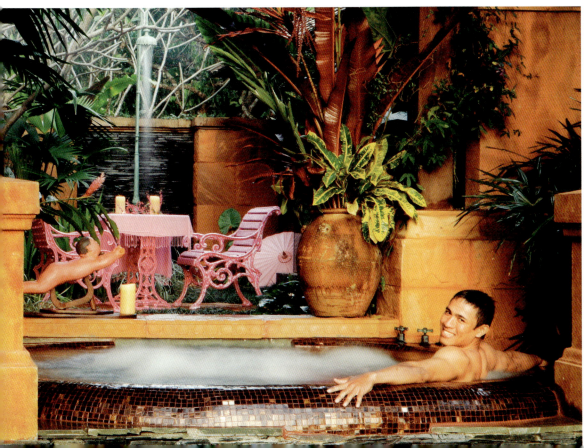

Opposite The performance courtyard is a series of lawn terraces that step down to the stage and this saffron-dyed wall. The bronze patina medallions, blown-up versions of a 100-year-old belt buckle from a Cambodian army officer's uniform—or at least that is what I was told by the seller in the Thieves Market in Phnom Penh—make handsome back-lit waterspouts behind the stage. In the foreground is a Chinese poet-inspired water game of running water. **Above** The living pavilion is designed to receive light from all four sides. One can also see the mountains to the west, the water gardens to the north, the secret gardens to the east and the swimming courtyard to the south, that is, if one is bored looking at the plethora of unique finds in the room itself! Here, an almost detail-less Thai coffee table built with chunky reclaimed teak wood anchors the scheme and a variety of "collections." **Left** To the north of the guest room is a charming pocket garden featuring a beautifully styled bronze outdoor shower with a patina green finish, a cosy pink-hued dining alcove surrounded by pink plants, and a hot Jacuzzi pavilion.

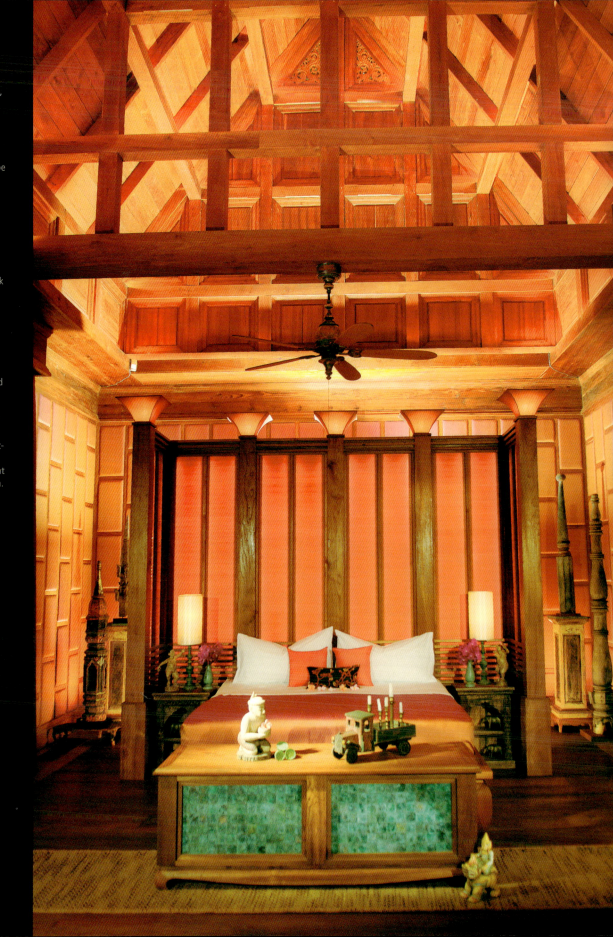

Right Featured on the House and Garden television channel as one the sexiest bedrooms in the world, the master bedroom pavilion displays classic Thai architectural features: a tall, triangulated "cathedral" ceiling made of teak planks, its height paralleling the high gables of the roof which slope downward into long projecting eaves; a carved gable to allow for air circulation; inward-sloping walls made of separate wooden panels fitted together and, with a luxurious twist, padded with stretched Jim Thompson silk in saffron tones to harmonize with the golden teak wood, and a plank floor. Behind the bed, a double layer of the same silk allows for back lighting. At the foot of the bed is the color foil: the ever-present patina green. **Opposite** The focus of the living room is a stunning backdrop composed of an old carved Indian double-leafed door and two triangular gables (*na baan*) carved in a climbing plant motif; all were enlarged and raised by Howie's carpenters to give them more presence. Comfortable woven seating, stunning flower arrangements and abundant candles add Thai style to the room. The pair of wall-mounted tables below the *na baan* are replicas of the original pair of smaller Burmese tables that we used on the side wall, just out of this photo. Behind the door is the peacock powder room where we display Howie's collection of 24 peacocks in all shapes, sizes and materials. Beyond this room is the Secret Garden, which, for now, must remain a secret.

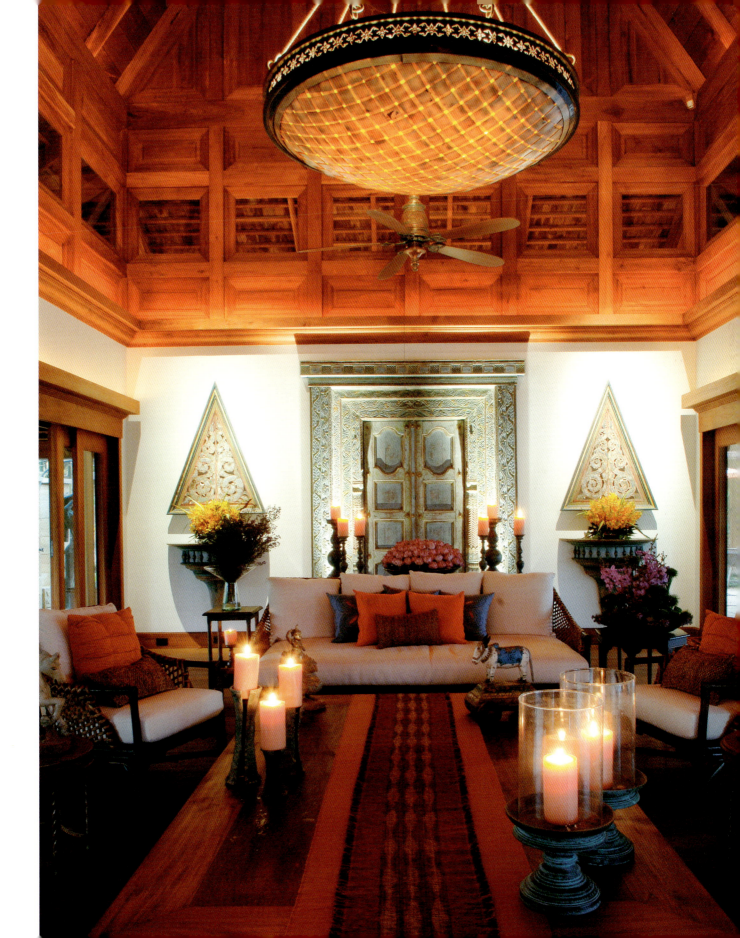

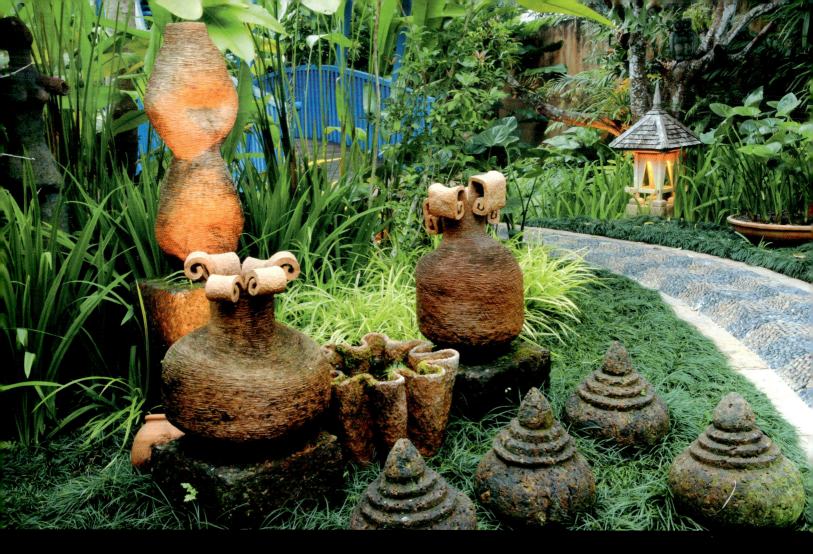

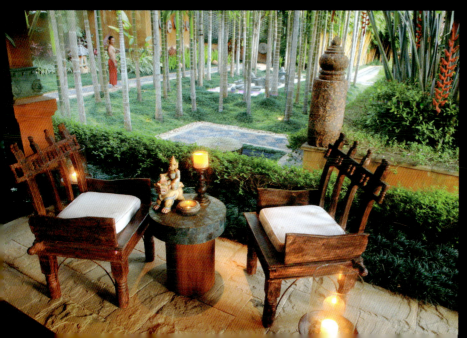

Above Chiang Mai is a wonderful center for crafts. One of our favorite craftsmen makes fanciful shapes and figures in terracotta. Fragile and porous, they rapidly attract moss and free-riding ferns. The four column capitals on the grass in front are carved out of laterite. **Left** The subaxis of the dining pavilion is marked by the same laterite column capital as above. To complement this pair of Indian chairs, purposely made low, I designed a simple table with a copper tile top. **Right** Against the back wall of the peacock powder room, a pair of custom-made patina green candle stands flanks a fabulous peacock wood-carved relief. **Opposite** The blue chopstick bridge spans a public irrigation canal that passed through the estate's gardens. Blue painted wood in lush green gardens is a heavenly combination.

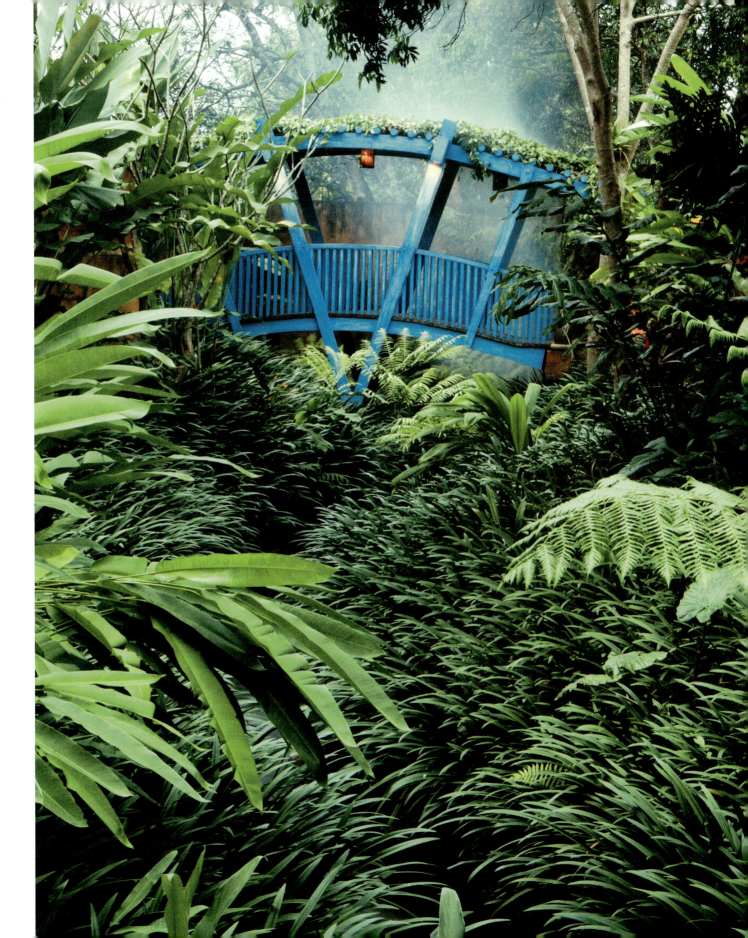

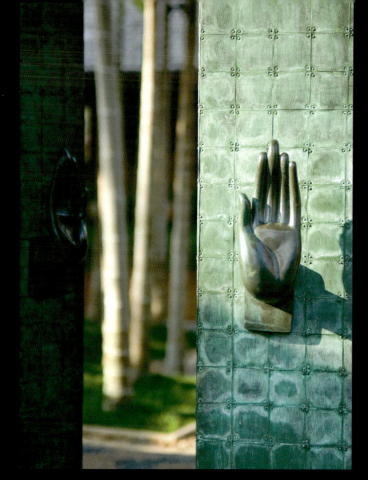

Left The front door of the first garden court is adorned with small squares of copper, a tiling technique I first tried at our own home. The open palms forming the door handles were modeled in our studio in wax before being cast in bronze. **Bottom** The porch of the living pavillion faces west and is the perfect place to see the sun set over the Mae Rim Mountain range. The Thai green sandstone in the pool works beautifully with the green patina of the bronze. **Right** Standing proudly in this man-made pond is the water pavilion, used for informal meals. It is placed exactly on center with the dining pavilion and the pool. Behind it is the living pavilion and beyond, on the left, the guest pavilion, our home in Chiang Mai. In the foreground, an old Thai boat lined with copper makes a unique water feature. **Opposite below left** Throughout the gardens are several follies, this one being the blue bench trellis, while beyond is the gate to the Secret Garden. **Opposite below right** Another folly, a zigzag bridge made of reclaimed railroad sleepers, playfully crosses the pond.

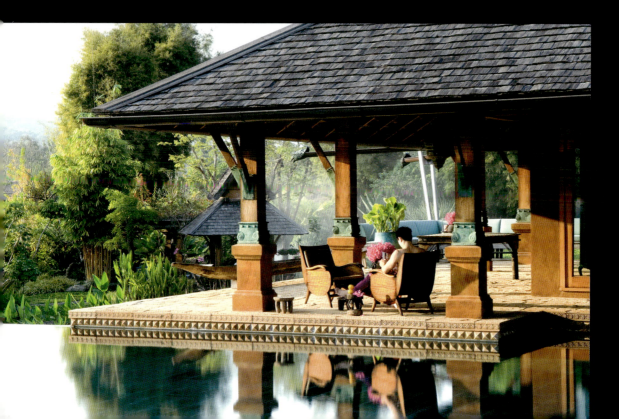

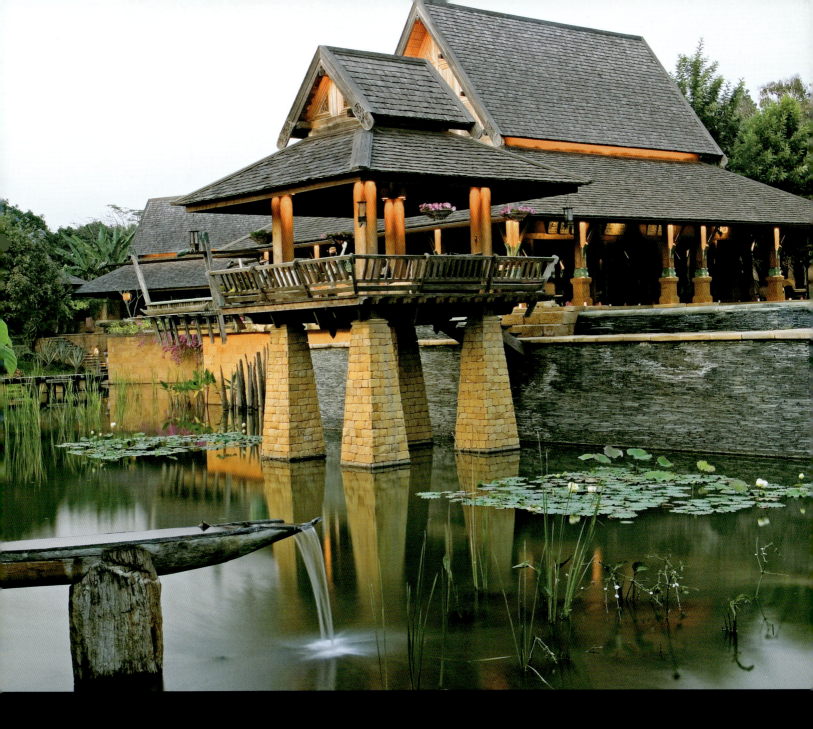
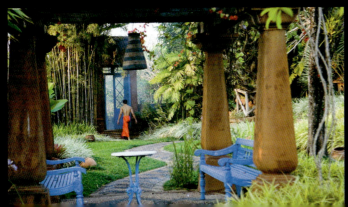
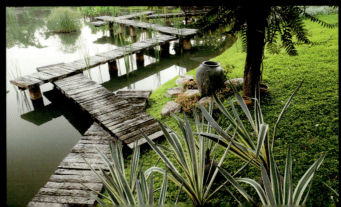

MARRIOTT HUA HIN
TROPICAL SAFARI

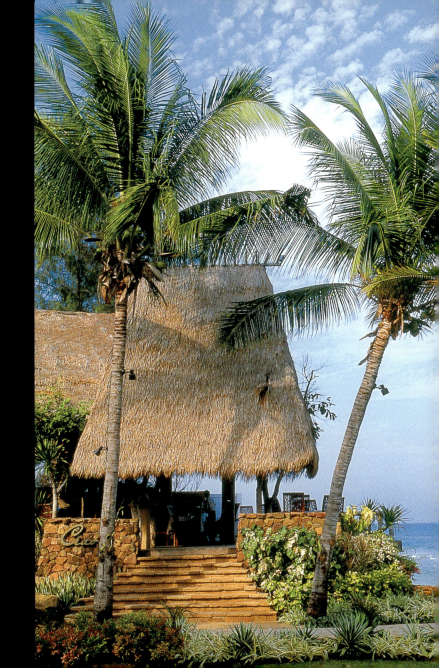

Enveloped in 6 acres (2.5 hectares) of tropical gardens and a man-made lagoon right next to a secluded white-sand beach overlooking Thailand's mystical Gulf of Siam on its western coast, the seven-story Marriott Hua Hin Resort and Spa is a sanctuary of peace and tranquility and a wonderful destination for sports lovers and outdoor adventurers or for those who want simply to relax and pamper themselves. The architecture of the resort combines space, natural light and color with traditional Thai design themes and materials to create a sense of harmony with nature.

We first became involved with the 20-year-old Robert G. Boughy-designed resort, Thailand's oldest, in 1992 when we began an extensive renovation, and this involvement has continued annually. We first reconceived the swimming pool, adding crocodile slides, a swim-up grass-roofed pool bar and some seriously cool pool beds. Then we moved the reception to the porte-cochere, where a giant bamboo swing now hangs. At Ciao, the right-on-the-sand Italian restaurant, we used up lights from under a seemingly floating wooden deck to emphasize the horizontal banding of the adjacent walls. The upshot is a tropical safari look.

Left One of the more recent hallmarks of the Bensley Design Studios is the use of swings. In the new lobby at the Marriott Hua Hin Resort and Spa, we installed a huge swing that can seat some 14 guests; at one count it held nine children, four babies, two grandparents, six dogs and a parakeet! **Right** Ciao Italian restaurant, set right on the beach amidst a "dry" garden, has high triangulated thatched roofs and braced stilts to withstand the strong landward blowing winds.

Below I designed this "Jack and the Beanstalk" lamp to poke out through a small hole in the counter top. The tree bark for the lampshade was purchased in Bali. The two small "leaves" are receptacles for sweet-smelling jasmine flowers, which are replaced daily. **Right top and below** In a small corridor we made a series of tiny "puppet" boxes themed after the Thai festivals. **Opposite above left** A terracotta sculpture from Chainman. **Opposite above right** As with all of our restaurants, the tables settings are unique to the resort and custom-made. **Opposite below** The "dry" garden in front of Ciao is planted with hardy species to withstand the onslaught of wind and salt water.

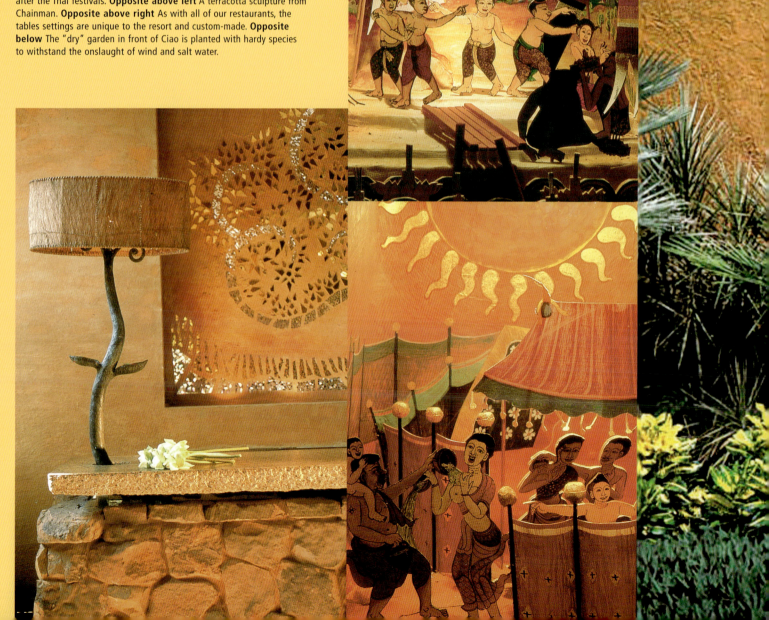

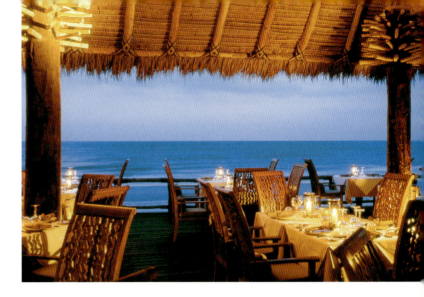

Below This rusty iron Thai lamp, dressed with sensuous plumeria blossoms, is mounted on simple plaster washed with iron sulphate—rust on rust. **Right** The existing trees on the site were used to support this primitive entrance pavilion at Ciao. **Below right** The back wall of Ciao is dramatically up lit. The logo was designed to resemble spaghetti being picked up with a fork. The backs of the chairs are in a "primitive" wash.

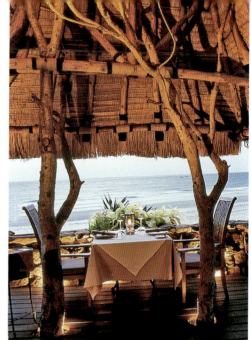

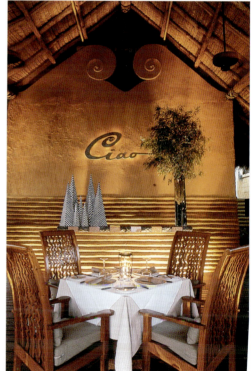

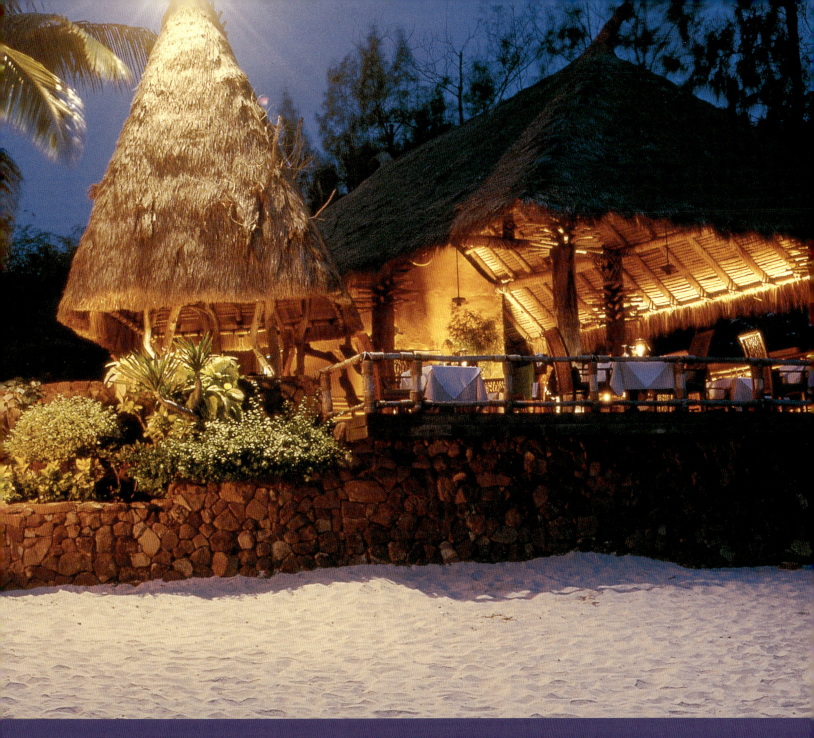

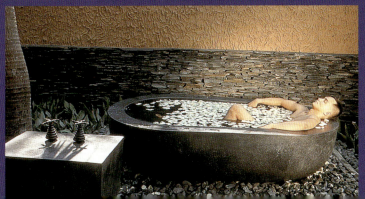

Above Ciao Italian restaurant from the beach at night. The steeply sloping thatched grass roof of the entrance pavilion is silhouetted dramatically against the sky. A rugged wall of natural stones guards against encroaching tides. **Right** This black terrazzo bathtub at the Anantara Spa at the Marriott is the perfect place in which to soak and relax. The garden wall behind, made of stacked black slate and coloured cement "textured" by human fingers when still wet, provides privacy to the serene setting.

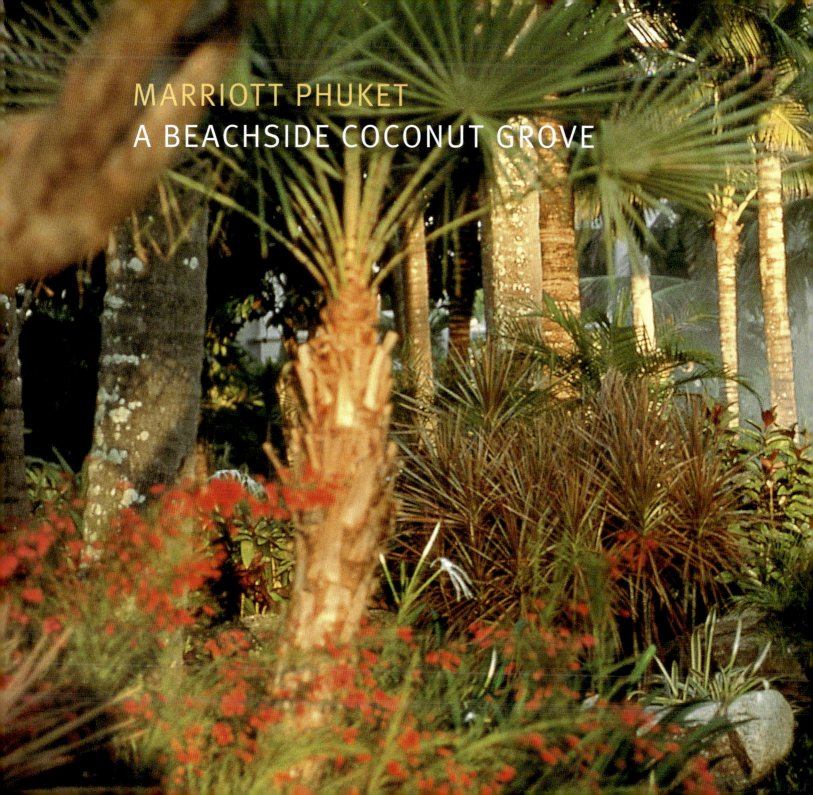
MARRIOTT PHUKET
A BEACHSIDE COCONUT GROVE

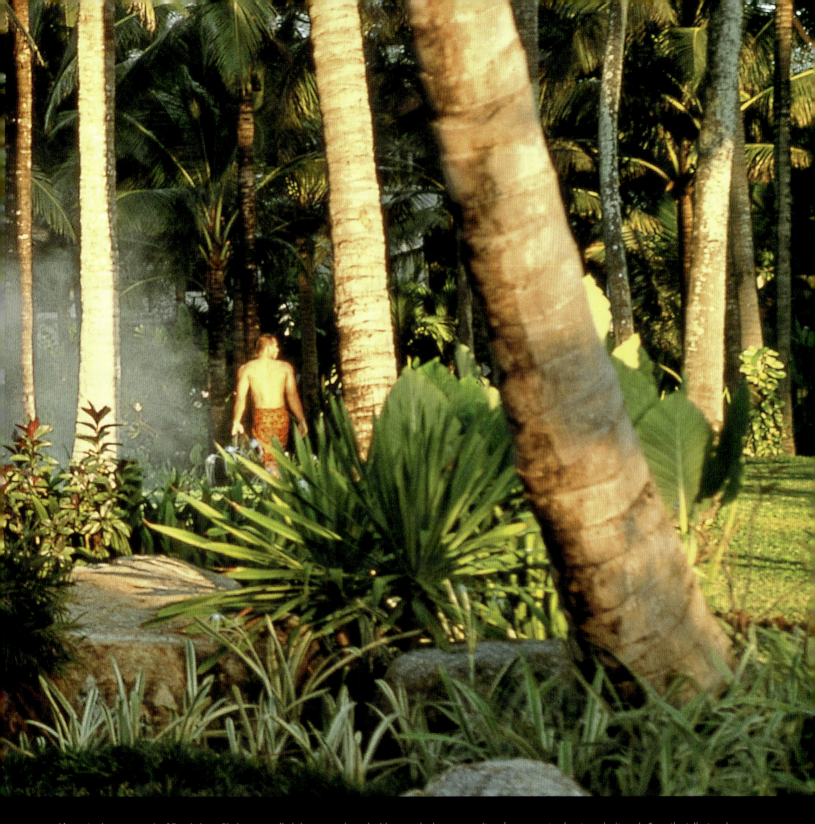

Above In the past, much of Tongkah, as Phuket was called then, was planted with rubber or coconut plantations or seriously ripped up for tin mining. Because of the very strong winds that blow along the west coast of Phuket in the summer, coconuts (*Cocos nucifera*) were found to be the most suitable crop. Our landscaping canvas was thus a site that had been used as a tin mine and then a coconut plantation. Because the blueprint of Plan Architects' building was very large, we had to move quite a few coconut palms to make it work. Even the tallest and oldest palms can be transplanted from their home direct to a new location without laying them down horizontally provided their root ball is more than 6–7 feet (2 meters) in diameter. Coconuts grow about a foot (0.3 meter) per year and have a life span of about 100 years. Unlike most trees, the girth of the trunk never increases, which makes them ideal plants in a landscaping context of this nature.

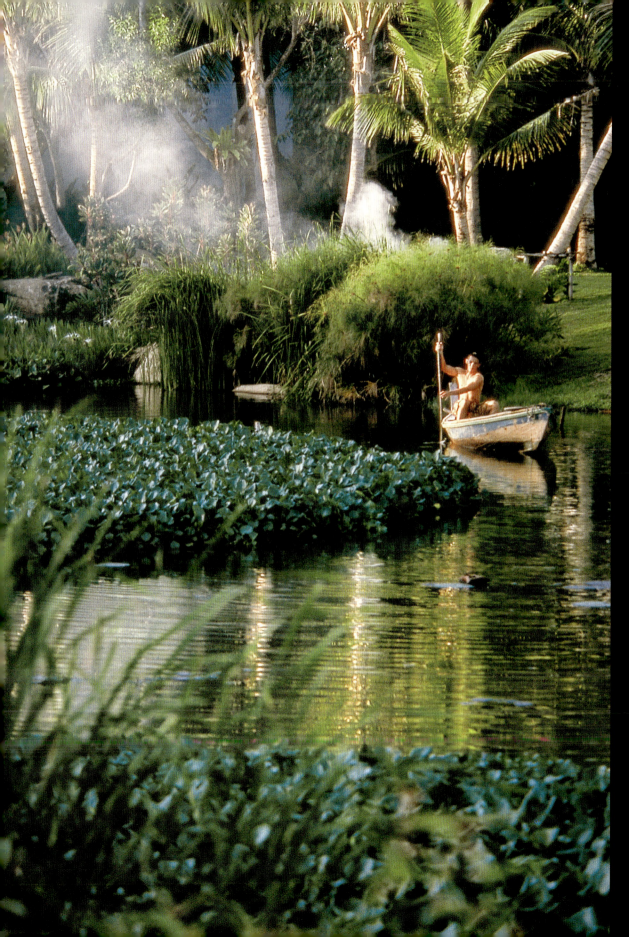

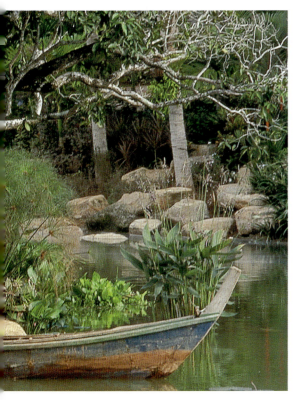
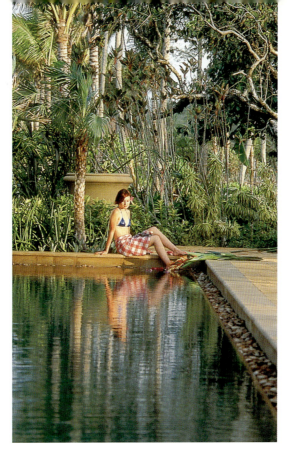

Far left The tin mine excavated generations ago left us with this large lake, which retains rain and flood waters. The Thai government encouraged us to maintain it as a natural estuary and a home for the wildlife in the parklands. **Center left** We built a wooden boardwalk over to the island in the center of the estuary, which was designated by the local Thai monks as the most holy place in the gardens. We also built two temples on the island that receive daily offerings of flowers, incense and small icons. **Left** Emma Lim, daughter of the eminent interior designer H. L. Lim, sits poolside at the private lap pool of the presidential suite with the forested parklands beyond. **Below** Throughout the parklands we have built a series of "natural" streams to connect a network of "natural" ponds.

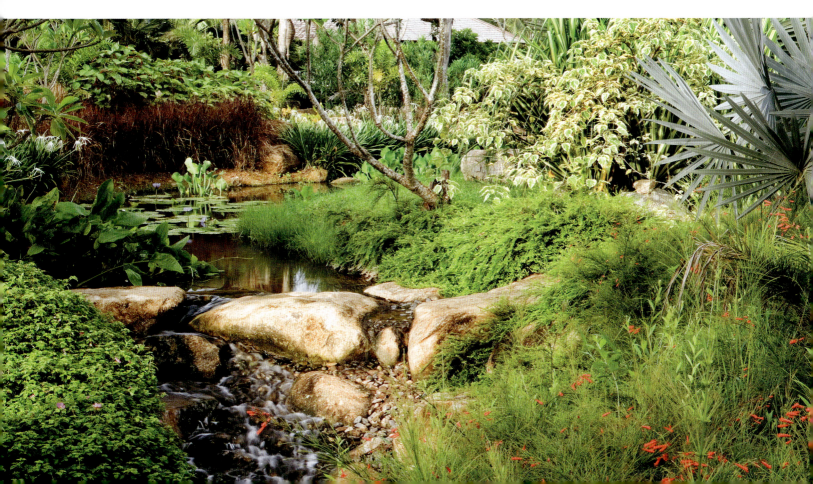

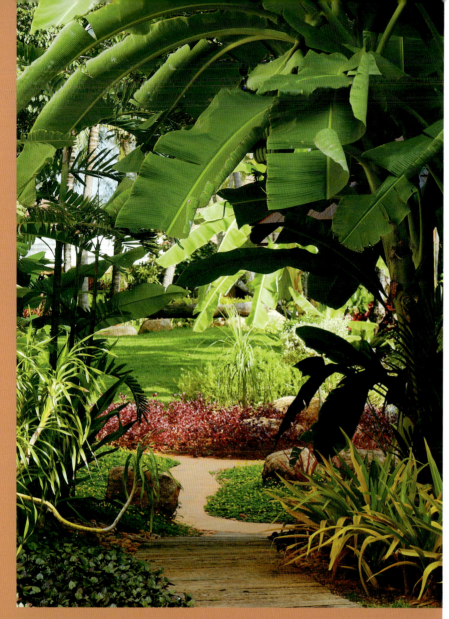

Left We used Thai sandstone for the smallest paths, recycled railroad sleepers for larger paths, and dyed cement with leaf imprints and a pebble border for the most frequented paths. On the right, a huge heliconia creates a tunnel leading to the grassy parklands beyond. To the left is the gorgeous queen orchid (*Grammatophylum speciosum*) which is native to Phuket and its environs. When in bloom, the size of this orchid is rivaled by no other. Red flame ivy (*Hemigraphis alternata*) and yellow crinum are used as ground cover on the left and right of the path. It took me a while to warm up to the idea of using yellow crinum, because to my eye it looked chlorotic and needing manure. Now I group it into the very useful yellow group along with *Pisonia grandis* and *Psdeuranthemums*, where we need some lightness in a shady place. **Below left** Approaching

the temples on the island in the middle of the lake. **Above** This adorable sandstone fish is displayed on the south side of the adult only Black Pool, one of three swimming pools on the property. **Right** Bridging one of the parklands many streams, this pathway leads to the well-concealed hard tennis courts via a torchère-lined canal. I have never come across really nice-looking hard tennis courts. Although we can paint them a variety of greens or terracottas, lay them with plastic grass or plant trees on the perimeter, they remain what they are. In all our resorts I try to have plenty of buffer space to plant the walls of the courts, and we try to minimize the use of wire fencing. We also always use low focus lights that minimize obtrusive glare. The tennis courts of these parklands are our most successful attempt at this philosophy to date.

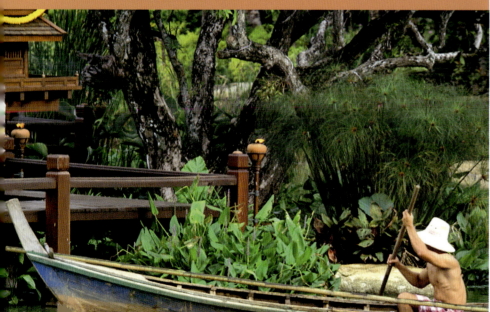

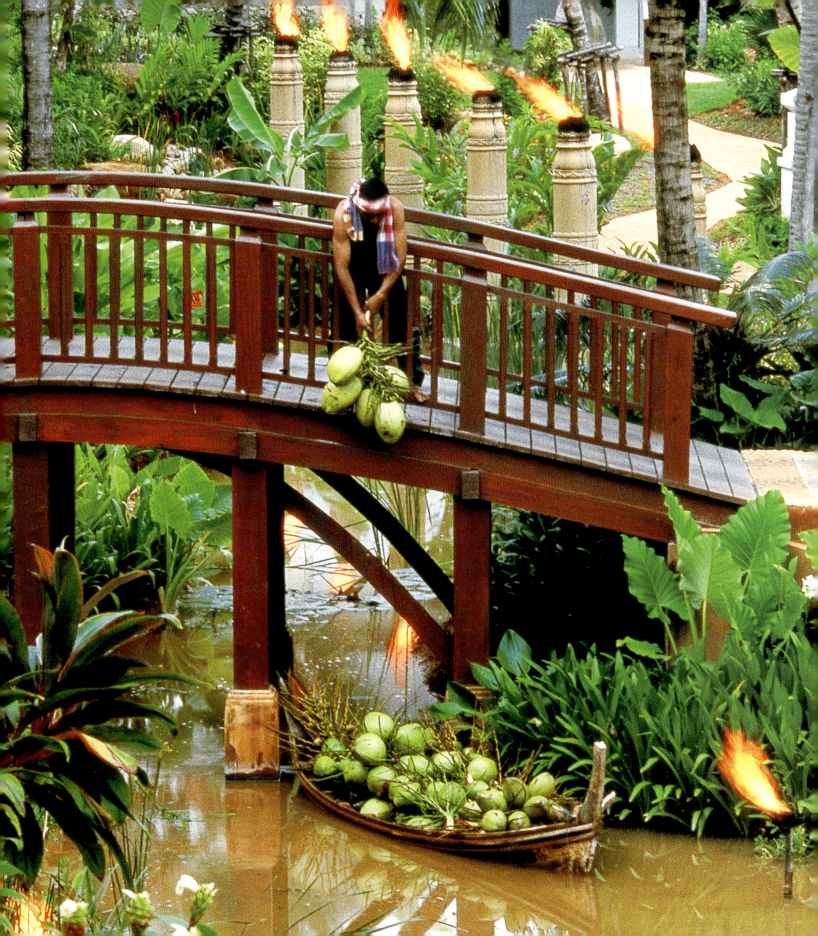

The multi award-winning JW Marriott Phuket Resort and Spa, perhaps the most popular resort in the whole Marriott chain, commands 10 miles (17 km) of Phuket's pristine Mai Khao Beach on Phuket, Thailand's largest island, located in the Andaman Sea off southern Thailand. The resort is set amongst 27 acres (11 hectares) of beachside parklands, complete with lily ponds and areas of natural preserved coastal wetlands, blending perfectly with the local environment. The low, sweeping design of the resort, with its ornate roofing, invoking a somewhat imperial ambience, was the brainchild of Plan Architects. Design firm Abacus took care of the interiors while Bensley Design Studios was responsible for the site planning and all landscape architectural elements, including the seafood market and all the pools and ponds and their ancillary buildings. Since the opening in 2002, we have also reworked the lobby, adding perhaps Phuket's longest sculpture behind the reception desk. Formed of hundreds of teak wood pieces of positive mold parts of steam engines, used when engine parts were made by the sand-cast system, it is a striking addition to the entrance.

Bordering the extensive beachfront we designed three very different pools. The main pool, right in front of the lobby, is some 394 feet (120 meters) long and appeals mostly to families on the north side and to serious swimmers on the south. The Black Pool in the north is for the use of adults only and is quiet and secluded, while the newest pool on the far south end of the resort, with its cool Blue Bar and Splash, appeals to young adults. We also designed the cooking school as an overflow for Ginja, the boutique Thai restaurant, the resort's most frequented eatery.

One of the biggest landscaping challenges was finding the right plants to resist and survive the fury of the strong, salt-laden winds blowing off the ocean, especially along the "front line." It was also necessary to locate the parklands well back from the beach so as not to disturb the sea turtles which come to the beach annually to lay their eggs. As we had also inherited a site that had been scarred by a tin mine and later planted with coconuts, much thought had to go in to how best to capitalize on these features. Happily, the result is a vast tropical landscaped paradise.

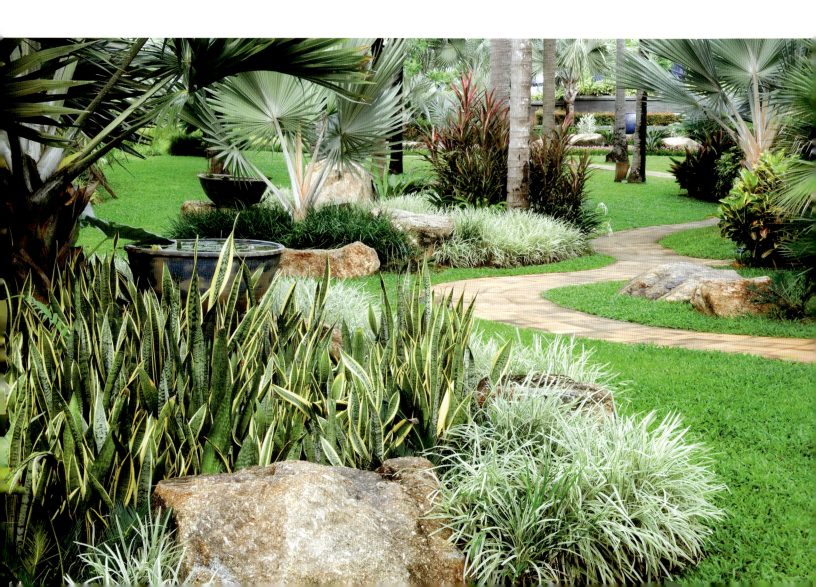

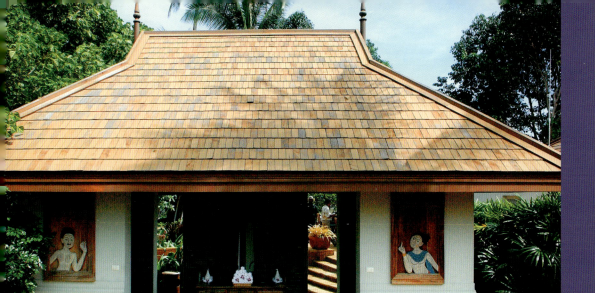
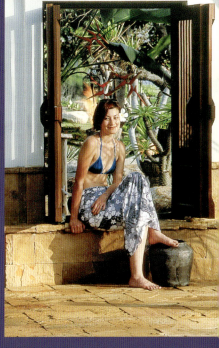
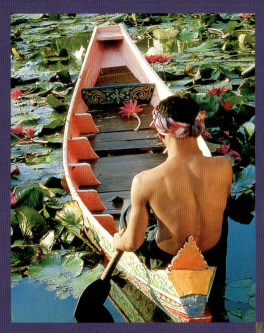

Above Designed after a southern style Thai house, these poolside toilets are animated by classic "girl/boy" figures in wooden windows. **Above right** At the two-bedroom presidential suite, this window and the adjacent door can be locked if one of the bedroom pavilions is used or sold to another party. **Left and right** Crimson, pink and purple water lilies (*Nymphaea* sp.) grow profusely in the parklands estuary, which is slowly fed with well-treated gray water from the resort. **Below** On axis with the main lobby on the ground level is a fire-on-water court-yard. Set in a large, still black pond are 16 beige sandstone *chedi* and 16 bronze lilies charged with fire.

Left A large component of the resort comprises timeshare accommodation. This is the newly planted parkland of the second phase of the timeshare built just three years after opening. A third phase is in progress.

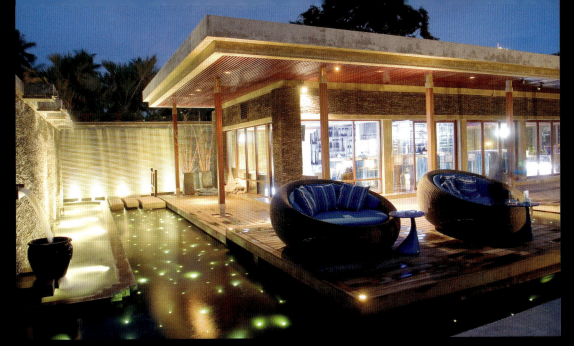

Opposite The cathedral-like ceiling of the beachfront seafood restaurant is dramatically lit with huge woven brass lanterns fashioned after fishing baskets. At the base of each of the columns is a broken white painted stand with brass boats filled with sprouting coconuts. **Left** The beachside Blue Bar and Splash is the coolest place to chill with the best of today's music. **Below** A white Thai arch supporting a bell marks the south or deep end of the 394 foot (120 meter) long main swimming pool. The ledges on the right between the crouching elephants are pool beds for "pool potatoes."

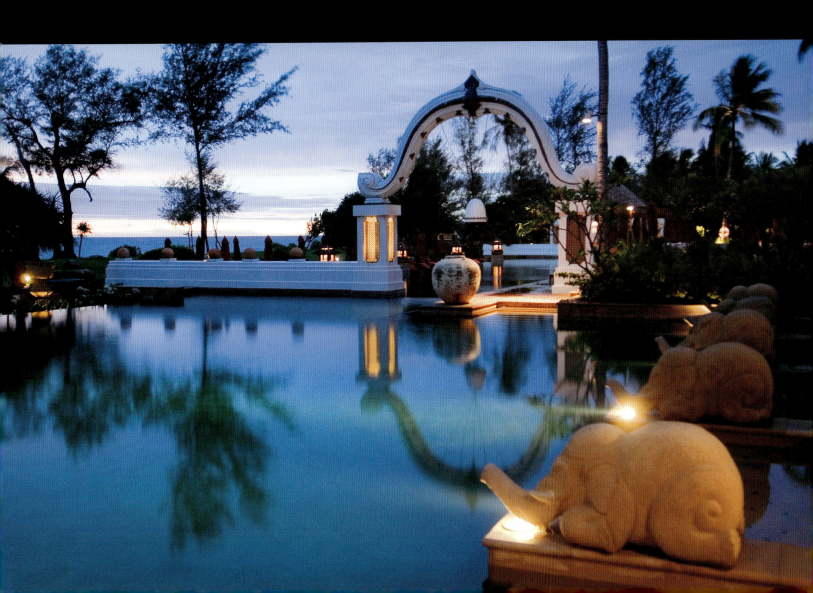

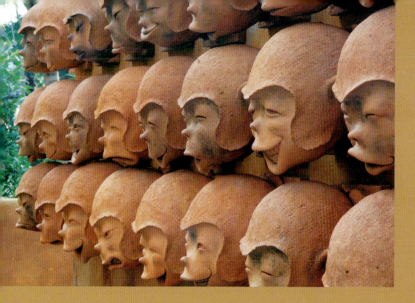

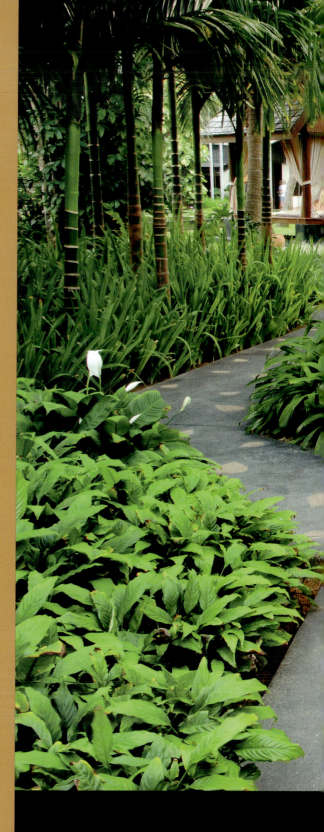

ANANTARA KOH SAMUI
SERIOUS MONKEY BUSINESS

In ancient Sanskrit, Anantara means "borderless water" – like an endless stream. In many Asian cultures, water is associated with wealth and good fortune. Our vision for the Anantara Resort and Spa Koh Samui—as with the other resorts and spas in the Anantara stable—was to achieve a sense of exotic timelessness, but in a uniquely Thai way.

Nestled in a north-facing bowl of well-established coconut plantation and primary forest in Fisherman's Cove at Bo Phut Beach on the northwest side of Samui island, the resort comprises 60 bungalows and ten larger residences, all made from wooden shingles. When Bill Heinecke bought the property it had been in the Thai courts for a long time. It was vermin-infested and smelled of mildew. I thought it was a hopeless case, but Bill encouraged us to try, and asked us to reinvent the architecture, build a new spa, and replant the landscape, while the design firm P49 would be responsible for the interiors of the main hotel. The run-down skeleton clearly needed a serious three-step facelift.

The first step was to maximize the outdoor private garden space as this usually attracts extra revenue. The second step was to create one major icon or focal point—this we did by building the Full Moon restaurant. The third step was to bring in Mandara to run a spa to enhance the image of the resort.

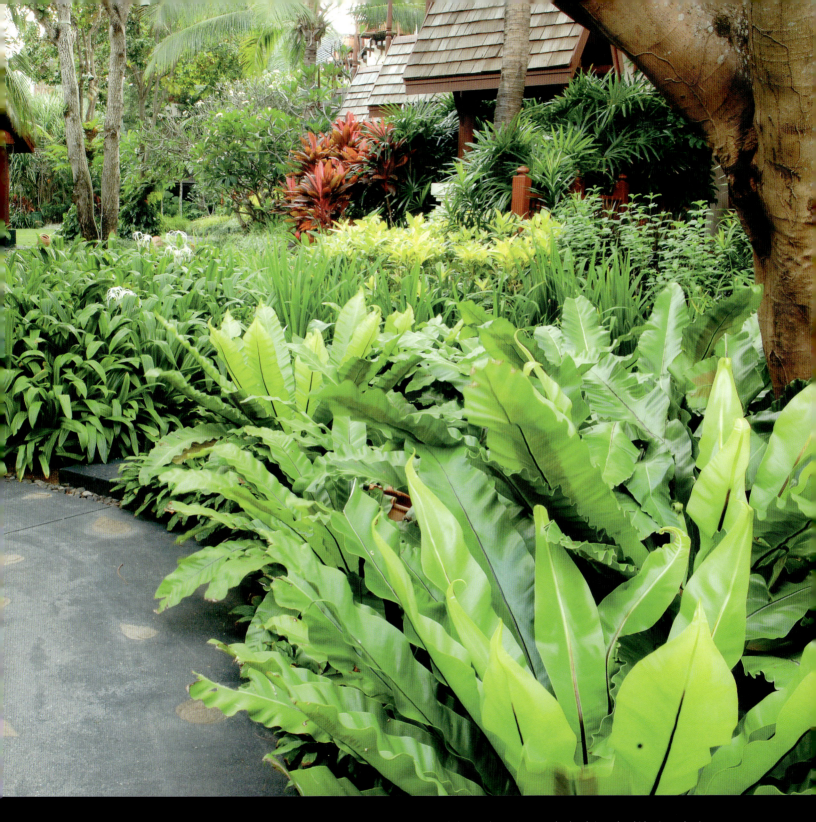

Above left Many years ago, before the bevy of over-zealous property developers struck the quietly farmed coconut plantations of Koh Samui, farmers here used well-trained monkeys to harvest the coconut crop. Harnessed monkeys would scamper up the tall trunks and twist and twist the coconuts until they fell to the ground. Now, only a handful of monkeys perform their trade of old for tourists. Nevertheless, and most importantly, they bring a local identity and unique story to this island retreat. **Above** The hotel is set out as one U-shaped plan with all rooms looking to this garden courtyard and the sea beyond. In the foreground, bird nest ferns (*Asplenium nidus*) and other leafy species, their growth enhanced by the frequent rains, form an attractive cover of variegated greens and yellows.

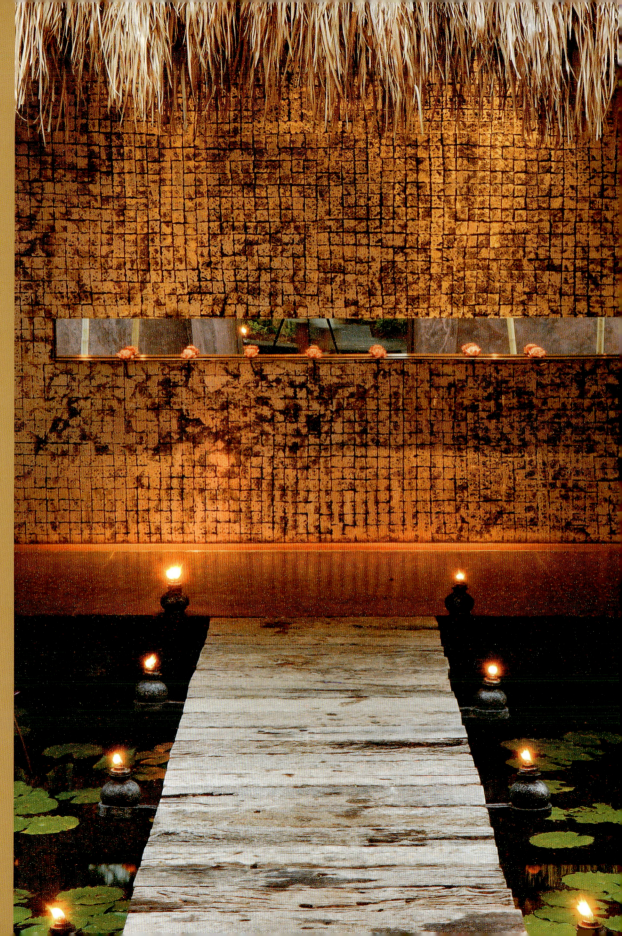

Right Guests enter the Mandara Spa across a single-lane walkway flanked by cast pewter lanterns and through a huge Thai-style gate with an untrimmed grass thatched roof. At the end of the walkway, a silver-leafed wall supports a dozen folded lotus flowers on a shelf. **Opposite above** The Full Moon restaurant, named after the wild rave beach parties for which this island is famous, is noted for its elegant cantilevered roof. **Opposite below** At the main road we created a dramatic water garden bisected by a one-way wooden pier. Guests arriving by car are directed by guards at each end to alight and, one at a time, cross the bridge and pass under the Thai-style rice barn to the hotel lobby perched on a hill overlooking the beach.

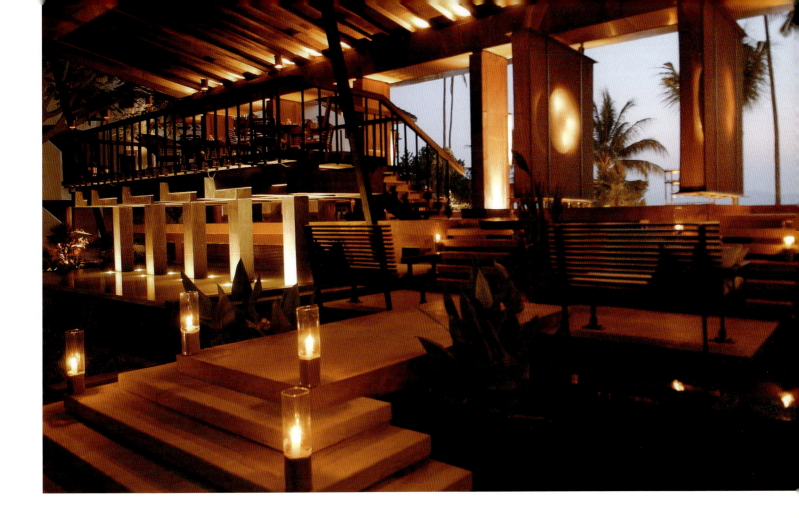

The Mandara Spa sports a rich color palette of wet charcoal and aborigine pigmented and polished cement walls. Its modern grass roof lobby pavilion floats in a water courtyard of *Thalia dealbata*, water lilies and Thai torches which sparkle at night. Minimalist sofas cantilever over the pond. A small collection of modern art and ceramics adorns the walls of the salon, which sits in its own courtyard under a butterfly roof supported by a single column. A long pathway leading to the treatment rooms, fitted with soaking tubs and outdoor showers, terminates in a thatched roof pavilion dedicated to yoga. The spa at Koh Samui has benefited from the design developments at other properties, and the high, lotus purple walls and chic installations and fittings create a unique, modern yet still inherently Asian spa feel.

The signature restaurant, Full Moon, has one of the best wine cellars in Koh Samui and one of the best sommeliers in Thailand. The butterfly roof is clad with copper, and in the first year of operations turned from shiny orange to tarnished dark orange to purple; parts of it are now turning a lovely green. The restaurant's airy roof still allows views of the horizon from the lobby some 260 feet (80 meters) inland. It is three stories high on the edge of the beach pool, with the swim-up pool bar, wine cellar, kitchen and rest rooms on the ground floor. Above is the main floor and mezzanine, designed so that all guests have a great view of the sea.

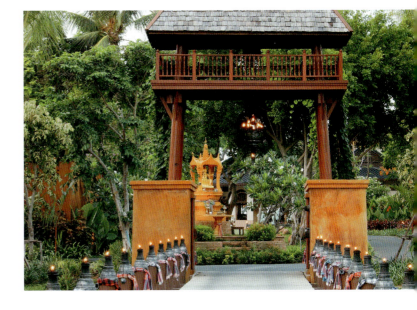

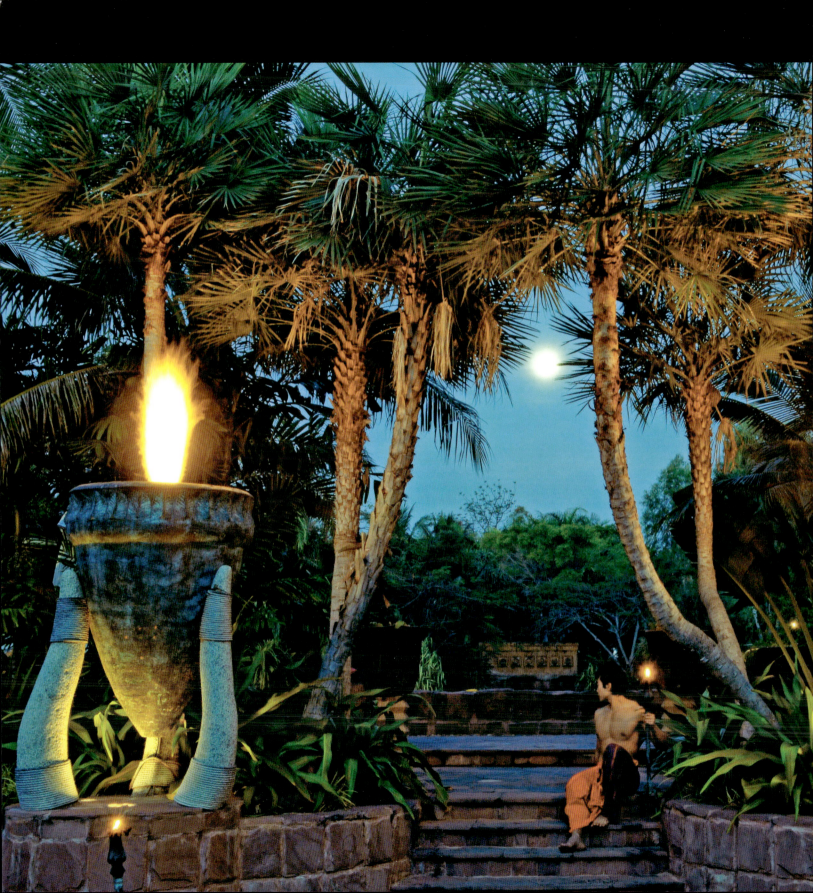

ANANTARA HUA HIN
ON THE WATER'S EDGE

This uniquely Thai village-style boutique resort, one of the most romantic and luxurious hideaways in Southeast Asia, nestles on the beach at the sunrise side of the Gulf of Siam. It holds a special meaning for me because it is where I "cut my teeth" – not literally in the Balinese sense of the expression of holding a tooth-filing ceremony for a boy reaching puberty in order to leave the animal-like qualities of youth behind and to celebrate the attainment of adulthood, but, rather, when Bill Heinecke, our client and later great friend, allowed us – "the gardeners" – to design hotel room interiors, a restaurant, and the lobby for the very first time.

Over the years, we have used Anantara Hua Hin to experiment, and in doing so I developed a taste for designing interiors. My first project was to redecorate the lobby of the resort. Nothing was to be built in. Instead, I was going to design and purchase a whole new set of furniture. The general manager at the time agreed to let us take out the old furniture after midnight and we had until six the next morning to put the lobby back together again. Sitting in the parking lot were three trucks full of some very nice furniture we had made by reworking some older pieces. Among them were two extravagantly oversized couches composed of four Burmese beds created by talented stage designer Richard Dixon in Chiang Mai. But, as the wee hours of the morning approached, I started to feel panicky. The furniture just didn't look right. It seemed to be floating around the space. Fortuitously, a new base for my king-size bed in Bangkok had been mistakenly sent along with the rest of the furniture to Hua Hin. At 3.00 a.m. I called for the bed to be sent over to the lobby. It fitted perfectly and anchored the whole scheme as the central coffee table!

Left The entrance to the oval-shaped Lagoon Pool is flanked by two giant bronze torchères supported by white Thai granite elephant tusks, and gently curving wax palms (*Copernicia prunifera*).
Above right A Thai *kanok* flame pattern in bronze forms the handle for the entertainment armoire in the first hotel room interior we designed. **Right** A collection of old paddles stands against an up-lit wall in our Baan Thalia restaurant.
Far right A blue Japanese glass panel, one of a series, on the courtyard wall at the front entrance.

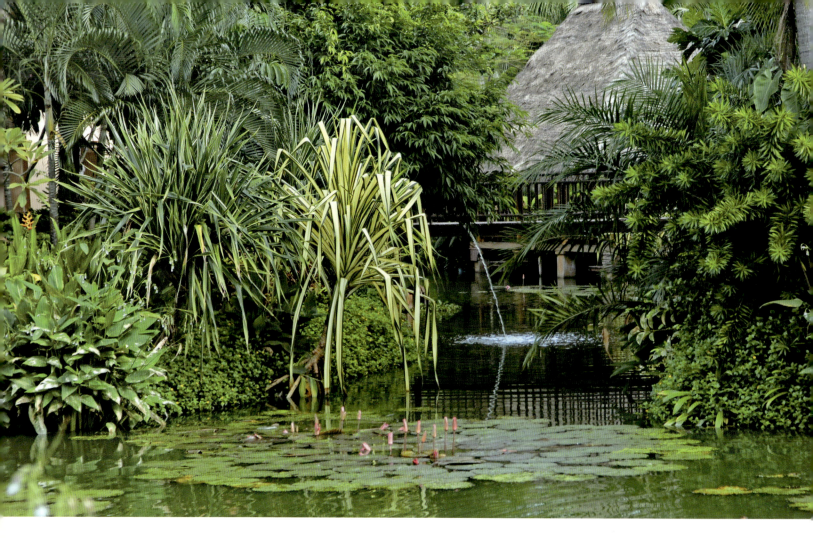

I then badgered Bill Heinecke to let us redo the Italian restaurant, which we renamed Baan Thalia, and the three-meal restaurant, Issara Café. At both outlets we experimented with the table settings, menus and uniforms. It was all great fun.

Following this, Bill hired Lek Bunnag to design the Lagoon Wing, a complex of 38 luxurious rooms and suites, and the adjacent Mandara Spa (see pages 202–7), which share a secluded infinity-edge pool. Lek was gracious enough to let us decorate his wonderful rooms with sliding glass doors to connect the bath to the rest of the room. It was also the first time that he used the idea of the overhanging bench to extend the space of a room, a design feature that we have employed quite a few times since.

From the beginning of our initial redevelopment, guests have been invariably entranced by the sheer beauty of our gardens, intertwined as they are with lily-filled lagoons—overlooked by Lagoon Rooms with full-length sliding widows and huge terraces featuring ultra-comfy built-in loungers—meandering paths, sculptures, water features and carefully placed lighting. Yet, we have never really completed this resort. Pong, Jirachai and I have been improving these gardens since 1990, pot by pot, plant by plant.

Above The lush tropical landscaping at the resort is inspired by the classic elements of traditional Thai landscape. **Below** Just outside the library is a relief built up from the plaster painted wall. **Bottom** The front entrance courtyard is designed to have the feel of an old-style elephant corral. Placed high on top of the entrance gate is this pachyderm carved from one piece of sandstone, its howdah a working torchère. **Right** The two-story Lagoon Rooms form a backdrop to the oval Lagoon Pool. A gentle gradation of the pool's infinity edge gives it a natural flow into the lagoon, so that the pool merges quietly into the environment. Center right are the tall gateways leading into the spa area.

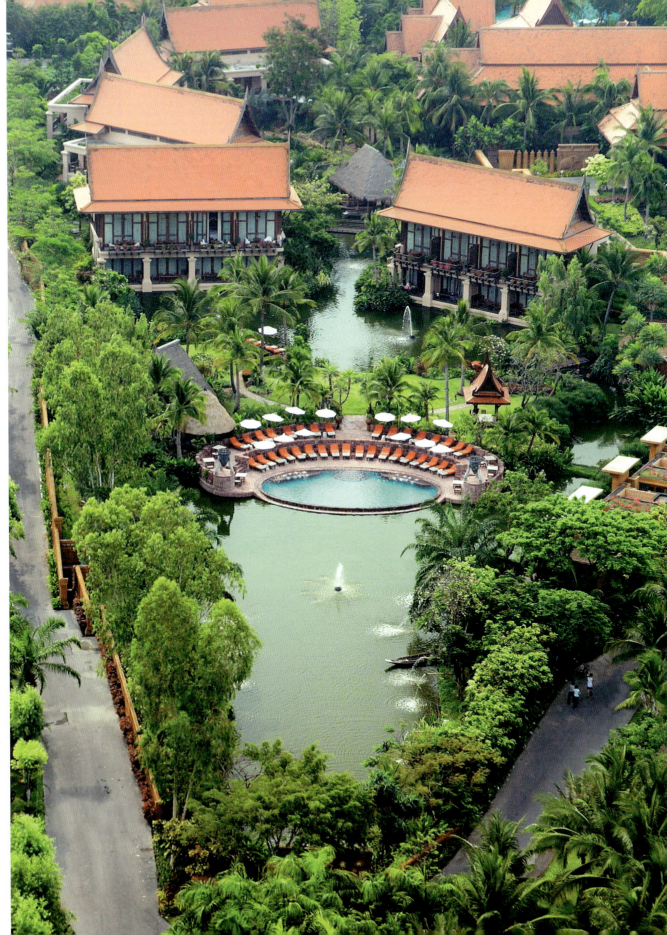

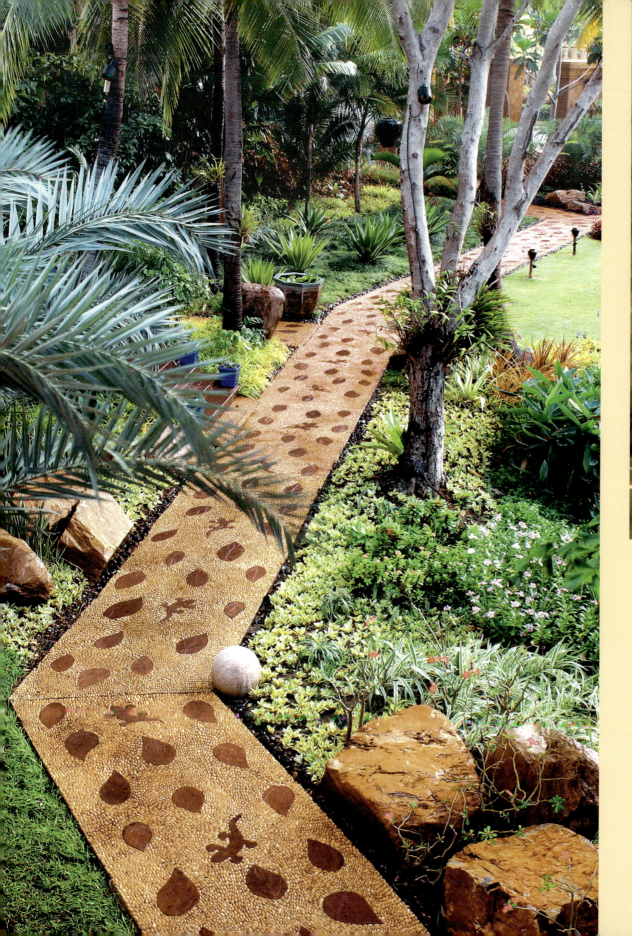

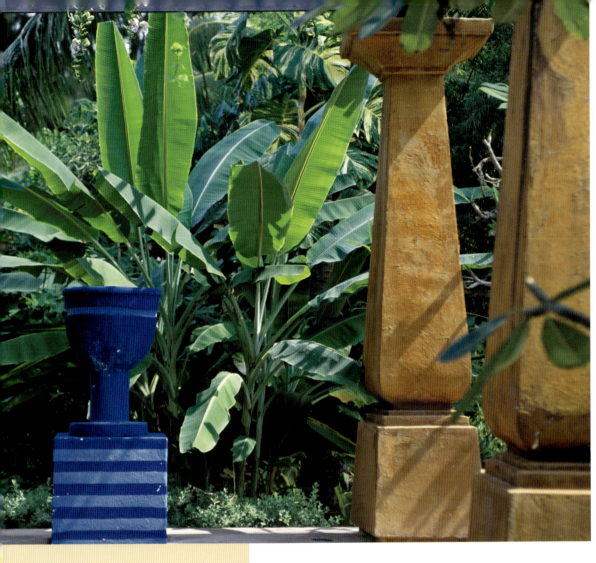

Far left This unusual pathway is made from a combination of orange pebbles laid on their sides and sandstone leaves and geckos, all set in cement. **Left** A trellised loggia links the hotel entrance to a side driveway for guests arriving by coach. The blue striped pots were inspired by a visit to the Jardin Majorelle at Marrakesh in south-western Morocco. **Below left** The colorful tropical blooms floating in this extra large *urli*, a traditional South Indian bronze temple cooking vessel which we purchased in Cochin, are changed daily. Beyond, to the right, we hung a series of blue square ceramic pots on the wall, in which we planted Vietnamese dragon fruit (*Hylocereus undatus*). These have not yet borne their hot pink fruit, but when they do, it should be quite a sight. **Below** Whitewashed birdcages—*sans* birds—add contrast to the carved wooden posts in this dining retreat located just off the Italian retaurant Baan Thalia. The pergola is shaded with the gorgeous creeper *Thunbergia grandiflora*.

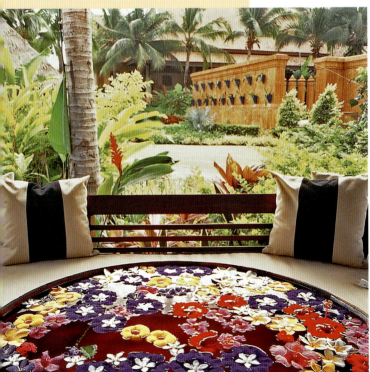

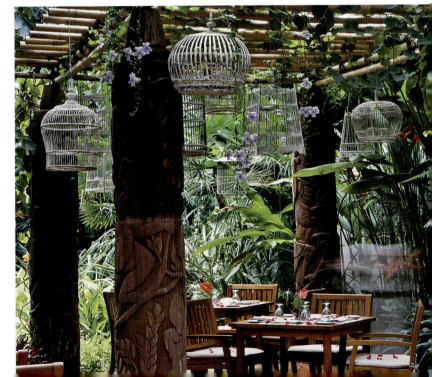

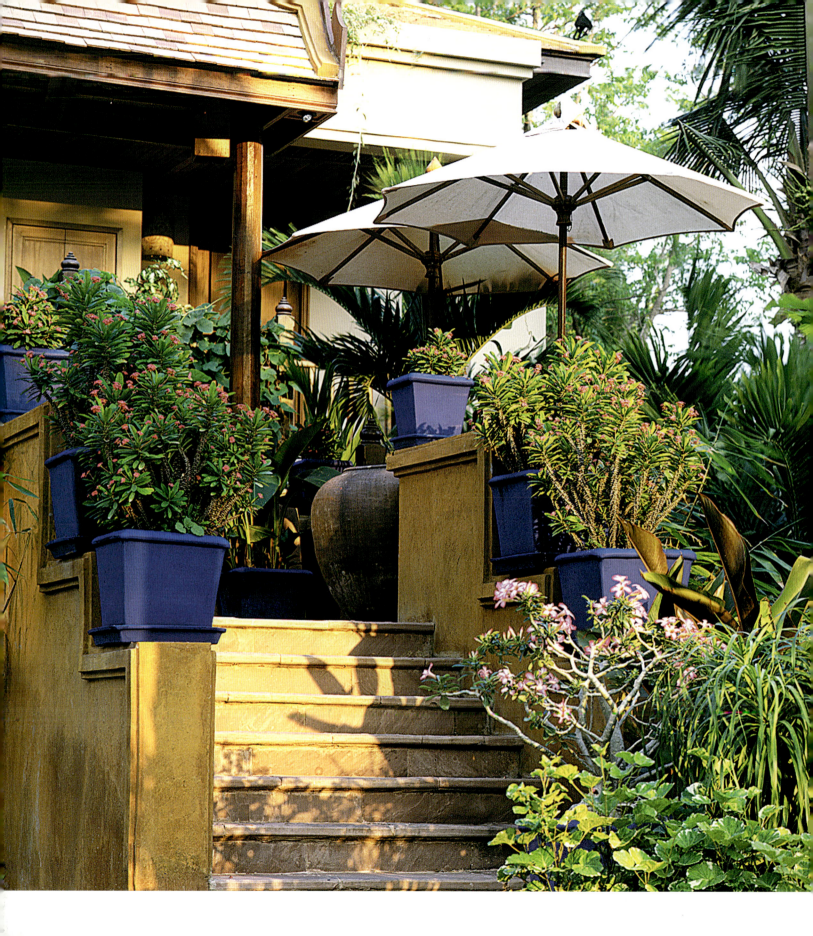

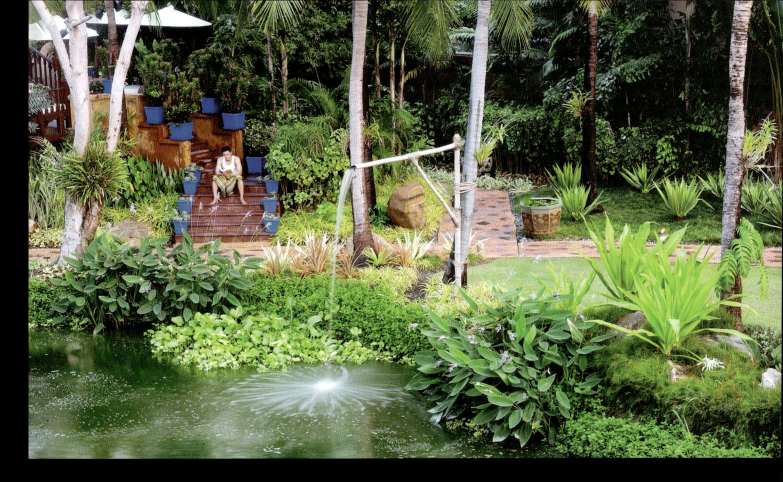

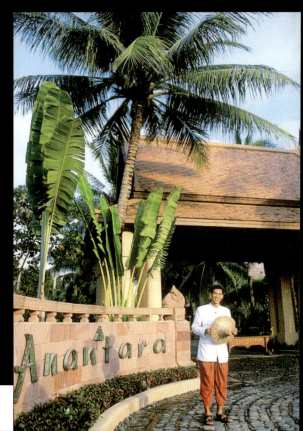

Left A profusion of plants in blue pots, canvas-covered umbrellas and wooden benches adorn the steps leading to the first floor of the Lagoon Rooms. The maids' service rooms are tucked out of sight below the steps. **Above** The lower portion of the same stairway leading down to the lagoon, accentuated by the bright blue flowerpots. We reticulate water into the pond from some 6 feet (2 meters) in order to oxygenate the waters and keep the plants and fish healthy. Here, the water is falling into a patch of water hyacinth (*Eichhornia crassipes*). To the right is my favorite water canna, with a small purple flower, *Thalia dealbata*. **Right** A blue painted terracotta pot displaying the succulent *Sedum weinbergii* and the small screwpine *Pandanus pygmaeus* behind. **Far right** An animated Doan greets guests in front of our eye-catching entrance sign and gateway pavilion. We deliberately used 8 inch (20 cm) river stones on the driveway to make drivers slow down after speeding along the four-lane highway connecting Bangkok and Hua Hin that passes in front of the hotel.

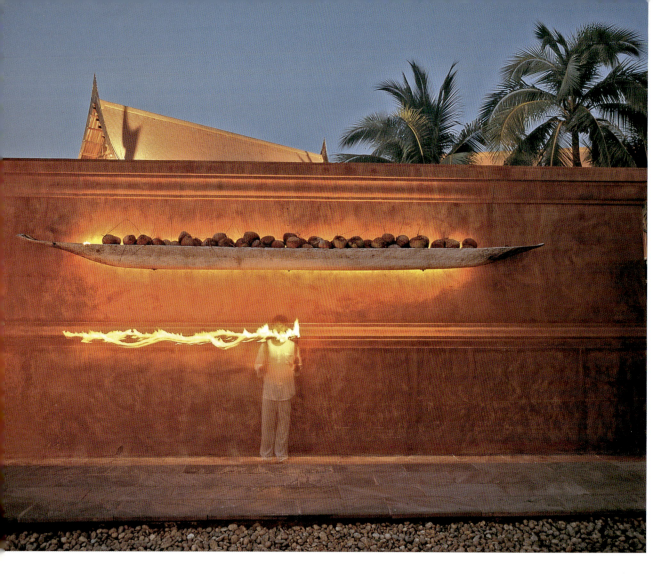

We are in the unique position of being able to undergo almost any improvements here that we like—as long as they are uniquely Thai—thanks to owner Bill Heinecke. This does not mean I have not made blunders. One year, after an assignment for the Hyatt Regency in Istanbul, I returned to Thailand enamored with the art and history of ancient Turkey. Wanting to inject something Turkish into the Thai, I ordered Thai stonemasons to carve a huge Turkish head in red sandstone for Anantara. Needless to say, Bill was not impressed, arguing that it had nothing to do with anything Thai. He was quite right, and now my silly idea of a head sits in the resort's gardens, camouflaged by a plethora of plant life.

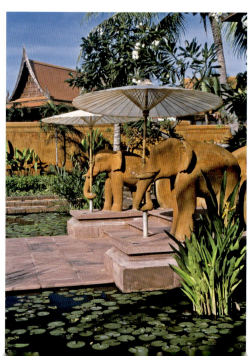

Above This long, shallow boat, carved from one piece of wood, is typically used in this southern region of Thailand. We filled the boat with coconuts and back lit it. **Right** On the main axis with the lobby, two carved cement elephants playfully holding Chiang Mai paper umbrellas flank a small stage that sits in the lily pond. In the background is the central Thai-style roof of the Lagoon Wing. **Opposite** Up lighting this simple carved cement wall achieves a dramatic effect, especially when someone walks in front of it carrying a kerosene torch.

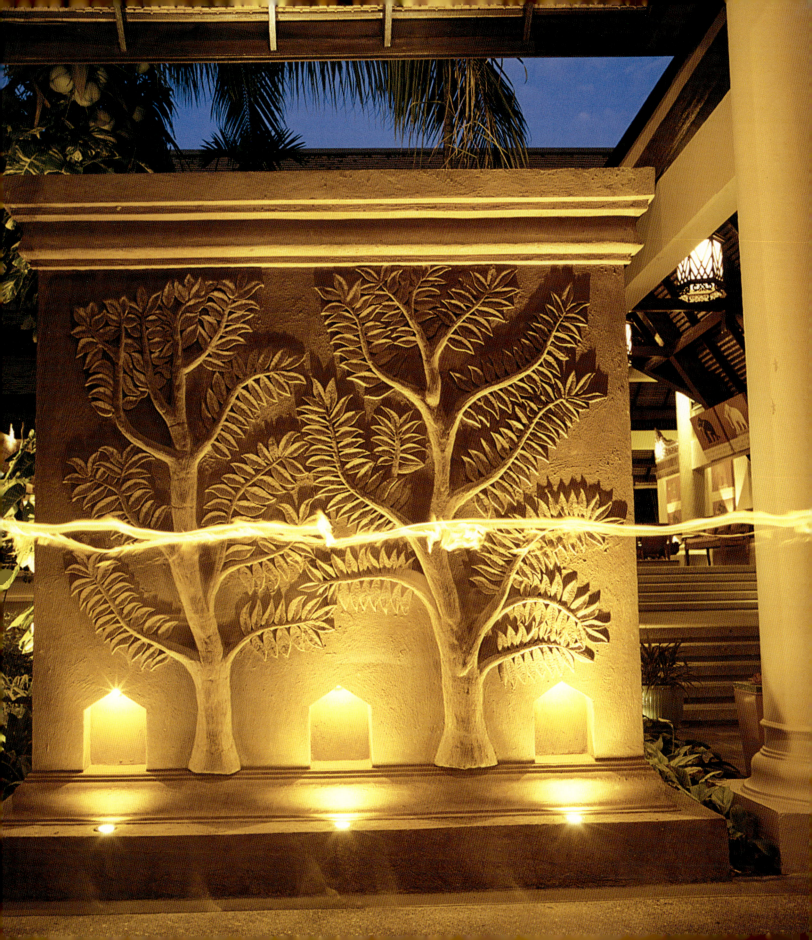

ANANTARA SPA BY MANDARA HUA HIN
TESTING THE WATERS

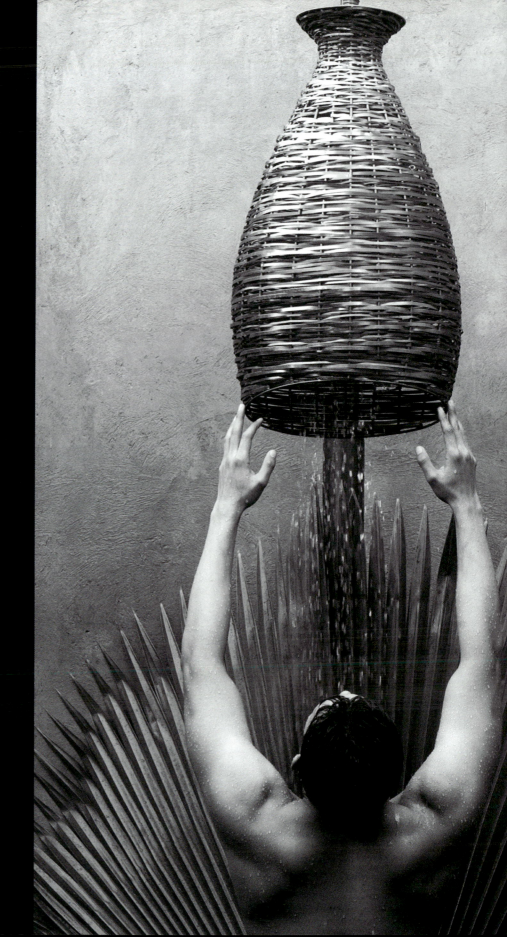

Way back when spas were still a new idea on the resort scene, the Mandara Spa at Anantara Hua Hin was a pioneer. Not knowing if spas were going to be just a fad, my client Bill Heinecke cautiously moved forward, approved the expenditure, and challenged us to create a first-class contemporary but uniquely Thai spa in a rather restrictive space—the least desirable sliver of land between the entrance road and the water gardens—on a very limited budget. But by employing the language of a Thai village—gateway, wall, narrow alley, irrigation canal, low roof, high roof, lake, etc. we managed to create a surprisingly dramatic experience. Sometimes restraints are good!

The spa wing, reached along a narrow wooden boardwalk above the vast water lily pond at the edge of a fortress-like orange wall punctuated by imposing doors, features eight treatment rooms and a beauty salon. Five of the rooms lead out to their own private tropical garden, open to the sky, with a massage pavilion, terrazzo plunge pool and outdoor shower.

Right The suspended showerheads, made of woven and burnished stainless steel by John Underwood, were inspired by Thai fish traps. I propped a leaf of the Fiji fan palm (*Pritchardia pacifica*) against the wall to add more texture.
Opposite The dramatic background to this plunge pool is nothing more than carved cement accented by a sheet of patina green copper cut into the shape of a Thai vessel.

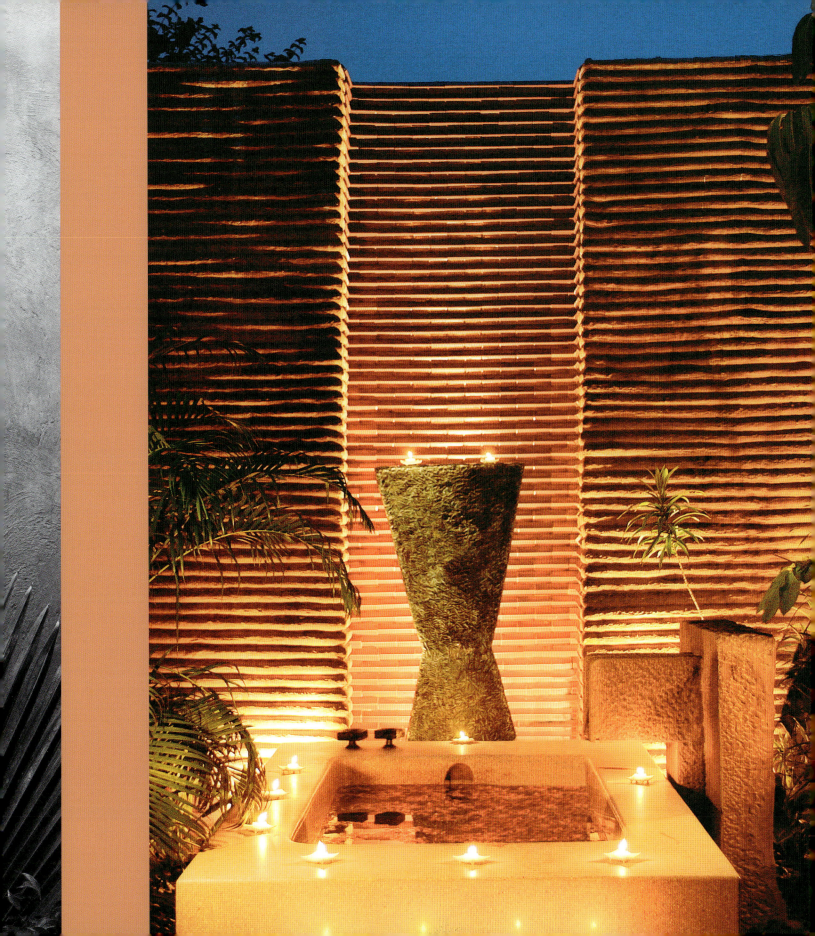

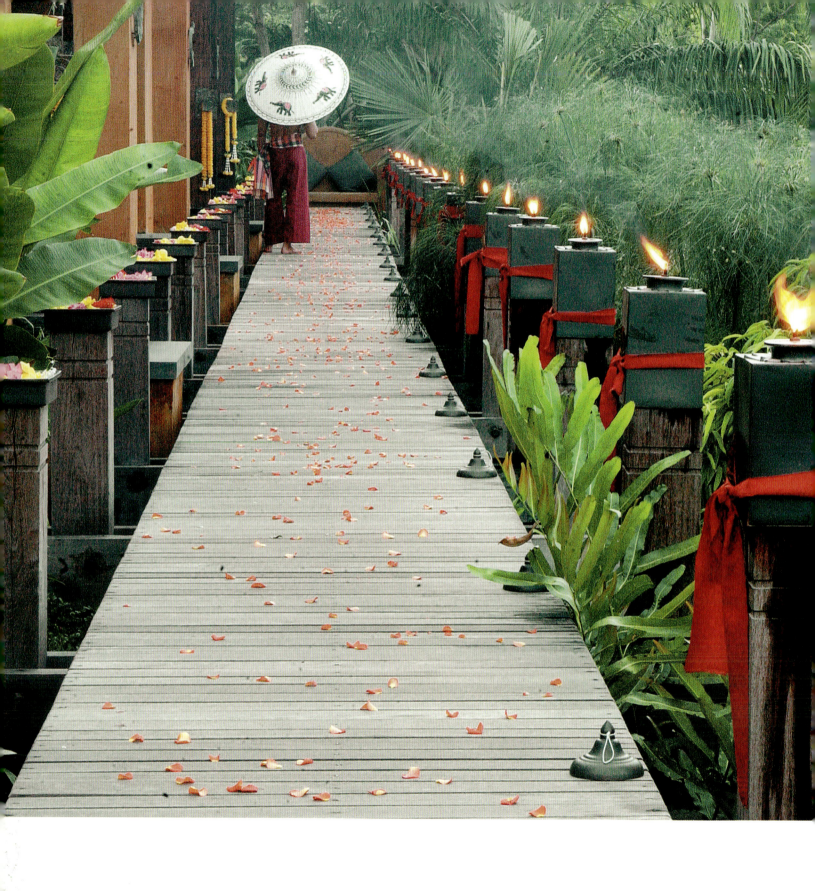

Left This long, narrow boardwalk—reminiscent of the walkways along waterways in the Thai countryside—leads to five of the treatment rooms. The boardwalk is flanked by custom-made ceramic torchères in charcoal gray and flower bowls, and terminates in a comfortable couch. On the right is the main body of the lagoon planted with Egyptian papyrus (*Cyperus papyrus*). **Below** Guests must cross a small bridge to get to a tiny Thai pavilion-style washroom with a shared vanity.

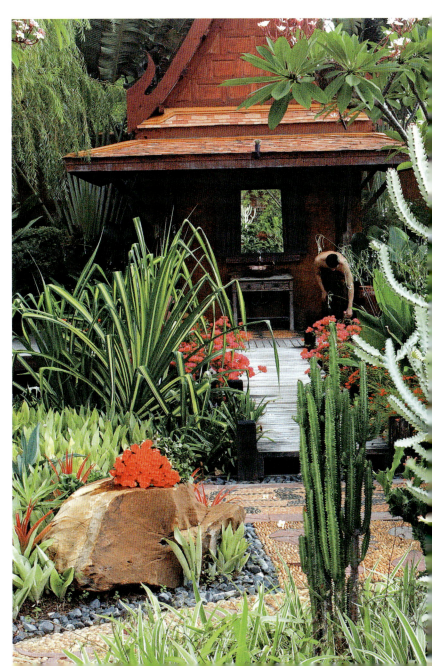

Above left to right We made our own cement tiles for a wall in one of the treatment rooms. A copper cut-out in a Thai shape is placed against a carved cement niche behind a tub. This simple washbasin is made from polished cement. In the past, it was very popular to chew betel quids to get a buzz. This copper cut-out, hung from a stacked slate wall in an outdoor shower, is a two-dimensional interpretation of a Thai betel nut ingredient box. **Below** The Thai number four, used as identification on the fourth treatment room, was made, along with the numbers for other rooms, in our Bangkok studio. **Below right** An elegantly turned Thai marble basin is coupled with a faucet bearing modified handles plated with copper. Colorful *Pandanus pygmaeous* is planted in the background.

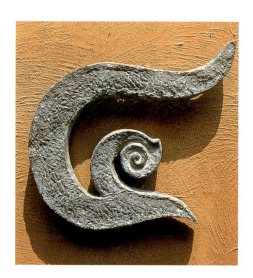

Right We made the top portion of this wall more sculptural than its stacked slate base by randomly finger painting it while the cement was still wet. **Below** The terrazzo bathtubs are deep and luxurious. This bath is fitted with a pair of intriquing custom-made cast bronze faucets, while the back wall is clad with a local Thai triangular dark blue ceramic glazed tile to resemble a blind. *Rhoeo discolor* and *Polyscias scutellaria* are planted in the pots on the left.

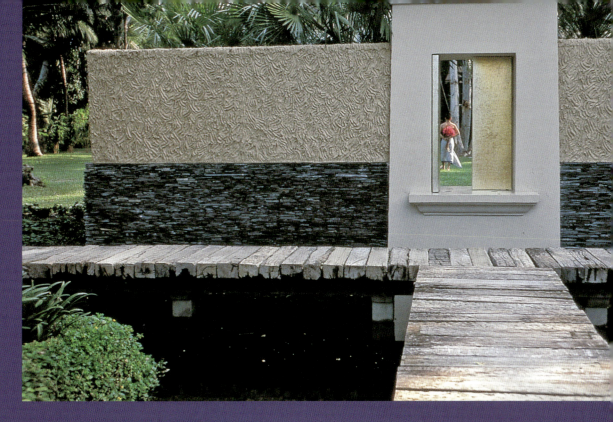

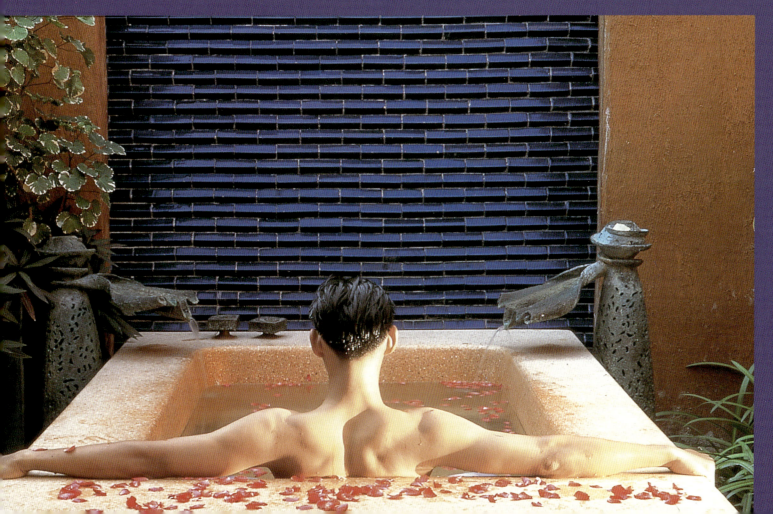

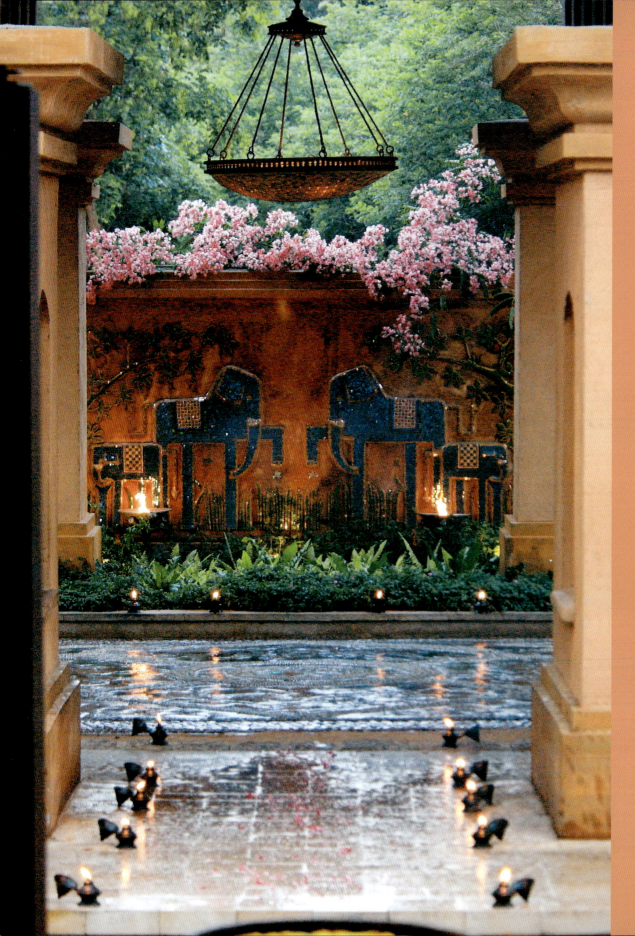

Left One of the prime attractions of the Anantara Resort Golden Triangle is the elephant camp. Set up as both a sanctuary and a way for guests to learn about these gentle giants, it is run by British environmentalist and trained mahout John Roberts, who shares his obvious enthusiasm for his large, elephantine ladies with guests. Naturally, elephants feature in much of the resort's décor, including the porte-cochere (left) with its mirrored glass mosaic elephant mahout, and the Elephant Bar. The brass lanterns in the foreground are a modified version of an old lime container, part of a betel chewing set. The handsome hanging lantern is made from cast bronze and woven rhino skin. In truth, the pink flowering vine is a clipping from a flowering tree (*Cassia javonica*), used to soften the wall for this photograph.
Right The cool weather in Chiang Rai in the far north of Thailand, where the resort is located, is generally cooler than in the south, allowing us to grow annual flowers, which for Thai people are very exotic. **Below right** Our drawing of the elephant gate at the front entrance to the resort.

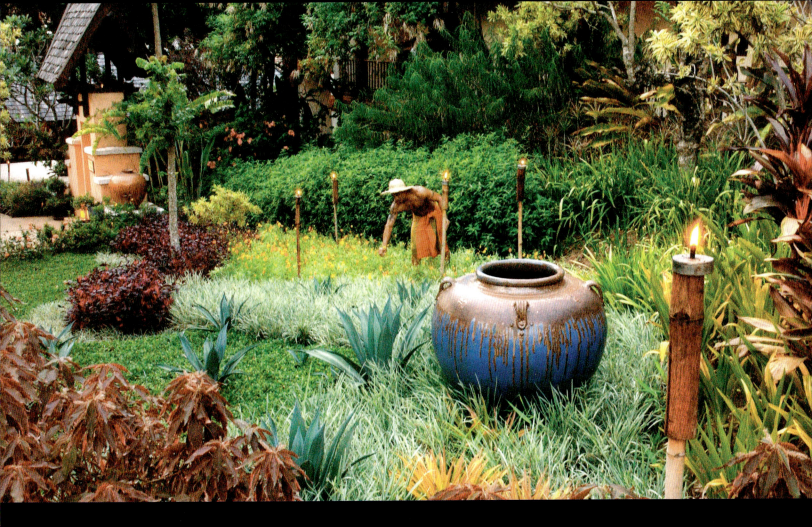

ANANTARA GOLDEN TRIANGLE
ALL ROOMS WITH VIEWS TO BURMA AND LAOS

Perched on a ridge at the confluence of the Mekong and Ruak rivers, and boasting what must be the only swimming pool from which three countries are visible, the Anantara Resort Golden Triangle is strategically placed to explore this evocative corner of Southeast Asia. Visitors can enjoy the exhilaration of a ride on an elephant through the surrounding forest, the rush of a longboat ride up the Mekong to Laos, the joy of exploring the wilderness or rice fields along numerous walking trails which spiral from the resort—or simply spend time rejuvenating at the breathtakingly beautiful Anantara Spa. Everything is on a grand scale in this resort, built in a style which shifts between authentic Lanna-style Thai heritage utopia and sprawling African safari lodge, from its mammoth lobby to its lotus ponds which appear to go on forever.

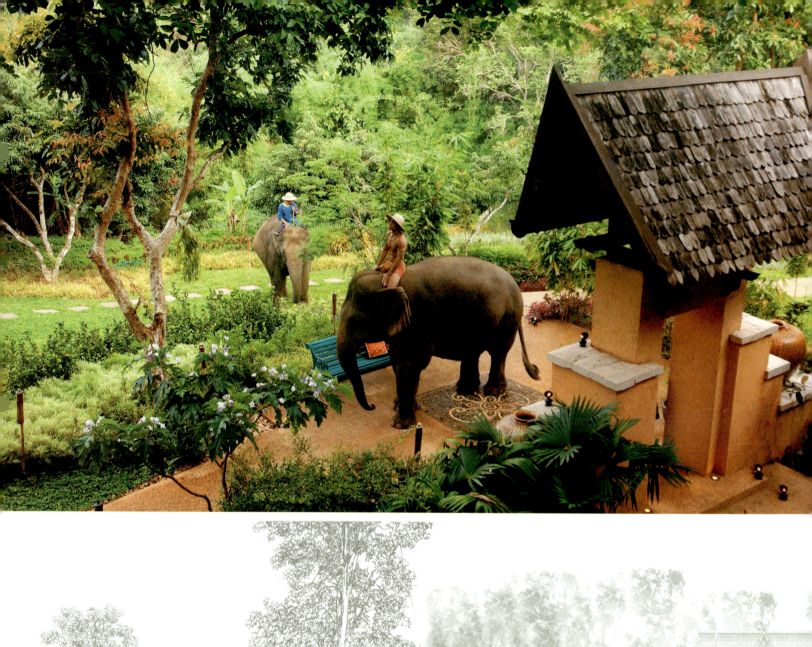

Left Organic crops have been planted and fertilized very successfully by our elephant mahouts and the harvest is always plentiful. I was not afraid to let the gentle giants stamp their way into our precious gardens during photography as they ate only what they knew and spared my exotic plants. They do, however, tend to leave their massive footprints behind. **Below** The seeds of the lotus, which is planted extensively in the ponds throughout the resort, are edible. When steamed and sweetened, they make a popular dessert. **Bottom** This is one of our early drawings of the resort. A restaurant on stilts on the far left is strategically placed to capture views of Burma and Laos. **Right** Jirachai planted layers of colorful ground cover and flowering plants throughout the gardens. The Song of India (*Pleomele reflexa*) to the left of the striking blue bench is a particularly magnificent specimen.

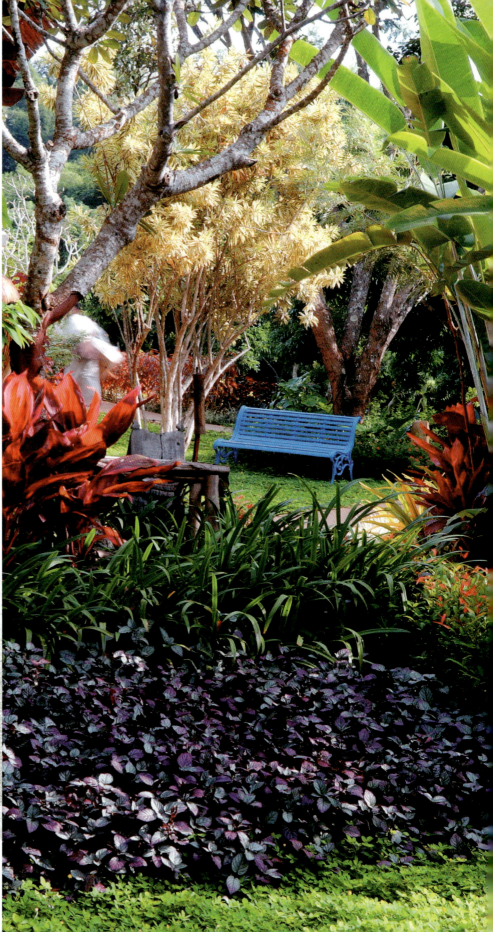

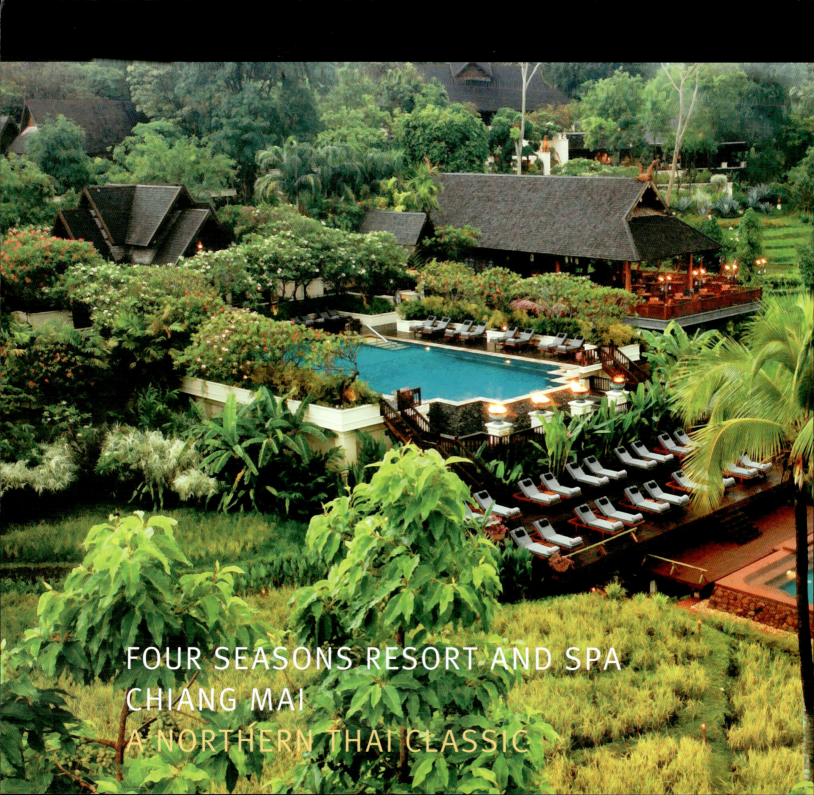

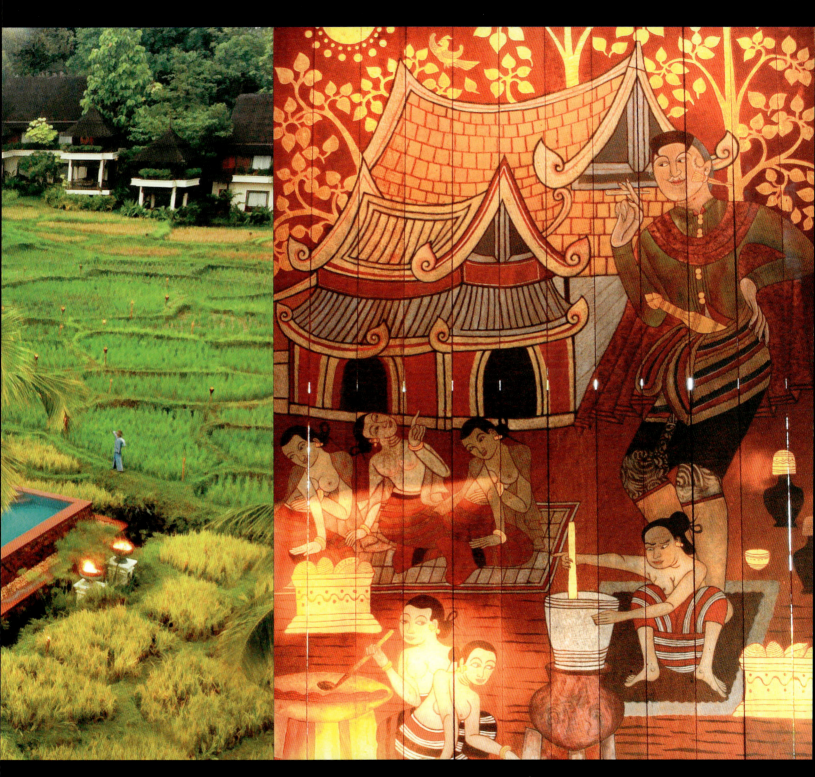

Above left Terraces restaurant, named after the rice terraces that it floats above, is situated on the far side of the upper swimming pool. The lower swimming pool, gas lanterns, a wondrous sight. **Above** In the cooking school, we designed and painted this 11 foot (3.5 meter) high Lanna-style painting, tongue in cheek, showing a

The Four Seasons Resort Chiang Mai is an extraordinary inland hideaway overlooking terraced rice paddies flowing in manicured rivers of green and the mountains of the beautiful Mae Rim Valley. This was the first resort garden Bensley Design Studios ever designed—in a way, it can be considered our first child! – and since its opening in 1992 we have returned several times a year to prune, replant and change the landscape and to improve other aspects of the resort so that visitors will always have something fresh to return to. The resort has become like an ancient Lanna kingdom, and its gardens an old-fashioned handmade quilt composed of hundreds of precious, different colored materials. Guests can leave their elegantly appointed Lanna-style pavilions or their magnificent residences to wander along volcanic stone paths that weave between the houses set amongst the rice paddies, over bridges and rushing rivers to the acclaimed Lanna Spa or, further afield, to explore elephant treks, hilltribe villages or local bazaars.

Over the years we have added an adults only swimming pool to the main pool, set amongst the rice fields; a new, much-extended restaurant, Terraces, in a stunning open-air setting, created from the original pool bar; and a Thai cooking school where up to eight students can have their own stove and working area.

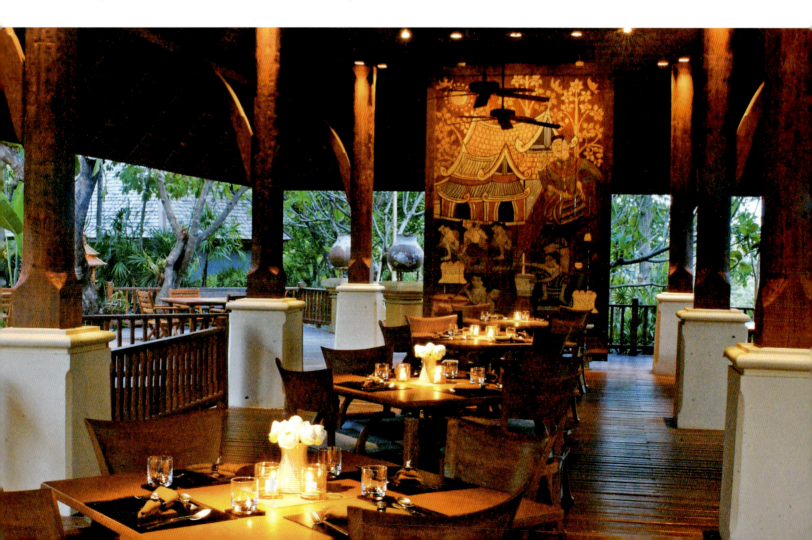

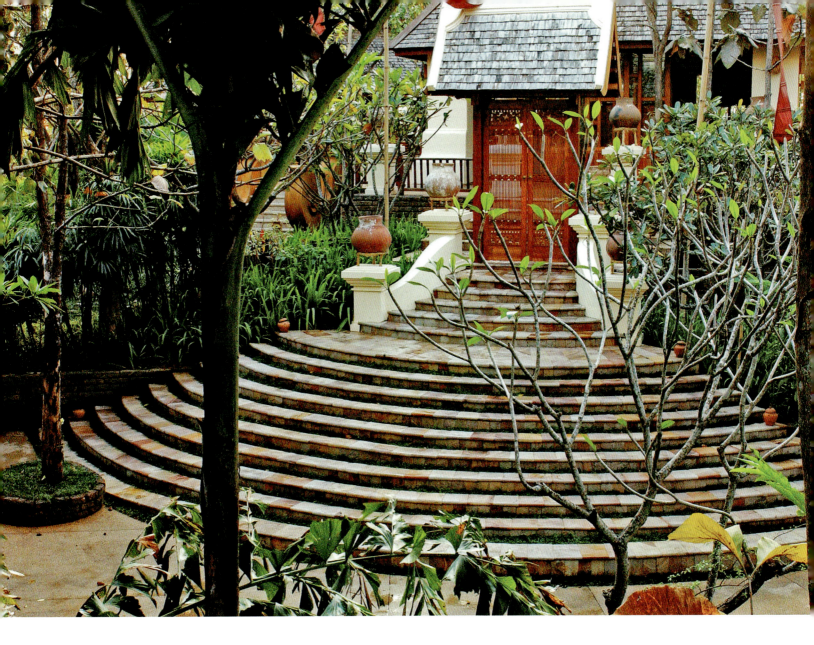

Above left The Lanna-style signage for the rest rooms was hand-painted by Bensley artist Khun Siri Wattana. **Left** The wooden deck of the dining pavilion attached to the Thai cooking school allowed us the flexibility to preserve every existing tree on this mountaintop. **Above** Circular and sculptural steps lead up to the cooking school. **Right** The rice fields at the resort were the cheapest thing to plant in the beginning but, in fact, have become the resort's greatest and most stunning asset as the rice stalks change color with the agricultural cycle.

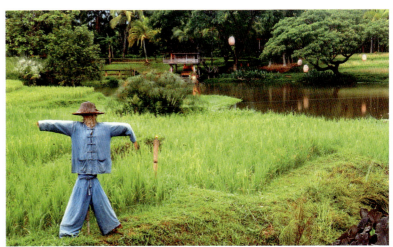

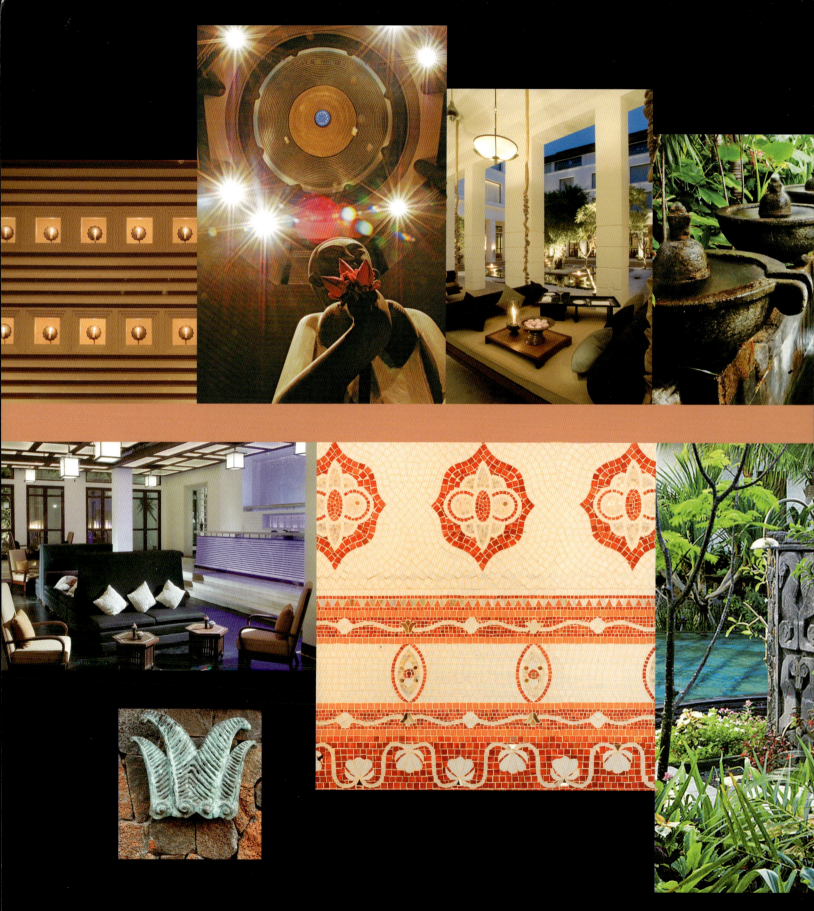

OTHER TROPICAL PARADISES

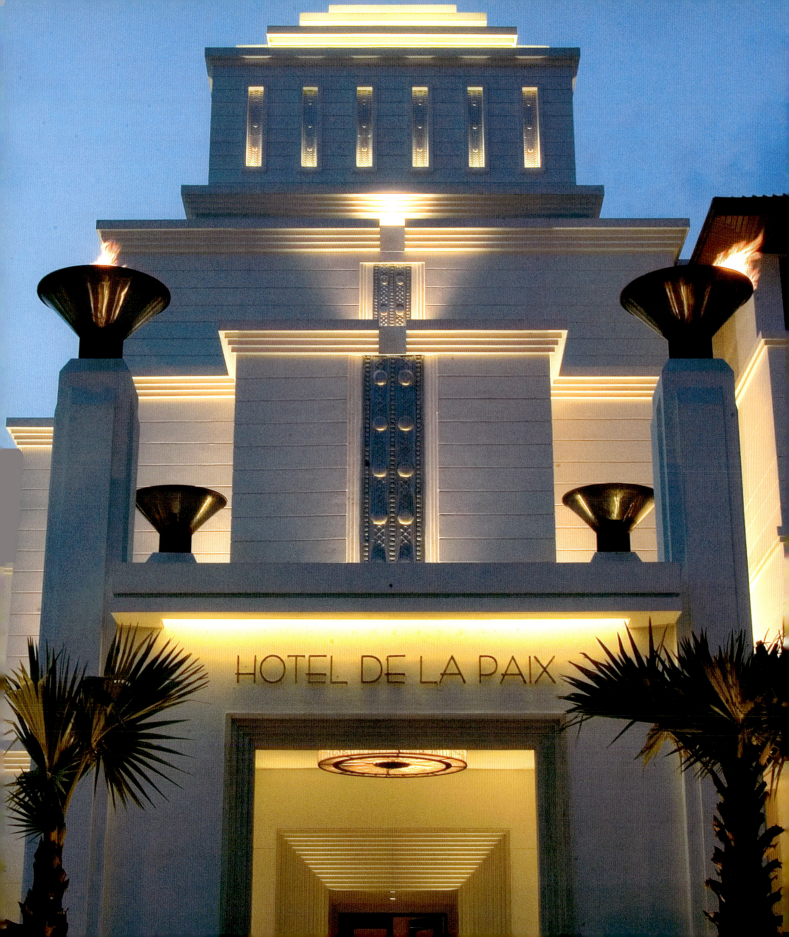

HOTEL DE LA PAIX
SIEM REAP, CAMBODIA
ART DECO RELIVED

The Hotel de la Paix in Cambodia's Siem Reap, gateway to the famous world heritage complex of Angkor Wat, was one of our first projects involving architecture, interiors, and landscape. Built on the site of the original, dilapidated 1950s Art Deco Hotel de la Paix, and managed by the same group who set up Bangkok's über-cool Bed Supperclub, the new five-story building is set around an inner courtyard enhanced with a reflecting pool, water features and one huge fig tree. Behind, overlooking a swimming pool and water garden is the three-story stand-alone Spa Indochine. The hotel's Art Deco-inspired design is complemented by strong Khmer influences. The color scheme of the interiors, which are very architectural and design driven, is black, white and silver, with a touch of bronze. Offsetting this stark palette, staff uniforms and table flowers are a dusty pink lotus hue. Other, brighter colors are present only in the seven-room spa bungalow.

In the language of Angkor's inner sanctum, the entrance to the hotel is a 65 foot (20 meter) high atrium finished in stone and paginated metal. A dome on the roof reveals a tiny oculus that focuses a beam of light through the shaft. A long hallway connecting the entrance foyer, reception desk and meeting rooms terminates in our contemporary Art Deco version of an *apsara* (celestial dancing girl). A series of archways leads off this corridor, much like in a Khmer temple but with higher ceilings.

Left This is our most expressive exterior façade to date. We chose to follow the Art Deco architectural style of the original hotel, built on this very corner in the 1950s. The brushed stainless steel torchères are blown-up versions of a 6 inch (15 cm) 1920s Art Deco silver chalice. The main central tower—the entrance foyer—has an oculus some 20 inches (0.5 meter) in diameter at the top. On a sunny day, this lets in an animated shaft of light which travels around the floor of the foyer. It is especially eye-catching when the sun is directly overhead and the shaft of light illuminates the beautiful stone *apsara*. **Right** This is our interpretation of an Art Deco-influenced Khmer *apsara*, or celestial dancer, lining the galleries of Angkor Wat.

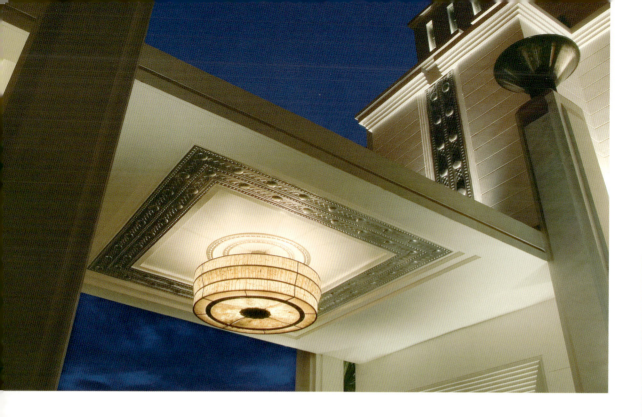
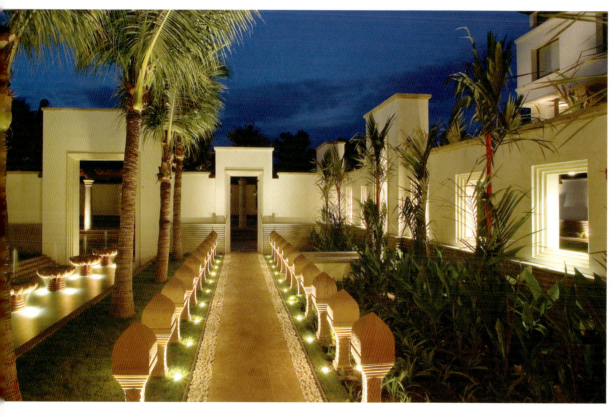
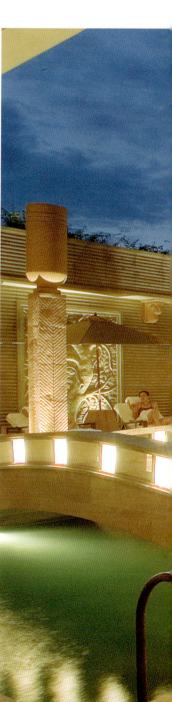

Left The roof of the porte-cochere is a simple flat slab straddled by decorative columns. A silver leafed plaster relief made by Australian designer John Underwood frames the striking pendant lamp. **Below left** This small corner of the gardens looks much bigger than it really is because of the repeating lanterns. **Right** The full façade of the sleek, geometric, Art Deco-inspired building is quite dramatic when lit up at night. **Below** The swimming pool and the three-story Spa Indochine are richly detailed in Khmer-style ornamentation, such as the bas-reliefs on the walls of the corridors, reminiscent of the galleries at Angkor; the detailed columns along the corridors; the coping of the pool; and the lotus-shaped ends of the brass pool ladder.

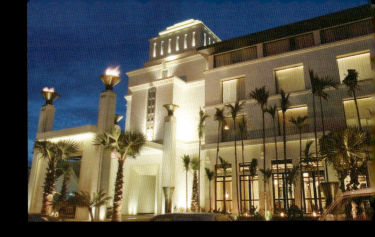

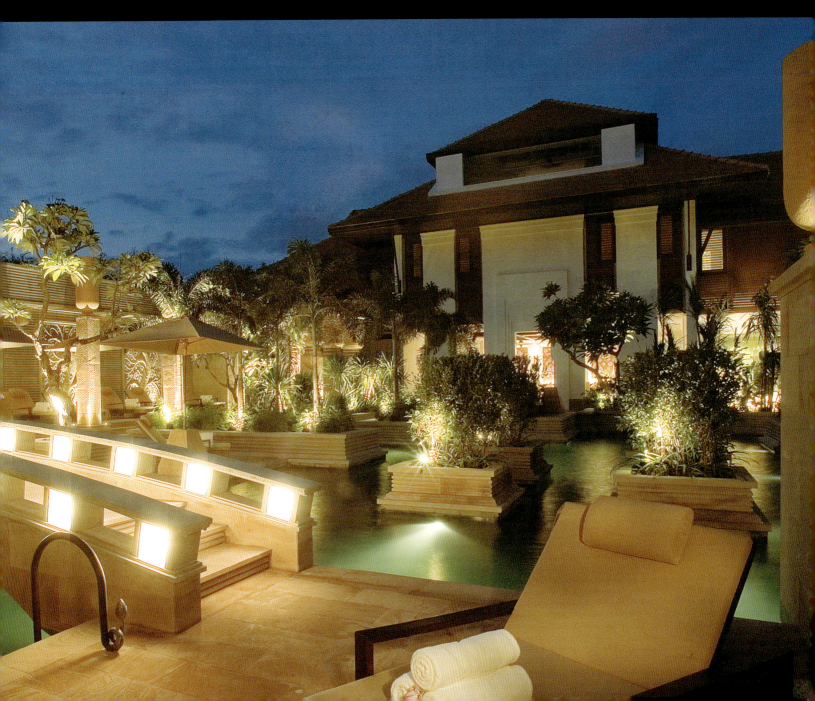

Left Rotating exhibitions are held every 6–8 weeks in the Arts Lounge, a unique venue for showcasing a variety of modern and traditional Cambodian art forms and the hotel's way of fostering local artists. One of our first exhibits, shown here, was a series of avant-garde photographs. Because of the unique lighting style of the photos themselves, we turned out all the lights and gave guests a flashlight with which to view the art. **Below** The lower area of this space is sometimes flooded with water. The reflections are magical. Above the bar, in white on white, is an Angkor-inspired botanical relief lit by a ceiling of many panels of back-lit white glass. **Right** The repetitive lines of this and all of our doorways are Art Deco but influenced by local Khmer architecture. I placed a mirror in the final niche to emphasize the length of the space.

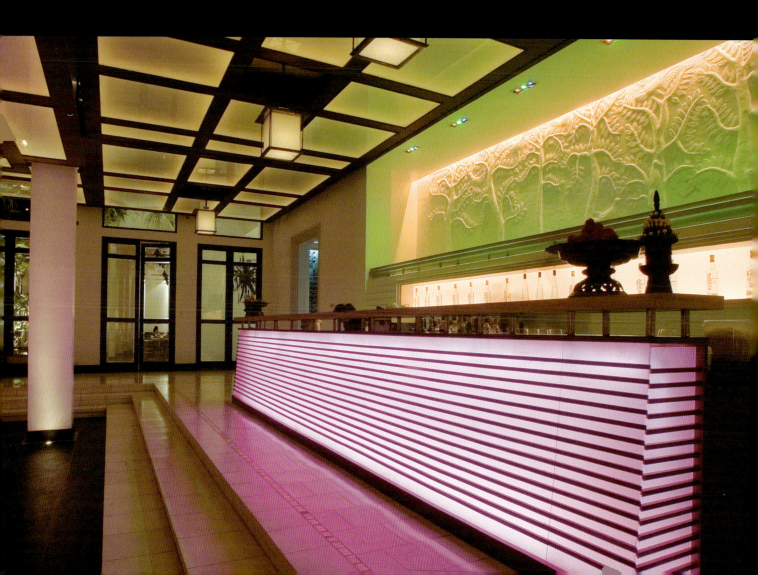

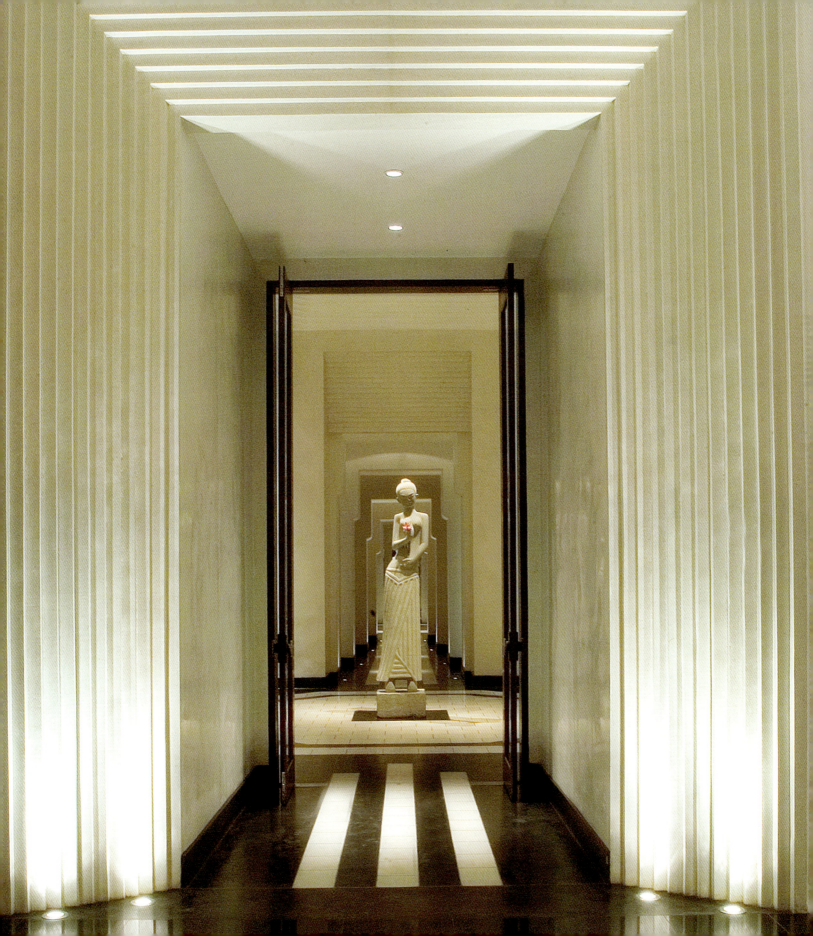

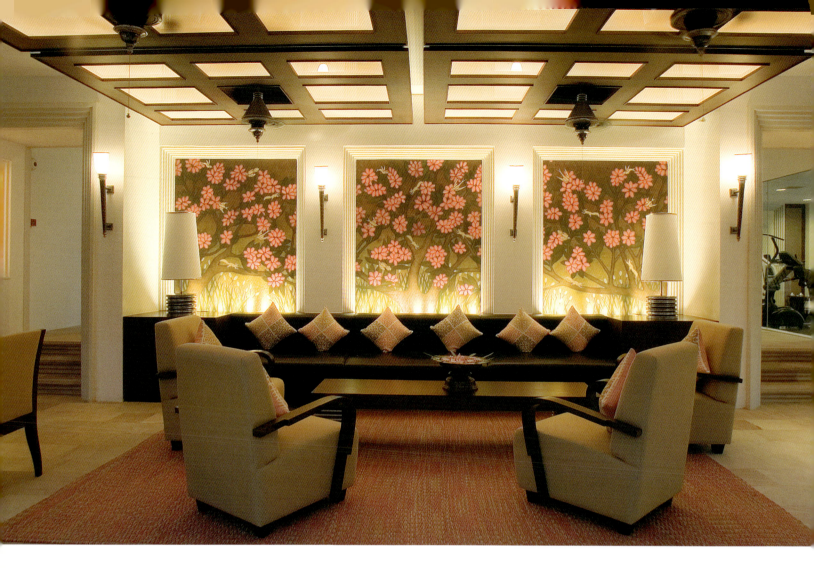

Above The award-winning Spa Indochine is the only place in the entire hotel where we used a color other than black, white or silver. Korn, Siri and Kit painted this triptych of pink flowering plumeria trees in my Bangkok studio. **Left** This popular cabana suite faces directly onto the pool and is one of a kind among the 107 rooms and suites in the hotel. Because the building twists and turns to fit the site, there are, in fact, 28 different room plans. This quirkiness only adds to the small boutique feeling of the hotel. My favorite room type is the duplex spa suite with its private bathtub, sunning deck and spa on the roof. **Above right** The swing arcade forms the fourth side of the performance courtyard, which is lit by four theatrical torchères and anchored with an ancient-looking banyan tree that we found outside of the village and brought in by hand; some 29 men struggled for a full day to get it in place. **Right** This Khmer bas-relief on the pool courtyard wall screens out noise from the neighboring T-shirt printing factory.

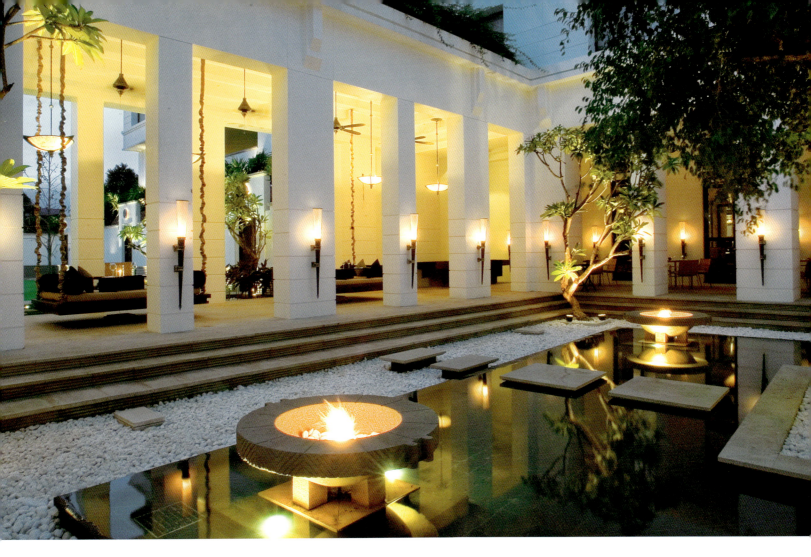
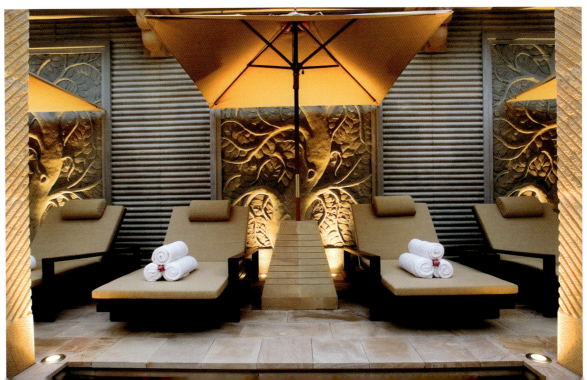

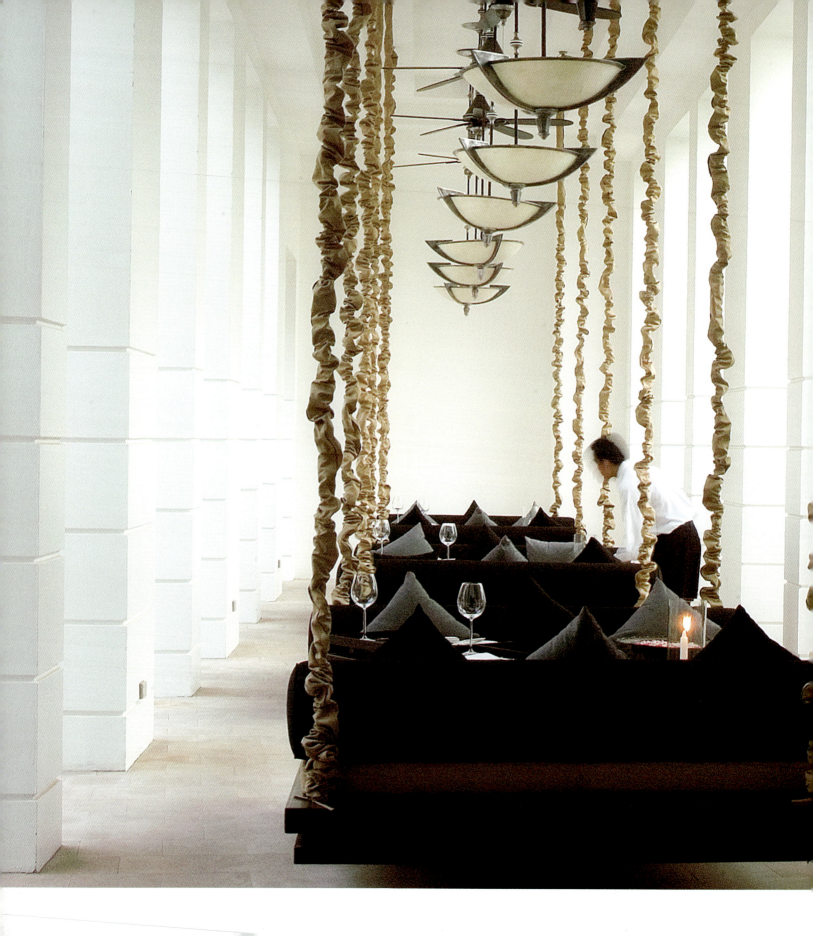

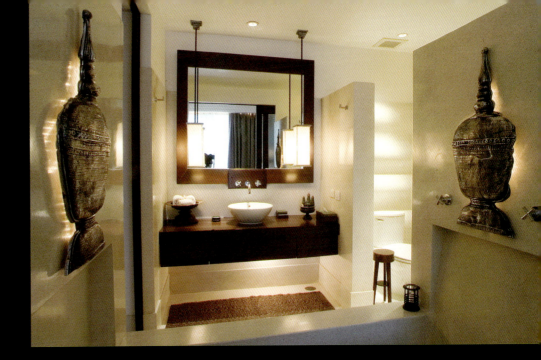

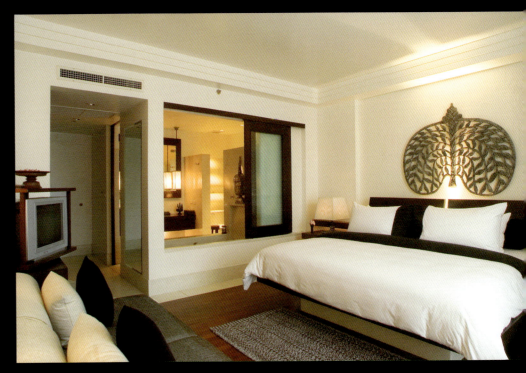

Left Part of the Meric restaurant (*meric* means "pepper" in Cambodian), these three swings are a very popular alternative to conventional tables and chairs. The restaurant serves the best breakfasts in Asia as well as cutting-edge Khmer cuisine showcasing the distinctive harvests of local farmers and "wild" produce. **Top** We used white terrazzo for this bathroom and bath. The wall decorations are cast in pewter. To the right, the rain shower is recessed in the ceiling and lit, while the back wall is a wavy terrazzo. **Above** The bath can be a part of the bedroom or closed off. The wooden platform of the bed floats above a terrazzo base. Behind the bed is an enlarged version of a very small thirteenth-century Khmer bronze fragment that I first saw in the National Museum in Phnom Penh.

LE TOUESSEROK MAURITIUS
A TROPICAL OASIS OF TRANQUIL LUXURY

Above The mosaic wall behind the reception desk at Le Touesserok makes a stunning focal point in the light-filled lobby. Designed by Jan Clausen, formerly of HBA, the mosaic is composed of hundreds of tiny Italian glass tiles and features vegetal motifs and medallions. In the foreground, a ceiling-to-floor column is covered with a lavish arrangement of fresh *Anthurium* sp., a flamingo lily grown extensively on Mauritius for export.

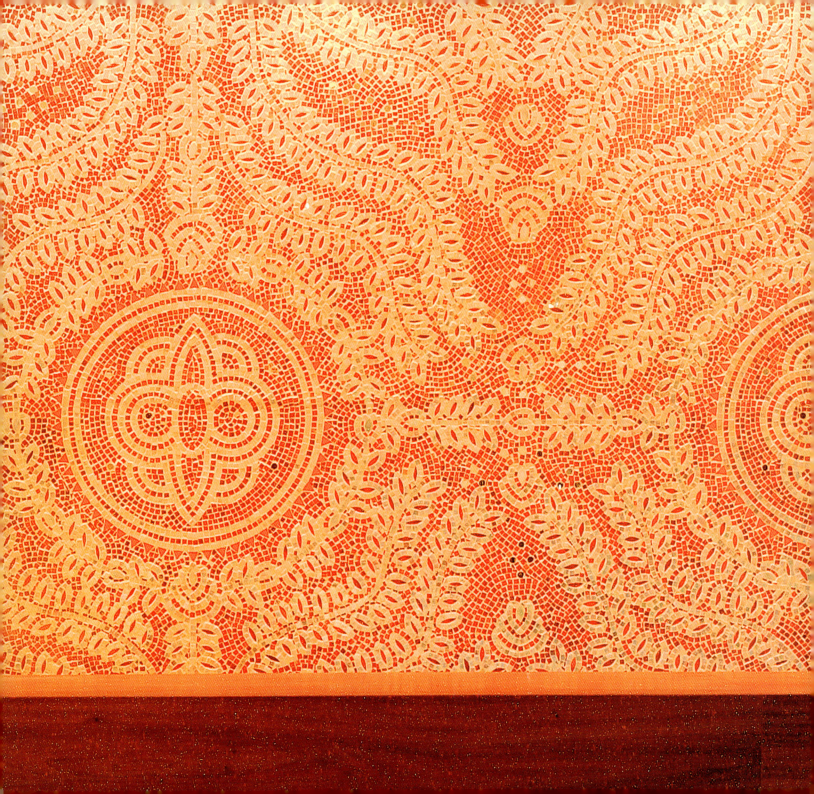

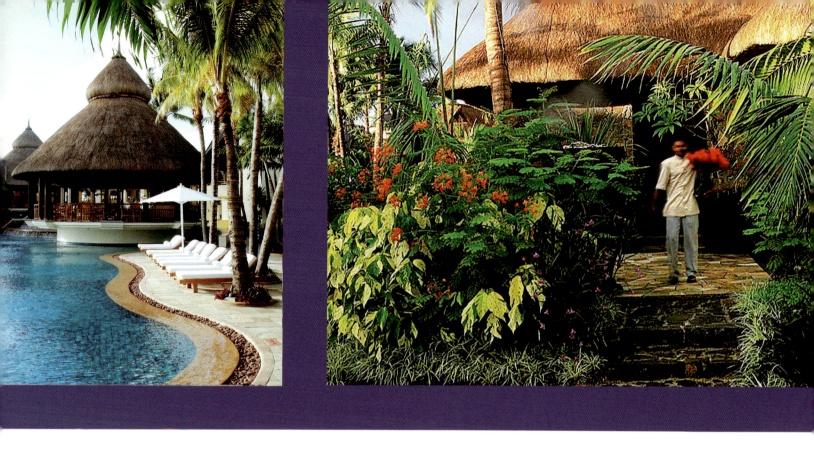

Located on the east coast of the coral-fringed island nation of Mauritius in the southwest Indian Ocean, and on a cluster of tiny islands nearby reached by bridge or boat, the One&Only Le Touesserok has been named one of the world's great romantic getaways. The architecture of the spectacular and spacious resort combines dazzling off-white Mediterranean-style stucco walls with Mauritian-accented thatched roofs, set off against brown wicker furniture and bursts of color. The gardens capitalize on the existing natural features. This was Bensley Design Studios' second commission for One&Only, the first being the classic One&Only Le Saint Géran just 20 minutes away, and our brief was to revamp the gardens in conjunction with a renovation of the existing hotel, redesigned to cater to the younger European crowd. Jonathan Ridler and Beata Kaleta of RSL were the architects, while Jan Clausen conceived the trendy interiors. In addition, we landscaped almost the entire Ile aux Cerfs, home to a stunning 18-hole championship golf course, a short boat ride away from the resort.

The most magnificent specimen at Le Touesserok, a colossal 100-year-old sacred Indian fig or banyan (*Ficus benghalensis*) with a diameter of 100 feet (30 meters), greets arrivals who are driven around it to reach the drop-off point. I decided to hang 20 burnished stainless steel birdcages crafted by John Underwood in the tree. The cages, warmly lit within using a lighting design by David Bird, are a wonderful sight at night.

Elsewhere on the property, we set about improving the softscapes, making them richer and more ornamental. Maintaining an overtly beachy theme, we installed primitive blackstone andesite sculptures, custom-made in Indonesia. We also designed and built new features on Frangipani Island, accessible via a wooden bridge from the main hotel, including the Givenchy Spa, Barlen's "toes-in-the-sand" type restaurant, coconut swings, and a beautiful pool, which picks up the motifs of Jan Clausen's hip interiors.

Magical scenery can be found on the resort's IMG-designed golf course, which was whittled out of the mangrove and forests on nearby Ile aux Cerfs. Our Brian Sherman directed the planting and Bob Thor designed the signage. After clearing the weeds and brush, we exposed a host of natural features and advised IMG not to touch these, but to show them off. The main design was centered on the clubhouse, putting green, driving range and the series of landscape terraces leading from the 18th hole to the clubhouse.

Far left The main free-form swimming pool as well as the stage for the main restaurant and the bar beyond look straight out to the lovely curve of Trou d'Eau Douce Bay. **Center left** As is invariably the case in the tropics, gardens grow profusely. I took this photograph four months after we planted the gardens. **Left** Custom-made to our specifications and shipped all the way from Java, this *batu candi* planter showcases the firecracker plant (*Russelia equisetiformis*). **Right** One of our drawings for the splendid burnished stainless steel birdcages made by John Underwood for hanging in the ancient banyan tree at the arrival court. **Below** We landscaped almost the entire Ile aux Cerfs. The golf course is stunning and almost every hole is seafront. No accommodation can be seen from any part of the course, only the ocean and the green, undisturbed mountains of Mauritius. The primitive agrarian terraces, visible from the 18th hole up to the stone-and-thatch clubhouse designed by Alistair Macbeth, are lined with pandanus trees, noted for their intriguing aerated roots and spiky, strappy leaves.

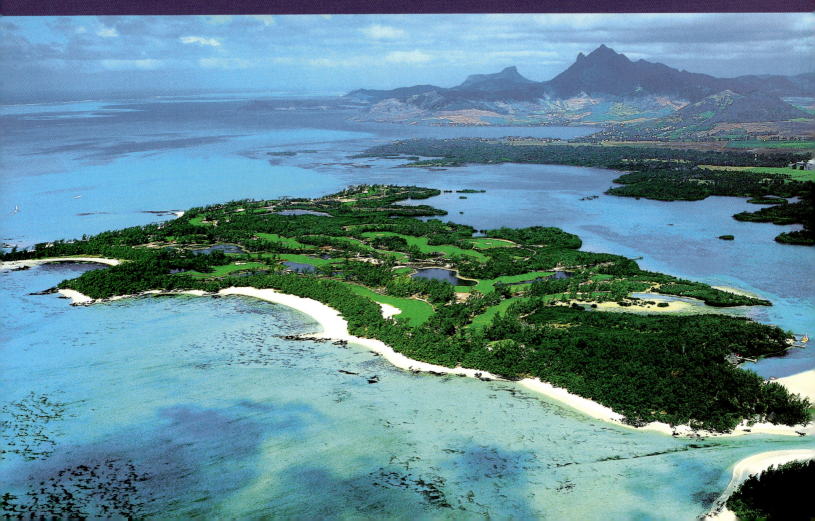

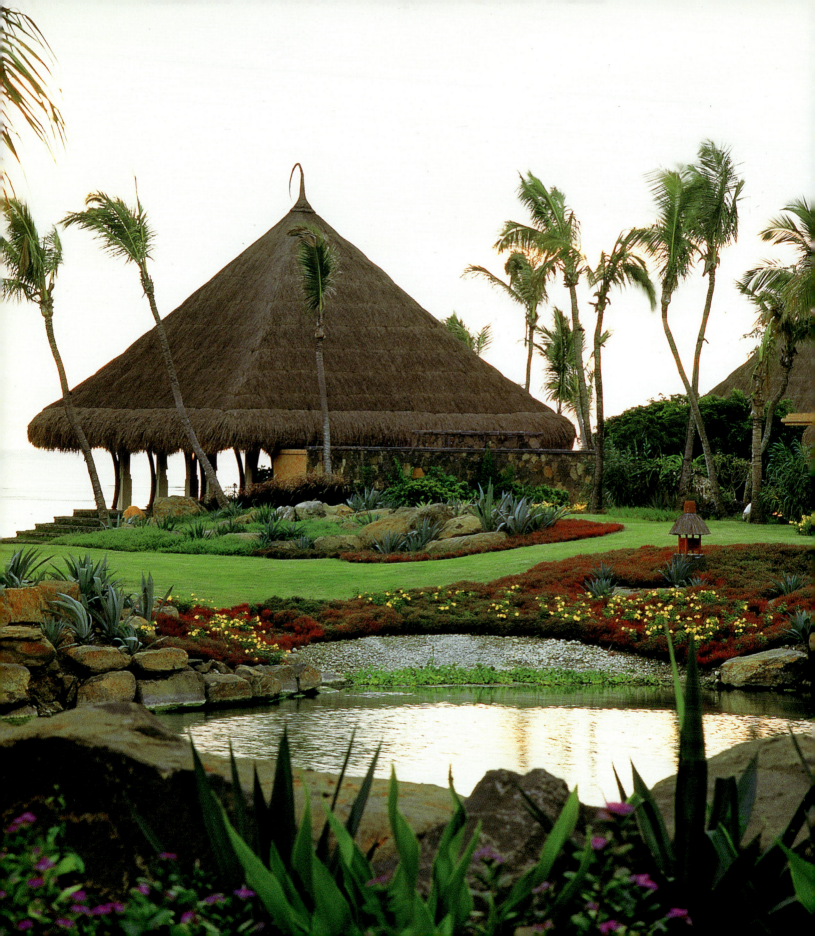

OBEROI MAURITIUS
SUNSET IN PARADISE

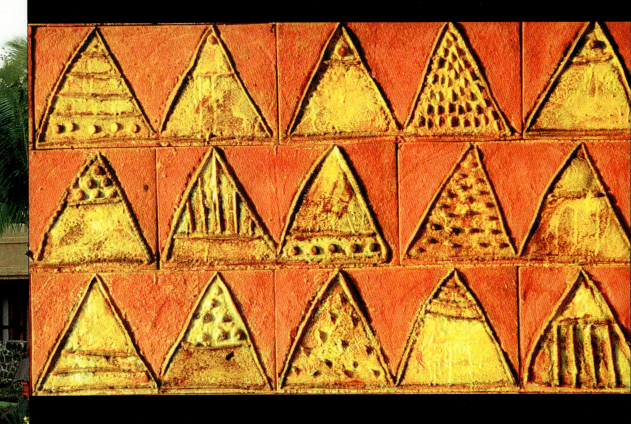

The Oberoi Mauritius, tucked in the sand-filled Baie des Tortues on the northwest coast of Mauritius, is a refreshing addition to the local resort scene on the idyllic island. Not only does it pay homage to the stunning natural surroundings but it also captures the spirit of the island and its diverse cultural influences in its buildings, interiors, gardens and cuisine. Lek Bunnag, H. L. Lim and Bensley Design Studios were engaged by P. R. S. Oberoi, veteran hotelier and chairman of the Oberoi Group, to reinvent this project which had been started by another firm, with the goal of achieving sea views from 95 percent of the rooms. This was a challenge as the site was very flat. But by devising a plan of five U-shaped bays, with views of the sea stretching deep into the site and the back of each U artificially raised, we were able to produce undulating contours and give each bay a unique character. Some 106,000 cubic feet (30,000 cubic meters) of blue stone basalt boulders, some as large as a car, had to be excavated and relocated. Many were stacked to create beautiful boundary and retaining walls for the sunken gardens. Using the local sugar cane, Lek created a magical soaring roofscape, while many stone sculptures around the resort celebrate the ethnic diversity of Mauritius.

Left The bar and the restaurant beyond, located in the first U-shaped bay along with the lobby, face west for great sunsets. **Above** Australian ceramicist-cum-artist Graham Oldroyd, inspired by the textiles of the Congo, made these ceramic murals for our pool bar. Most of the island's residents are descendants of people from the Indian subcontinent, but there are also large immigrant populations from continental Africa, Madagascar, France, Great Britain and China, among others.

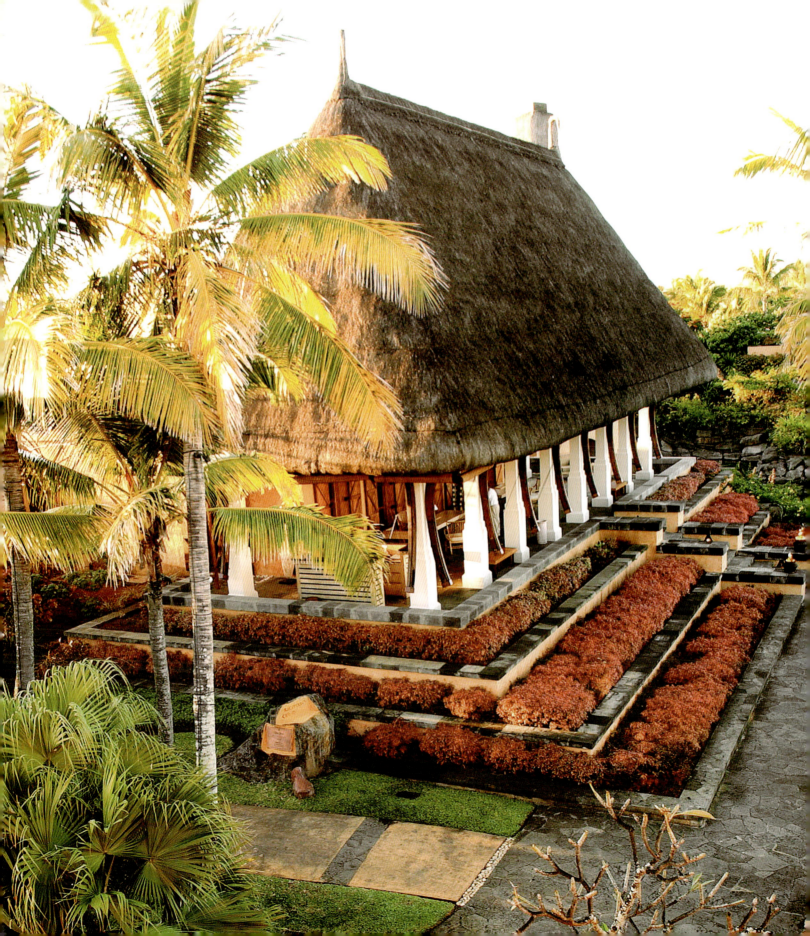

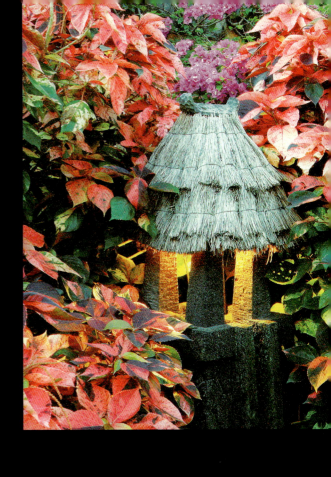
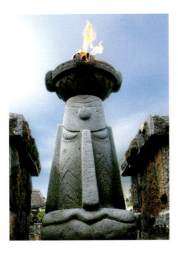
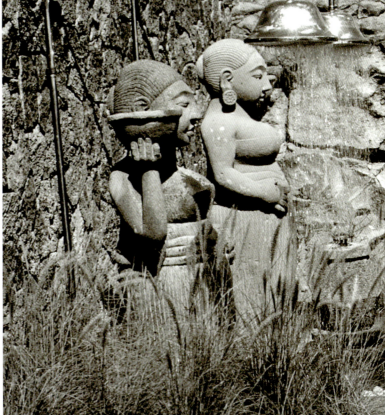

Opposite We placed Lek Bunnag's stately reception pavilion on a series of steps planted with red joyweed (*Alternanthera bettzickiana*), while H. L. Lim, founder of LTW Designworks, deftly handled the African-inspired interiors. **Above** Detail of the playful andesite columns in the family swimming pool (see page 239). **Above right** Purple bougainvillea and copper leaf (*Acalypha wilkesiana*) make a rich combination around this garden lantern crafted of grass and Javanese sandstone. The cool tropical climate of Mauritius allows some plants to produce more vibrant colors. **Left** Our director Bob Thor, with a great hand and a huge personality, designed many of the fantastical sculptures, drawing inspiration from Mauritian folklore. **Right** Here, two well-endowed Mauritian mothers stand guard at the pool showers. The resort is located among 20 acres (8 hectares) of subtropical gardens.

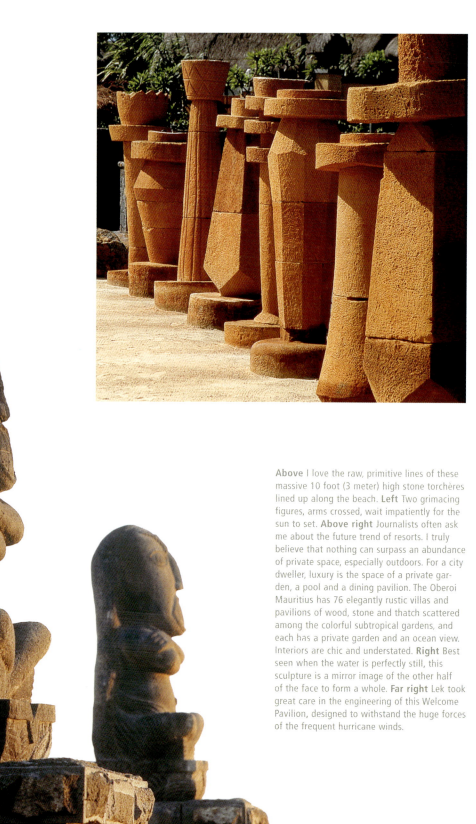

Above I love the raw, primitive lines of these massive 10 foot (3 meter) high stone torchères lined up along the beach. **Left** Two grimacing figures, arms crossed, wait impatiently for the sun to set. **Above right** Journalists often ask me about the future trend of resorts. I truly believe that nothing can surpass an abundance of private space, especially outdoors. For a city dweller, luxury is the space of a private garden, a pool and a dining pavilion. The Oberoi Mauritius has 76 elegantly rustic villas and pavilions of wood, stone and thatch scattered among the colorful subtropical gardens, and each has a private garden and an ocean view. Interiors are chic and understated. **Right** Best seen when the water is perfectly still, this sculpture is a mirror image of the other half of the face to form a whole. **Far right** Lek took great care in the engineering of this Welcome Pavilion, designed to withstand the huge forces of the frequent hurricane winds.

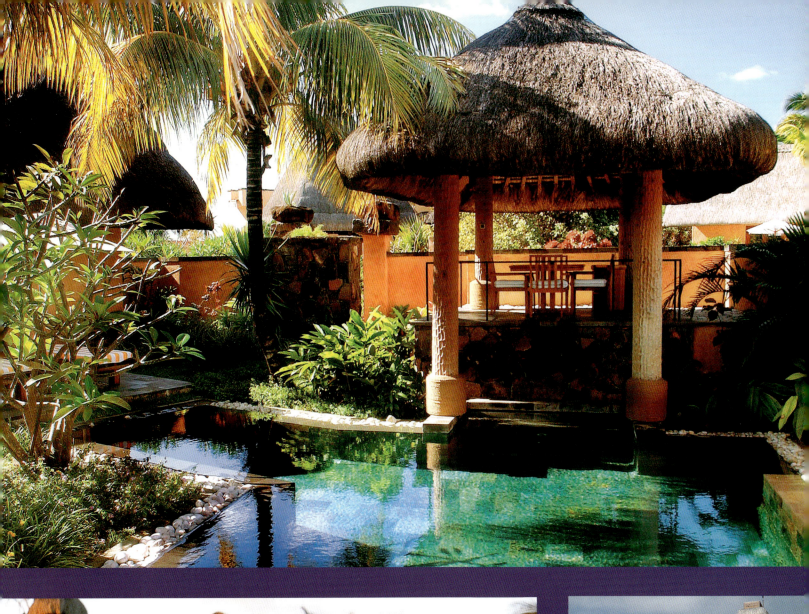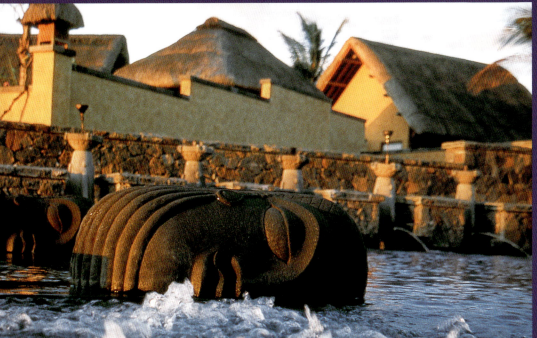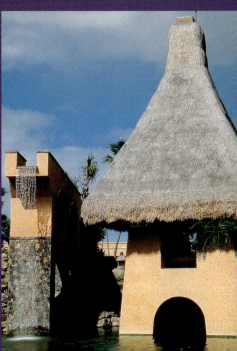

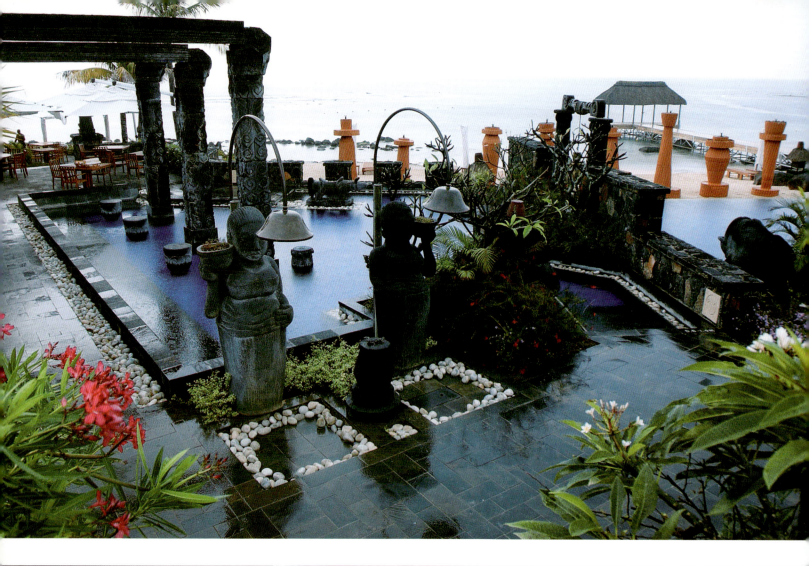

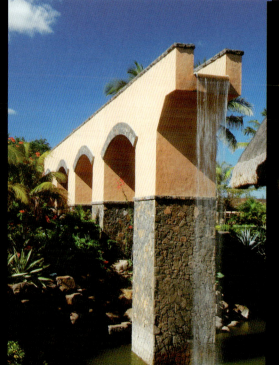

Above The family pool, located in one of the five U-shaped bays, is richly animated with waterfalls, murals, sculptures and art. More stone statues of Mauritian women guard the pool showers. **Right** Sugar cane is grown on about 90 percent of the cultivated land area in Mauritius, and many aqueducts were built previously to irrigate the fields of cane. Here, I borrowed from that history to make a dramatic 50 foot (15 meter) waterfall at the entrance to the resort. **Center right** In 1985, I bought a series of primitive candle stands made by a betel farmer in Probolingo, Java. We used them at Baan Botanica until this project came along and they proved to be the perfect inspiration for these beachside torchères.

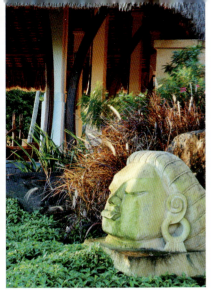

Above Placed just outside the beachfront bar, this Mauritian beauty has witnessed every sunset since we opened in 2002. **Right** Three wooden troughs originating from above the pool bar, bring life and the white sounds of falling water to the family pool complex. Dramatic water features of carved heads—renditions of Mauritian women—and stone pillars create the effect of swimming through a half-submerged temple in both this and the adult only pool.

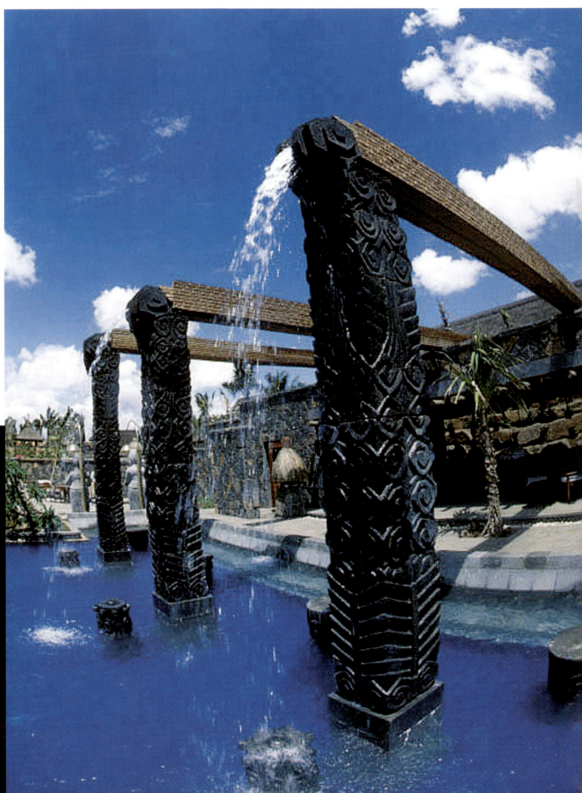

ACKNOWLEDGMENTS

I would like to pay tribute to many friends and family for their inspiration and help with this book.

Thanks to Brian Sherman for being my big brother and for looking after Bensley Design Studios through thick and thin.

Thanks to Ouant, the most talented designer on the face of the earth.... You know no limits!

Thanks to Putu, our rising star in Bali, for your great work.... May you have time to paint happily with your fingers and toes.

Thanks to our endearing and loyal designers of ten plus years: Chang, Wat, Thor, Pong, Korn, Siri, Noi, Nui, Kit, Ja, Nueng, Tui, Toi, Neng.... You are the heart and soul of BDS. Not forgetting our always cheerful ringleader, Ms Keng.

Thanks to Lek Bunnag, the best architect I know, for being a wonderfully patient teacher.

Thanks to John Underwood, the Renaissance man, for always making us look great.

Thanks to Bill Heinecke for giving me many chances to experiment with landscape, interiors and, more recently, architecture.

Thanks to Tan Hock Beng for inspiring me to write and to publish, as well as Peter Meyers and Kuk for editing this book.

Thanks to Howie and Mam and Simon and Jeffrey Wilkes for being my great friends and sounding boards. Thanks, Jeffo, for teaching me something about interiors whether you wanted to or not! You are my idol.

Thanks to my sweet mum, my ever learning, ever inquisitive father, and my always caring brother and sister, John and "Dr Ann."

And, most of all, thanks to Jirachai, my partner in life.

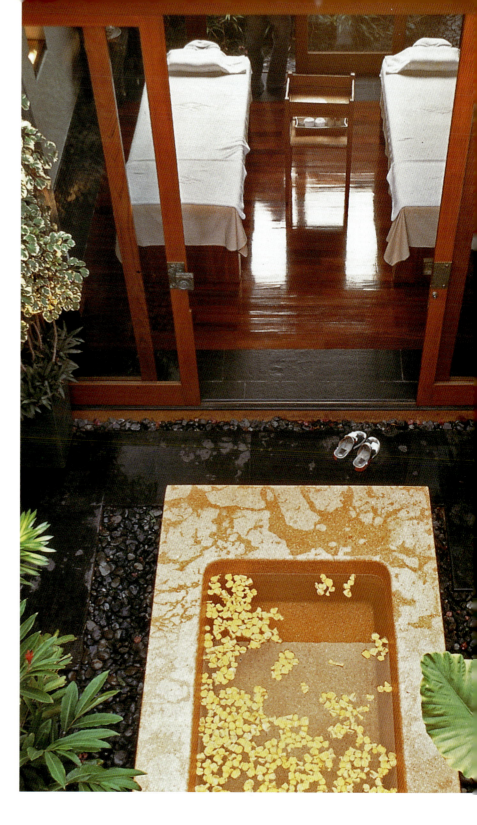

Right One of the treatment rooms at the Anantara Spa by Mandara, Hua Hin, Thailand (page 202).